# THE ART OF RESPONSIVE DRAWING

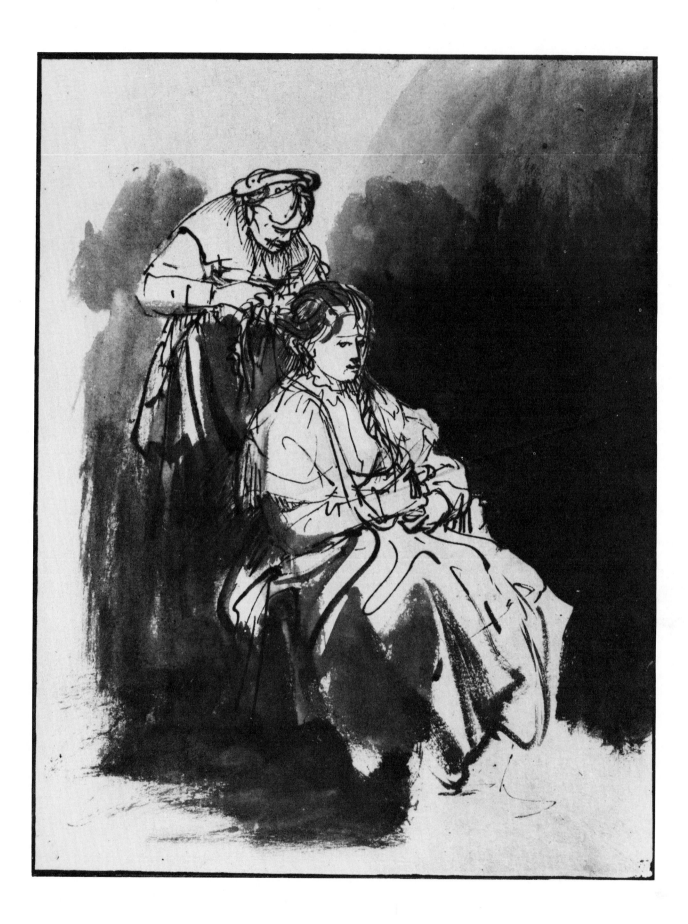

# THE ART OF

# RESPONSIVE

# DRAWING

## NATHAN GOLDSTEIN

PRENTICE-HALL, INC., ENGLEWOOD CLIFFS, NEW JERSEY

ISBN: 0-13-048637-X

*Library of Congress Catalog Card Number: 72-12289*

PRINTED IN THE UNITED STATES OF AMERICA

10  9  8  7  6  5  4  3  2  1

PRENTICE-HALL INTERNATIONAL, INC., LONDON
PRENTICE-HALL OF AUSTRALIA, PTY. LTD., SYDNEY
PRENTICE-HALL OF CANADA, LTD., TORONTO
PRENTICE-HALL OF INDIA PRIVATE LIMITED, NEW DELHI
PRENTICE-HALL OF JAPAN, INC., TOKYO

The frontispiece illustration, Rembrandt
van Rijn (1606–69), *Young Woman at Her
Toilet* (Pen, ink and wash) is used courtesy
of the Albertina Museum, Vienna.

*For Renee and Sarah*

*"Art hath an enemy called Ignorance."*

BEN JONSON

*"O young artist, you search for a subject—*
*everything is a subject. Your subject is*
*yourself, your impressions, your emotions*
*in the presence of nature.*

EUGÈNE DELACROIX

# Contents

# Preface

This book is intended for the art student, the interested amateur, the art teacher, and the practicing artist who wants to broaden his understanding of the concepts, potentialities, and processes involved in drawing from nature.

All drawings, whether they reflect our interpretation of observed or invented subjects, are responsive. They are all founded on our intellectual and intuitive judgments about a subject *and* its organized expression on the page. But, the primary concern of beginning students (and many practicing amateur and professional artists) is to expand their ability to experience and to state their world in graphic terms, and to better understand the options and obstacles that confront them when drawing from nature. For this important reason, and because there is no way to test the aptness of responses to imaginary stimuli, this book focuses on drawing as a responsive encounter with our physical world.

Here, *responsive* refers to our perceptual, aesthetic, and empathic interpretations of an observed subject's properties that hold potential for creative drawing. In responsive drawing, comprehending a subject's actualities precedes and affects the quality of our responses. Such drawings do more than recall what the outer world looks like. They tell us what our intuitive knowledge informs us it *is*.

This is not a how-to-do-it book; rather, it is a kind of how-to-see-it book. The exercises in the first nine chapters are designed to help the reader experience the issues dealt with in each, and not to suggest techniques or ready-made solutions. It explores the disguises of shapes and forms in nature, examines the visual elements and relational and emotive forces that constitute the language of graphic expression. I have omitted references to color, and to drawings made on surfaces other than flat, bounded ones, because both are incidental to the fundamentals of responsive drawing. Most of the drawings reproduced here were made in the presence of the subject depicted. Those few that were not are included because they clearly illustrate points in the text.

The book begins by examining the factors that enable us to respond to a subject's measurable actualities, its relational possibilities, and emotive character. It then proceeds to explore the concepts, forces, and "pathologies," or common (but seldom discussed) failings of perception, organization, and expression in drawing. The examination, in Chapter Ten, of these pathologies, is, I

believe, the first attempt to catalog the various misconceptions, inconsistencies, and errors that every one drawing responsively faces. The pathologies discussed should enable the reader to apply a much wider range of criteria in evaluating his drawings.

I have not attempted the impossible task of defining all the characteristics of great responsive drawings. I have, however, pointed out those factors, which if left unregarded, make the creating of such drawings impossible.

I wish to acknowledge my gratitude and thanks to the many students, artists, and friends whose needs, experiences, advice, and interest helped to test, shape, and sustain the forming of this book. I wish also to thank the many museums and individuals for granting permission to reproduce the drawings in their collections.

I wish, especially, to thank Professor Jack Kramer of Boston University's School of Fine and Applied Arts, a fellow artist and author, for his time and good counsel, Jonathan Goell, whose excellent photographs make an important contribution to the book's clarity, Walter R. Welch and William Gibson, of Prentice-Hall, Inc., for the many considerate and generous ways in which they helped along the way, Paula Cohn, the production editor, Joe Nicholosi, the designer, and Marvin Warshaw, the art director, for their skill, patience, and care in helping to give the book its present form, and Mrs. Carol Love, who worked hard and well, typing the manuscript. I owe a particular debt of gratitude to Martin Robbins, a poet and deeply valued friend, for many hours spent helping me to state my thoughts. His interest in art and wholehearted involvement with the book provided me with much wise guidance. My greatest debt of gratitude and thanks I owe my wife, Renee, who handled the voluminous and often intricate correspondence with museums, artists, and collectors on three continents, provided invaluable advice, proofread every word at every stage, and provided the working atmosphere that helped so much. Finally, I want to express my gratitude and apologies to my daughter, Sarah, who, at the age of five, understood (usually) and allowed for a part-time and generally distracted father.

NATHAN GOLDSTEIN

# 1

# Gestural Expression

*DEDUCTION*

*THROUGH FEELING*

## A DEFINITION

When confronted for the first time by any subject matter, whether a model, landscape, or still-life arrangement, many students ask, "How shall I begin?" For them, the complexity of a subject's forms, its values, textures, scale relationships, and position in space seem too difficult to grasp. There appears to be no logical point of entry, no clue to what should be done first—or last. If the subject is a figure, many students decide to begin by drawing the head, *followed* by the neck, *followed* by the shoulders, and so on. But such a sequential approach inevitably results in a stilted assembly of independent parts, which have little or no affinity for each other as segments of *one* thing—a figure. Whatever the subject, this process of visual induction, this collection of parts which should, when completed, add up to a figure, tree, basket, or building, is *bound to fail* —always.

It will fail in the same way the construction of a building will fail if we began with the roof or windows, or, realizing this is impossible, build by finishing and furnishing one room at a time. Such a building will collapse because no structural, supportive framework holds the independently built rooms together. Without an overall structural design, none of the requirements com- mon to various rooms, such as heating, wiring or plumbing systems can be installed (without tear- ing apart each room) because no appropriate steps of construction for the *entire* building oc- cur. Without such a design or plan, none of the relationships of size, shape, placement, etc., can be fully anticipated.

Any building process must begin with a *gen- eral* design framework and its development be advanced by progressive stages until the *spe- cifics* of various nonstructural detail are added to complete the project.

But, before construction can start, there is al- ways the design—the blueprint. Even before the measurements and layout of the building "hard- ened" into the blueprint, there was the archi- tect's idea: a *felt* attitude about certain forms, their scale, placement, textures, and materials as capable of an expressive order. An architectural structure really begins as a state of excitation about certain form relationships.

Similarly, a drawing should start as a sense of recognition and excitation about certain form re- lationships, actual and potential, of a subject. But, unlike the architect, who does not often di- rectly respond to nature by extracting and re- ordering the visual and expressive properties of

an observed subject, the responsive artist is, by definition, always interpreting the "raw material" of nature.

The artist's first interpretation *must* be the most inclusive recognition of what his subject *does* in space—how its forms relate as a system of visual and expressive affinities and contrasts of volume, direction, shape, value, and scale to create a sense of animated, expressive force—*gestural expression*.[1] To draw the gestural expression of a subject is to draw the intrinsic nature of the action of its components rather than their more specific physical characteristics. A building's construction is started with the erection of a structural design that carries the gestural expression of the building's forms *before* its completion. A drawing is also begun by conveying the gestural expression of the *entire* subject, *before* its component forms are drawn. Like a building without a cohesive system of structural design to hold it together, a drawing begun without the search for the cohesive system of gestural expression "collapses." And, similarly, to introduce the gestural expression *after* a drawing is underway, would require "undoing" and reworking nearly all of it.

Gestural expression must be understood as not simply the action or rhythms of a subject. These are always present, but they are present in the broader, more inclusive sense of a subject's components as they are infused with a comprehendable design or order which conveys the *character,* or expressive quality of movement. It is not to be found in any one of the subject's visual properties of shape, value, or direction, nor in its type or class, its pose, or even its "mood," but in the sum of all these qualities. The emotive energy of gesture cannot be seen until it is experienced—it must be *felt.*

It requires our "empathy," our ability to give meaning to a subject's configuration in space. The gestural character of a swimmer's body about to "knife" into the water is fairly evident—that of an old shoe requires a more penetrating and sensitive response. The term *character,* as used here, should be understood as the collective temperament of a subject in a particular configuration. We attribute human attitudes and feelings to a subject's expressive state in expressions such as "an angry sea" or "a cheerful fire." In the same way, an artist responding to a subject's gestural expression, feels a doll as "limp," a cave as "yawning," and a tree as "stately" or "gnarled." The response to a subject's gestural expression then, is the comprehension of its total behavior in space as performing an emotive action.

[1] See, Kimon Nicolaides, *The Natural Way to Draw* (Boston: Houghton Mifflin Company, 1941), pp. 14–28.

In Plate 1.1, Rembrandt uses gestural means to convey the tired, resting figure of his wife, Saskia. Rembrandt *feels* (and consequently we do, too) the essence of her pose as an expression of limp weight. What Saskia is doing and feeling is as important to Rembrandt as the delineation of specific forms and textures. His felt perception of her relaxed body pressing into the pliant bedding is intensified by the forceful speed of the lines in the pillow. Their radiating action conveys the tension in strong folds produced by the pressure of weight against soft materials. Those lines *enact* as well as describe the action.

As mentioned above, gestural expression comes from the physical and emotive qualities of a subject's action, and, as such, results from the *totality* of the subject. Drawing the gestural expression of a single figure and its immediate environment, as Rembrandt did, is fully responsive if this alone is the subject. To do so when two or more figures constitute the subject falls short of the perceptual scope necessary to see the gestural expression of the total configuration.

Exercise 1A suggests a means by which we can extract the gestural expression of a subject. Because gestural expression engages our feelings as well as our ability to see, and because of its pervasive and intangible nature, many drawings will have to be made in the approach about to be described, before a sense of the felt action can be experienced and made manifest in drawing.

### EXERCISE | 1 A

The "rules" suggested here should be regarded as temporary aides to help you extract a subject's gestural expression. They are not intended as a "how to draw" scheme. There is only one way to draw—yours. Learning to respond to a subject's expressive action is essential to developing your way.

Use a black or sanguine conté crayon, compressed charcoal stick or any soft, dark tone of pastel, and draw on an 18″ by 24″ sheet of newsprint paper. Do not use an eraser (there will not be the time or need). If possible, use the human figure, draped or nude, as your subject. If no model is available use house pets, plants, or simple still-life arrangements of objects and drapes which offer strong, sweeping curves and shapes. Some lamps, vases, and toys such as dolls are frequently usable. Articles of clothing can be used. Some of the more visually interesting or fanciful furniture forms, such as a rocker or wicker chair can serve as model. Finally, one's own arm and hand can be placed in a variety of active poses. For the present, do not use photo-

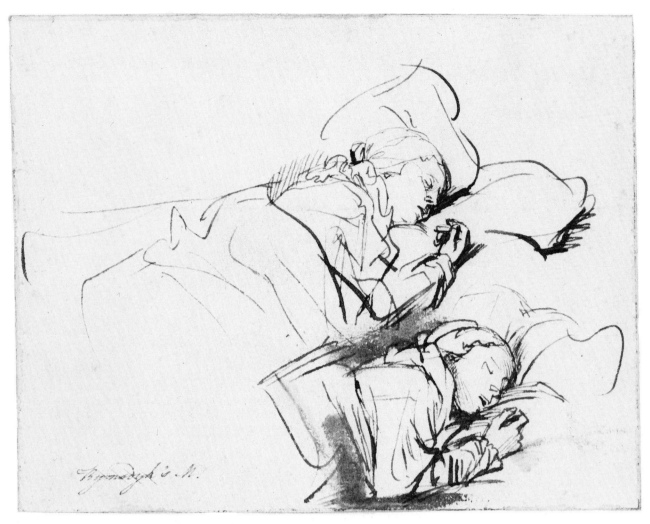

Plate 1.1

*Rembrandt van Rijn* (1606–69). SASKIA ASLEEP.
Pen, brush and ink.
THE PIERPONT MORGAN LIBRARY.

graphs, as their use generally injects a stiff and artificial note to a drawing. Also, the camera's monocular image lacks the sense of depth perception our binocular vision supplies, thus reducing or confusing our understanding of the subject's forms in space. A baking-timer, or some comparable device will be necessary unless, if drawing in a group, someone keeps track of the time of each pose. Where possible, draw in a standing position at an easel or any suitable support.

You will make a total of twenty drawings. The first five will be two-minute poses. The next ten will be one-minute poses and the last five will again be two-minute poses.

During the first half-minute of *every* drawing —*do not draw*. Instead, search for the most inclusive action of the subject by relying as much on your felt response to its character as your visual response to its configuration. You may not be able to describe it verbally, but you should get an impression of the nature of its action: fast or slow, limp or rigid, supporting or supported, straining or relaxed.

Only when you feel you are responding to both the design and mood of the action, when the subject is understood as "doing," as well as "being," begin to draw.

Use a small fragment of your drawing tool (approximately one-half to three-quarters of an inch long), holding it loosely by your fingertips. Do not hold it in the manner used for writing. The fine, hard lines such as a "pinched" grasp of the drawing instrument produces will be too restricting for gestural drawing. Let your hand and arm swing freely as you draw. Be daring to the point of recklessness. If you see a movement that runs through the entire subject, draw it as one expressive action. Try to match the energetic force, lazy ease, etc. of a movement by the way you draw it (Illustration 1.1). Avoid lifting your drawing instrument often. When you want to stop to make new observations or new associations of parts, simply stop your drawing instrument,

3

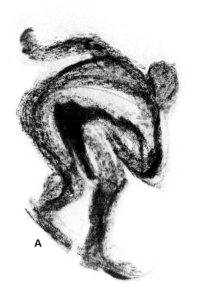

A

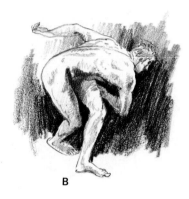

B

*Illustration 1.1*

*In Part A, the longest, sweeping, gestural movements have been "extracted" from the pose of the model in B.*

*Illustration 1.2*

*Using the side of a crayon or pastel stick helps to "stay with" the gestural expression. This example represents about eighty seconds of drawing time.*

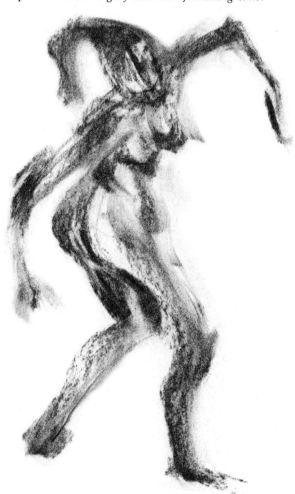

leaving it touching the paper and, when ready to begin again, start it moving. This is not always possible, for a new observation may take you to another area of the subject. But, when it can be done, it reduces the amount of short, broken segments of line or tone which imply a faltering in the search for the most inclusive action. And it is the summary of the expressive action you want, so avoid the enticements of interesting, smaller considerations. If you leave the "mainstream" of gestural expression when the drawing has just begun in order to develop some small part, you lose the rest of the gestural qualities of the subject and depart from the *general to the specific* procedure. This is a step that few seasoned artists will risk or advise.

A gesture drawing is not a contour drawing. As you draw, you will almost certainly find that you cannot stay away from the edges of the forms. It will require a concentrated effort to leave the contours and make your drawing describe the "path" of an arm, branch, or chair-leg in space. Occasionally using the side of the small fragment of your drawing instrument will help to check the tendency to draw the contour because the broad, foggy tone thus produced is more suited to describing the "core" or direction of a form, rather than its edges (Illustration 1.2). Using your crayon or pastel this way also helps to keep you from being distracted by specific details—such a tone-line is too broad for small particulars. Try to feel the forms moving into and out of a spatial field of depth, because whatever the subject, it exists in space. You should imagine your hand actually reaching in and out of space to describe the action of the forms (Illustration 1.3).

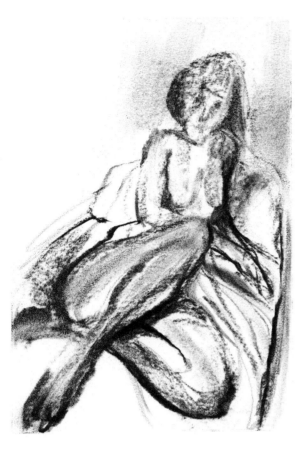

In the two-minute poses you will actually draw only about one and one half minutes. This may seem brief, and it would be if you intended to make a fairly realized graphic statement. But all you want to do in these exercises is grasp, in as free and bold a manner as you can, your subject's expressive action. Indeed, the gestural expression should be stated within the first minute. Spend the remaining half-minute to check between your subject and your drawing and make further extractions of gestural qualities.

In the one-minute poses only half of your time will be spent drawing. This will make it necessary to see, summarize, and extract the gestural expression much faster. Now there will be only enough time to perceive the strongest, most important visual cues that convey the character of the action. These drawings should look bolder and more direct in their "attack" on the essence of the gestural expression, as in Illustration 1.4. Often the one-minute drawings capture that essence more successfully than the two-minute ones You become more aware of the limited drawing

time and more intensely see a subject's components massed into greater generalities of action. For example, a side view of a model, legs straight, leaning over and touching his toes, might be seen as an inverted teardrop form.

Imagine you are an artist-correspondent making a visual recording of a subject. If you do not use the thirty seconds to grasp the essence of *all* that you see for development afterward, you will be unable to complete your visual report (Plate 1.2).

Your experience in speeding up the pace and broadening the scope of your observations during the one-minute drawings will help you use the expanded time better in your last five drawings. Now, a two-minute drawing time feels more comfortable and allows you to see some of the smaller affinities, contrasts, and characteristics which evoke the gestural expression. You will also find that the more you draw, the more you will tend to reach the edges of the forms. As observed earlier, a gesture drawing is not a contour drawing, but neither is it a "stick figure" drawing. These pro-

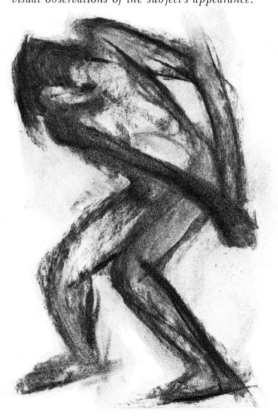

cedures both pertain primarily to what a subject looks like. The former is concerned with the undulations at the edge of the forms, the latter, with the directions of the forms in space. While some rough indications of edge and direction occur, your search is primarily for the character of the action (Plate 1.3).

The twenty different poses of the subject present no problem when a model is used, or when you are drawing your own arm and hand or a house pet. With still-life arrangements, you may find it easier to move around the subject, completing a circle in twenty moves. You can also rearrange some of it occasionally. Whatever the subject, the poses need not drastically change each time. Even the subtlest of changes creates new visual relationships and gestures.

## THE DIVIDENDS OF GESTURAL EXPRESSION

Drawing from the general to the specific leads us from the gestural to the factual. The longer we continue to draw in search of the gestural expression, the more fully we extract a subject's *general* state. After this has been established, further searching inevitably leads to smaller, more specific contributors to it. If you continue with a gesture drawing for five minutes or more, your responses will begin to shift from the analytical depths of general responses to character and movement toward the surfaces of the forms. Like the swimmer who dives to the bottom, we *do* come up to the surface. But the perception of factual specificities *evolves from* our comprehension of the

*Plate 1.2*

*Annibale Carracci* (1560–1609).
STUDIES FOR A PORTRAIT.
Pen and ink.
ALBERTINA, VIENNA.

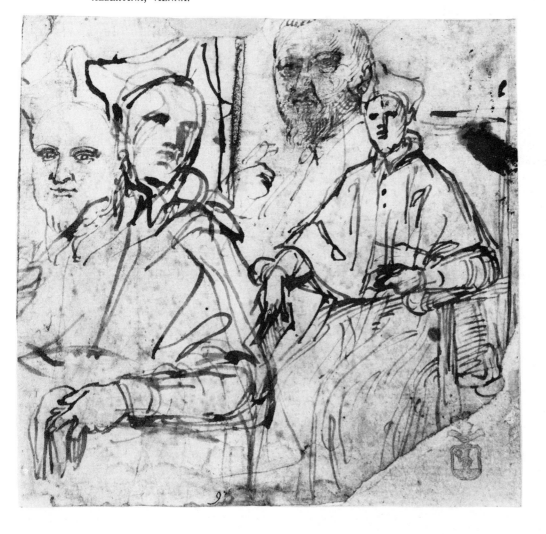

gestural expression and cannot, as we have seen, precede it.

Searching for gestural expression in drawing first is creatively logical for two reasons: it is the necessary basis for all that follows and it cannot enter a drawing already underway. But this search does more than infuse the drawing with a sense of expressive movement. Having done Exercise 1A, you may have recognized that seeing the character of the action provides other kinds of information about the subject.

There are no less than eight important ways in which establishing the gestural expression serves to inform and aid us in drawing. The first five yield *types* of information that are at least partially revealed through this approach. They are: the proportions or *scale relationships* between segments of a subject; the general "tilt" or *position in space* of a subject's segments; the general tone or *value* differences between segments of a subject; the limits or *shape-states* of all a subject's segments; and the particular nature or *visual character* of the segments. Of these five types of information, the first three are natural "by-products" of seeing *all* the subject within thirty seconds or a minute. In a figure drawing, we may see the torso one or two seconds after we have seen, say, the right arm, the head, a second or so later, the left leg a second later, etc. We grasp the entire figure almost at once. The likelihood of seeing the relative scale, position, and value relationships are improved since we are "everywhere" in seconds and draw by "hovering" over the entire image, advancing it "on a broad front."

The search for the gestural expression *does* include responses to the physical position, scale, and, when vital to expression (Plate 1.4), value. This is always a rough, general estimate because the goal is not, "where is it, how big, and what value?", but "what is it doing?" Nevertheless, a rough approximation of where the subject's components are, and their scale and value relationships *can* be established through drawing the expressive action. It becomes much easier to advance the drawing by studying these rough approximations and making the needed adjustments for them to convey both the physical and expressive states as you see them (objectively), or as you intend to state them (subjectively).

The severe restriction in drawing time compels us to be everywhere at once. This time limit, as stated earlier, greatly increases awareness of the relativeness of these three areas of response. No one intentionally misjudges the scale, placement, or value differences of a subject's components. These errors of judgment result from failure to

see relationships. This failure is also the result of a piecemeal, sequential system of drawing wherein each part is dealt with independently and "finished" with little or no reference to other parts. Drawing a figure in this way, several min-

*Plate 1.3*

*Alfonso Cano* (1601–67).
STUDY FOR THE FIGURE OF A FRANCISCAN MONK.
Pen and ink.
PRADO MUSEUM, MADRID, SPAIN.

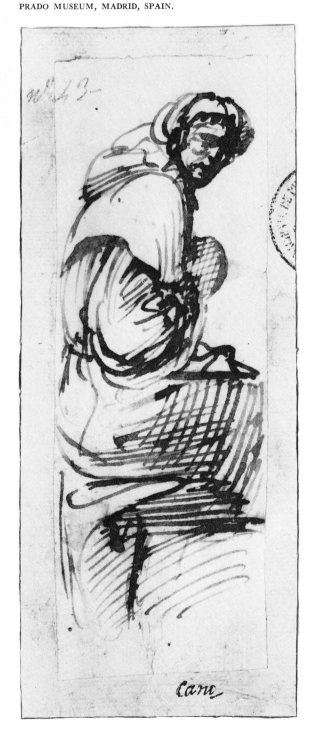

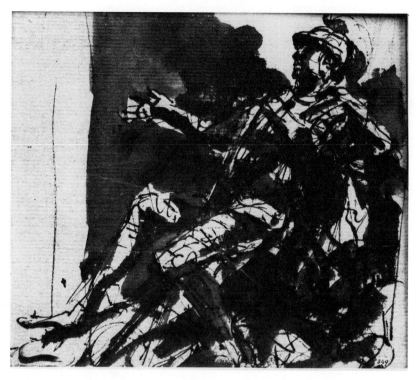

*Plate 1.4*

*Salvator Rosa* (1615–73). STUDY OF A SOLDIER.
Pen, brush and ink.
VICTORIA AND ALBERT MUSEUM, LONDON.

utes or even hours may separate the drawing of the head from that of the feet. If the feet are drawn with no regard to anything above the knees, it is mere chance when their scale, placement, or value is in accord with the rest of the figure.

No one intentionally makes errors in perception, but many artists do alter their drawings, to varying extents, away from the subject's actual state. But these changes are based (or should be) on a knowledge of what the subject's actual conditions are. In responsive drawing seeing the state of things as they are is prerequisite to change.

The remaining two types of information—the shape-state and visual character of the subject's components, begin to emerge in the later stages of a gestural drawing. As we have seen, the continuance of this mode of drawing leads us from the most encompassing of general responses to more specific observations about smaller surface conditions of a subject's forms. As we approach these surfaces, we may find it desirable or necessary to draw the particular undulations of a form's edge. This delineation of the shape of a form (*see* Chapter Two) should not be confused with the establishment of its scale. The perception of a form's scale precedes that of its contour. The visual character, in the dual sense of a sub-

ject's general character and the idiosyncratic particulars of its components, is a further refinement of both the scale and shape-state of a subject's components. The visual character of the parts conveys a unique *physical* quality and should not be confused with the expressive character of a subject, though they can be interrelated to an extent. That is, the physical character of a subject's parts may partially determine its expressive character, as is the case in Plate 1.1, where Saskia's heavy, limp, and flowing forms help to convey the figure's expressive action.

The three remaining ways in which the gestural mode of approach assists our general ability to draw are: to aid in establishing an *economical* and *authoritative* graphic statement; to develop the first general references to the volumetric or *structural* state of the forms; and to develop the first broad "confrontations" of volume, space, shape, line, value, and texture, as elements of the organizational design or *composition* of the drawing.

Since a gestural drawing proceeds from the general to the specific, any line, value, or texture which "works," i.e., serves to declare the artist's intent early in the drawing's development, can be allowed to remain as a completed visual and expressive remark. Because of the "fluid" and inclusive nature of gestural drawing, not many

such lines are likely to survive. Some do, and their broad, simple quality serves to influence the artist in establishing other equally economical drawing expressions. The bold, driving quality of gestural drawing and the subsequent drawing influenced by it convey a sense of courageous directness. These qualities of resolute authority and economy born of a comprehensive grasp of a subject's essence, and the resulting sense of spontaneity, are essential. No great drawings are without these qualities. In Plate 1.5, the gestural expression of the scene tells us much more than "horses-carriage-people"; it evokes the clatter of the carriage, the nervous energy of the animals and their speed. In this sketchbook drawing by Toulouse-Lautrec, note the economy of means, the authority and the quality of spontaneity they create—the energetic *presence* of the subject.

Because we wish to see the expressive action of forms *in space,* gestural drawing requires us to move back and forth in a spatial field describing not only the tilt, shape, scale, and (where desired) value of the forms, but (in later stages) some general suggestion of their third dimensional quality. In Rembrandt's vigorous drawing of a man in a wide brimmed hat (Plate 1.6), the gestural drawing of the figure also conveys some broad suggestions about the volume of his cloak—we can even

sense the volume of his right arm beneath it, as well as the volume of the hat, hair, and right hand. Though several areas of the figure's forms are not fully explained as structural masses, there is a general feeling of his weight and substance. In Augustus John's drawing (Plate 1.7), we again sense the emergence of volume, even in the most sweeping gestural responses to the character of the action. Note that the influence of the graceful, curvilinear lines still "echo" in the more developed passages of the drawing. These two drawings, so different in temperament and goal, are alike in their manner of evolving from an initial concern with the character of the subject's general qualities to a controlled and concise expression of their more specific properties. The desirable quality of an authoritative economy in graphic expression often guides the artist to those general summaries of volume which the gestural approach frequently extracts.

The compositional issues of a subject in a bounded, flat area (*see* Chapter Eight) is likewise aided by the requirement of gestural expression to be "everywhere at once." We can thus see, within the first minutes of a drawing, the placement of the subject on the page, the general divisions of the page resulting from its placement, and the general state of any other visual matter

*Plate 1.5*

*Henri de Toulouse-Lautrec* (1864–1901).
Page from a sketchbook.
STUDY FOR PAINTING, LA COMTESSE NOIRE.
Black grease crayon.
COURTESY OF THE ART INSTITUTE OF CHICAGO.

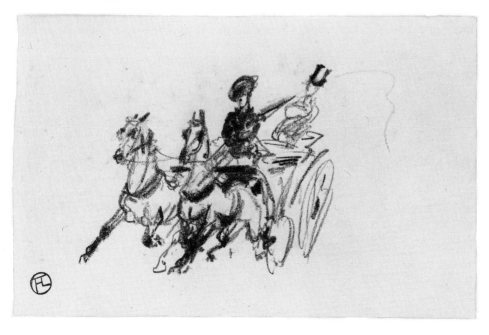

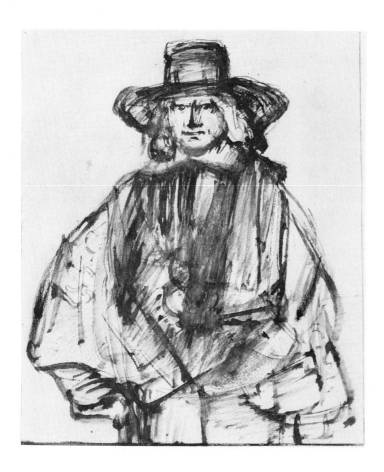

*Plate 1.6*

*Rembrandt van Rijn* (1606–69). PORTRAIT OF A MAN.
Brown ink and wash on white paper.
COURTESY OF THE FOGG ART MUSEUM, HARVARD
UNIVERSITY.
PURCHASE—A.S. COBURN AND ALPHEUS HYATT FUNDS.

related to the subject, such as its background or anything constituting the subject's immediate environment. These are some of the visual and expressive forces which will participate in the evolving of a balanced, unified pictorial design or composition. The earlier we state them, the more integrated the drawing becomes. Drawings which proceed without design are chaotic.

In John's drawing (Plate 1.7), the searching gestural lines are clearly in evidence throughout the drawing. Note the still visible lines of the far side of the hat's brim. Here, the artist utilized the gestural search to establish the design of the figure's placement within the bounded frame of the page.

In "Two Barristers" by Daumier (Plate 1.8), again the general indication of an intended compositional idea is seen in the lines near each figure, which begin to search out the overall action of two more figures. Here, Daumier lets us see his very first gestural and compositional probes. Similar gestural lines underly the more developed figures of the barristers. Although it is impossible to know whether Daumier began the drawing by indicating the placement of all four figures, or began to add the others later, a study of his approach to drawing would certainly suggest the first possibility. In any case, the drawing allows the opportunity to see the artist's first gestural drawing actions, the energetic developments upon them, and his use of such gestural probes to explore compositional possibilities. Note the character of the action of the figure on the right. It is expressed by the action the forms describe, *and* by the animated character of the lines creating the forms.

In Exercise 1A, the search for the gestural expression was the exclusive goal of your efforts. Whatever dividends of this approach emerged as you drew came "unbidden." In the next exercise, look for the five types of information which the gestural expression includes and the three influences of economy, volume, and composition

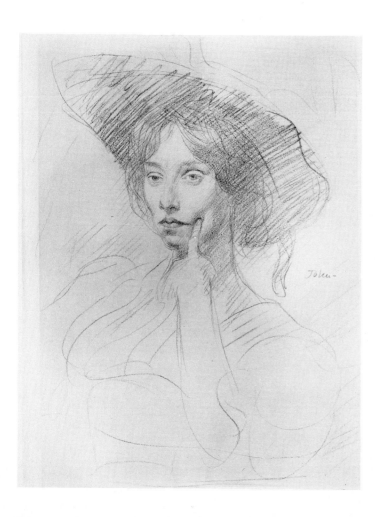

*Plate 1.7*

*Augustus John* (1878–1961).
PORTRAIT OF WOMAN IN HAT.
Pencil.
PRINT DEPARTMENT, BOSTON PUBLIC LIBRARY,
BOSTON, MASS.

to help you establish more responsive gestural foundations.

## EXERCISE | 1 B

Use the same materials and subjects as suggested in Exercise 1A. Again, draw in a standing position. Try to *feel* the subject's action and emotive state and begin boldly, with the most inclusive statements you can perceive.

One purpose of this exercise is to "build" upon the five types of information provided by the gestural approach and to allow its tendency toward simplicity, volume, and compositional concern to direct your drawing actions. Another purpose is to experience the shift from drawing expressive action to drawing the factual state of your subject *and* its immediate environment.

Because a composition requires an enclosed area, draw a border just inside the limits of your paper, as in Illustration 1.5. The page itself *is* a bounded, flat area, but you will become more aware of the limits of your drawing area by using this inner border. Drawing the borders is a temporary but helpful device. If some segment of your subject warrants inclusion, let your drawing go beyond the border and off the page. Should you do this, disregard (or erase) the rest of the borders and use the entire page for your drawing. But the presence of the border will increase the likelihood of getting all the subject on the page.

You will make three ten-minute drawings and one half-hour drawing. Again, do not draw for the first half-minute or so, but use the time to familiarize yourself with the subject's character, its suggestions of movement, and its general design. This time, also observe the subject's overall shape. Decide where you will place it within the bordered area and what its scale will be. Avoid drawing the subject so small that it appears as a "tiny actor" on a large "stage."

*Plate 1.8*

*Honoré Daumier* (1808–79). Two Barristers.
Pen and ink.
VICTORIA AND ALBERT MUSEUM, LONDON.

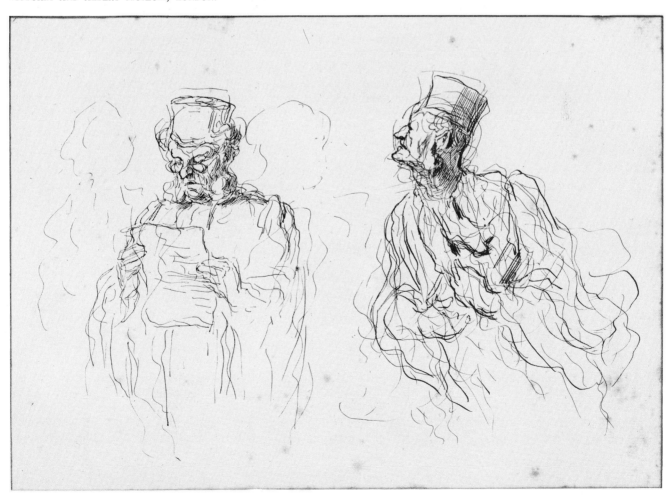

*Illustration 1.5*

*Drawing with a border just inside the edges of the page helps to sense the composition better and assists in getting the subject on the page.*

Instead, use a scale that will make the subject fill a large portion of the page.

Now look around your subject to see what foreground or background material you wish to include. If the background is a blank wall, plan to place your subject on the page so that the surrounding blank areas are divided up into interesting shapes. Should there be some other objects, values, or textures around the subject you wish to include in your drawing, consider how their scale, shape, character, and gestural qualities may augment or hinder the subject's gestural expression. Plan to omit anything that you feel will conflict with, crowd, or confuse the drawing of your subject.

Those things you choose to include in the drawing are now regarded as an extension of your original subject. For example, if your original subject is a figure and you plan to include a chair, rug, table, and darkened corner of a room, your subject is the figure and *all* these, not just the figure.

Begin all four drawings as if they were two-minute gesture drawings. In all four, after the half-minute or so of study, use the first two or three minutes to state the subject's gestural expression (which now includes its immediate environment). After two or three minutes, keep searching for further, smaller gestural actions until you feel that the character of the entire subject's action has been stated, as in Plates 1.9 and 1.10. In the Dufy drawing, note the engaging

impartiality with which he regards the components of his subject. Note, too, the animated character of the chairs and the drawings on the wall, the drawing's economical and authoritative qualities, the suggestion of volume and its balanced, unified character. In the Carpeaux drawing we have an excellent example of the gestural approach. The economy of means and authoritative quality are remarkable, for so much has been said by so few means.

In the last three or four minutes of the ten-minute drawings, "revisit" every part of the drawing, this time, estimating the scale relationships of the forms, their position in space and their relative values. As you thus alter and modify your earlier gestural perceptions, you will find that you are drawing the contours of the forms —you are establishing the shapes of the forms (*see* Chapter Two). We saw in Exercise 1A that continuing a gesture drawing eventually brings us to the edges of the forms. There it marked the end of the exercise, now it is the beginning of a shift from the concern for what the subject is doing to a search for what it looks like.

Continue to draw the contours of the forms, slowing down somewhat to follow the major changes in the directions of the forms' edges. Erase any earlier, gestural marks that seem to confuse or obscure the forms. Most of the gestural tones and lines *do* become integrated into the values and textures of the later stages of a drawing. It is surprising how little of the original gesture drawing is visible at the completion of even a ten-minute drawing. Avoid overemphasizing the edges. Contours that are heavy or hard tend to stiffen the drawing and weaken the gestural quality.

Use those values you feel are necessary to convey your intent and now, also, the broad masses of the subject's volumes. Avoid the "coloring-book syndrome" of adding values *after* the drawing is developed through line. If you mean to use values, do this early in the drawing (Plate 1.11).

In these drawings, as in those of Exercise 1A, it is important to advance the entire drawing on a broad front. Try to check the tendency to settle on a particularly interesting place, developing it ahead of the rest.

As you draw, be mindful of the eight ways in which gestural expression can assist perceptions and broaden the range of your responses. It may be helpful to list these in a corner of your drawing board or sketch-book for easy reference, checking occasionally to see if you are using them as you draw. With so much to be aware of—and *do* —ten minutes is not much time. This restriction

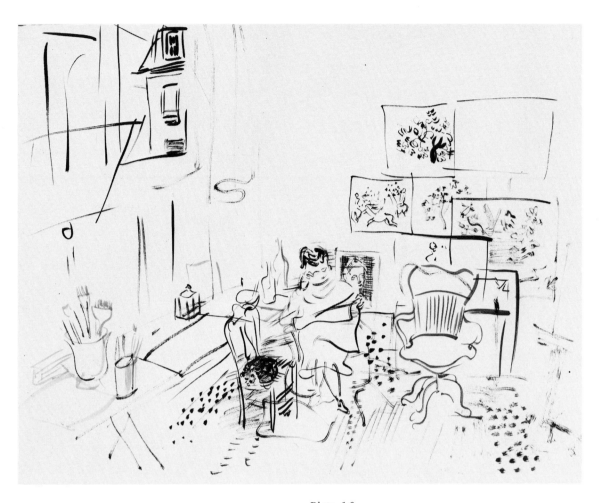

Plate 1.9

*Raoul Dufy* (1887–1953). THE ARTIST'S STUDIO.
Brush and ink.
COLLECTION, THE MUSEUM OF MODERN ART, NEW YORK.
GIFT OF MR. AND MRS. PETER A. RÜBEL.

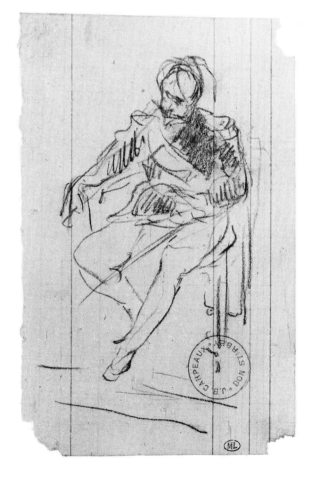

Plate 1.10

*Jean-Baptiste Carpeaux* (1827–75).
GENERAL IN COURT DRESS.
Black chalk.
CABINET DES DESSINS, MUSÉE DU LOUVRE.

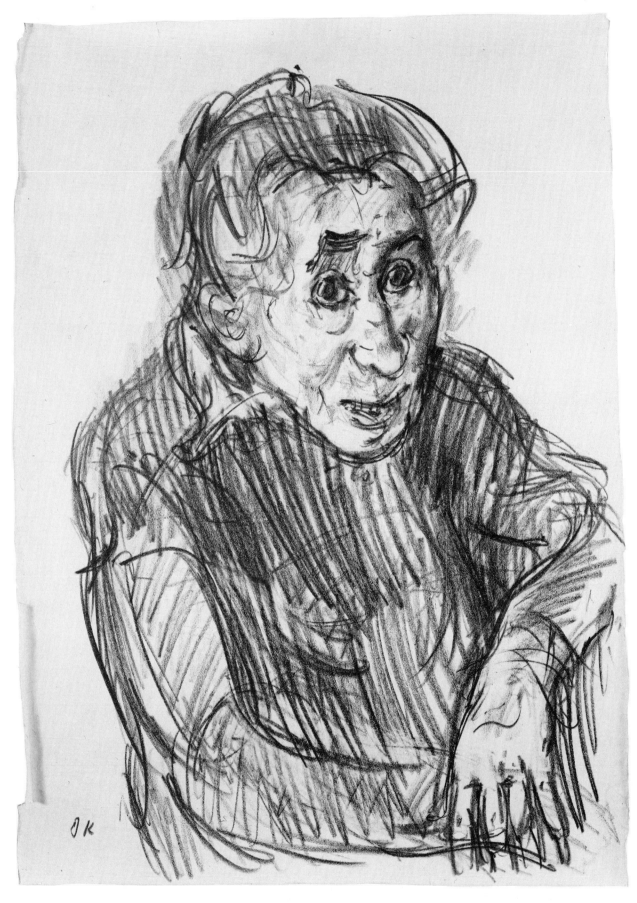

Plate 1.11

*Oskar Kokoschka* (1886–    ). PORTRAIT OF MRS. LANYI.
Crayon.
THE DIAL COLLECTION.
WORCESTER ART MUSEUM, WORCESTER, MASS.

is intended to keep your attention focused on the subject's major expressive and visual cues.

Regard the ten-minute drawings as warm-ups for the thirty-minute one. At the end of ten minutes you should have developed this drawing as far as the earlier three. At this point, stop drawing for a minute or so. Look at your drawing from a few feet away. You will more easily see perceptual errors, the gestural quality, and the composition of the subject on the page. Continue drawing for the remaining time, stressing the structural, volumetric character of the forms. This sense of the third dimension should be a natural development of the perceptions you made during the first ten minutes of the drawing, when you felt *and* delineated the subject's gestural and visual character. Many of these perceptions carried strong clues about the subject's volumes. Now you are *using* the gestural expression, rather than strengthening it further. The shift from comprehending what the subject *does,* to what it *looks like* (or what you want it to look like), depends on the guidance and influence of the drawing's expressive action.

If, toward the end of the thirty minutes, you cannot see any further changes, deletions, or additions to help state the expressive *and visual* character of the subject—stop. In the weeks and months to come, you may find thirty minutes to be as brief a span of time as ten minutes seem now. As you continue your study of drawing you will perceive more relationships in a subject and demand a more probing encounter and a more responsive result.

In the ten-minute drawings, there was about as much time for stating the gestural character of your subject as for its visual character. But in a thirty-minute drawing, the gestural expression often becomes somewhat muted. While personal attitudes will determine whether gestural expression continues to play a major or minor role, here we use gestural expression mainly to support the development of the visual responses for which there is now more time (Plate 1.12).

There is a danger here. If you lose too much of the gestural expression, if you sacrifice too much economy of means, if the felt and analytical, searching quality of the drawing is too muffled by a meticulous rendering of surfaces, too much of the life and excitement of the drawing will be lost.

The shift from the expressive action to the visual, measurable actualities does not mean that you must stop your felt, gestural responses. You may see some strong expressive ideas late in the drawing. Nor does it mean that some visual facts about the subject's physical properties are not

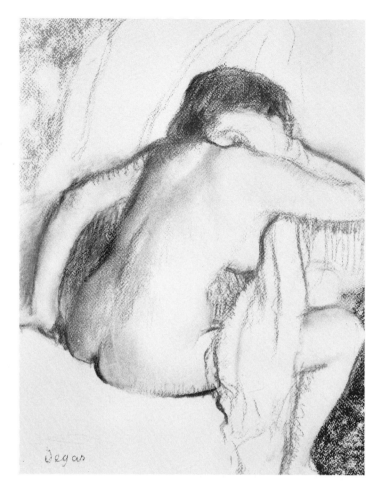

*Plate 1.12*

*Edgar Degas* (1834–1917). After the Bath. Charcoal with red, green and brown pastel. COURTESY OF THE FOGG ART MUSEUM, HARVARD UNIVERSITY. BEQUEST OF META AND PAUL J. SACHS.

discovered early. There is no such "clean break" in responding to a subject. Rather, it is a change in emphasis.

Do several of the ten-minute drawings daily (seven or eight would not be too many) and at least one thirty-minute drawing. Do as many as you can in your sketchbook. Regard your sketchbook as personal and "off limits" to browsers. Be selective about who is allowed to see it, for in the early stages of the study of drawing the wrong compliments are as damaging as the wrong criticism.

The search for gestural expression is no more the key to drawing than any other of the several basic concepts that are necessary to an understanding of drawing. But mastery of gestural expression is essential and must come early in the study of drawing. Whatever goals and ideals in drawing we wish to pursue, the *process* will be that of advancing our drawings from the general to the specific and not through a system of piecemeal assembly. Drawings do not accumulate—they grow.

# 2

# Shape

*AN IRONY*

## A DEFINITION

Like gestural expression, shape is a basic, given quality. If perceiving the gestural expression tells us what a subject *does*, then seeing the subject's shapes and those of its immediate environment tells us what it looks like.

The first shape drawn on a blank, flat, and and bounded surface—or *picture-plane*, by its presence, creates a second shape—the remainder of the picture-plane. This first drawn shape, understood as an area of active "thingness," is called a *positive shape*; the remaining, passive, "empty" area, a *negative shape*. In this relationship, positive shapes are not seen as "hovering" in a spatial field of depth, nor do negative shapes represent a spatial field of depth. They all should be understood as existing *on the same level*. Together, they *are* the picture-plane. Having no volume, and intending no spatial depth, they are *two-dimensional* (Illustration 2.1).

All volumes, when viewed from a fixed point, offer an absolute shape delineation. Perceiving this two-dimensional state of a three-dimensional subject is essential to understanding its placement and structure. What its shape *is* will largely determine what its volume and position in space *will be*.

Some of the "guises" of shape are invisible.

When we look around us we see volumes. The several vital roles of shape in producing the impression of volume and space are not readily apparent. Seeing through the camouflage of a subject's surface to shape's visual and expressive potentialities is basic to responsive drawing.

Put simply, *a shape is any flat area bounded by line or value or both*. Shapes are classified in two general families: *geometric* or *organic* (sometimes called biomorphic or amoebic). A geometric shape may be just that, e.g., a circle, triangle, etc., or any combination of the angular and/or curved boundaries associated with pure geometric shapes. An organic shape is any irregular, "undulating" shape in which extensive use of straight or evenly curved edges is minor or absent. They tend to echo the contours in nature. Organic shapes are less severe and more animated, than those of the geometric order (Illustration 2.2).

As discussed above, shapes may have a positive or negative function. They may be hard-edged or vague. They may be active, gestural shapes, or passive, stable ones. They may be large or small, totally or only partially enclosed. They may have simple or complex boundaries, and be consistent or varied in their properties.

Because we are conditioned to see *things*,

A             B

*Illustration 2.1*

*Shape on a picture-plane. Part A shows a positive shape on a negative field. In B we see the three shapes separated. They have a puzzle-like sameness of level.*

rather than the spaces that separate them, learning to see these interspaces as negative shapes requires concentration. Exercise 2A presents a drawing problem that makes it necessary to see these "empty" shapes with all the conscious attention generally given to positive ones. Perceiving their actual delineation makes possible the necessary understanding to manipulate the positive-negative relationship, as an effective tool of graphic expression. As you do Exercise 2A, you should begin to *experience* the interchangeability of positive and negative shapes, and the realization that one cannot be fully comprehended without the other. In all drawings, shapes either enhance or hurt expressive order—none "ride free." Disregarding so basic a concept as the positive-negative relationship blinds the student to half of shape's potential for expanding visual perception.

*Illustration 2.2*

*Geometric and organic shapes. Part A shows a few of the infinite number of geometric shapes possible; B, some of the organic shapes possible.*

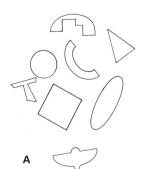

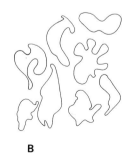

A             B

When doing these two exercises, erase whenever necessary. Too much erasing gives an unpleasant fussiness, but here you can make as many changes and adjustments as you need to complete your drawings.

***Drawing 1.*** Using a moderately soft pencil (2B or 3B) and a sheet of tracing paper (or any paper thin enough to see through), draw a square approximately five inches by five inches. Use a ruler if you wish. Inside the square draw a rather simple organic shape (Illustration 2.3A). Draw it large enough to allow some of its projections to touch the borders of the square, causing the remainder of the square to be seen as four or five isolated segments. Leave the organic shape the white of the paper and apply a gray tone to all of the remaining segments.

Draw the shape in a relaxed manner, without lifting your pencil, so that it emerges from a single, flowing line. The completed drawing should look somewhat like a puzzle piece touching each of the square's borders at least once. Avoid making the shape too complex and contorted—the simpler, the better.

The resulting shapes seem to exist in space. But to see the *shape* of the space, disregard its spatial impression and treat *all* the shapes within the square as two-dimensional divisions of the picture-plane.

Now take a second sheet of paper and draw another five inch square. Inside this second square, draw the organic shape again as accurately as you can, using the first drawing as your model. This time you will find that letting your hand flow across the paper will not reproduce the original shape. Your second drawing may be fairly close to the original, but it should reproduce it *exactly*. To do this, you will have to study the original with some care. You will want to see the tilt, or *axis*, of each projection *and* hollow of the original, as well as their relative scale. As you draw, ask yourself, "which is the largest projection? . . . which the narrowest?" Examining the several negative shapes bordering on the organic shape and ending at the limits of the square, you will see differences from the original. In adjusting these in your drawing, you will be adjusting the organic shape as well. Soon you may find that you no longer regard the organic shape as more important than the shapes around it. You may sense that until *each* shape in your drawing matches its original, the organic

Illustration 2.3

*Examples of Exercise 2A. Note the projections touching the edges of the picture-plane.*

tration 2.3B. Try to locate the axis of a positive or negative segment by finding its position on the clock. For example, a segment that is vertical would be twelve o'clock (or six o'clock), if tilted slightly to the right, it might appear at one o'clock, etc.

When you cannot find any further differences between the two drawings, place one over the other and hold them up to the light. You may be surprised at the several differences still remaining. Continue to make further adjustments based on these observed differences between the two drawings. Holding them up to the light again you may still find some subtle differences. Developing an appreciation of the critical nature of one shape's influence upon another, and the physical skill to draw it, requires some time and practice.

***Drawing 2.*** In drawing the several shapes which formed the square, the camouflage of the "squareness" that each participated in may have kept you from seeing and considering them as much as the organic shape. In this drawing and using the same materials, combine any three shapes that form an irregular outline. Do not enclose them in a square. These shapes can have some geometric properties, as in Illustration 2.3C. Again, make as accurate a duplication of this group as you can. Now, the shape-state of each will be very evident. They do not contribute to a common geometric shape strong enough to obscure an awareness of each. It is important to be able to visually extract and objectively regard any of a subject's shapes, no matter how actively engaged they are with others in making greater shapes or forms. The three shapes you have selected are, of course, collectively producing a fourth. As you draw this group, divide your attention between seeing each of the three shapes separately and seeing the greater shape they make. Recalling the advantages of working from the general to the specific, begin this drawing by roughly searching out the overall shape of the configuration first. When completed, again match the two drawings and make any necessary adjustments.

This exercise, or any variation of it that causes a search for the actual state of shapes, should be practiced every day for several weeks—or until you find it easier and more natural to reproduce a shape by these means. To see shapes in this objective and analytical way is one of the most necessary and powerful resources of responsive drawing—not for purposes of imitation, but for invention based on perceptual acuity.

shape will not have been accurately drawn. At this stage of the exercise, try to see the positive-negative roles reversed. That is, imagine the white "puzzle piece" to be missing from a gray puzzle. Now the white shape is a negative one. Seeing your drawing this way, continue to adjust the remaining "puzzle pieces" to correspond to their originals. To more accurately estimate the angle of a particular projection or hollow, imagine a clock-face surrounding the part, as in Illus-

## THE SHAPE OF VOLUME

Being two-dimensional, a single shape generally cannot convey the impression of volume convincingly. Only when two or more shapes join or interact do they communicate the idea of structure and mass by which volume in space, i.e., the third dimension, is achieved.

When shapes unite to form volume, they are seen as straight or curved facets of the volume and are called *planes*. The various ways these planes abut and blend into each other determine and convey the particular "topographical" state of a volume (Illustration 2.4). To interpret a subject's shape and structure, we must begin by avoiding exclusive attention to its existence as a form in space and see its planes as a system of positive shapes on the same plane as the negative shapes around it. A simultaneous "reading" of the subject as three-dimensional and two-dimensional then occurs. Illustration 2.5 visualizes the dual role of a plane as a segment of a volume's surface, and as a shape upon a picture-plane. Illustration 2.5A tells us nothing about mass or structure. It is a flat, vertical configuration. We cannot tell whether it is a solid or whether the outline describes an empty interior. In Illustration 2.5B, the outline of the shape remains identical: only the interior lines have been added, subdividing the original shape into three smaller ones. Perceiving these shapes united as planes creates an impression of volume. This volume appears to be solid because we cannot see any of the boundary lines that would be visible if the structure were made of glass or wire. In addition to its vertical character, we now understand the

*Illustration 2.4*

*Shapes as planes formed to give the impression of volume.*

*Illustration 2.5*

*Part A is a shape, B is a volume formed by shapes, and C is seen as three positive and one "open" negative shape.*

*Illustration 2.6*

*Some implied, or open shapes, formed by the convolutions of one shape or the placement of several shapes.*

volume to be turned at an oblique angle to the right. Further, the three visible planes strongly imply the three unseen planes necessary to our understanding of the volume as a box form. In Illustration 2.5C, separating the three planes creates three shapes which suggest no more about mass and structure than Illustration 2.5A does. Taken as a group, they form a "y"-shaped negative area. While not wholly enclosed by boundaries, this is still "readable" as a shape. These "open" shapes occur when encompassing positive shapes provide segments of enclosure greater than segments of separation. The partially enclosed area is seen as a shape since we tend to "complete" shapes that provide strong clues to their simplest totality[1] (Illustration 2.6).

Considering the single-shape limitations of the silhouette artists of the eighteenth and nineteenth

[1] Rudolf Arnheim, *Art and Visual Perception* (Berkeley and Los Angeles: University of California Press, 1954), pp. 54–55.

centuries, many did quite well in suggesting, to a degree, a sense of volume. But their efforts, (Plate 2.1) tend to support rather than contest the view that a single shape is understood primarily as a flat configuration and only secondarily suggests some clues about a volumetric state.

Shapes, then, tend to "offer" their edges. The simpler their interiors, the more emphasis on edge and the shape configuration it describes. When an observed shape's interior, by textural, tonal, directional, or decorative properties, becomes more interesting and active than its boundary, the chance is increased that the unwary student can be diverted from a recognition of the shape's "edgeness" and character. Likewise, when shapes combine to form a volume, their individual characteristics and their collective shape-state might be missed.

This is not to suggest that edge, contour, or outline must necessarily be a dominant graphic idea. But the search for the shape-state of a volume helps us locate those edges of straight or curved planes forming the volume's boundary, and thus better comprehend its structure and mass. Like the search for the gestural expression, the reduction of a volume to its shape components must be an early perception in the act of drawing. To proceed without either concept contributing its basic and penetrating information is to draw preconceived notions of a subject's class, and not a visual and expressive response to a particular subject as seen from a particular view.

This "flattening" of volume is especially helpful to clarify the outline of foreshortened forms. A common error in perception is the drawing of foreshortened forms in a way that suggests they were seen from above or a side view. At first, many students find it almost impossible to turn a volume such as an arm or leg nearly on end and "send it" back into a spatial field. If they see

that from their view the form *is* foreshortened, their exclusive attention then turns directly to the "telescoped" volume problem *before* they have seen the shape-state of the foreshortened form. They miss a crucial set of observations that could have helped them understand what the structure of that particular mass actually looked like, seen from a particular position in space. The seasoned artist recognizes a subject's shape-state will change as he changes his position in relation to it. He knows that perceiving the outline of that particular form "traps" both the information that shape provides about structure *and* the form's position in space; for its position creates its shape—its "field of play" (Illustration 2.7).

Further discussion of the means available to understand foreshortened volumes will be found in Chapters Five and Six. The following exercise should help you to make the indispensable perception of such a volume's shape-state.

### EXERCISE | 2B

Place any cylindrical form (rolled sheet of paper, mailing tube, juice can, etc.) on a flat surface about twelve to fifteen inches away, and about two or three inches below the level of your eyes, so as to see a side view only. It should not exceed fifteen, nor be less than eight inches in length. Correctly placed and centered, neither end plane of the cylindrical subject should be visible. Using a 2B pencil, begin your drawing in the middle of the page. Draw the shape *you see.* Draw it approximately actual size. Try to estimate the proportion between the shape's height and width as well as you can. Imagine you are going to draw a foreshortened view of a wheel containing eight or ten spokes. Move the cylindrical subject to the next position

*Illustration 2.7*

*Part A shows the shape-state of a foreshortened view of the arm seen in B.*

**A**

**B**

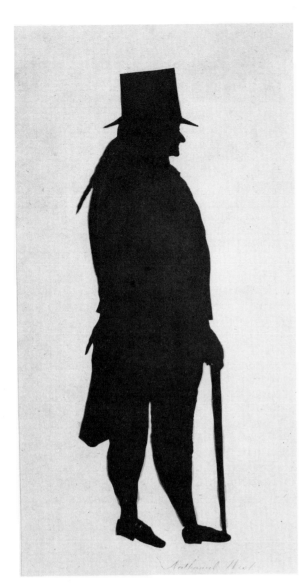

*Plate 2.1*

*Nathaniel West* (19th century). SILHOUETTE.
Cut black paper.
COURTESY, MUSEUM OF FINE ARTS, BOSTON.

your eye-level, even a quite long cylinder, when foreshortened, will show a smaller shaft than end shape.

Do this exercise often using simple forms such as blocks, books, bottles, or pencils. Point a finger in the general direction of your eye and draw it. Continue to practice turning forms to varying degrees back into space, until you feel no reluctance or discomfort in the presence of such a view of a subject, but rather enjoy solving the puzzle of a foreshortened form with the clues provided by its overall shape and by the planes that comprise its volume.

Though they are composed of joined planes, simple subjects such as the cylinder, cube, apple, or pebble can be seen as a single shape. Even complicated subjects (Plate 2.1) can be seen in this way. When this is possible, there is useful information to be gained by studying this overall, "final" shape of the planes. We can better decide where to place the drawing on the page and be informed of the subject's structural "terrain" at its edges.

Other subjects appear as a group of volumes, some of which partially block our view of others—as in a view of a still-life arrangement, a group of figures or houses, or one complex, but physically connected subject, such as a human figure. When studying such an intricate system of forms, it is generally necessary to divide the subject into several shape groupings in a more or less arbitrary way—more or less because the subject itself will suggest groupings according to size, value, placement, directions, character, or texture. Included in these considerations, should be any negative shapes present, such as those in areas A and B in Illustration 2.8. Whether the subject is reduced to a single shape or several shape subdivisions, this simplification increases the understanding of the *general* state of the subject, which must occur, if the smaller shapes are to have receptive "containers" in which to be formed. When the general state of a subject's shapes are comprehended, all subsequent departures from the "facts" become intended, subjective interpretations and not the inevitable results of poor perception.

If a volume requires two or more shapes, what about the sphere? It would seem to have only one: the circle. But recall that shapes may be hard-edged or *vague*. The sphere, cylinder, cone, arm, leg, or any other volume formed exclusively or mainly of curved planes, will offer a preponderance of subtly graduated value transitions. Here, the exercise of arbitrary divisions (*see* Chapter Four), becomes a necessity. To

(where you plan to place the next "spoke") and, observing two shapes now—the shaft and one end plane of your subject—try to see them as if they were on the same plane in space. You will notice that the shape of the shaft is no longer rectangular, but appears narrower at the upper (farther) end. Notice, too, that until you have placed the cylindrical subject in a totally foreshortened position, the end plane will not approach the shape of a true circle. In your second drawing of the subject, the end plane should appear as a narrow oval—or ellipse. Continue to draw these "spokes," moving your model each time, until you have completed the eight or ten drawings of the subject in a wheel-like radiation of "spokes." Each position will provide a new two-shape combination. Placed just below

*Illustration 2.8*

*Negative shapes A and B formed by enclosures of the figure's forms.*

establish shapes made of *values*, it will be necessary to group values according to their lightness and darkness, and declare these regions to be shapes. These differences in value result from the direction and nature of the light source upon a volume and tend to change as the planes turn toward and away from the source of illumination. The more abrupt the change between the direction of planes, the more abrupt the changes in value will be.

To simplify the grouping of differing degrees of value, it is useful to establish a few general value divisions. Considering white as zero degrees and black as one hundred degrees, and calibrating a scale in degrees of ten, we have a value scale that is helpful in establishing some order out of the many and seemingly elusive value changes of a subject. Using this scale, we can group the perceived values into three or four divisions more easily. A four division grouping might be: white, or the tone of the surface upon which the drawing will be made, a light gray (30%), a dark gray (70%), and black. There will, of course, be many more than these four values in most subjects. Each of these values should be drawn as belonging to the value division closest to it in degree.

Some artists, by inclination, and when a medium allows for it, find it clearer and more manageable to use this four value system. Then, after completing this stage of the drawing, they make whatever adjustments in value they feel necessary. Other artists will do this sorting in their mind's eye. Bypassing the preliminary stage of drawing the values in four divisions, they draw whatever values they need. The mental sorting will have influenced their use of value and the completed drawing will reflect the tonal order of the four value system.

Whether or not such value groupings appear at some stage in the drawing is less important than their having been consciously searched for and responded to. These four divisions help seeing the generalized shape-state of a subject's values. As the observed values are assigned to their appropriate division, larger value affinities spring up between parts of a subject creating new shapes. These shapes may be composed of parts of several independent volumes—as would occur if we were to shine a flashlight into a darkened room. A "shape" of light could then include all or parts of several pieces of furniture, part of the floor, wall, etc. In Illustration 2.9, the value-shapes frequently exist independent of the shapes of the volumes. The early perception of these larger value-shapes also serves to clarify their scale relationships, and help the artist to sense their gestural and directional qualities. Value-shapes within a form, like the overall shape that describes the boundaries of a volume, should be seen first as flat areas, and not as existing in space upon advancing and receding terrain.

The following exercise will necessitate a confrontation with the values of a subject. It should help you experience the semi-autonomous nature of value-shapes and see them as an intrinsic part of a subject's visual condition.

EXERCISE | 2C

Upon a simply draped cloth of one value (towel, pillow case, etc.), arrange a simple still-life consisting of nonreflecting surfaces such as unglazed pottery, wood and paper products, or foodstuffs in any combination of three or four objects you find interesting.

This exercise requires three drawings. Each will cause you to make different value groupings, resulting in different value-shapes. They will provide progressively greater freedom and control in the use of value. You will also find the "carving" of the general masses achieved through the organization of values progressively more convincing.

*Illustration 2.9*

*Part B shows a four-value grouping of the still-life
arrangement A.*

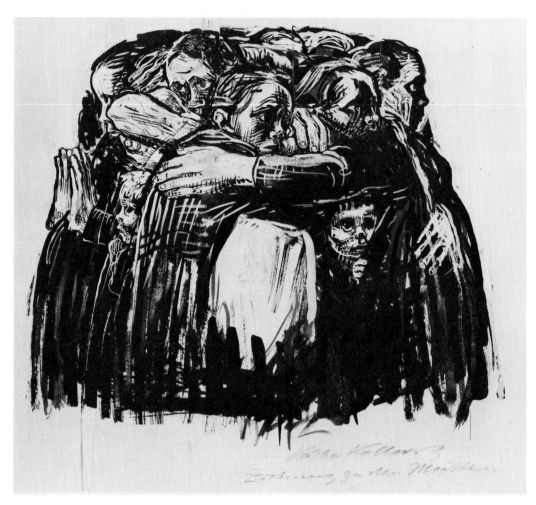

*Plate 2.2*

*Kathe Kollwitz* (1867–1945). The Mothers.
Brush drawing, india ink and Chinese white.
COURTESY, MUSEUM OF FINE ARTS, BOSTON.
FREDERICK BROWN FUND.

***Drawing 1.*** Group all the observed values into two divisions—black and white. Select any point near the middle of the value scale and leave any observed value lighter than that point (nearer to the white end of the scale) as the white of the paper; any value darker than that point (nearer to the black end of the scale) should be drawn as black. As in Illustration 2.10, if you are drawing a book upon a drape-covered table, with the light falling from a point directly overhead, the top planes of the book, drape, and table would appear as white, all the other planes as black.

Selecting a point nearer to the white end of the scale will produce a drawing with fewer white shapes and much larger black ones. Conversely, placing the point of separation nearer to the

black end of the scale will result in fewer black shapes and larger areas of white. By changing the point at which the values will be separated, you can create different value-shapes which will convey new structural clues about a subject's volume, as well as a different light intensity and expressive mood.

Plate 2.2 is a good example of the structural strength that this limited value system can provide. Here, Kathe Kollwitz *designs* the black and white shapes, both as a positive-negative arrangement on the picture-plane, and as a system of volume-producing planes in space. Your drawing, too, should have the look and feeling of a bold brush drawing, or a woodcut.

Using compressed charcoal or black conté crayon and a large sheet of charcoal or pastel

paper, draw the still-life arrangement approximately life-size. Begin by searching for the gestural expression, keeping your drawing fluid and all-inclusive, advancing the entire drawing together by reaching to all parts within the first two minutes, as described in Exercise 1A of the first chapter. You can use light tones and lines in a liberal manner at this stage, as the subsequent black value-shapes will absorb most of them and the remainder can be removed at any later stage in the drawing's development. Begin to search for the shape-state of volumes *and* value-shapes while the drawing is still in a fluid state. The search for these shapes should evolve from the latter stage of the gestural drawing. The values are as much a part of the subject as any other visual aspect, and the shapes they make should be an early perception.

Being limited to two values, you will be unable to "shade" or "blend." But the black and white shapes may, through their scale and placement, appear to "turn" or model the forms. This is a helpful restriction. It will serve to keep smaller observations and interests regarding the object's surface at bay and help you to "carve" the larger planes of volume by use of value-shapes.

When the forms in your drawing give at least a general impression of volume, you have completed the first part of this exercise. For many students, one surprise of this severe tonal restriction is the persistence of the sense of volume. Though many values disappear into the black or white groupings, and many smaller planes are

*Plate 2.3*

*Giovanni Battista Tiepolo* (1696–1770).
Two Magicians and a Youth.
Pen and brown ink wash.
THE METROPOLITAN MUSEUM OF ART.
ROGERS FUND, 1937.

*Illustration 2.10*

*A two-value drawing.*

absorbed into them, still, the big planes that these value-shapes create convey a sense of structure.

***Drawing 2.*** Draw the same subject from the same view. Draw this second version in the same way, but use *three* values: the white of the paper will represent the lightest third of the values in the still-life arrangement; a middle tone of approximately a 50% gray will represent the middle, darker tones; for the very dark values (70% or darker) use black. This may still seem to be a severe restriction, but as Tiepolo used it (Plate 2.3), it became an effective and handsome format for his visual and expres-

sive interests. The economy of three values permitted him to show value-shapes both as a pattern of spirited shards of tone that seem to drift across the page and as clearly defined planes that "carve" the volumes with great authority and vigor. Notice how Tiepolo changes values to indicate strong changes in the direction of the planes, as well as the gestural force of the shapes.

These are things to try for in your drawing. As your drawing develops, search for ways in which you can get the greatest "yield" of volume through these three values, and engage the animating and unifying properties of gestural expression.

As Tiepolo's drawing shows, this second system of organizing values can produce a great sense of volume. Working within its limits, continue your drawing until you cannot improve the sense of structural mass without using more than three values.

**Drawing 3.** This will again be the same view of the still-life, but use the four value divisions mentioned on page 22. Depending on the nature of your subject's values, the lighting, and your own inclination toward lighter or darker drawings, you may wish to adjust the range that each of the four values will cover. The following variation would result in a darker, more sculptured image: observed values from white to 15% gray will be stated as the white of the paper; a 25% gray will represent observed values in the 15% to 40% range; the darker values (40% to 70%) would be represented by a value of about 60% gray; for the deepest tones and black, use black. Whichever four division grouping you choose, you may be surprised by how many of the observed values can now be stated as they actually appear in the subject. Not nearly so many will have to be altered in tone (and many of these only slightly) to join one of the four divi-

Plate 2.4

*Edgar Degas* (1834–1917). AFTER THE BATH.
Charcoal.
COURTESY OF THE FOGG ART MUSEUM, HARVARD UNIVERSITY.
BEQUEST OF META AND PAUL J. SACHS.

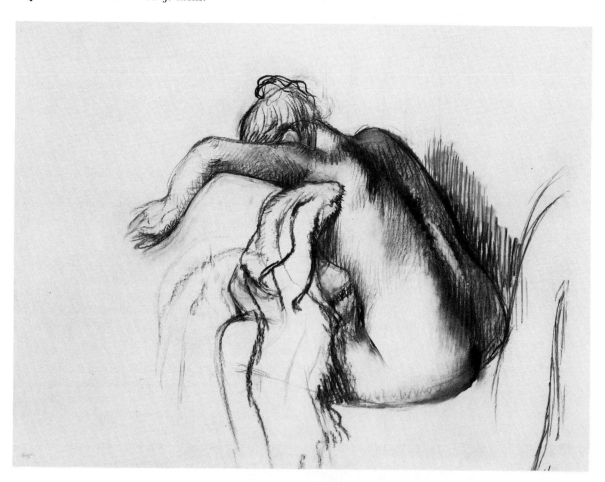

sions. In Plate 2.4, Edgar Degas has used similar four divisions of value. Note the white shapes of the figure, towel, and sofa; the light gray on the arm and torso; the deeper grays on the figure and wall; and the black tone in the center of the woman's back. Kathe Kollwitz (Plate 2.5) also uses four values to build a strongly sculptured and moving self-portrait. Both artists achieved a full sense of volume within this system. Part

of the unity, strength, and grace of these drawings comes from an understanding of the uses of value-shapes to create a system of expressive order.

This drawing can be carried further, since four values can distinguish more differences between value-shapes. Try to use this expanded value range to establish some of the smaller planes. After the drawing has been carried to a firmer, more volumetric stage, you might wish to aban-

*Plate 2.5*

*Kathe Kollwitz* (1867–1945). SELF-PORTRAIT.
Lithograph.
FOGG ART MUSEUM, HARVARD UNIVERSITY.
GRAY COLLECTION.

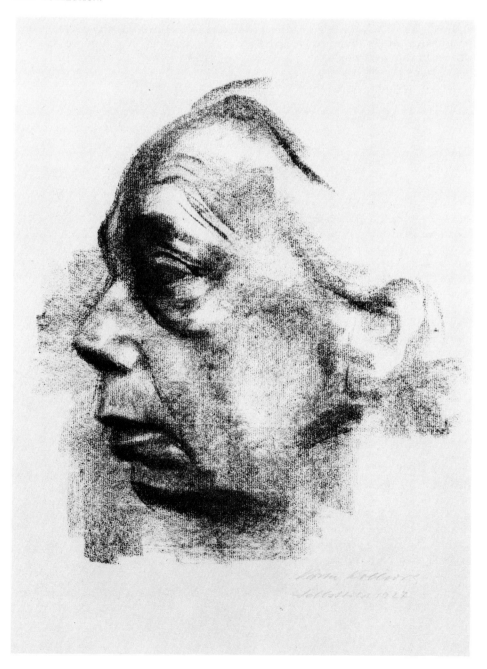

don the restriction on values to "get at" some useful nuances of tone and develop the forms further. However, avoid going so far as to lose the sense of shapeness and planar structure.

These three exercises in value grouping are in no way intended as "how to draw" systems (though, as we have seen, a number of notable artists have used the several formats discussed here). Their primary purpose is to have you experience the value-shape as a unit of volume building. Also, they may help you to produce some drawings that depend more on the powerful but less familiar and thus, more "feared" values, and less on line, than you may have done before. And finally, they will help you to see the shapes that planes and values make.

Continue to use all three of these limited value systems in sketchbook drawings of a few minutes duration to extended drawings of an hour or longer. Try to apply them to different kinds of subject matter, and try to alter the lightness or darkness of a drawing by setting the range of values in different ways.

## THE INTERDEPENDENCE OF SHAPE AND VOLUME

When volumes emerge from shapes, their third dimensional quality does not suppress the viewers awareness of their shape-state, but can effect the degree of awareness to the two-dimensional "life" of the shapes in a drawing. It is important to recognize the power we have to increase or diminish the viewer's attention to "edgeness." To subdue and thus deny shape *most* of its stimulating, aesthetic possibilities denies the viewer picture-plane "confrontations"—such as surface tensions between shapes, their directional "play," contrasts of value or texture, and gestural and structural character. The absence of a sense of shape activity then, diminishes the means by which the expressive intent and organizational design can be established. Such denial is a loss which impoverishes the volume one may want to produce. It generally leads to a fussy rendering of surfaces as an end in itself.

This seeming modification of one dimension by the other has been seen by some as creating a dilemma. How, if emphasis upon the third dimension reduces attention to the second dimension and vice versa, can one maintain a satisfying activity of both? A rich union of both can occur and is attested to by the drawings of Rembrandt, Cezanne, Matisse, and many others. This issue is largely absent in the works of those artists who intentionally eliminate structured, volumetric content, thereby clearing the way for the expression of concepts not otherwise possible. Paul Klee could not have probed the visual and expressive issues necessary to him (Plate 2.6) if the third dimension continued to be a major factor in the pictorial organization of this drawing.

Nor could Rubens have created his powerfully "sculptured" images if he had insisted on shape confrontations as the primary visual message. (Plate 2.7). But unlike artists working without volume (although two-dimensional drawings do impart a sense of spatial depth), Rubens was not free to abandon a dimension. No artist who requires a convincing impression of solid volume as part of his language of graphic expression is free of the responsibilities of the two-dimensional activities of his drawing. He must be sensitive

*Plate 2.6*

*Paul Klee* (1879–1940). THE ANGLER.
Watercolor, pen and ink.
COLLECTION, THE MUSEUM OF MODERN ART, NEW YORK.
JOHN S. NEWBERRY COLLECTION.

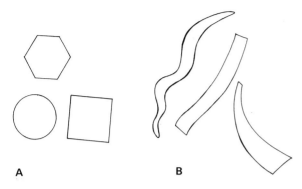

*Illustration 2.11*

*Group A show little or no sense of directional movement. Those in B move in the direction of their main axis.*

Shapes, whether as two-dimensional configurations only, or as stressed boundaries of volume, do much to guide us in or out of the picture-plane or in any direction on it. All shapes, except those whose radii are roughly equal, such as circular or square ones (Illustration 2.11), are seen as suggesting movement in the direction of their main axis. We tend to follow such movements whether they are in straight, curved, or variable directions.

Generally, the more geometric a shape or the simpler its outline in the direction of its main axis, the faster and more forcefully it appears to move in a direction. Compared to others in a

to the ways in which the second and third dimensions can assist and spur each other on (*see* Chapter Eight).

Actually, the dilemma disintegrates in the presence of a need to communicate the experience of an encounter with a subject. The need to express this experience (within the framework of a personal aesthetic persuasion), not the exploration of both dimensions (or either) as an end in itself, is at the heart of responsive drawing. The richest visual and expressive responses result from realizing the inventive possibilities of the interdependence of the dimensions. In art, one man's dilemma can be another's motive.

## SHAPE AS AN AGENT OF DIRECTION AND ENERGY

So far shape has been considered for its role in the structural organization of volume and for its capacity to stress "edgeness." It has others. Shape is important as an agent of direction. The familiar arrow on signs directing us to exits, shelters, etc., aims us toward a goal—and the shape itself suggests movement. We not only understand it as symbolizing an arrow in flight, but its intrinsic sleek, straight nature also allows our eyes to "read" it quickly. In the first chapter we saw the compelling force of shape when activated to convey the gestural expression of a subject. Our sense of the arrow's 'movement' is a response to that energy. But the role of shape as an agent of direction goes beyond gesture. If gestural expression is understood as the emotive character of movement, then direction is the "itinerary," the design of movement.

*Plate 2.7*

*Peter Paul Rubens* (1577–1640).
STUDY OF A MALE FIGURE SEEN FROM BEHIND.
Charcoal heightened with white.
REPRODUCED BY PERMISSION OF THE
SYNDICS OF THE FITZWILLIAM MUSEUM, CAMBRIDGE.

drawing, longer shapes and those with more sharply defined boundaries appear to move more swiftly in a direction. Moving with other shapes headed in the same general direction, a shape will impart to them, and receive in return, the suggestion of additional speed and force. Conversely, the more complex the shape, the more convoluted and/or diffuse the boundary, the more it is interlocked among stronger, faster shapes, the less active and directional it will appear to be (Illustration 2.12).

Exercise 2D will help you recognize the possibilities for control over the speed of the forms in drawing. The last part of the exercise is useful as a preliminary rough drawing "probe" before an extended effort, to help determine what directional cues the shapes of a subject offer.

### EXERCISE | 2D

Using any medium, fill a sketchbook page with three pairs of squares or squarish rectangles of the same size, making six squares, or picture-planes in all. For our purposes here, we will call the first pair A1 and A2, the second pair B1 and B2, etc.

In A1, place, at any angle, a straight or simply curved geometric shape which appears to move fast. Do not let its boundaries touch any edge of the picture-plane. Fill the rest of the picture-plane with shapes that seem to you to augment its speed, as in Illustration 2.12A.

In A2, redraw the original, fast moving shape in A1 (a good opportunity to practice Exercise 2A), and try to slow down its speed by filling the rest of the picture-plane with shapes which counteract its movement. These can appear to move faster or slower than the original shape and can cut across or under it to "cancel" its speed by moving in another direction, as in Illustration 2.12C.

You may use both geometric and organic shapes for this purpose.

In B1 and B2, repeat the exercise, using an organic shape for your original. First, try to speed it up by other shapes, then slow it down. Again, both geometric and organic shapes can be used to influence the speed of the original.

In 3A and 3B, repeat the exercise, using simple geometric and organic *volumes* as in Illustration 2.13. As with the shapes, use the volumes in 3A to permit and speed up the movement of the primary one; in 3B, to block or slow it down.

In all three parts of the exercise it is permissible to place a shape or (in the last part) volume *over* some of the primary configuration.

There are other factors that affect the speed and clarity of a shape's direction; the differences of value between shapes, their scale and textural differences, even the haste or deliberateness with which a shape is drawn affects its directional energy. Re-examine some of your earlier drawings to see how changing the directional function of the forms can improve them by making some more, and others less active. Responding to the directional cues of shapes in nature and governing the character of their movement are important perceptual and graphic skills.

### THE CHARACTER OF SHAPE

Shape can be a picture-plane "occupant," volume participant, and agent of direction. But it has another, somewhat more autonomous role. This role does not immediately serve other visual necessities, but declares the shapes in a drawing as having certain "rights." One of these is the "right" to a sense of "familial" resemblance. Another is the right of shapes to lend them support to the expressive as well as the visual forces of

*Illustration 2.12*

*Part A shows "fast" shapes, while those in B appear to suggest less movement.*

*Illustration 2.13*

*In Part A the volumes suggest speed. In B, the volumes "cancel" each other's movements.*

graphic order for more *subjective*—or imaginative results. This character of shape, its "personality" as being clearly defined or unfocused, curvilinear or angular, boldly or delicately bounded, etc., and its behavior as an agent of expression, must be recognized as another given factor of drawing. Because drawing without shapes is impossible, the need to establish their collective unity—their "oneness," *and* their suit-

ability to the artist's expressive intent—is inescapable.

In the drawing by Degas (Plate 2.4), the general feeling of bulk, the avoidance of intricate specificities of edge, the inclination to generalize, and the forceful "rush" of these undulating shapes establishes their unity of character and expressive power. How these differ from the character of the shapes in a similar subject is shown

*Plate 2.8*

*Pierre Auguste Renoir* (1841–1919). THE BATHERS. Red chalk.

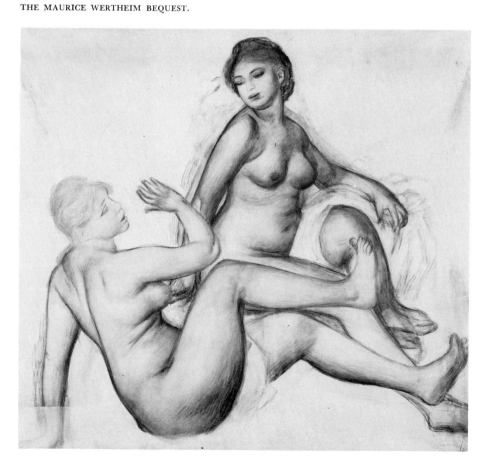

Plate 2.9

*Jacque Villon* (     –     ).
L'ATHLETE DE DUCHAMP.
(Torso of Young Athlete after Sculpture by
Duchamp-Villon of 1910).
Blue chalk drawing.
COURTESY, MUSEUM OF ARTS, BOSTON.
GEORGE P. GARDNER FUND.

Plate 2.10

*Paul Cézanne* (1839–1906). VIEW OF GORDANNE.
Pencil.
COLLECTION, THE MUSEUM OF MODERN ART, NEW YORK.
LILLIE P. BLISS COLLECTION.

Plate 2.11   (right)

*Peter Paul Rubens* (1577–1640).
STUDY FOR DANIEL IN THE LION'S DEN.
Black chalk, heightened with white.
THE PIERPONT MORGAN LIBRARY, NEW YORK.

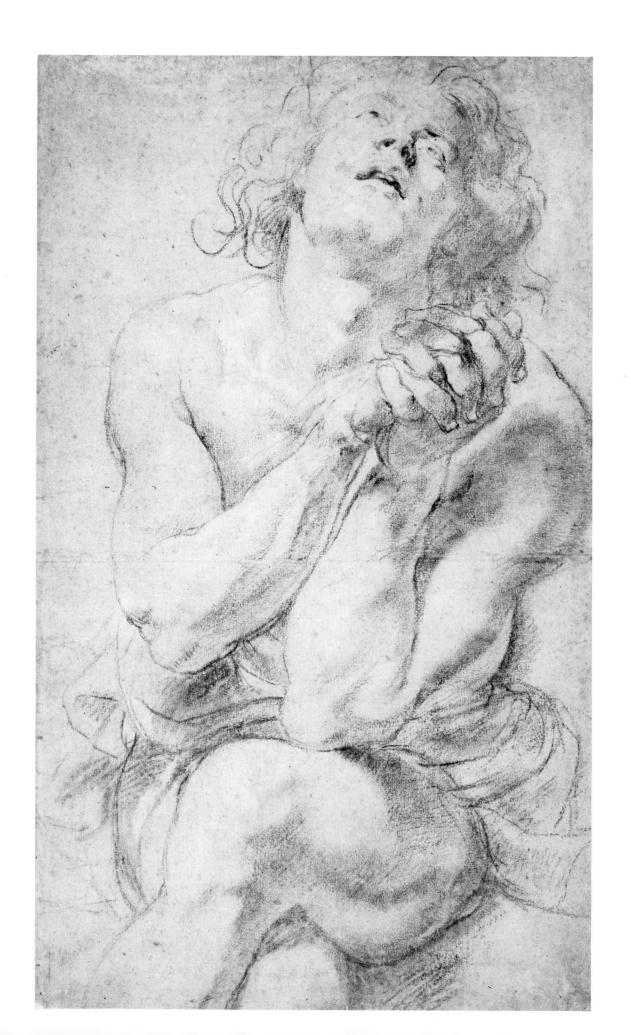

in a drawing by Renoir (Plate 2.8). Here, the shapes flow in a graceful, easy manner. There is a sharper "focus" to their edges and they seem to hint at a geometric simplicity. They have a playful, rhythmic, animated quality. In Villon's drawing (Plate 2.9) the shapes are angular; their various tilts create an agitation that plays across the surface of the entire group. Most of the shapes contain value changes and many appear to hide segments of each other. As a family, they are active, harsh, and aggressive. In Cezanne's drawing (Plate 2.10) the interlacing of geometric and organic shapes creates a handsome "weaving" of straight and curved edges. Here, too, we see a suggestion of the shapes reaching for a simpler, "purer" state. The edges of the shapes seem to vibrate, as if to avoid a final "corraling" into clearly delineated configurations, and often Cezanne opens the boundaries between shapes, creating larger ones, while not losing the identity of the smaller ones. Compare Cezanne's use of shape with those of Rubens' (Plate 2.11). Here, shapes twist, interlock, and strain against each other in a stormy turbulence of gestural activity.

These artists used the expressive power of shape character to help convey expressive intent, and gained the additional unifying benefits of shapes that share a family resemblance. Neglecting or censoring the expressive power of shape character invites a randomness of shape and a muffling of intent.

Responsive drawing involves a complex of perceptions, feelings, and ideas about an ob-
served subject *and* an emerging drawing. The conscious recognition of the several roles of shape is only one consideration, though a crucial and often overlooked one. How shape considerations fare in the medley of responses to a subject is determined by the artist's expressive intent and aesthetic persuasion. But if shapes are to play any active part in drawing, they must first be seen in their various dual roles.

Recognizing the "double life" of shape in drawing creates an appreciation of the ironies (1) of finding a shape's boundaries by seeing the boundaries of the shapes that surround it, (2) of finding a volume's planar structure by seeing the shapes which constitute it, (3) of finding a volume's direction and delineation by seeing the shape of the volume, and (4) of finding the expressive characteristics of shapes in a subject by feeling their emotive force. This duality of shape, only *potential* in the raw material of the physical world, if perceived by the student, becomes one of the most important insights in his perceptual development. Left unregarded, all that remains is the ultimately futile assemblage of details about surfaces. It is offering the viewer a visual "frosting" with no "cake" inside. And this, it seems, is the ultimate irony: that those for whom a realistic image is an important goal, will not reach it until they turn from it to learn the visual and expressive abstractions that constitute the language of drawing. The contributions to the language of drawing provided by shape are indispensable.

CHAPTER

3

# Line

*THE*

*ABSTRACT NECESSITY*

## A DEFINITION

The use of line as the primary means of graphic communication is universal. For most people, drawing consists of lines which make boundaries that represent a subject's physical limits and mark off major subdivisions within it. Line is a visually concise, familiar, and generally manageable system for communicating many kinds of information in graphic terms. Maps, blueprints, and diagrams utilize line's ability to represent in symbols organic or man-made things in nature. Charts and graphs use line to show concepts of weight, cost, and time. Line produces language symbols as well as visual symbols—we even tend to doodle with lines.

This natural and unquestioned acceptance of line as the chief method of producing graphic statements tends to blind us. We do not recognize that line does not exist in the physical world of matter. Virtually everything we regard as a line in nature is, in fact, a thin, solid volume such as a wire, pole, branch, or convex fold, or a thin depression such as a wrinkle, fissure, space interval between forms, or concave fold. In drawing then, line must be understood as a wholly abstract device for conceptualizing a symbol that stands for the thing seen or intended. With line, the limits of a color or value can be stated. Texture can be explained, abutments of planes shown, the

position of forms explained as located before, behind, or alongside others in space, and movement suggested.

In Chapter One, we found that contours emerged from gestural drawing. There, it was the way edges expressed our interpretation of the subject's action and actualities that concerned us. In Chapter Two, we focused on the way the edges of shapes bear important information about volume. Here again, edges, as line indicates them, will be a major, though not exclusive consideration. Line in drawing—as we shall see—is hardly limited to the delineation of contours.

Drawing in line demands a resolute and unflinching conviction. A black line drawn upon a white surface holds a finality that most art students find both exciting and terrifying. Understandably so, for a drawing limited to line only, will "falter" every time the student falters in his perceptions or daring. Certainty, self-restraint, and confidence are necessary to create a line that simultaneously records the artist's directional, proportional, volumetric, textural, and compositional responses as well as his expressive ones. Distilling observed "raw material" to a system of lines is a sophisticated act of visual and expressive comprehension.

A drawn line has certain given properties. It

*Plate 3.1*

*Alberto Giacometti* (1901–66). AN INTERIOR.
Pencil.
COLLECTION, THE MUSEUM OF MODERN ART,
NEW YORK. GIFT OF LESTER AVNET.

always has direction, interrupts or divides the picture-plane, has a certain length, has along its course one or more values, and is consistent or varied in width or *weight*. It also has a "personality" or *attitudinal character* mainly derived from the artist's aesthetic and intuitive attitude to line in general, and his visual and expressive responses to a subject in particular. The medium and surface used also influence the attitudinal character. The artist using pen and ink will produce a very different kind of line than when he is using compressed charcoal. The first, being a liquid medium, has none of the characteristics of compressed charcoal which is an abrasive medium (*see* Chapter Seven). It, in turn, cannot produce the precise and fluid qualities of ink. Papers with a pronounced surface texture do not permit as

fast and free-flowing a line as do papers with slick, hard surfaces. Not only does the medium limit the character of the lines produced, it deflects the artist's lines onto certain tracks of usage which influence his perceptions of the subject. The medium thus influences his selections. He will tend to respond to those qualities in the subject that his medium and paper are compatible with and avoid those that would create technical problems or are beyond the medium's range of usage.

Line can be used in two basic ways: descriptive and emotive. *Diagrammatic lines* and *structural lines* are descriptive in character, *calligraphic lines* and *expressive lines* are emotive. Diagrammatic lines clarify the artist's impression of space, shape, volume, and direction. Structural lines emphasize a subject's volumetric aspects. Calli-

graphic lines convey a sense of animation, touch, and rhythm, and are generally curvasive.[1] Expressive lines enable the artist to convey an emotion or mood in drawings where these qualities are of utmost concern to him. Although *all* lines have expressive qualities, here an expressive use of line describes lines whose *dominant* theme is emotive, rather than perceptual or organizational. All four kinds of line may be present in some drawings and it is possible for a single line to function in several, or all four ways at once (Plates 1.1 and 3.6). Although in practice these categories always overlap in various combinations, here we will regard them separately, to better examine the nature of each.

## THE DIAGRAMMATIC LINE

The experience and clarification of spatial depth, shape, volume, and direction are conveyed in Giacometti's drawing, "Interior" (Plate 3.1). Here, line measures distances, estimates scale, and weaves through space to explain the environment in which the forms are placed. The diagrammatic line is a searching, analytical, investigatory line. It reveals the general scale, shape, and structural nature of forms and their location in space. Giacometti's need to "know" the subject's structural and spatial relationships causes him to send lines exploring *through* forms, making them appear transparent, connecting one form with another. His intense need to experience the three-dimensional life of forms and shapes in space—the *plastic* nature of his subjects, and the desire to fuse form and space into a system of rhythms and tensions—energizes the lines and causes their darting, inquiring activity. Note the emphasis on the shapes of the volumes.

In Lautrec's drawing, "La Pere Cotelle" (Plate 3.2), there is again an inquiring, diagrammatic use of line. Again, line explores the general structure of forms *and* their spatial "container" by moving freely upon, through, and between the forms.

The drawn line immediately and dependably records the artist's perceptual comprehension, motor control, intent, and feelings at the instant it was produced upon the page. In these drawings Giacometti and Lautrec are deeply concerned with visual discovery and experience—with exploring and manipulating volume and space—

and their lines affirm this. The artist, and consequently the lines he produces, are responsive to the stimuli of visual cues about space, shape, and volume. But, although the resulting lines are primarily diagrammatic in function, they also convey an expressive quality—the artist's excitation about his visual discoveries. Thus, their perceptions precede their feelings. As these drawings show, descriptive and emotive attitudes to line are not mutually exclusive.

## THE STRUCTURAL LINE

Although related to diagrammatic line, structural lines have some distinctive characteristics. They stem from the same necessity to explore and

*Plate 3.2*

*Henri de Toulouse-Lautrec* (1864–1901).
LA PERE COTELLE.
Charcoal with colored crayon.
COURTESY OF THE ART INSTITUTE OF CHICAGO.

1 Roger Fry, "On Some Modern Drawings," *Transformations* (London: Chatto and Windus Ltd., 1926).

explain space, shape, and especially volume. They differ mostly because of their emphasis upon volume. Here, line is used almost sculpturally to build solid, three-dimensional forms. Often, groups of lines are used together to create optical values that suggest the presence of light (*see* Chapter Four). Leonardo da Vinci's and Michelangelo's pen-and-ink drawings (Plates 3.3, 3.4) emphasize a full realization of the subject's forms through the use of such lines grouped to function tonally. So many lines are used that, unlike dia-

grammatic line, of which we are always aware, these lines, collectively, are seen as tones. A structural use of line tends to suppress attention to contours and emphasizes the volumetric character of forms. Often, as in the Michelangelo drawing, the artist using structural line limits his presentation to the subject's forms with little or no attempt to develop the surrounding environment. Not surprisingly, many sculptors, like Michelangelo, draw almost exclusively in structural line. Because structural line, like diagram-

*Plate 3.3*

*Leonardo da Vinci* (1452–1519).
FIVE GROTESQUE HEADS.
Pen and ink.
WINDSOR CASTLE, ROYAL COLLECTION,
COPYRIGHT RESERVED.

*Plate 3.4*

*Michelangelo Buonarroti (1475–1564).*
STANDING NUDE, SEEN FROM THE BACK.
Pen and ink.
ALBERTINA, VIENNA.

matic line, is exploratory, artists sometimes combine these two attitudinal approaches to line. In Cezanne's drawing of a card-player (Plate 3.5), the structural lines in the hat, hand, and sleeves merge with the probing diagrammatic lines that establishes the shape-state of those forms. The lines in the drawing's lower half are almost exclusively diagrammatic which suggests that Cezanne first used lines to explore forms and space throughout the drawing, and developed the up-

per part of the figure based on the information so gained. The use of diagrammatic line, functioning in a gestural way, is understandable when rock-like monumentality is a desired goal. Some gestural-diagrammatic drawing is visible in the card-player's legs, cloak, sleeves, and hat, as well as in the areas around the hat and head.

## THE CALLIGRAPHIC LINE

The rhythmic, tactile nature of calligraphic lines usually have strong gestural qualities. Kokoschka's chalk drawing (Plate 3.6) contains many kinds of calligraphic line, from the chair's ghost-like delicacy to the forceful lines of the skirt and jacket. Kokoschka's lines offer numerous variations of thick–thin, short–long, flowing–angular, fast–slow and light–dark line ideas. These all function as units in symbol-making, i.e., woman, but show an independent play of line variations as a simultaneous plastic, or abstract theme.

Some of the lines, such as those of the chair, or the faint lines on and around the head, are more investigative, as much concerned with diagrammatic searching as with calligraphic exposition. They serve as quiet, inquiring foils for the bolder, emphatic lines. If the drawing had an unchanging sameness of line-character, much of its *type* of calligraphic play would be lost, for one of the drawing's strengths is in its line variety.

Yet, an unvarying line, when *it* is an artist's theme, provides another kind of calligraphic line. Matisse's pen-and-ink drawing of a figure (Plate 3.7) has a consistency of line that helps create an impression of the drawing as a two-dimensionally active, linear design. Unlike the Kokoschka drawing, where a rich variety of line assists in locating planes and edges and establishes a solidity of the forms, Matisse's more uniform line tends to flatten the forms somewhat by stressing the cut-out character of the edges. This occurs because contours represent the most distant surfaces of a rounded form. Emphasizing contours tends to bring forward the receding, foreshortened planes they are meant to represent. Matisse further accents the second dimension by altering the observed contours to create a strong, curvilinear flow of lines.

Though these two drawings are very different in concept, mood, and intention, both are strongly calligraphic. Both artists rely on line's capacity for visual and expressive excitation and not on its ability for descriptive delineation alone.

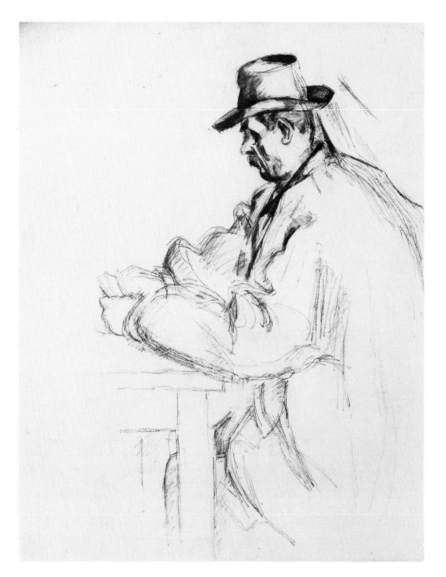

*Plate 3.5*

*Paul Cézanne* (1839–1906). THE CARD PLAYER.
Pencil and watercolor.
MUSEUM OF ART, RHODE ISLAND SCHOOL OF DESIGN,
PROVIDENCE, R.I.

It should be stressed here that *expressive line,* generally regarded as such when a need to experience or share feelings *supercedes* any other motive for a line's use, should not be confused with the expressive properties of the calligraphic, diagrammatic, or structural uses of line. As observed earlier, all lines in drawing convey *some* expressive properties. They represent an artist's intellectual *and* emotional encounter with a subject, resolved through his aesthetic and temperamental attitudes to line. The Kokoschka drawing is sym-

pathetic and somber in mood, the Matisse, animated and playful—and the character of the lines help tell us this.

## THE EXPRESSIVE LINE

Unlike the artist for whom line's expressive power is triggered primarily by visual stimuli, other artists, such as Francisco Goya (Plate 3.8),

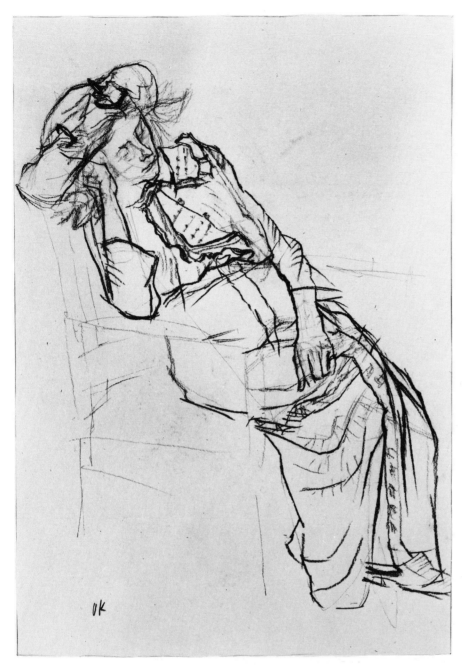

come to the blank page with an established expressive intent of another kind. For these artists the expressive character of line, though it may result in part from visual challenges and insights that occur while drawing, receives its initial impetus and potency from a need to experience or share feelings *through* and not merely *about* the representational content of the drawing. In Goya's etching, the first in a series called "The Disasters of War," it is not the representational matter alone that expresses his ominous warning of impending doom. The attitudinal character of the lines imply this through their slashing, cross-hatched clash and the brooding tones they form. That these lines carry the grim message intrinsically can be seen by covering any portion of the drawing. Even small segments cannot be seen as cheerful, gentle, or serene. Lines of such

*Plate 3.7*

Henri Matisse (1869–1954).
ODALISQUE WITH A MOORISH CHAIR.
Pen and ink.
COLLECTION, THE MUSEUM OF MODERN ART, NEW YORK.
ACQUIRED THROUGH THE LILLIE P. BLISS BEQUEST.

*Plate 3.8*

Francisco Goya (1746–1828).
SAD PRESENTIMENTS OF WHAT MUST COME
TO PASS from, THE DISASTERS OF WAR.
Etching.
PRINT DEPARTMENT, BOSTON PUBLIC LIBRARY,
BOSTON, MASS.

expressive force do not come from a calm, contented attitude, but from a deeply felt anguish.

Goya's interest in any of the visual processes and principles of drawing exists only insofar as they strengthen his message. This is not to suggest that these matters were of little importance to him, rather that they were not important as ends in themselves. They were a necessary means to attain his expressive ends.

Jules Pascin (Plate 3.9) uses line to express a sensual, even erotic interest in the female figure. There is an honest fascination evident in the slow search of the forms. These lines, *by their nature,* express the pliancy and weight of the body. Pascin delights in experiencing every fold and swell of the figure and of the yielding, receiving character of the sofa. Everything in this drawing is felt as supple and pliant—terms which describe the character of the lines themselves. Again, covering a section of the drawing would show remaining portions capable of communicating Pascin's sensual, tactile message. That lines can function in more than one way is evident in the calligraphic qualities of Pascin's drawing. While the drawing's main thrust is toward the tactile experiencing of forms through lines born of, and imbued with his visual encounter with the model, Pascin's lines simultaneously suggest an "awareness" of each other. They create rhythms and affinities which are satisfying in themselves.

Artists may support the emotive message of their drawing's representational content through line's expressive powers for many reasons. Historical, religious, political, and social issues have been catalysts for such drawings.[2] But many other motives can, and have stimulated artists to use line for expressive purposes beyond those stimulated by visual issues alone. The lines that convey Picasso's understanding of a mother's feelings for her child (Plate 3.10) are themselves gentle caresses.

## ON USING LINE

This discussion of the several basic attitudes to line may leave the impression that these are consciously selected by the artist. This is not the case. Although the more experience the artist has in exploring attitudes to line, the wider his control of it will be. Therefore, we should strive for some rapport with these line categories (Exer-

cise 3A) to experience their possibilities. But there are several reasons for our not being altogether free to choose attitudes to line when we draw. No completely free choice occurs for the same reasons that we do not choose our styles of handwriting. First, our neuromuscular coordination and control imprints certain pathways of line-making and blocks others. These personal idiosyncracies are not easily overcome. Nor should we try to overcome them for they form part of our unique way of drawing (or writing). This personal style of using line, is in itself neither good nor bad—it is just our way—and as capable of stating perceptions and intent as any other. Second, our intuitive and intellectual interests—how we like to use and see line—insists on a particular "recipe" made of all, most, or some of these attitudes to line. This personal necessity of line-function may vary with the choice of subject or medium and as our moods and interests fluctuate within a certain aesthetic point of view.

There *are* drawings which convey little sense of line's attitudinal abilities. Such drawings tell us that their authors were unaware or not especially interested in the various analytical and emotive uses of line, that no benefits were gained from line as *aesthetic events* in their own right, or as supportive of a drawing's representational content. Such drawings show a limited, unexplored use of line. Generally, they indicate an exclusive concern with the surface effects and appearances of a subject. But the use of line to symbolize a subject places the drawing (as has been mentioned) well away from the "real." To convey the experiences of our visual and expressive encounter with a subject through line is possible only by utilizing line's ability to explore, act, and express. Mere delineation is too often unselective outlining and, as such, always expressively dull. This kind of line does not search, feel, declare, or play; it simply *describes* boundaries. Such delineation is primarily the scrutiny of edges as ends in themselves.

In responsive drawing, a line always functions at three levels: it *describes,* it *acts,* and it *interacts* with other lines visually and expressively. If descriptive delineation is the only motive for making a drawing, we lose more than line's aesthetic potential. Descriptive drawing alone skirts all the responsive possibilities of line. It merely notes outward appearances at the cost of line's ability to communicate relationships and meanings. As we have seen in the previous two chapters, an emphasis on a subject's surface appearance blinds us to a subject's gestural expression and shape-state. Here, it blinds our responses to the

2 For an interesting exploration of such motives see Ralph E. Shikes, *The Indignant Eye* (Boston: Beacon Press, 1969.

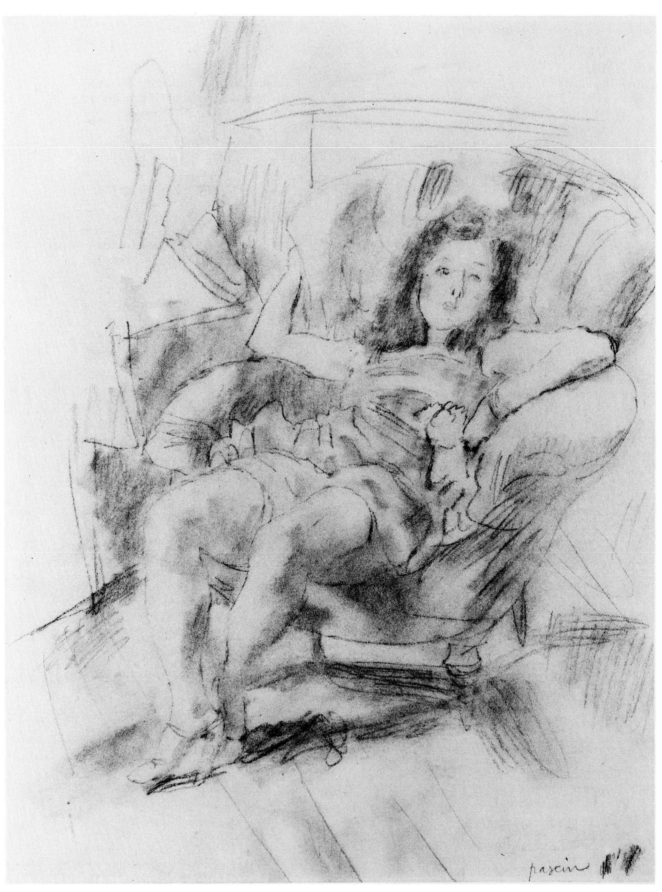

*Plate 3.9*

*Jules Pascin* (1885–1930). GIRL IN AN ARMCHAIR.
Charcoal, some yellow chalk.
COLLECTION OF THE NEWARK MUSEUM.

many possibilities for creative activity and meaning of the very means being used to make the drawing . . . line.

For a better understanding of the several attitudinal roles of line discussed, it will be necessary to make some drawings in which each can be experienced. To better grasp their differences, a single subject in a single pose should be used.

### EXERCISE | 3 A

This exercise consists of five drawings. Two of these take thirty minutes each, the remaining three, fifteen. All five should start as two-minute gestural drawings. In each drawing your model will be the same: your own hand, holding a tool, letter, utensil, flower or anything that is not much larger than the hand, is comfortable to hold, and has some interest for you as a visual and/or expressive subject.

The five drawings and the time alloted for each are:

1. a calligraphic drawing—fifteen minutes
2. a diagrammatic drawing—fifteen minutes
3. a structural drawing—thirty minutes
4. an expressive drawing—fifteen minutes
5. a combination drawing—thirty minutes

For Drawings 1 and 4, use India, or any black ink, and a pen capable of line variation, such as a steel crow-quill or artist's sketching pen. For Drawings 2 and 3, use a stiffer pen-point or a fountain pen used for technical drawings that produces a line of unvarying width. For Drawing 5, use either one or both as needed. Do all five drawings on a rather stiff paper, such as bristol or vellum stock, or on a good grade of drawing or watercolor paper that has a moderately even surface. The drawings should all be about the same size, approximately 10″ × 14″. In each of the drawings, try to work about actual size, but do not hesitate to work larger if your drawing requires it.

Making a gesture drawing in pen-and-ink may create some anxious moments for the student. The earlier gestural drawings in pencil were "safer." An unsuccessful passage could, if light enough in tone, be worked over with darker tones or lines and erasure was possible. It was like walking a tight-rope with a net below. Here, there is no net. The foggy tone-lines, so useful in establishing the spirit of the expressive action and so helpful in avoiding a lapse into outlining,

*Plate 3.10*

*Pablo Picasso* (1881–    ). A Mother Holding a Child and Four Studies of her Right Hand. Black crayon.
COURTESY OF THE FOGG ART MUSEUM, HARVARD UNIVERSITY.
BEQUEST OF META AND PAUL J. SACHS.

are not possible in this medium. Obviously, the student must alter his approach to gestural drawing in pen-and-ink.

Many artists will precede a gestural drawing in pen-and-ink by another one in pencil, *on another sheet of paper.* Tracing the original drawing in ink will destroy its spontaneity. In any case, there is no satisfactory way to transpose the soft, light tone-lines so natural to chalks and pencils, into pen-and-ink. Such a preliminary pencil drawing will help you become familiar with the subject and allows for a more sparing use of line in the pen-and-ink gesture drawing. And using the fewest lines possible is now necessary, for unlike the gesture drawing in pencil, almost every mark will be visible in the completed draw-

ing. Because the emphatic and permanent nature of the ink line allows only a modest amount of linear searching for gesture, more time and effort must be given to perceptual analysis and summary *before* you begin to draw. Where pencil or crayon could make an uninhibited sweep in tone, a few short, broken lines or even dots may have to suffice to show the action. However, do not hesitate to use continuous lines if you wish. That such a pen-and-ink gesture drawing can, in its own way, convey as much about the character of the action and need not be cautiously drawn is evident in Gaudier-Brzeska's spirited drawing (Plate 3.11). Although intended as a final statement, it is an impressive example of how much gestural expression can be grasped with a few felt, selective lines.

Think of these lines and dots as clues—a kind of gestural shorthand—about the expressive action. These clues should also refer to direction, shape, and any other perceptions you wish to note for further development. Remember to develop all parts of the gesture drawing together (Illustration 3.1).

***Drawing 1.*** After the two-minute gestural phase, try to complete the drawing by lifting the pen from the paper as little as possible. Holding your pen upon the paper at the completion of a line, while you look up to make further observations, often leads to discoveries of nearby edges or tangential forms that allow the line to continue. This continuity of a line gives it a sense of animated life, as in the Matisse drawing (Plate 3.7). Though a shorter, vigorous line like Dufy's (Plate 1.9) also suggests an energetic, calligraphic quality, as does the rich variety of Kokoschka's line (Plate 3.6), the extended, flowing line more clearly reveals line's capacity for visual and expressive activity of its own. However, do not

*Plate 3.11*

*Henri Gaudier-Brzeska* (1891–1915). STANDING WOMAN. Pen and ink.
COLLECTION, THE MUSEUM OF MODERN ART, NEW YORK.

hesitate to use line ideas such as those in the Dufy and Kokoschka drawings where you feel they are necessary to your drawing. Note that Matisse uses some short lines and dots, as well as lines drawn speedily, as in the hair, or slowly, as those of the contours of the figure. For your first attempt at a calligraphic attitude, favoring fewer, longer lines will make you seek variations of

*Illustration 3.1*

46

direction, weight, rhythm, speed, and visual "play." By using fewer lines you will more likely invest them with greater visual and expressive duties. You will then more easily become aware of their plastic possibilities. Sensitivity to line's autonomous life is a prerequisite to those responses that "call forth" the calligraphc quality.

There is no one way to draw calligraphically. Your continuing study of the drawings by artists using calligraphic line will reveal the endless possibilities for linear play. The suggestions above will help you experience the visual and expressive independence of line from its role of descriptive delineation. Such lines are not "freeborn"—to wander where they will—but *can,* simultaneous with their representational role, offer linear configurations that are aesthetically satisfying.

In Lautrec's pen-and-ink drawing of a mounted officer (Plate 3.12), gestural and calligraphic lines occur throughout. We sense that Lautrec enjoyed the "confrontation" of contrasting types of lines, and the knowledgeable flourishes of his "handwriting" are graphic activities in their own right.

The lines are descriptive of a confident young mounted officer, but simultaneously assert their own exciting existence. Although these lines are expressive as well, their *dominant* impression is of calligraphic play. Here, again, perceptions precede feelings.

With fifteen minutes to make your drawing, you need not feel hurried. Indeed, a slower line permits you to respond more explicitly to some of the smaller or subtler perceptions. It also acts as a brake on the desire for fast flourishes which, because of the speed with which they are executed, may not be the result of sound observations, but of a wish to impart a calligraphic "look" to the drawing. But in responsive drawing, lines not stimulated by felt perceptions are either personal drawing cliches or aimless motor activity. The calligraphic line is always a felt, informing line with a plastic life of its own.

Your goal in this first drawing is to interpret the subject as a system of forms which offer interesting linear ideas—ideas you feel extract the subject's essential character and allow for a satisfying use of line, much as you use line when

*Plate 3.12*

*Henri de Toulouse-Lautrec* (1864–1901).
HORSE-GUARD, LONDRES.
Pen and ink.
MUSÉE TOULOUSE-LAUTREC, ALBI, FRANCE.

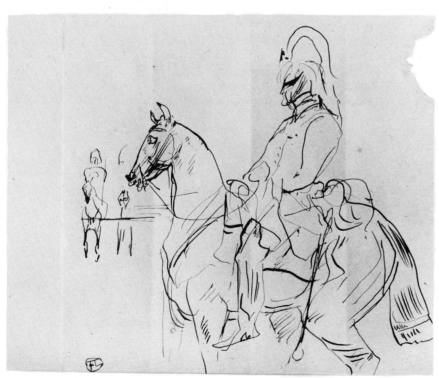

writing. The lines in the completed drawing should convey not only your perceptual responses to the subject's actualities, but simultaneously, interactions and affinities that exist as an abstract and autonomous activity.

These several functions of calligraphic (or any other) line to *describe, act* and *interact* are ultimately inseparable. Examining Lautrec's drawing of a mounted officer, it is impossible to determine whether his visual perceptions of, and feelings about the subject led to the drawing's calligraphic system, or whether a predisposition towards the particular line used in this drawing resulted in just that interpretation of the subject. Many Lautrec drawings can be cited in defense of either view. Actually, to some degree, both are always present.

All artists (excluding medical illustrators and others for whom unselective copying is a requirement or a goal) are attracted by both considerations in response to a subject before them. Artists want to make permanent their impressions of, and experiences with, something they see, and they need to do so in a particular way.

These interests depend on each other. The comprehension of, and response to a subject's figurative factors *and* the organizational and expressive ideas used to form them, create the give-and-take between a drawing's "what" and "how" that determines those particular insights and innovations that make it an invention rather than a report. It is the quality of the negotiations between these simultaneous and mutually stimulating considerations which creates the union called art in which the whole is greater than the sum of its parts.

**Drawing 2.** After the two-minute gestural phase, explore the planes that comprise the volumes of your hand and object, and the distance separating the volumes from one another. Notice the angle, or tilt of the volume, their scale relationships and the shape, scale, location, and direction of any "empty" or negative areas. Do so by a liberal use of line.

Your goal in this drawing is to explore and explain the subject's measurable shape, scale, spatial, directional, and structural characteristics. This analytical theme must be so insistent that responses to the surface effects of texture or light are disregarded to avoid weakening the diagrammatic message.

The calligraphic line was, to some extent, a tactile, sensual line. The sensation of touching the forms to feel their "terrain" helped suggest ideas for line activity. Here, the goal is not to caress a form, but to tell us about its physical properties and its relationships to the subject's other forms. The diagrammatic line is primarily intellectually informing. Its expressive properties come from the artist's excitation about the visual perceptions he makes regarding the subject's actualities, and the relational ideas they suggest to him. When a diagrammatic line responds to an edge or "rides" upon a form, it describes, it tells about, rather than *feels* that edge or surface just as the longitude and latitude lines of the globe indicate divisions of that form without responding to the undulations of the earth's surface.

Like the arbitrary lines upon a globe, *cross-section* lines, sometimes called cage or cross-contour lines, help to explain the general nature of a form's surface. Plan to use such lines wherever you feel the need to further explain a form's volumetric character (Illustration 3.2). This is more

*Illustration 3.2*

*Plate 3.13*

*Giovanni Battista Piranesi* (1720–78).
ARCHITECTURAL FANTASY.
Pen, brush and ink.
ASHMOLEAN MUSEUM, OXFORD.

frequently necessary when the form is not comprised of flat planes, but is more rounded and organic in character.

When diagrammatic lines are used to explain a form's cross-section character at a particular location, they will differ from calligraphic lines performing a similar role. Where calligraphic lines will show a tactile sensitivity to subtle nuances of the changing mass, diagrammatic lines state a form's general structure.

Although a line can function in more than one way at once, in this drawing try to use lines only to explore the forms and the spaces between them. These spaces, like the solid forms, should be "measured" and explored by lines (Plate 3.1). Draw as if you can see through a solid form to the forms located behind it. In this way you can more fully understand the location of forms and the spaces which separate them.

In the drawing by Piranesi (Plate 3.13), the liberal use of line helps explain the forms he is representing. Piranesi reinforces our understanding of a plane as flat or curved, a volume's position in relation to others and the spaces that separate and surround the volumes by using groups of lines which explore surfaces, placement, and space more fully than a single line can.

Like the Giacometti and Lautrec drawings (Plates 3.1, 3.2), the Piranesi drawing conveys a sense of excitement about the creation of a three-dimensional environment. In your drawing, regard every perception of scale, direction, space, etc., as an important discovery. Allow—or encourage—a sense of satisfaction about each new "find." Once you have established one or two areas in the drawing that convey a sound grasp of the volumes and their spatial relationships, other, less clearly understood passages will call for clarification. Continue to work on these less developed passages so that the drawing, at the end of fifteen minutes, will show an even standard of clarity throughout. Like the Giacometti, Lautrec, and Piranesi drawings, you should let your drawing "grow" to include the immediate environment of your subject, thereby including new spatial relationships.

In drawing, any kind of line can perform a diagrammatic function. When an artist uses a line to tell us something of a volume's dimensions or position, the space in which it exists, or its

physical relationship to other volumes, that line, whether additionally functioning in a calligraphic or any other way, is performing a diagrammatic function.

Again, it is important to recognize that lines generally function in several ways simultaneously. We have seen that Pascin's drawing (Plate 3.9) is made of expressive lines that have calligraphic properties. Lautrec's drawing (Plate 3.12), while primarily calligraphic, offers lines which function additionally in diagrammatic, expressive, and structural ways. When we add to this considerations such as lines' contribution to the drawing's composition and their plastic activity among other lines, we begin to see the challenges and possibilities that exist beyond the merely reportorial aspects of drawing. With the realization of choices expanded by these considerations, you will recognizes that discovery, experience, and invention, not reporting, is at the heart of responsive drawing.

***Drawing 3.***   You have thirty minutes in which to make a structural line drawing. Again, begin with a two-minute gesture drawing. This time, however, modify the gestural aspects and stress a diagrammatic search of your subject, as Cezanne does in Plate 3.5. There we saw how the diagrammatic "armature" helped to guide the structural drawing. Concentrate, then, on drawing (in a general and simplified way) all the positive and

negative shapes, study the scale difference between forms and their various directions in space. But do not sacrifice the search for the gestural action altogether, or the resulting drawing may be stiff and lifeless.

After the two-minute phase, you will often be drawing groups of lines. It may be helpful to fill a practice page with line groups such as those in Illustration 3.3. The few moments taken to do this exercise within an exercise will provide you with a better control for making the various line groups or *cross-hatchings* you will use in this drawing.

Now your goal is to explain the structural role of the flat and curved planes of the volumes. Also, try to convey the volumes' sense of weight. If your hand is holding a flower, show through the vigor or delicacy of your lines, their weight and group density, the lightness of the flower, and the relative heaviness of the hand.

Instead of drawing the outline of each plane, use cross-hatch lines, so closely placed alongside each other as to appear to be a tone as in Illustration 3.3, and in Plates 3.3 and 3.4.

Place your hand with the object in a position which allows a single, diffused light to fall upon them. Avoid strong sunlight or a position too close to a harsh, artificial light source. These conditions create extreme and often abrupt value changes and dark cast shadows. A cast shadow occurs when a form blocks the path of light rays,

*Illustration 3.3*

*Forming line groups by lines that overlap, as in A, B, and C, is called cross-hatching.*

leaving the area behind the form in darkness (*see* Chapter Four). In your drawing, avoid cast shadows except for those small, form-revealing ones you feel will strengthen your subject's structural message. Daylight, preferably a north light (which changes least during daylight hours) will best reveal the tonal differences of the planes and their directions, and permits you to see into the darker recesses of, and between the forms.

Often, a plane's direction can be selected by the artist. In Illustration 3.4A, the same planes are drawn to carry the eye in different directions. Here, the cubes' volumes are not affected by the differences in the direction of the line groups. They are equally solid but we "read" them differently. When a form's **structure** can be stated equally well in any one of several ways, the choice should be one that assists in clarifying other issues such as compositional or expressive ones. In Illustration 3.4A, cylinder 1, lines direct our eyes along the length of the body, while in cylinder 2 the lines move around it, implying the existence of the cylinder's unseen back. The first cylinder is seen as moving in a direction with more force than the second one but tells us less about its volume than the second. Usually, lines that appear to move around a form, or to ride upon its surface undulations (as in Illustration 3.4B), tell us more about a volume's surface-state than lines that go in other directions on it.

Lines can also deny a volume's surface-state by being drawn in any direction volumetrically illogical to it, as in Illustration 3.4C. Sometimes, especially in drawing curved planes, the direction of the lines that constitute the planes determine our understanding of a volume's structural mass. In Illustration 3.5, the direction of the line groups clarifies the volumes of the hand. Changing the direction of these lines would diminish our understanding of the subject's structural actualities. Therefore, indicating the direction of planes through line groups that ride upon them in a form-revealing way is an important method to convey a subject's structure.

It should be stressed here that using these line-groups should not be understood as a particular

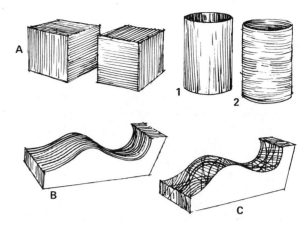

*Illustration 3.4*

style of drawing, but as a general approach or process. Many artists, of very different aesthetic persuasions, have for centuries applied this concept of structural line to convey volume. Developed in the Renaissance (Plate 3.3. and 3.4), it continues to provide artists with an effective tool for the manifestation of volume in original ways, as in Picasso's "Sketch of a Nude and Classical Heads" (Plate 3.14).

Another way to state perceptions about volume uses line-groups to convey the effects of light upon surfaces. Light waves do not bend; the differing values of a form's planes represent their tilts toward and away from the source of light. When planes abut at pronounced angles the value change is abrupt, as in Illustration 3.6A; but is gradual when a curved plane turns toward or away from the light source, as in Illustration 3.6B. Line, then, used in groups to suggest the behavior of light on volumes through value changes, can, like directional line-groups, convey the sudden or gradual changes of a form's surface. It thus provides the viewer with another set of clues about a subject's structural character.

In your drawing, use both of these form-revealing concepts to "carve" the forms of your subject. In the drawing by Jacques de Gheyn (Plate 3.15), both means have been used effectively. Here, groups of lines, *by their direction*, explain the

*Illustration 3.5*

Plate 3.14

*Pablo Picasso* (1881–   ).
SKETCH PAGE WITH NUDE AND CLASSIC HEADS.
Pen and ink.
COURTESY, MUSEUM OF FINE ARTS, BOSTON.
ARTHUR MASON KNAPP FUND.

A                    B

*Illustration 3.6*

tilts of planes throughout the drawing. Note especially the clear direction of the planes of the hands, bodice, and collar.

Planes facing the light source falling from the figure's right side de Gheyn leaves as white. Those which parallel the direction of the light and thus receive a raking, weaker light, often called a *halftone,* he states as light values of several shades. The variations of these halftones are determined by the slight turns toward or away from a true parallel with the light source by these planes. Those turned well away from the light source he draws as darker line-groups. De Gheyn does not offer a fully toned drawing. He states the subject's major structural nature by lines that convey both direction and light.

Note the few cast shadows, how well integrated they are among the other values, how they contribute to the pattern or *design* of the other values, and how they help explain the terrain upon which they fall. Despite the liberal use of line in this drawing, nowhere do lines deny the form. They all "earn their keep" through volume-producing tasks.

In thirty minutes, drawing *from the general to the specific,* you should have time to establish many of the smaller planes that make up a volume. Divide the planes into several value groups as de Gheyn does, or as suggested in Exercise 2C in Chapter Two. This will help you control the many values of your subject more easily. Look for the direction a plane seems to suggest. If flat, which direction should the lines take to explain that plane's union with adjoining ones better? If curved, should the plane's lines move in the direction of the form's axis or wrap around its body? Each plane will present a perceptual challenge in selecting the best direction for the lines that will comprise it. The choice will usually

depend on the terrain surrounding or adjoining the plane. Sometimes, as in reflections of highly polished surfaces, driftwood, wrinkled folds of cloth or skin, or in many highly textured objects, the answer is revealed by these surface conditions. Look for such clues, however subtle. They can help you build stronger, more lucid volumes.

Your completed drawing should look more carved than illuminated. Because you have emphasized planes more than the effects of light, your drawing may seem rather blocky, rough-hewn, or rock-like. With practice and experience, such characteristics can be modified or strengthened depending on your interests and goals.

If, at the end of this thirty-minute drawing, you have established most of the subject's major planes and sense the resulting impression of volume, you will have experienced and controlled a sophisticated set of visual perceptions. This is one of the most demanding and instructive ways of using line. It requires your constant observation analysis of shape, scale, direction, and value.

Structural line can more thoroughly explore and establish a form's volume than any other kind. An inability to control line in this sculptural way seriously limits the student's understanding and use of line *and* his ability to comprehend the structural nature of his subjects. We cannot draw what we cannot fully understand.

*Drawing 4.* As mentioned earlier, the attitudinal character of any line may primarily express emotive qualities. In this drawing with the steel crow-quill or artists' sketching pen, after the two-minute search for the gesture continue to advance a felt theme such as strength, delicacy, fear, anger, mystery, or joy. It will now be necessary to look at your hand and the object in it in a new way. If you have been doing the drawings in this exercise in sequence, you are, by now, quite familiar with the visual issues of your subject. Now respond to its *meaning* for you. You may not be able to express your feelings in words. They may be too diffuse or too interlaced with visual responses for language, i.e., you may be emotionally stimulated by visual as well as psychological responses. But try to draw whatever your emotional response *feels* like. Let fear, joy, or whatever your emotional response affect the choices you make from the raw materials—what you will and will not use—as well as affect your "handwriting." Here, the object you selected will surely be an influence. If you are holding a flower or a sea shell, you are not likely to respond to your subject's mood or character in the way you would if you are holding a pistol

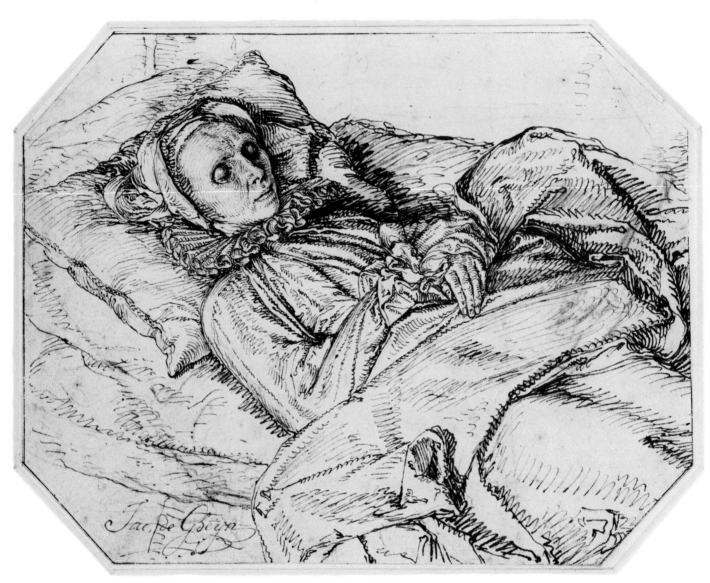

Plate 3.15

*Jacques de Gheyn* (1565–1629).
WOMAN ON HER DEATH-BED.
Pen and ink.
RIJKSMUSEUM, AMSTERDAM.

or a shrunken head. The quality of the light upon your subject may influence your feelings, as may the time of day or your disposition at the time you make the drawing.

Your "handwriting" will reveal your feelings but these feelings should not supplant sound visual perceptions. Rather, they should act as a brake on mere copying and serve as a *basis* for selecting those cues that express your theme.

You may wish to clarify and emphasize your theme by exaggerating the bigness or littleness of some, or all of the forms. You may want to change your subject's contours, alter the values or placement of its parts. Make such adjustments only when the attitudinal character of the line cannot, itself, intensify the feelings you want. Or, if the intended theme is conceived in a way that

must include such changes, include them from the start of the gesture drawing. However, resorting to distortions before expressive line has had a chance to convey your intent, or carrying such changes too far from the actualities of the original, can introduce more problems than they solve. Such changes carry with them the greater risk of *unintentional* discrepancies in scale, shape, and structural control. Sometimes the drawing drifts so far from the subject's actualities that further references to it are impaired. At least in this first attempt at expressive drawing, the prudent course would be to make only modest adjustments of the original, allowing the main responsibility for the expressive intent to be carried by the *nature* of the lines you draw.

The tight limit of fifteen minutes for this

54

drawing is designed to prompt your first, felt responses to participate in this expressive act. Often, in drawings without a time limit, these are censored by second thoughts. Here, it is your feelings, advised, but not dictated to by sound visual perceptions about the subject, that must be communicated through line's character. To modify your first, felt impulses for other, less spontaneous ones, can weaken or obscure your meaning.

The expressive force of Van Gogh's "The Cypress Grove" (Plate 3.16) is mainly declared by the swirling lines of the trees, clouds, and nearby undergrowth. Had Van Gogh drawn these trees "correctly," that is, had he held his feelings in check and merely reported upon their proportions, textures, placement, etc., we would have a drawing that testified to the physical characteristics of some cypress trees in southern France, but not much more. Instead, he shares with us his

*Plate 3.16*

*Vincent Van Gogh* (1853–90). GROVE OF CYPRESSES. Pencil and ink with reed pen.
COURTESY OF THE ART INSTITUTE OF CHICAGO.

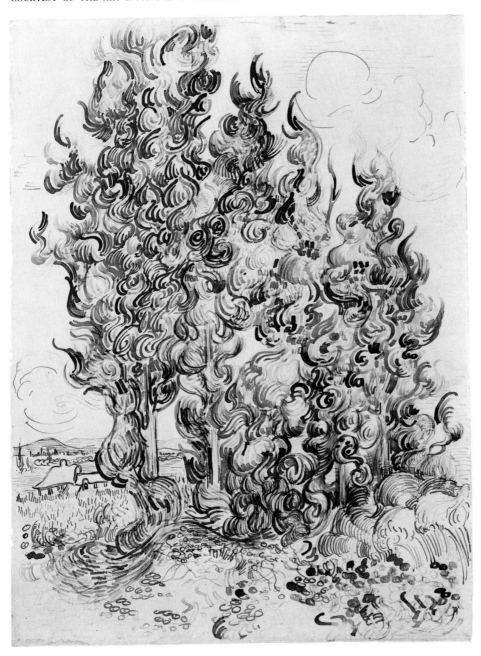

feelings about their movement and growth—their animated swirl. He tells us the entire countryside and sky can be understood as trembling with flame-like energy.

Compare this drawing with Bresdin's pen-and-ink drawing (Plate 3.17). Like Van Gogh, Bresdin tells us about the growing, animated quality of a spring landscape. But Bresdin's line is more lyrical, less intense. The scene is active but temperate—gentle. He sees the foliage and even the rocks as cloud-like and stresses their affinity. Here, the breezy spring day is declared by the rolling, graceful nature of the line.

Daumier's drawing (Plate 1.8) is similarly animated by expressive lines that do more than describe physical facts. Their own nervous, vibrating movement tells us about the subject's movement and mood.

Segonzac's etching, "Portrait of Colette" (Plate 3.18), is more than a likeness. His bold, authoritative line carries some of the strength and energy of the brilliant French novelist. In your drawing also, tell us, through the nature of the lines, what your subject says to you.

As discussed earlier, line can be put to any expressive undertaking. From the moving and grim message of Goya's lines (Plate 3.8), to the elegant and gentle lines of Modigliani's drawing of a woman (Plate 3.19), line, imbued with the artist's feelings about his subject, can provide a dimension of meaning not otherwise possible.

***Drawing 5.***    In this last drawing, use either or both types of drawing instrument. Begin it as you did the other four, but develop the drawing through any combination of line uses you wish.

Just as any line that explores space is, whatever its primary attitudinal character may be, functioning diagrammatically, so can calligraphic, expressive and structural lines simultaneously

*Plate 3.17*

*Rodolphe Bresdin* (1822–85). BANK OF A POND.
Pen and ink.
COURTESY OF THE ART INSTITUTE OF CHICAGO.

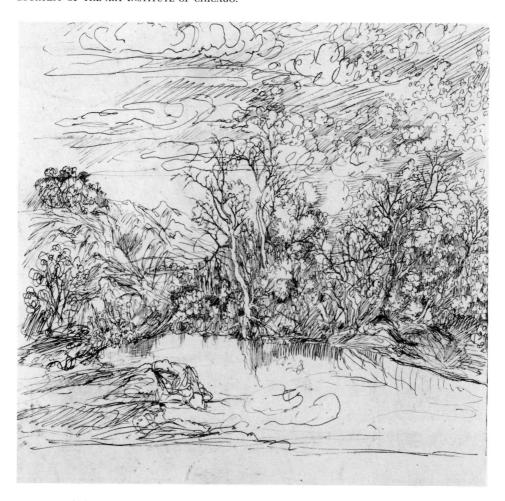

undertake each other's functions. Here, you should try to make lines convey several of these line attitudes at the same time.

We have isolated and examined these attitudes to better understand their nature and function. Exploring their differences is essential to understanding the possibilities of line in drawing and warrants their temporary separation for study only. But avoid thinking of line as being neatly sorted into four fixed categories. In all of the plates used here as illustrations of one or another of these line uses, there are lines that function in other ways. There are diagrammatic functions in Kokoschka's essentially calligraphic drawing, structural properties in the lines of the Goya etching, calligraphic qualities in the Van Gogh drawing. Further, we have seen that *every* line is expressive of some motive—is energized by some visual or expressive idea—either descriptive, emotive, or both. Remember, too, that the medium and the surface used affect the "look" and even the usage of a line.

In this drawing you are on your own. Forget about line attitudes; instead concentrate on your visual and expressive responses that are now under none of the influences and restrictions of the previous four drawings. Having worked with each attitude has helped you understand their various abilities. You made some judgments about their nature, their capabilities, and their "feel." Much more drawing experience is needed to fully grasp their worth. But let your experience of the previous four drawings influence your use of line in this drawing. Your attention should shift from line's uses to what it is you want to convey. But your expanded "repertoire" of line uses should help you convey your responses in a more economical and satisfying way.

This drawing may lack the control and expression of meaning you had hoped for. Even though your primary attention is upon comprehension and response, it will take patience, commitment, and the experience of many encounters with subjects drawn in line before these concepts and procedures, adapted to your interests, become necessary, natural, and satisfying. As William Hazlitt has observed, "We never do anything well till we cease to think about the manner of doing it."

## DELINEATING CONTOUR

To delineate should be understood here as establishing the physical limits of a form with any of the four line concepts already discussed. That any kind of line can be used to convey the "edge-

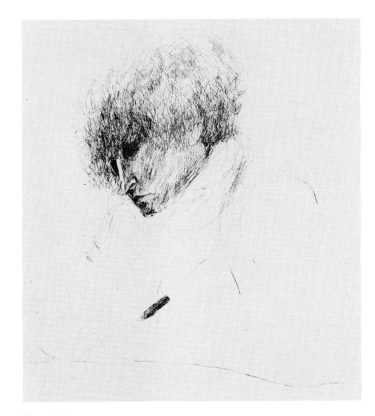

*Plate 3.18*

*André Dunoyer de Segonzac* (1884–1955).
PORTRAIT OF COLETTE.
Etching.
COLLECTION, THE MUSEUM OF MODERN ART, NEW YORK.
GIFT OF PETER H. DEITSCH.

ness"—the *contours* of forms—is clearly seen in the plates that illustrate this chapter. Whether by Cezanne, Segonzac, or any other artist, the delineating function of their lines is largely *consistent with* the type of line attitude being used. Delineation, then, is a task that *any* type of line can perform by modifying its own type of activity. But among the untrained, general public, as mentioned earlier, the establishment of a form's limits occurs through lines used as boundaries—as outline. Used this way, delineation merely marks off boundaries determined by shape, color, value, or texture. There is little evidence of an edge as a plane seen in full foreshortening. But to delineate *contour*, which is a volume-producing process, instead of outline, which is not, we must understand the edges of a form to be planes seen on end, just as a calling card can be held in such a way as to reduce it to a line.

The tradition of drawings which stress selective delineation of form-revealing edges dates back to the pre-historic cave artists of France and

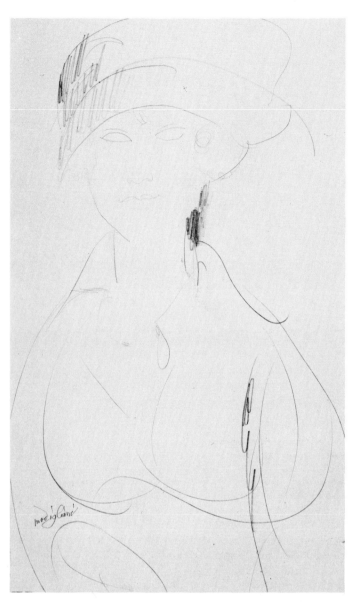

*Plate 3.19*

*Amedeo Modigliani* (1884–1920).
PORTRAIT OF A WOMAN.
Pencil.
COLLECTION, THE MUSEUM OF MODERN ART, NEW YORK.

Spain. In Europe, the emphasis on contour by using sharply "focused," incisive line, usually of a continuous nature, was a dominant graphic device until the late Renaissance. Contour drawing remains a universally popular means of graphic expression because of its ability to economically state volumetric impressions of a form at its edges and suggest impressions of the form's terrain well within its edges.

Contour drawing is not another attitudinal category of line, but as mentioned earlier, is an "adopted" function of any of the line attitudes already discussed, restricted to edgeness. The other four types of line can range within, upon, or beyond a form's borders. Even structural line can move beyond a form's edge as in the Altman drawing (Plate 3.20). But the delineating contour line is wedded to edges and must remain primarily informational of a form's planar state at its limits. Beyond only modest incursions into plastic or expressive matters, it loses all traces of independent identity as a contour line.

The distinction, then, between a form seen as delineated by a contour line, or as wholly expressed by one or more of the four basic line attitudes is a subtle but important one. Any kind of line, stressing contour, has two "affiliations": as a member of one (or more) of the four line attitudes, and as a separately functioning line, that, with others, creates a system of form-revealing edges. Should such lines abandon their informational, descriptive role to become more deeply engaged in visual and expressive invention, we would tend to see them in their former role only. While functioning as contour lines, they may bear only a slight family resemblance to whichever type of line category they issue from. In the Matisse drawing (Plate 3.7), the contour is entirely calligraphic. The identity of the lines that comprise it with the other lines in the drawing, is far greater than our understanding of them as an informational line system in any sense apart from the other lines in the drawing. But Michelangelo and da Vinci (Plates 3.3 and 3.4) *do* use their structural lines at the edges of forms in a different way. Here, the lines are not less structural, but more unified as expressive of contour. In the lower half of the Michelangelo drawing, the legs are delineated by structural lines and reveal the volume of these forms without the aid of any interior lines. In the upper body, the lines which extensively carve the planes of the forms are, at the edges, just darker enough—continuous and edge-oriented enough—to permit us to see them as a separate system.

For the beginning student, drawings restricted to volume-revealing contour lines help him see the often complex state of a subject's edges with heightened objectivity. Such restrictions encourage conscientousness in perceptual efforts required to "track" the conditions of edges similar to the kind of searching for edge discussed in Exercise 2A in Chapter Two. However, here the lines are understood to represent planes in space as seen on edge and not just the limits of a shape.

Whether or not delineation becomes unselec-

tive copying—a kind of fussy scrutiny—depends upon the artist's ability to recognize what is essential to the suggestion of volume and what is irrelevant or confusing. Ingres' drawing (Plate 3.21) is a faithful recording of his subject, but not slavishly imitative. His changes and choices make each delineating line convey volume. Also, Ingre is sensitive to the rhythmic flow that organic forms possess and his delineation includes that graceful relatedness of the parts. His line is endowed with a knowing ease that looks deceptively simple. Far from mere copying, Ingres, despite his close adherence to his subject's actualities, developed a style of delineation so distinct that his drawings are easily recognizable.

Exercise 3B offers some suggestion for delineating contour that will help you experience line as edge *and* volume-maker.

### EXERCISE | 3 B

This exercise will take thirty minutes. Use any kind of pen or pencil and a sheet of good quality bond paper, approximately 18″ × 25″.

For your subject, select one or several of the following: a hand lawn-mower, egg beater (crank type), tricycle, bicycle (or parts of either), typewriter, or any other mechanical device that offers an interesting collection of gears, wheels, cylinders, pipes, or tubes. Parts of discarded engines and even old, carved furniture can be used. The more unfamiliar and unusual these things are to you, the better. All too often, forms we possess some knowledge of cause us to slip into remembered cliches. This drawing requires your sharpest perceptual acuity—not for purposes of scrutiny, but to analyze and understand the volumes you will be delineating.

Arrange your subject so that parts overlap or touch one another. This time do *not* make a gesture drawing but begin by sighting on some edge of your subject and, drawing approximately actual size, slowly follow the edge with a single, continuous line. Lift your drawing tool as seldom as possible. Do not feel pressured to complete the drawing within the time allowed.

At all times your line should record edges as the last, fully foreshortened planes at a form's limits, or the abutment of planes at various angles to each other. Because your line informs us of a form's direction in space, try to feel it moving in and out of space as it follows an edge. By increasing and decreasing pressure on your drawing tool you can vary the value and weight of a line. These variations can convey the impression of a line going far back or advancing in space

*Plate 3.20*

*Harold Altman* (1924–    ). Matriarch.
Felt pen.
Philadelphia Museum of Art.
Given by Dr. and Mrs. William Wolgin '64-37-5.

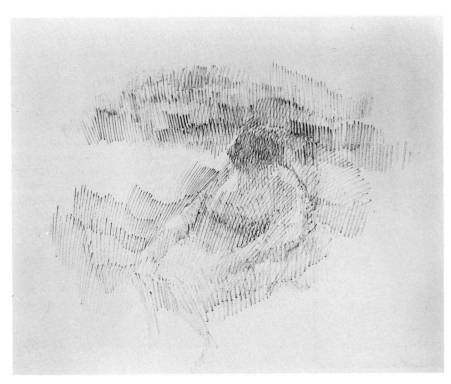

as it delineates a form's edge. This sense of a line coming toward and away from you provides strong clues about the position of edges in space and should be used here to stress the role of the delineating line as volume-revealing rather than shape-making.

Ideally, you should not lift your drawing instrument more than seven or eight times during the entire thirty minutes. However, do not hesitate to do so more often if you find this restriction too limiting, or less often, if you can. While most artists do not restrict their contour line in this way (Plate 3.21), in this exercise it will help to increase your sense of delineation as a distinct graphic idea. A line can be kept going by continuing to find "routes" for it to take. Often, a line, having reached a dead-end, can be made to continue by back-tracking. Just draw your line (as slowly and as well observed) along the same edge it came up, until you find some way out (Illustra-

*Plate 3.21*

*Jean Auguste Dominique Ingres* (1780–1867).
PORTRAIT OF A LADY SEATED.
Pencil.
THE METROPOLITAN MUSEUM OF ART.
BEQUEST OF GRACE RAINEY ROGERS.

tion 3.7). As you draw, you will notice that some lines begun at a form's edge have moved into its interior, as may happen with an object such as a spiral-shaped chair leg. Follow such lines with an awareness of their coming toward and away from you. Each time a spiralling edge turns away and out of your view, continue your line on the new edge that blocked your view. But recognize that doing this means leaving a form at one level in space to "hop" to another one located nearer to you.

Do not use lines in any way that will suggest value. To do so now is to release the delineating line from some of its responsibilities. Here, you want to test your ability to perceive, and lines' ability to convey volume, as edges may reveal it, without other aids.

When the delineation of edges alone conveys volume, you will find that the angle of interception of one line by another—the impression of space and volume resulting from perspective principles—is as important as particular changes along a form's edge. Perspective is a factor in all volumetric drawing, but drawings that rely on the single, delineating line to communicate several kinds of information require the artist to be especially sensitive to the direction of edges in space. Part of the impact of such a line is in being "right" the first time. If several lines are needed to adjust or repair the original one, there is some loss of the clean, economical control that you want to command in this drawing. In Chapter Five, the critical effect of the direction of lines upon the sense of volume is examined.

The slower your line, the more you will see. Avoid the common tendency to speed up the line. This usually results in drawing vague generalities to represent intricate or subtle passages in the subject. Here, your attitude should be "the more difficult the passage, the more committed my perceptual skills will be to changes" at the edges. An extreme example of this attitude would be to draw every strand of spaghetti in a dish, just as you see them, avoiding none of their coiled, interlaced complexities. One of the frequent pitfalls of the beginner is to relax his perceptual powers when confronting a complex or unusual subject. Just at that critical moment, where continued or even intensified efforts to perceive would cause the breakthrough to the understanding necessary for the control of a demanding passage, there is a retreat to vague generality. Known as "lazy vision," this turning away from visual challenges must always be guarded against.

In this drawing, do not worry about proportions which may go awry or about poor organiza-

*Illustration 3.7*

tion. You are extracting one idea only: "Here is what I found about the volumetric properties of my subject stated in a few, slow, continuous lines."

Other concepts and uses of line are dealt with in Chapter Eight. Here, though, it should be mentioned that while our interest has been focused on the properties and responsive usages of line, its influence as a visual and expressive idea abounds in virtually all of nature's—or mans'—formations. In Chapter One, we saw in the search for gestural expression some of the linear forces that forms generate by the direction and sense of energy. This sense of directional and expressive linear pathways running through a subject, grasped in the gestural phase of a drawing, should be permitted to influence your use of any or all of the kinds of line discussed in this chapter.

You will use line in drawing as your physiological, psychological, and aesthetic dispositions allow. Within these limits the freedom to state your visual and expressive meaning through an understanding of line's many uses is basic and calls for a dedicated, searching study.

# CHAPTER

# Value

## LIGHT,
## LOCAL-TONE, AND MOOD

### A DEFINITION

A children's riddle asks us what the subject of a black sheet of paper is. The answer is: a coalminer with no headlamp, in a mine at midnight. Why not? A black surface *can be* imagined to be anything—in itself, it *is* nothing. A coal-miner *with* a lamp—and there is no riddle. Forms in nature, as even the children who ask the riddle know, are revealed by light. In drawing, the impression of light is conveyed by changes in the values of a subject.

There are just two ways by which value can be produced: by line-groups creating optical grays, that is, impressions of value resulting from the collective tone of massed black lines and the white spaces between them, their value resulting from the density of such massed lines; and by deposits of actual gray tones by media such as ink, paint, chalks, or pencil. Diluted, inks and paint can produce a wide range of tones. The varying degrees of softness of chalks and pencils, and the variations of pressure upon them in drawing, as well as the smudging of such materials, also produces a wide range of tones.

For the student, the use of massed lines in modelling forms provides important experiences in perceiving and explaining the direction of planes in space and is, therefore, highly instructive of the structural aspects of volume (*see*

Chapter Six). But the application of actual gray tones has its own versatile uses and characteristics, as we shall see.

Value, whether it is the result of optical or actual tones or both, is the necessary and (excepting color) only tool for modelling form with light. It gives the artist the means of showing subtle changes in a form's surface-state, and it helps clarify the relative distance between forms. Value also conveys the inherent lightness or darkness of a form—its *local-tone*. This is a given quality of all forms. It is affected by, but separate from the light and dark areas that result from light falling on forms. The local-tone is the intrinsic value of a thing—excluding any effects of light. The local-tone of a pearl is very nearly, but not quite white; that of a lump of coal, nearly black. If we use the value scale described in Chapter Two, the pearl's local-tone is about ten degrees of value, the lump of coal's, about ninety degrees. Light falling on both objects would make them lighter and darker in places, but the darkest value seen on the pearl will not be as dark as the lightest value seen on the lump of coal. The light is incidental to the local-tone. Values enable us to state a subject's intrinsic *and* incidental tonalities.

Through contrast, scale, shape, distribution in

a drawing, and manner of transition from light to dark, value also suggests a broad range of expressive meanings. In the powerful seventeenth-century Venetian drawing of a triumphant general (Plate 4.1), the scale, the manner of application, and the bold contrast of values between the configuration and the white of the page suggest power and grandeur. The forward part of the horse and rider "burst" out of the splashy field of tone to assert aggressive strength. Note the shapes of the tones; their spontaneous

application, only loosely confined by the lines, further suggests energy breaking loose.

Like line, shape, texture, and volume, value is a fundamental compositional force. In drawing, value's influences on those issues which determine composition can be subtle or powerful (*see* Chapter Eight). Value can command attention to a form's direction, weight, or importance, helps create visual diversity, and serves as an effective unifying agent.

Unfortunately, most beginning students sel-

*Plate 4.1*

*Italian, 17th century. Venetian School.*
A TRIUMPHANT GENERAL CROWNED BY A FLYING FIGURE.
Brush, pen, and ink.
COURTESY OF THE FOGG ART MUSEUM, HARVARD UNIVERSITY.
BEQUEST OF META AND PAUL J. SACHS.

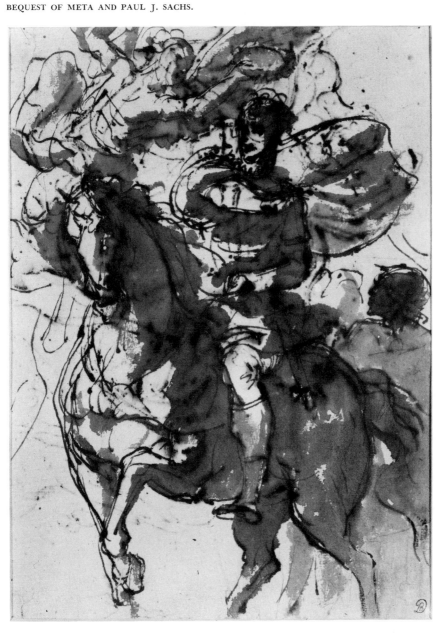

dom use value. Partly due to a universal tendency to regard drawing as a process limited to line, and partly because of its relative unfamiliarity, they restrict their responsive means by a general avoidance of value. When introduced to value, many beginners are uneasy about drawing large or dark tones. They are afraid that such areas will be hard to manage—or remove—that they will "mess up" the drawing. These concerns are understandable. But when value's functions are understood and some approaches to its use suggested, it is often quickly adopted and controlled. How soon and how well it serves the student depends on how soon and how well he confronts his concerns about, and the functions and approaches to, value.

As suggested earlier, there are three ways marks make images: lines, lines and values (either optical or actual), and values alone. Each has a wide range of possible uses. Each has had, historically, its brilliant virtuosi. Drawing with line alone—freely selected over the other two ways—is excellent, but when a drawing is restricted to line only, by innocence or fear, it is a regrettable limitation. Value provides the only means to convey responses which must otherwise remain stifled.

## THE DISGUISES OF VALUE

Our world is a collection of colored forms in space. A lake is seen as blue, not as a value of fifty or sixty degrees; the grass is green—its value is not usually a conscious or unconscious consideration. The beginner, if he is painting a lemon and a plum, is generally more aware of their color than their inherent local-tone. Thus, the lemon may be painted yellow and the plum purple, but these colors may be lighter or darker in value, than those of the fruits. If he is drawing with charcoal, he will, of course, disregard the subject's colors. But often he will also disregard the values of the colors and will not extract their local-tone. Rather, he may begin to draw the various values or *value-variations* resulting from light striking the subject, as if the lemon and plum were actually white. If he does try to show their local-tone, it will generally be at the cost of the value-variations. Establishing the value-variations of a subject in the context of its local-tones is not likely before the student sees the difference between these two aspects of the subject's values. For him, color disguises local-tone. Or, seeing it, color adds to his confusion in at-

tempting to sort out local-tone and value-variations.

The basic skill of tonal drawing is the transposing of colored forms and the light upon them into values. Just as a black and white photograph is an extraction of the values upon an illuminated, colored subject, the student's tonal drawings should be tests of his ability to assign local-tones and value-variations to colored forms. However, unlike the camera, the student can and must make selections from, and changes in, the observed values, for light can *distort* as well as explain both local-tone and value-variations.

*Texture* can also disguise the local-tone and value-variations of a subject. "Texture," here, designates the character of surfaces. When a surface has a pronounced, all-over tactile quality like a tree trunk or silk, when it has qualities inherent in its physical composition like a calm or stormy sea, or when a surface results from the proximity of many small forms, like leaves or the threads of a lace collar—the visual activity thus generated should be regarded as texture. "Texture" also defines value and color changes of either a patterned or random nature in a form's surface. A plaid shirt, a tiger's stripes, and the markings of a marble slab are examples of nontactile textures. The term also includes groups of three-dimensional forms when they activate a large area such as a field. A herd of cattle scattered about a pasture, the organized rows of bushes in a formal garden, a crowd at a rally (Plate 4.2)—all these can be seen as texture.

Some subjects, like a tree with a deeply rutted trunk, or a shrub with its countless leaves catching the light from many angles, produce such an array of values that it is difficult to judge either the subject's local-tone or the behavior of the light striking it. Other subjects are so boldly textured they cannot be reduced to a single local-tone. A chessboard, a zebra, a boldly patterned wallpaper or flag—or anything else that has striking and frequent differences in color or texture, inherently possesses two or more local-tones. But, if an intense light illuminates part of such a surface, leaving the remainder in a pronounced shadow, the surface's tonal differences are made subordinate to the strong contrast of light and shadow upon it. When a strong light strikes half a chessboard it unifies the alternating light and dark squares of the illuminated portion as a lighter pair of values in contrast to the light and dark values in the unlit portion (Illustration 4.1A). From this example we see the importance in distinguishing which of a subject's values are given and which the result of light conditions.

Illustration 4.1

In Illustration 4.1A, the intense light unifies the two local-tones of the board by showing their differences to be less contrasting than the contrast between the lit and unlit halves of the board. But this is achieved at the cost of seeing the chessboard as split into two halves. In Illustration 4.1B, the intensity of the contrast is somewhat lessened and occurs less abruptly than in Illustration 4.1A. This results in a more unified chessboard and a more consistent texture, without losing the impression of strong light striking the board.

When textures can be seen as contrasts to a constant base or background, such as cattle in a field, markings on a marble slab, or red polka-dots on a yellow scarf, the local-tone of such backgrounds can be established before the cows, markings, or polka-dots are drawn. Disregarding the smaller "interruptions" of a broad base permits us to analyse its local-tone more easily.

Before such perceptually demanding differentiations can be made, we must experience the controlling of values as they relate to each other in some ordered scale. Once we can see and control degrees of value, we can be more sensitively responsive to the values observed in nature. Exercise 4A suggests ways these skills may be practiced and developed.

## EXERCISE | 4A

For your exercise you will need a good grade of bond paper, a ruler, and three pencils: a 2H, which makes a fine, light gray tone; a 2B which makes a moderately soft, deeper tone; and a 5B or 6B, which makes deep, velvet-like gray-black tones. Using the 2H pencil, rule a horizontal rectangle one inch high and eight inches wide. Divide the rectangle into eight squares by drawing light lines at one inch intervals.

Make eight values progress in even "jumps" from white to black (or as near to black as the 5B or 6B pencil will allow). The first square on the left will be the white of the paper. Fill the second square with an even, light tone. Use the

2H pencil for the first few squares, darkening them as needed with the 2B pencil. For the next few squares, the 2B pencil, used with increasing pressure, will be needed. If necessary, combine it with the 5B or 6B pencil. The last squares may require the softest pencil only. But use all three in any way that will help you control the changes in value.

Plate 4.2

*Francisco Goya* (1746–1828). Crowd in a Park.
Brush and brown wash.
THE METROPOLITAN MUSEUM OF ART.
HARRIS BRISBANE DICK FUND, 1935.

In choosing the first light tone to put beside the white square on the far left, remember that you need to make five more value jumps before you reach the black square on the right. All eight squares must show the same degree of difference between values. If you make the first tone too light (too near to white), the small difference in tone between it and the white square to its left sets the degree of value difference between all the values to come. Because the goal here is to have the eight values progress evenly—on the value scale where white is zero and black is one hundred —starting at the left, each square must be just over twelve degrees darker than the one on its left. In Illustration 4.2, there are intentional errors in the eight values shown. These cause some squares to be too greatly separated in value from neighboring squares, while others are too close. Avoid such blending as occurs between squares three and four, and such splits as occur between squares four and five.

Try to draw each tone evenly. There should be no value changes within a square. By placing lines close together in one direction, or by crosshatching and varying the pressure on your pencil, a uniform value of any degree can be produced. The control necessary to make line-groups produce a desired even value is a useful "byproduct" of this exercise. Therefore, do not smudge or rub the tones to get an even value. When pencil lines are rubbed with the fingers, the oil in the skin mixes with the tones deposited, making further adjustments difficult. Although the smudging of tones is a valid graphic tactic, it is often overused by the beginning student, causing overworked, "precious" results that destroy a drawing's freshness and spontaneity.

When completed, this eight-value chart should be placed about nine or ten feet away and studied. Are there any sudden breaks in the value changes? Are any values so similar they are hard to separate at this distance? Do the values on the left side seem to group together and split off from the values on the right? Are the values from left to right so light that they seem to drop off to black too suddenly? Check to see if any of the values, including white and black, break the even progression of the values. In making any adjustments in these tones, you may find that

changing one often requires changing one or more of the others.

In deciding whether your exercise is successful or not, you will be making judgments about its tonal organization, its *tonal order.* Evaluating the tonal order here—perceiving and weighing the differences between degrees of value—is similar to the way the values in an observed subject are assessed. Then, too, we want to see the range and relationships of the values. If our goal is reproducing the tonal order of the subject, we must study our drawing to search for false "notes"—for faulty tonal judgments.

Try some variations of this chart. Here are a few suggestions.

1. Draw a ten-square value chart. Try for the same kind of value progression from white to black as in the first chart. This time, the value changes will be subtler, their differences more critical.

2. Draw another ten-square chart using pen and ink only. The true black now possible will make it somewhat easier to show ten different values, but the inability to lighten any square will make establishing the values more difficult. Producing even tones in pen and ink will likewise prove more of a challenge, especially in the lighter value (*see* Chapter Seven).

3. Make another rectangle one inch high and eight inches long, but do not divide it into squares. Using your three pencils, make a gradual, unbroken progression from white to black. Here, the tone should continually grow darker as it moves to the right. On the rectangle's far left, some white paper should remain to establish the scale's zero. Placed at a ten-foot distance, the values should flow evenly from white to black.

4. Mix eight to ten gray tones with poster-paint or any opaque, water-based medium, then try to reproduce these tones in pencil. The painted tones should cover a wide range of value and be evenly applied. They need not be lined up in a chart-like way but can be used to create a small two-dimensional painting of clearly defined shapes. In this way, along with the challenge of perceiving the values of another medium, you can practice seeing shape-actualities.

5. Cut out of magazines, construction paper, etc., ten or twelve evenly colored one inch squares. Paste them down in a row according to their *value,* with the darkest color on the right. Seeing the value

*Illustration 4.2*

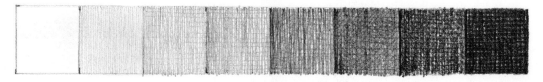

difference between a light blue and bright orange is a demanding test of your ability to disregard a color's hue and to extract its value. When this chart is completed, draw another row of one inch squares directly below it, and using pencils, match the value of each color in the square below it.

It is important that you occasionally practice these exercises or make some tonal drawings that test the ability to judge the local-tone and value-variations of color forms. Increasing your sensitivity to, and control of value expands your ability to respond to your world and to share your responses with others.

We have seen that sorting a subject's values into two, three, or four-value divisions (*see* Chapter Two), enables us to have an overview of the general distribution of a drawing's values in its early stages. Establishing these major value-groupings *before* we draw the smaller, specific ones that constitute them will reduce the possibility of destroying the tonal character of an area—whether that character is mainly the result of local-tones or light diversity. For example, in a drawing of a sunlit interior, a white cat lying in a shadowed, far corner of the room, seen in its value context as one of several forms darkened by the reduction of light in the corner, would be understood to be—not white—but gray. The darker the corner of the room, the darker the value of the cat. It is easier to see the white cat as actually gray if we first search for the major value divisions created by both local-tone and changes in the light.

To draw the cat in that tonal environment as actually white, forces it to "pop out" of the darkened corner's tonal order. Drawing values sequentially, and with no regard to the tonal order they contribute to, increases the danger of prior knowledge (the cat is white) replacing visual comprehension.

Color, texture, sequential drawing, and displacing perception by prior knowledge all camouflage value. Learning to extract a subject's tonalities from the visual factors obscuring them and avoiding attitudes that intrude on such perceptions require us to develop the visual comprehensions and insights necessary to overcome these factors and attitudes.

## THE EFFECTS
## OF LIGHT ON VOLUME

Light can reveal forms or hide them, explain forms or distort them, divide forms or unite them. The way light's indifferent behavior is understood and controlled determines whether its effects are merely copied or used as one more source of perceptual information. A drawing which tries to duplicate the values in the original will reveal no more than the light does about volume and space, and will even distort and divide the volume and space when the light does. But if light's behavior is understood, the light will be "edited"—selected and altered to convey the impression of volume and space. Where light's behavior conveys such impressions, it can be used; where light confuses, denies, or distorts them, it can be changed. In responsive drawing it is the artist, not the accidental effects of light, that determines what the volume will be.

Forms appear fragmented, that is, are seen as divided into tonal shapes when an intense light source casts harsh, deep shadows across their bodies (Illustration 4.1A). Such shadows can also distort a form's volume and obscure important passages (Illustration 4.3). But a moderate, well placed light helps the artist reveal, explain, and unify complex subject-matter. A tree need not be drawn leaf by leaf. Grapes, pebbles, hair, a stadium crowd, or any other subject comprised of small forms can be expressed in a unified way by broad value-variations that explain the overall volume these small forms contribute to.

Until the Italian Renaissance, most drawings comprised of small forms described all or most of them with roughly equal attention. A clump of leaves, a bunch of grapes, *resulted* from the delineation of virtually every member (Plate 4.3). In this Lombard drawing, each leaf has been carefully drawn in each tree. The physical proximity of the leaves communicates the symbol—Tree. Here the artist has drawn his concept, rather than his perception of a tree. As drawing moved toward perceptual response to observed matter, the additive process of drawing—ninety leaves equals one tree—declined. As ways of perceiving expanded, sensitivity to the ways volume could be suggested also grew. The drawing by Cesare da Sesto (Plate 4.4) goes far beyond the

*Illustration 4.3*

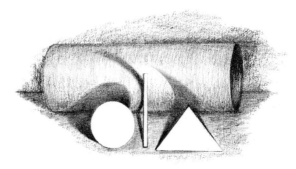

*Plate 4.3*

*Anonymous.* Page from a Lombard Sketchbook.
Pen, brush and ink.
THE PIERPONT MORGAN LIBRARY.

accumulation of particulars in suggesting mass.
We see light falling upon the tree from above
and to its right side. Although numerous leaves
are individually drawn, there are shaded passages
suggesting the darkened underside of masses of
leaves. Likewise, the shading of the left side of
each branch and the shaded branches beneath
the leaves on that side unify trunk and branches
into visually related volumes. Although da Sesto
sees masses as having particulars, and not merely
resulting from them, the particulars still receive
much individual attention. Rembrandt's re-
sponse to trees (Plate 4.5) stresses the gesture of
mass. In this drawing of a rural landscape he
disregards particulars altogether. Using the im-
pression of light in a simple, but eloquent way,
he carves the broad, structural planes of masses.

Treating whole trees as particulars of a general
panorama—a forest—Renee Rothbein (Plate 4.6)
orchestrates light and shade to unify the forest's
"small" forms, its textures, and even the larger
forms of the hills and valleys. The values in this
drawing create a pulsating light that appears to
move across the landscape "pulling together"
many small forms and explaining the greater
volumes they belong to. Here, light becomes
more than the means by which the subject is
revealed—it forms part of the subject. Light's
pulsating behavior and the mood it conveys are
as much a part of the drawing's theme as light's
volume-revealing role.

Responding to light as a subject as well as a
means, Edwin Dickinson, in his drawing "Cot-
tage Window" (Plate 4.7), creates a silent, strange
scene, in which the shadows of part of a house
and porch are projected on the wall and window,
making these "ghosts" of structures "off stage"
part of the drawing. Likewise, some trees across
a broad field are not seen directly, but as reflec-
tions in the window-panes. The cast shadows
ride upon the wall, shutters, window-frame, and
panes explaining their volume, but as they do,
they create unusual tonal shapes that tend to
emphasize the picture-plane, making us aware of
the drawing's two-dimensional activity.

Similarly, in Georges Seurat's conté crayon
drawing (Plate 4.8), light itself is both tool and
goal. Here, light bathes a field, with the figures,
animals, and house silhouetted against it. Note
how the white of the paper at the drawing's far
right appears to glow—like the sun's own blind-
ing light. The sun's life-giving light and warmth
is, together with the forms depicted, Seurat's
subject.

As Plates 4.6, 4.7, and 4.8 show, drawings in
which light is the dominant graphic idea, infer
a view of our world as existing in darkness—dark-
ness is the norm, light is the transitory, revealing
exception.

## THE ELEMENTS OF LIGHT

In drawings where values represent light (values
can be used in other ways, as we shall see), the
value contrasts can denote the forms, the spaces
surrounding them, and the shadows they cast.
These contrasts conform to six discernable divi-
sions, regarded here as the *elements of light*. As
seen in Illustration 4.4, they are:

1. The lightest value of an illuminated form, or
   *highlight.*
2. The next lightest value, or *light-tone.*

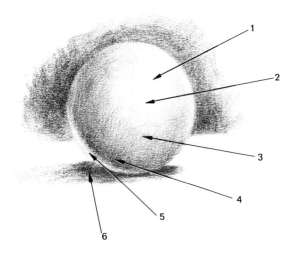

*Illustration 4.4*

3. The third lightest value, often found on surfaces that parallel the direction of the light rays, or *halftone*.

4. The darkest value, or *base-tone*.

5. The usually weak light cast upon the side of a form turned away from the light source, *reflected light* results from deflected light rays from the light source.

6. The dark tones resulting from the blocking of light rays by solid bodies, or *cast shadows*.

In Illustration 4.4, we see that the cast shadow is the one element that does not exist on the sphere. Because of its special projecting nature, a cast shadow behaves uniquely. Often troublesome, the cast shadow *can* be an effective device to reveal the distance between forms, and show the terrain of the form upon which the shadow is cast. It can also suggest the location of the light source, the time of day, and can function in ex-

pressive and compositional roles, as Plates 4.6, 4.7, and 4.8 show.

Cast shadows help explain spatial relationships. In Illustration 4.5A, the sphere hovers above the lower of the two boxes. In Illustration 4.5B, it seems further back in space, and just above the higher box. In both illustrations the placement and size of the cast shadows suggest the position of the sphere in its relation to the other two forms. The two drawings are identical, but changing the cast shadow's location and scale in each changes the spatial relationship of all three forms.

Cast shadows are projected upon surfaces in accordance with the laws of perspective (*see* Chapter Five). Their shape, value, scale, and direction in space tell us the light source's height, how close it is to the object casting the shadow, and the nature of the terrain upon which it is cast. Illustration 4.6A shows the card's shadow projected on the wall as larger and lighter than the cast shadow in Illustration 4.6B. Comparing the two illustrations we see that the radiating light rays, stopped by the card, continue to diverge and create a larger unlit shape on the wall. Maintaining the same distance between the light source and the card but holding the card further from the wall, increases its cast shadow

*Illustration 4.5*

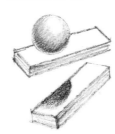
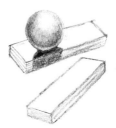

*Illustration 4.6*

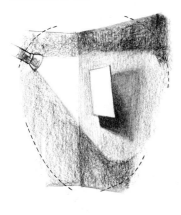
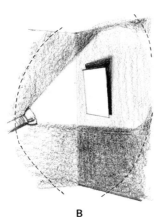
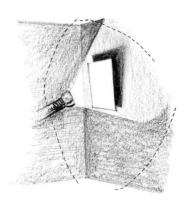

A                         B                         C

*Plate 4.4*

*Cesare da Sesto* (1480–1521). STUDY FOR A TREE.
Pen and ink.
WINDSOR CASTLE, ROYAL COLLECTION, COPYRIGHT
RESERVED.

in relation to the ever-widening cone of light. The smaller and darker cast shadow in Illustration 4.6B explains the card's closeness to the wall. Here, the shadow's closeness to the card and its sharp focused edges suggest that the expanding light rays travelled only a short distance before being stopped by the wall. The shorter distance separating the card from the wall permits only a little light—reflected from other nearby surfaces—to strike the area of the cast shadow, making it darker than the one in Illustration 4.6a. Here, the greater distance separating the card from the wall allows more reflected light to illuminate the area of the cast shadow, lightening its value and softening its edges. How-

ever, the closer the light source is to the object casting the shadow, the larger the shadow will be. If, as in Illustration 4.6C we bring the light source closer to the card, the shadow's scale will increase.

As Illustrations 4.6A, 4.6B and 4.6C show, cast shadows always retreat in the opposite direction from the light source. If, as in Illustration 4.6A, we see a cast shadow below the card, we know the light source is located above the card. When the cast shadow falls above the card, as in Illustration 4.6B, we understand the light to have come from below. Note the distortion of the card's shape as represented by the cast shadow in these illustrations. This results from the radiating light rays striking the wall nearer to one end of the card than the other. The shape of any cast shadow upon a flat surface is affected by the angle of the light rays in relation to the angle of the object casting the shadow, and the angle of the object casting the shadow to that of the surface receiving it. Should the card's shadow be cast upon an uneven surface, it will, additionally, ride and thus explain that surface's planar state (Illustration 4.7).

Gustave Courbet uses cast shadows (Plate 4.9) to help explain the structure of the head by projecting shadows from one part, such as the nose, upon other parts. Notice how the shadow of the hat reveals the volume of the right side of the head, and shadows cast by parts of the clothing explain other parts of it.

We see, in the strongly contrasted values of Courbet's drawing, in the areas of subtle value-variations, and in the sense of the subject as existing in an atmosphere of light and space, a presentation of the elements of light used in a manner sometimes called *chiaroscuro* (an Italian term meaning clear and obscure and used in the sense of light and shade) drawing.

Though drawings in the chiaroscuro manner represent only a small percentage of da Vinci's works (Plate 4.10), he led in the development of this style of drawing (and painting), and is per-

*Illustration 4.7*

haps its most gifted practitioner. In this study of drapery, the strong, but softly graded value contrasts show chiaroscuro's volume-revealing possibilities. Notice da Vinci's looser, broader manner, used in the earlier stages of the drawing and visible in the upper part of the figure. The drawing is a closely observed and fully realized study of light's behavior on volumes through the use of value. But at the beginning da Vinci's search for the general masses of the drapery, and some preliminary line drawing, show that his first responses were aimed at understanding the gesture and the essential volumetric and tonal actualities. Also observe that this brush-drawing, heightened with white, consists mainly of line-groups that effectively produce subtly graded value changes. These changes, like those in the Courbet drawing, show a use of all the elements of light.

When an object such as metal or glass reflects light, or has a polished or otherwise reflective surface, as when an object is wet, the highlights upon it produce a mirror image of the light source. Highlights on objects with a mat surface denote the small areas where the greatest concentration of light rays strike a form directly. A subject's surface may be only slightly reflective, and thus may offer both kinds of highlights. This makes it difficult to know when a highlight results from reflecting light or when it is an intense concentration of nonreflecting light. In the first instance—if volume through value is a goal—it can usually be omitted, for it is not relevent to volume but rather to surface texture. Indeed, drawing a subject's surface effects instead of its volume cues usually obscures the latter. When a highlight is nonreflective, it should be understood as part of the form's surface and not as an

Plate 4.5

*Rembrandt van Rijn* (1606–69).
LANDSCAPE WITH COTTAGE.
Pen, brush and ink.
ALBERTINA, VIENNA.

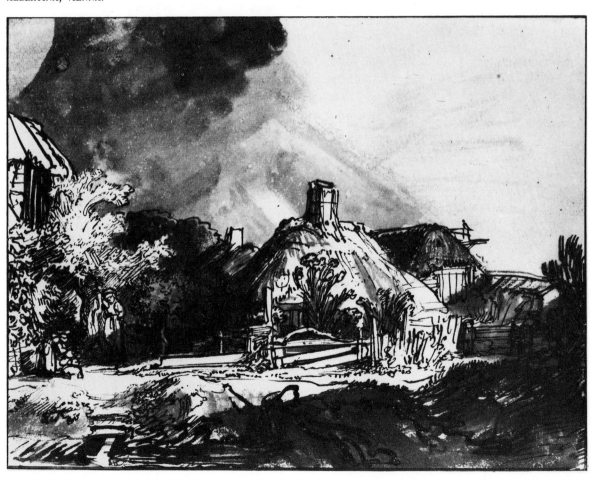

isolated, bright speck of light. Seeing it as a self-contained, little shape often makes the student treat it as something separate from the form's surface, with the result that it appears to occupy a position in space *in front of* the form's surface. The texture of the human figure often contains both kinds of highlights. When drawing human forms, the experienced artist often subdues or even omits both reflecting and direct highlights. The volume-destroying nature of reflecting highlights usually warrant their exclusion. Direct highlights, on rounded forms, are relatively unimportant because they describe only a small

area of a form, contributing little. If a volume has been sensitively perceived, their inclusion is not necessary. We understand a subject's volume mainly through its major structural character. When the major structural facts are not clear, highlights cannot contribute enough to make us understand the volumetric character of a subject.

The student can distinguish whether a highlight is a reflected or direct light by deciding if it seems to concern the form's texture or its structure. To take an extreme example, imagine drawing a large, shining, steel ball-bearing. Its mirroring of the light source (actual images of

windows, light bulbs, etc.) and the sudden, drastic changes of value inherent in any curved and polished surface, "blind" us to visual cues about its volume. But coat the ball-bearing with a mat paint, and the value-variations that reveal its volume become visible. Often very little of the shiny activity of the ball-bearing's reflective surface helps us see it as spherical. If both the volume and surface character of a form are desired, placing the emphasis on volume first and surface second communicates far more of the form's total character than the reverse. In three-dimensional drawing, the facts of a form's volume should precede any facts about the surface characteristics of the form.

Reducing the intensity and shape-clarity of any highlight improves its informational function. This will make it appear to belong to the surface of the form—to be a very lightly toned area of it—instead of seeming to hover above the drawing like a bit of confetti. In tonal drawing, where the impression of volume is intended the attitude to highlights should be the fewer the better, the less intense the better, and the less defined the better.

On rounded forms, the light-tone, half-tone, base-tone, and reflected light will fuse into each

*Illustration 4.8*

other gradually. On forms composed of flat planes, such as a cube, they may each occupy one or more of the form's planes (Illustration 4.8). The light-tones are usually found on all flat or curved planes in positions facing the path of the light rays. Those placed at a right angle to the light's direction will be most intensely illumi-

*Plate 4.7*

*Edwin Dickinson* (1891– ). Cottage Window.
Charcoal.
ATLANTA UNIVERSITY, ATLANTA, GEORGIA.
GIFT OF MR. AND MRS. CHAUNCEY WADDELL.

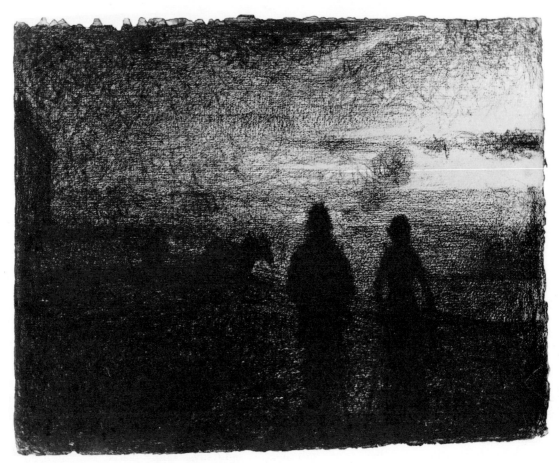

*Plate 4.8*

*Georges Seurat* (1859–91). PLOWING.
Conté crayon.
CABINET DES DESSINS, MUSÉE DU LOUVRE.

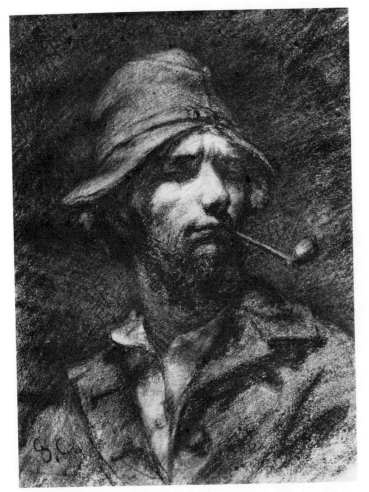

*Plate 4.9*

*Gustave Courbet* (1819–77). SELF PORTRAIT.
COURTESY, WADSWORTH ATHENEUM, HARTFORD, CONN.

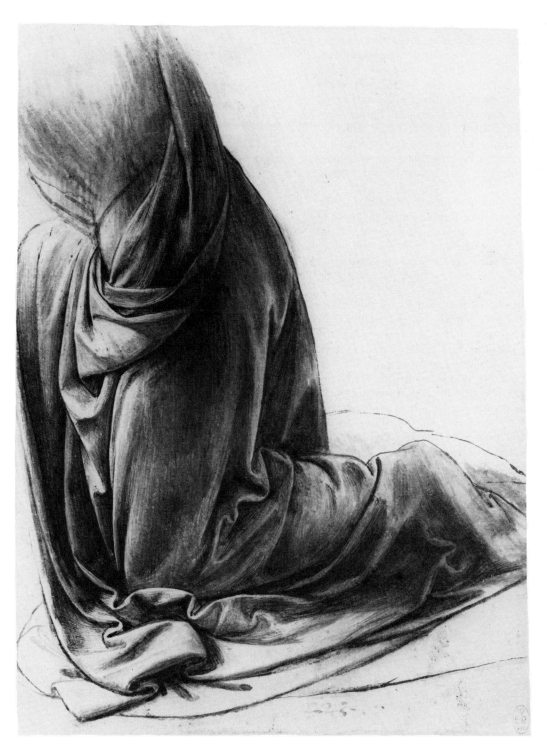

*Plate 4.10*

*Leonardo da Vinci* (1452–1519).
STUDY OF DRAPERY FOR A KNEELING FIGURE.
Brush and lampblack, heightened with white, on
bluish paper.
WINDSOR CASTLE, ROYAL COLLECTION,
COPYRIGHT RESERVED.

nated; those turned slightly away, somewhat less so. "Light-tone" involves the several light values of planes located anywhere from a right angle to the light's direction to any position just short of one running parallel to the light ray's path. "Light-tone" is a term that denotes a small range of values seen as having a general lightness in relation to the halftone, base-tone, and reflected light. These terms also denote not a single value, but a small range of values that set them apart as a discernable unit in relation to other tonal units.

The several darker values that constitute the halftone are, as mentioned earlier, generally found on planes roughly parallel to the direction of the light rays. Halftones may sometimes be seen in areas where weak cast shadows reach the lightness of the halftone range, or in strong reflected light areas (Illustration 4.9).

A form's darkest values are located on those planes turned farthest from the path of the light rays (except, of course, for shadows upon the form cast by another solid body). On a form constructed of flat planes, such as a hexahedron or cube, the darkest values are on planes facing in, or closest to, the direction opposite the source of light, as in Illustration 4.8. On rounded forms, the values of the base-tone are not always found at the edge farthest from the light source, but are often located well inside a form's limits (Illustration 4.10). This results when light rays, striking nearby surfaces, reflect back to illuminate areas of a form turned away from the direction of the light source, or when weak, secondary light sources illuminate those surfaces turned away from the primary light source. The value of an area illuminated by reflected light is dependent on the intensity of the light source, the local-tone of the nearby, reflecting surfaces, and the local-tone and texture of the form itself; but

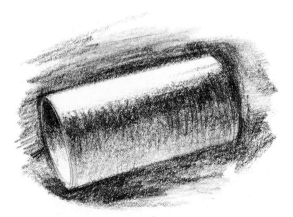

*Illustration 4.10*

is always darker than the light-tone and usually darker than the halftone. The weak reflectivity of most surfaces greatly reduces the original light ray's intensity. Often, the reflected light is barely perceptible. A form on a black drape will show a far weaker reflected light than the same form upon a white drape—and weaker still, if the tone itself is of a dark local-tone. If the form is naturally shiny, the reflected light may be stronger; if it has a mat surface, it will be weaker.

Reflected light, like highlights, is more convincingly shown as a subtle value-variation of a form, conveying volume better when subdued. Overstating reflected lights, an old cliché, produces harsh and gaudy effects that usually diminish the sense of volume. At its most extreme, exaggerated reflected light is heightened to the value of the light-tone, which leaves a band of base-tone running along a form's axis or along any pronounced ridge formed by planes abutting at strong angles. Often, a form's base-tone is not quite as dark as the shadow cast by the form itself. This depends in part on the form's local-tone and the local-tone of the surface receiving the cast shadow. Usually this effect occurs because the reflecting light rays can more easily strike those surfaces of a form turned away from the light source than the more sheltered area of the cast shadow.

These six elements of light just described, understood as general phenomena of light on volume, can support, but not supplant, visual comprehension of a volume's structure. Perception and intent, not an automatic dependence on a fixed system, should determine the visual and expressive usage these elements should have.

The nature of transitions between values in a drawing offers useful information about changes in a subject's surface-state and helps us comprehend its volume. As we saw in Illustration 4.8,

*Illustration 4.9*

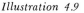

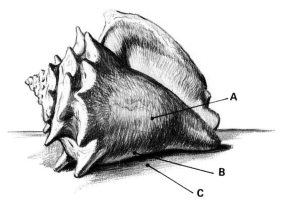

gradual changes in value suggest rounded form; abrupt changes, angular form. In Illustration 4.11A, the modelling of the woman's head suggests rounded volumes. But, in Illustration 4.11B, the forms of the same head are more angular, lessening the sense of volume. The gradual fusing of the tones in Illustration 4.11A, (*see also* Plate 4.10), enhance the sense of volume for two reasons: first, we are conditioned to expect gradual value-variations on rounded forms and second, because we are more conscious of the shape-state of abrupt tones, we tend to see them as shapes on the picture-plane—as two dimensional divisions. This is just what happens in Illustration 4.11B, where the black and white tone divisions suggest flat shapes. They appear to be somewhat more on the surface of the page, modifying the impression of volume.

Where intentional stress on the shapes of tones is desired (Plate 4.11), reducing the subject's values to black and white, and avoiding gradual transitions between them helps convey both two- and three-dimensional impressions. In the powerful drawing by Matisse, this strategy helps convey both a woman and the animated, tonal activity which is itself a visual and expressive event—these together are the subject. They are interdependent. Matisse also uses value as an agent of composition and to convey his emotional responses to the subject. We will return to his drawing when examining these additional properties of value.

## "LOST AND FOUND"

Seurat's drawing, "Seated Woman" (Plate 4.12), will help us comprehend the idea of "lost and found"—forms emerging from and dissolving into value. Seurat's drawing shows little of the traditional chiaroscuro devices within a volume. His interest is in conveying volume-generalities through gradual changes in value, and in showing the subject as bathed in a filtered, vaporous atmosphere. A gentle haze envelops the figure, unifying it. Forms are suggested rather than stated. They lose themselves into each other just as the figure itself begins to dissolve into its environment. Yet this figure appears to be almost monumental. Had Seurat clearly focused the figure's edges, it would have looked silhouetted and flat. As he drew it, it exists in space, has volume and weight, and even seems to be illuminated. Here, it is the "soft" edges and gradual value transitions that convey those impressions. Note the relatively clear edge of the woman's back and the pronounced value contrast between it and the background area that abuts it. This stress in edge-clarity and value contrast implies strength and stability. It also keeps the drawing from appearing merely unfocused. The impression of the torso rising like a pillar is made clearer *because* other edges and value contrasts are less defined. This visual "crescendo"—the figure's grandeur and strength—depends on the

*Illustration 4.11*

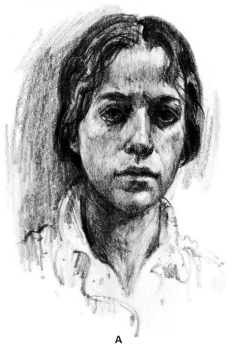

A

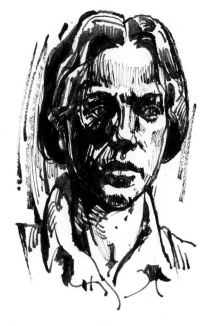

B

Plate 4.11

*Henri Matisse* (1869–1954). FIGURE STUDY.
Pen and ink.
COLLECTION, THE MUSEUM OF MODERN ART, NEW YORK.
GIFT OF EDWARD STEICHEN.

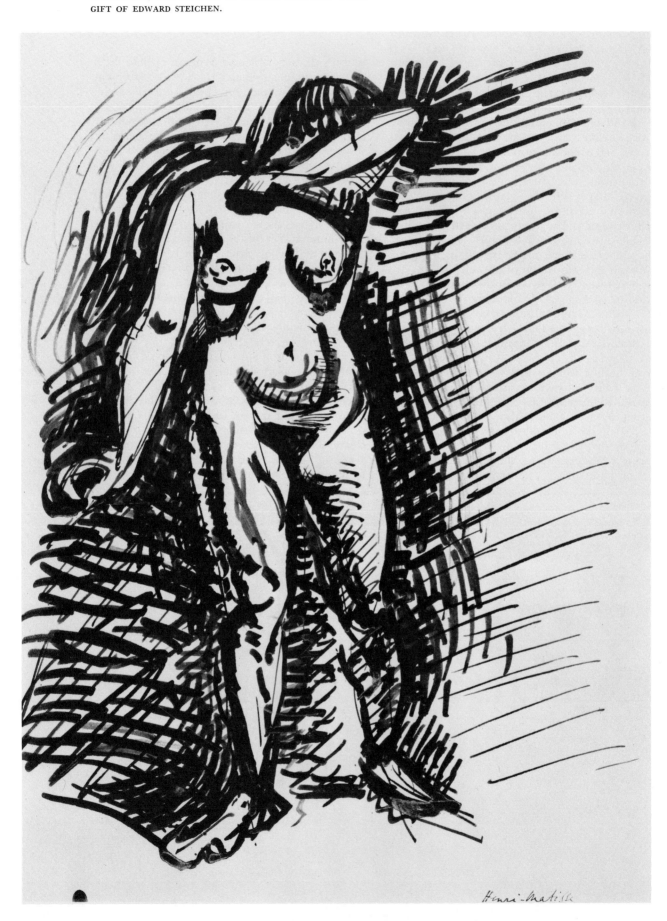

state of edges and values *throughout* the drawing. It is like a composer who creates big crescendos of sound by contrasting them with quieter, less emphatic passages.

Watteau (Plate 4.13) uses value to lose and find forms in emphasizing the graceful sweep of the woman's arm. He diminishes the contrast of her head with the background and darkens the area of the figure below the arm. He also avoids "cutting" the torso by the drape and the head by the uplifted arm, by losing the edges of these forms—allowing almost no value change between forms—in these places. This helps create a graceful letter "S" rhythm that starts in the lower arm as a gentle movement and, gaining momentum, moves through the figure to end very boldly in the woman's right hand. The values and edges throughout the drawing support this enveloping sweep.

We feel the locomotive's power in Hopper's drawing (Plate 4.14) through his bold use of large dark tones that hide some of the particular mechanical appurtenances which a more factual drawing might provide. By losing these details in strong, dark tones that stress the major volumes of the engine, Hopper makes us feel its heaviness and bulk—and its immense energy. The values of the tunnel and the engine dissolve into each other, uniting the two halves of the drawing and suggest the train's ability to move through the tunnel.

If Hopper tells us little about what a train is made of, he tells us—mainly through value—a great deal about its character and power. He even uses value to tell us that it is a bright day. The strong cast shadows, the gleaming metal (note that Hopper does not allow the highlights to "jump" off the forms) and the value contrast between the surface of the wall and the tunnel opening all suggest strong sunlight.

The impression of volume through the application of the elements of light and the concept of lost and found values provide versatile ways to state perceptions that are beyond the range of nontonal drawing. The following exercise suggests some general modes of approach to these uses of value.

### EXERCISE | 4B

This exercise consists of three drawings. Because it is important to go as far as you can in developing an impression of illuminated volume, none of these drawings have a time limit. For all three use soft, medium, and hard vine-charcoal sticks and a charcoal or pastel paper of good

quality. As you draw, use the soft charcoal stick for the deeper tones and the other two for the lighter ones. You may erase, but avoid erasing tones that subsequent drawings may incorporate. Ideally, all the tones in the first drawing should be made of line-groups. Where a particular tone or texture cannot be produced this way, some moderate adjusting of these line-groups by a kneaded eraser or a paper blending tool, called a stump or tortillon, may be used. But erase and blend only when absolutely necessary. Both erasing and blending tend to diminish a drawing's freshness and promote a concern with unimportant details. In the second and third drawings, erasing and blending will be necessary to pro-

*Plate 4.12*

*Georges Pierre Seurat* (1859–91). SEATED WOMAN. Conté crayon.
COLLECTION, THE MUSEUM OF MODERN ART, NEW YORK. ABBY ALDRICH ROCKEFELLER BEQUEST.

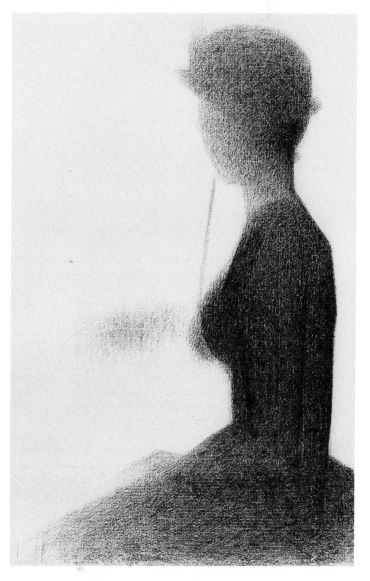

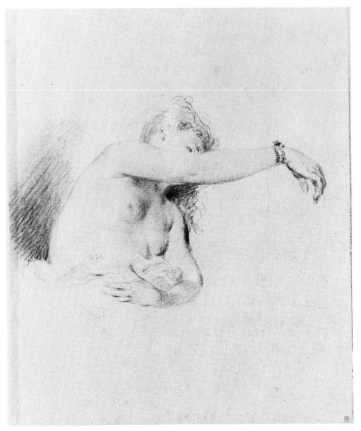

Plate 4.13

*Jean Antoine Watteau* (1684–1721).
NUDE HALF-FIGURE WITH ARM RAISED.
Red and black chalk.
CABINET DES DESSINS, MUSÉE DU LOUVRE.

duce the impression of light on form. Then, they will be "harnessed" and given an important creative role.

Your subject should be a simple still-life arrangement, illuminated by a single light source, preferably a north light. Use no more than four or five objects on a tabletop. Avoid large, complicated objects such as an ornate lamp or a decorated tray, and objects made of highly reflective materials such as glass or metal. Select simple, bulky objects. A drinking straw or coat hanger would be a poor choice. Their dominant visual impression is a linear one. Unglazed pottery and objects made of wood or paper, such as salad bowls or books, are usable. Articles of clothing such as shoes, gloves, hats, and handbags make interesting subject-matter—even the boxes they were stored in may be usable (unless their surfaces are decoratively "busy," or contain distracting lettering or illustrative material). Fruits

and vegetables provide a wide variety of simple forms useful in the first drawing.

Draw approximately actual size, or work as close to actual size as your still-life and paper size will allow. It is not necessary here to include all parts of each of the objects or the tabletop. They can be allowed to run off the paper on all four sides.

***Drawing 1.*** Concentrate on the single experience of modelling the form by the value-variations upon it. Therefore, disregard all local-tones—assume everything in the still-life to be *white* (*see* Illustration 6.5). With this in mind, begin with a lightly drawn search for gesture, shape, scale, location, and direction. Once you have quickly established a rough drawing (much of it may be linear, but avoid stressing the edges of forms), place the several values of the light-tone in every part of the drawing where planes face the direction of the light source. Less than five minutes should elapse between the first line drawn and your search for the light-tone. Avoid the "coloring book" syndrome—do not make a clearly established and "final" outline of each object to fill in with tones. Line's gestural and temporary appearance at the outset (almost all the line will be absorbed into the drawing's various tones) quickly and economically establishes some basic visual relationships that assist in the search for volume as it is revealed by light. It should not be relied on to do more than help you get the drawing underway.

As you draw in the light-tone, also place it in *all* other areas of the drawing where perceptions from the still-life show darker tones to be (Illustration 4.12). Except for any small areas intended to represent highlights, this will mean that the entire drawing will be covered with the light-tone. Because the light-tone represents a narrow range of values, use the darkest one of them (about a twenty degree tone on the value scale) to place in all the areas darker than the actual light-tone areas, as in Illustration 4.12.

*Illustration 4.12*

Continue by placing the halftones in *their* observed locations. Again, using the darkest of the halftone range, place it in all areas seen to be darker than the actual halftone areas. Next, place the base-tones in *their* observed locations only. Because you have been drawing tones on all but the highlight areas in your drawing (if any), the reflected light areas (if any) are now a darkish halftone. Adjust any reflected lights to their correct relationship with the other values of the drawing.

Remember that the entire still-life is regarded as white in local-tone, so a half-tone on a light object, such as an egg, will have the same value as one on a dark object, such as a black shoe. This similarity will require you to make tonal judgments that are based on the position of planes in relation to the direction of the light source. Do not merely follow the subject's value actualities. Instead, you must understand the direction of the planes in space so that you can assign to them their proper tonality.

When the entire still-life has been stated as more or less flat value-shapes, begin to "carve" at the borders between values where transitional tones are needed. Feel the nature of the turning that occurs between the planes they represent by constantly observing the planar nature of the forms of the still-life.

As you model the form at the shapes' edges— bridging sudden tonal changes between them with transitional tones—the sense of value-shapes will recede and the impression of planes forming volumes in space will emerge. Refer to the still-life continually to check on how gradual, or sudden, the value-transitions between planes are. Try to feel the weight and bulk of the subject's forms as you draw. As in structural line drawing, try to feel your lines are "riding" upon the surfaces of the forms.

Here, make any changes in value that help explain a form's volume when the light distorts it, or when the light fails to reveal the planar activity you know is there. Sometimes the light strikes a surface from an angle that does not distinguish its planar differences. Such changes in the subject's terrain may actually be difficult to see because of the sameness of the light. Coming nearer to the subject, or seeing it from another angle, will help you comprehend the planar structure of poorly illuminated parts. In explaining them in your drawings, you will arbitrarily have to widen the value range in such "blank" areas. The value differences needed to show the terrain in these areas must be strong enough to perform their modelling function and

subtle enough to stay within the value range of the immediate tonal area. If, for example, you are explaining the planar construction of a half-tone area in which the light failed to convey the volume, the broadened range of halftone value, if extended too far at either end of its range, would invade both light-tone and base-tone areas, distorting the volume. Such strong light and/or dark tones in a halftone area would appear as depressions or projections of the surface. Determine these arbitrary value differences by imagining a very weak light source falling across the planes in the blank area. Direct the light source from whichever angle would best reveal the various tilts of the planes.

As the drawing develops, check to see that the value range of one object has not grown lighter or darker than that of another. Should any cast shadows appear in your drawing, remember that they are striking surfaces assumed to be white.

The background can be handled more independently. Its main function here is to provide value contrasts for the objects in the still-life. It can freely, but subtly, change value to be lighter than a form against its dark side and darker than the form on its light side (Illustration 4.13).

Because you have been using light to explain volume, the drawing may say less about the subject's volume than if you had stressed structural clarity. But the completed drawing should still convey the impression of light revealing masses in space.

***Drawing 2.*** Begin by using the same still-life objects, but rearrange them. As in the first drawing, just a few minutes should elapse between starting to draw and introducing the first tones. But now these tones should represent each object's local-tone. Where an object cannot be reduced to a single local-tone, draw the two or

*Illustration 4.13*

more that are necessary to establish its inherent tonal character.

Draw the local-tones as flat areas whose limits will determine the various shapes. These local-tones are not volume-producing values—they merely state the object's own lightness or darkness, independent of the conditions of the light. They can be stated in any broad, simple way. Here, some blending may help to produce just the degree of value you want. Except for the few, brief notations to get your drawing underway, line (except for structural line-groups functioning as values) is not needed in this drawing. The boundaries of volumes will be conveyed by the values that formed the volumes. Surrounding tonally developed forms with line is visually redundant—it suggests a mistrust of value's ability to establish edges.

Keep relating the local-tones of the *entire* drawing. As you draw one local-tone, judge its value in the subject in relation to those far from it, as well as those nearby. If your still-life contains similar objects, for example, two apples, see if any value differences exist between their local-tones. Such differences, however slight, should be seen and stated. It is often helpful to determine the still-life's lightest and darkest local-tones. If established early, they serve as tonal "brackets"— all other local-tones are placed within the tonal limits of these two extremes.

Be sure what you draw *is* the local-tone of an object, not the effects of illumination upon it. If an object possessing a light local-tone, such as a lemon, is observed in deep shadow, its local-tone should be drawn, not its darkened state—not yet. When you have drawn all the subject's local-tones and have made the adjustments necessary to establish the same light and dark relationships of the local-tones that exist in the still-life, turn your attention to the modifications of the local-tones that light striking volume produces.

Two kinds of tonal change should occur: those which convey the impression of light rays coming from a specific direction to strike (or

*Plate 4.14*

*Edward Hopper* (1882–1967). THE LOCOMOTIVE.
Charcoal.
PHILADELPHIA MUSEUM OF ART.
PURCHASED: THE HARRISON FUND '62-19-17 (1)

miss) volumes, and those which convey volumetric information about parts of an object when the light does not. Both may require you to lighten as well as darken parts (or all) of every local-tone (making charcoal lines or tones lighter is best accomplished with a kneaded eraser, which can be shaped to make fine points that enable you to make a kind of "negative" cross-hatching—white or light gray lines in areas of dark value).

The first of these changes, those where light rays explain volume, may require that some local-tones be darkened entirely. If a form is located entirely inside an area of diminished light that results from a cast shadow, all its surfaces will obviously be much darker than its local-tone. To have drawn this darker tone earlier would have complicated the search for local-tones by including responses to the effects of light on form. Here, you want to experience value's several roles in a more isolated way. However, many artists do omit the search for the local-tone of objects located in shadowed areas, drawing the observed tonalities of the objects *and* the areas around them instead. That is, they respond to the tonal order of an area.

Now that the local-tones are established you should adjust the values of your drawing to establish tonal order. As you do, another advantage of developing the local-tone first becomes evident. It is much easier to see that a local-tone is too light or too dark by a particular degree for its counterpart in the subject, and adjust it, than it is to state exactly the right tone upon the white page from the start.

At this stage, begin, as in the previous drawing, to search for the six value-divisions—the elements of light. Again, draw these value-divisions in a flat, clear way, before you begin to model the forms with transitional values.

The major difference between this drawing and the previous one is that each form is now modelled in its own value range—the result of its local-tone and its position in relation to the light source. Here, an egg *is* light; a black glove, dark. Here, a halftone in one object may differ greatly from a halftone in another. Several dark objects grouped together, or objects in shadow, may merge their edges. Others may stand out in dramatic relief against the values that surround them.

Now, try to strengthen the drawing's sense of atmosphere by losing the clarity of some edges and emphasizing others. Now, too, the shift from shape-divisions to volume should coincide with a shift in your attention from light's behavior on each form to the clarity of each form's volumetric

character. Again, some parts of the still-life may not be explained by the light, or may be distorted by cast shadows. The subtle changes in value that you will make to explain the surface-state of such areas must now agree with the local-tone of each object and the tonal order of the area in which it is located.

The completed drawing should convey the impression of light revealing the volume of several objects of various values. Here, the lightest value of a black glove will be darker than the darkest value of an egg if the light upon them is roughly the same.

***Drawing 3.*** Coat your paper with a layer of soft or medium vine-charcoal. The value of this tone is not critical, but should not be lighter than a thirty degree or darker than a sixty degree tone. Extend the tone to the edges of your paper.

Begin this drawing as you did the other two, working from another rearrangement of the still-life. Again, begin using values within the first few minutes. Now, values can be "subtracted" as well as added. With the kneaded eraser, values can be easily removed from the toned surface to give the impression of light striking planes. This subtraction of value, of revealing volume the same way light does—by illuminating most those planes that are turned nearest to the path of the light rays—was not possible in the first drawing, and it had only limited use in the second one. Here, you actually draw both the light and the absence of it.

Drawing upon a toned and erasable base encourages a fuller involvement with value and often results in more convincing volumes and richer tonal activity. Often, the impression of light striking forms is stronger. Generally, tonal drawings are begun on a white sheet of paper with the move toward tonality always down the value-scale. Some students, in this downward progression, never reach the "lower register" of the value-scale. They feel the lighter range of values to be "safer" or more manageable. This hesitancy to use the darker values is abetted by the intimidating nature of the page's whiteness. As you start a tonal drawing, any tone, no matter how light, *does* seem to intrude on the purity of the white page. When this feeling checks a student's advance upon the darker values of a subject, the result is usually similar to a photograph removed too soon from the developing tray—a weak and incomplete suggestion of illuminated volume.

In this drawing, you begin with an over-all tone somewhere near the middle of the value-scale, with the extremes of black and white

roughly equidistant from it. For once, white is not a given condition of the drawing but must be produced by removing tone from the page. When this is the case, it is more likely to be seen as present in most subjects in small amounts, if at all.

Beginning with a toned surface also helps to establish a subject's local-tones, and the elements of light that its forms, and the nature of the light, produce. If you begin with an all-over tone that is close to many of the tones of the subject, it is easier to match these by making the minor adjustments required than to estimate and draw the precise value upon the white page.

Once the search for value-shapes has begun, the tone of the page can be altered depending upon the still-life's local-tones, tonal order, and, later, the behavior of the light that falls upon the still-life's forms. Advance the entire drawing together. As you study the way the forms affect and are affected by the light rays, notice that you can better grasp the behavior of both by viewing your subject both ways. When you concentrate on a form's volumetric character, the light rays can be seen to be interrupted and altered by it; when you fix upon the light's path, it can be seen as illuminating planes according to their position in space. In the first instance, you "identify" with the form; in the second, with the light. Doing both gives you a fuller understanding of the nature of the light *and* the volume. One explains the other.

When completed, this drawing may look rather like the second one—the goals in both were the same. But here you began with an erasable, toned surface, and it may have resulted in a darker over-all character, a wider value range, and more convincing volumes. Because the common tendency to draw tones too lightly was here circumvented by the tone of the page which required a special effort to make light values, your drawing may more nearly approximate the still-life's actual tonal order.

Drawings in which light reveals volume should be done often. The demands they make on your perceptual skills increase your capacity to see shape, scale, direction, and texture, as well as your general understanding of value and volume building.

Even the ability to use line to suggest volume is improved through tonal drawing. When values are made to carve volumes into being, the deeper understanding gained of the way edges and planes contribute to the impression of volume, increases the empathy, economy, and eloquence of lines that convey volume.

The drawings in this exercise may suggest other variations of tonal drawing. These three approaches are not intended as "how to" systems. Rather, their selection here provides three general modes of approach to the *issues* of forms in light. The results of each depends on visual comprehension, not on method. They are intended to promote, not replace understanding.

The following variations on the drawings in this exercise are helpful, and may, in turn, suggest others.

1. Using a sheet of gray pastel paper, draw in black and white conté crayon or chalks. Here, the forms emerge from the page's fixed tone as you adjust the tone with light and dark values. By varying the pressure on your crayons or chalks, you can produce a wide range of values. The only "rule" here is never to mix the black and white to produce grays. Every value from black to white can be made without doing this. Black and white, or any tone they can *separately* produce, may appear side by side in the drawing. But all grays should result from black *or* white being "mixed" with the gray of the page (preferably by line-groups)—not with each other. When a gray identical with the page's tone is required, let the page provide the value (Illustration 4.14).

2. Start a tonal drawing on a stiff, white support, such as illustration board or a heavy-weight cold-pressed water-color paper, using black and white goauche, casien, or acrylic paint. Use the paint thinly to establish the local-tones, and continue to develop the forms, using black and white conté crayon or chalks. Here, the black and white paint may be mixed together to produce grays, but the conté crayon or chalks should be used separately, their tones "mixing" with the underpainting to make the required tonalities.

*Illustration 4.14*

*Plate 4.15*

*Sung Kuo Hsi,* attributed to Chinese. 11th Century.
CLEARING AUTUMN SKIES OVER MOUNTAINS AND VALLEYS.
Ink and tint on silk.
FREER GALLERY OF ART, SMITHSONIAN INSTITUTION,
WASHINGTON, D.C.

3. Using india-ink washes of varying tints to develop the local-tones, continue to establish the illuminated volume with pen and black and white ink. Here, the black and white ink lines may cross each other or combine to make various optical grays.

## VALUE AS
## AN EXPRESSIVE FORCE

In the previous exercise, perceptions of the subjects values helped us to create the impression of light on forms. But values can do more. They can help the artist convey his expressive responses to a subject. Whether value is used to illuminate form, to describe the value differences between forms, or used somewhat independently of such perceptual matters, as in Plate 4.1, value can also help excite, calm, cheer, sadden, frighten, or otherwise affect the viewer.

Returning to Matisse's "Nude Figure Study," we find the values of the background and figure express powerful vibrations. Although we see most of these values as composed of thick lines, and even react to their forceful actions, the *dominant* impression of their collective behavior is more one of value than of line. These values not only convey form and to some extent, light, they pulsate with vigorous rhythms, reinforcing the figure's action. The energy with which Matisse slashes at the page is necessary to his expressive idea—the figure's bold stance and the background's rhythmic envelopment of its forms. It also conveys the animation and clashing of the strong light and dark values. In the lower part of the drawing the values seem to "invade" the figure; above, the stark white of the torso and arms "break free" of the background to give the upper body a dramatic strength. In this drawing, Matisse's values are expressively descriptive *and* plastic—they inform and they act.

Whether Matisse's disposition to such energetic drawing had found a "cause" in the subject's potentialities, or was triggered by them, energy and idea are fused here to create an image of explosive force.

In contrast with the Matisse drawing, Kuo Hsi, an eleventh-century Chinese artist (Plate 4.15), uses values to express a majestic serenity in this section of a handscroll. Tonalities range from nearly invisible nuances that describe dis-

*Plate 4.16*

*Hyman Bloom* (1913–    ). FISH SKELETONS.
White ink on maroon paper.
COLLECTION, MR. AND MRS. RALPH WERMAN.

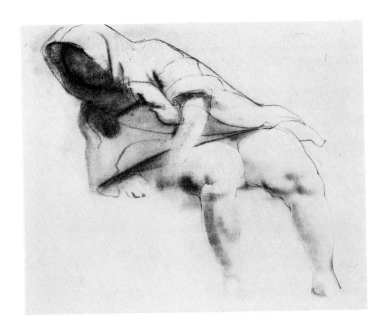

*Plate 4.17*

*Rico Lebrun* (1900–64). RECLINING FIGURE.
Pencil, ink and chalk.
COURTESY OF THE FOGG ART MUSEUM, HARVARD
UNIVERSITY.
GIFT OF ARTHUR SACHS, ESQ.

*Plate 4.18*

*Nathan Goldstein* (1927–    ). ELLIE.
Pen, brush and ink.
COLLECTION OF MARTIN ROBBINS, BOSTON, MASS.

*Plate 4.19*

*Charles Sheeler* (1883–1965). Interior with Stove.
Conté crayon.
COLLECTION OF JOANNA T. STEICHEN, NEW YORK CITY.
PHOTOGRAPH, COURTESY OF THE MUSEUM OF MODERN
ART, NEW YORK

tant peaks to emphatic contrasts in the mountainside on the right. Kuo Hsi's values suggest space, atmosphere, texture, and volume in a way that conveys a feeling of stately silence. Kuo Hsi's handling of the drawing, so unlike Matisse's, is as gentle and delicate as the value transitions and the mood they convey. Both artists use value to express their meaning. In these drawings, as in the examples following, the way values are employed and the manner used to state them are determined by the artist's expressive responses, which modify, intensify, and edit his visual responses.

"Fish Skeletons" by Hyman Bloom (Plate 4.16) offers an approach to value drawing we have not yet considered. Reversing the usual role of white or light paper and black or dark drawing materials, Bloom draws in white ink upon a dark red surface. Depending on the subject and the intent, this can be logical both visually and expressively. Here, the reversal of light tones upon a dark surface helps suggest the feeling of underwater depths—its mystery and darkness. In this way, the spikey fish skeletons are drawn as being light in value—which they are. Note the flowing quality of the forms and how Bloom causes them to "flash" into bright light and then fade into the deeper background.

Lebrun, in his drawing "Reclining Figure" (Plate 4.17), draws the figure's head obscured by the shadow of the hood-like drape, as contrasting with the lines and light tones of the rest of the drawing. The head becomes the visual and expressive center of emphasis—the focal-point of the drawing's representational *and* abstract considerations.

Values then, like lines, can convey expressive meaning. Just as some artists rely on line (*see*

*Illustration 4.15*

A

B

C

Chapter Three) to convey meaning by its character and behavior, so others, like Matisse, Kuo Hsi, Bloom, and Lebrun produce values whose character and behavior express the mood and meaning of the drawing's abstract and figurative content. As these drawings show, responsive drawing concerns more than perception of the measurable facts of scale, shape, direction, distance, or value. It also concerns felt responses to a subject's plastic activity and to its emotive character.

For many artists, like Watteau and Hopper, the expressive intent of a particular drawing is largely triggered by their subject. Although such artists *do* bring attitudes, feelings, and ideas, or *concepts* to their confrontation with the subject, perception is a dominant factor in forming their expressive responses. Thus, their general disposition to use value in certain ways for certain purposes is given its specific opportunities by the subject's expressive potentialities.

Other artists, like Bloom, Rothbein, or Dickinson, experience a deeply felt "presence"; more than an idea, less than a vision, they seek forms that will help them make their meaning visible. They can be said to intend before they see. Neither kind of artist functions as he does exclusive of the other's means of approach. The perceptually stimulated artist brings certain concepts to the encounter with a subject; the conceptually stimulated artist responds to the visual and expressive stimuli of the subject. Both require value to do more than merely describe.

## VALUE AS
## AN AGENT OF COMPOSITION

Value's uses in pictorial issues such as direction, balance, emphasis, diversity, and unity will be examined in Chapter Eight. Here, it is helpful to mention, in general terms, the various ways in which value can convey these considerations of pictorial design.

Like line, value is capable of a vigorous abstract existence of its own. For example, in Plate 4.18, the dark tones of the dress and the light ones of the background serve to intensify the sense of rushing vertical movement that contrasts with the figure's inactive stance. The visual and expressive impacts of value co-existent with, or independent of its representational role, that is, its abstract activities, constitutes the means by which not only expression but also compositional order is developed.

Value can relate dissimilar shapes, forms, textures, and spatial areas. In a drawing where these graphic impressions appear to fragment, confuse, or destroy its over-all cohesion as a system of design, value can enforce visual affinities that cause groupings, emphasis, and directions to emerge (Illustration 4.15). Note how Charles Sheeler (Plate 4.19) directs our attention to the play of vertical and horizontal movements of a room's interior by values that unite the subject in groupings organized to convey direction and emphasis. The strong dark tones of the stove, seen against its surrounding light tones, fix our attention upon its "mysterious being" and its powerful sense of verticality. Throughout the drawing, values merge and contrast, stating a value "plan" that unifies the subject and establishes a sense of balanced value-design. In this drawing, the values simultaneously convey the descriptive, expressive, and organizational message. Through value, Sheeler also guides our attention to both shape and volume so that we sense the organization of both two- and three-dimensional space.

As mentioned in Chapter Two, shape is a basic, given quality. It is important to recall that value always has shape. Whether as clearly defined as a sharply focused tonal drawing of a square or as diffuse as a puff of smoke, the termination of a value within the boundaries of a drawing establishes its shape. The scale and character of the shape always influence its visual and expressive behavior. When two or more shapes are identical, or even just similar, value can help locate the volumes they represent in their respective positions in space, as in Illustration 4.16. Here because of the value differences, we read the distant hill on the right as farther away than the similarly shaped hill on the left. Likewise, the spheres and cubes occupy different positions in space because of their value differences, despite their sameness in shape and scale. In this illustration, the impression of distance given through value is assisted by the phenomenon of aerial perspective (*see* Chapter Five) which causes distant objects to appear lighter in value. The same clarity of spatial position between like forms, by value contrast, will also occur in shallow space situations such as a still-life arrangement. Then, the value of the forms relative to the value of the background determine their position in space. An object possessing a light overall tone, seen against a background of a similar tone, will appear farther back than an identical object of a dark tone located alongside it.

Value can also exist free of form. As mentioned earlier, light can envelop several forms or segment them. In Illustration 4.17A, a shape of

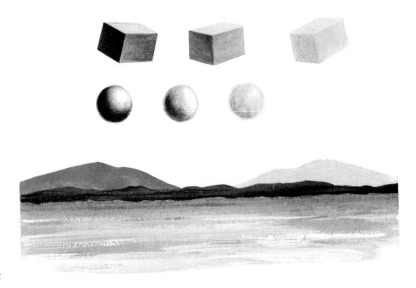

*Illustration 4.16*

light dominates our attention and envelops a wall, dancer, and floor. When objects stand in the path of a light source, cast shadows can take on unusual shapes. When light creates such pronounced light and dark shapes, they become important factors in composition. Sometimes, as in Illustration 4.17B, although the objects in the path of the light source are located "off stage," their influence on composition can be considerable.

We have seen that value is a potent graphic force. Its uses in drawing are limited only by our perceptual understanding and inventive wit. Its relevence to responsive painting, which, like responsive drawing, conveys our intellectual and intuitive judgments based on a subject's actual and inferred potentialities for expressive order is clear though sometimes overlooked by the student. Many responsive painting problems are often really drawing problems, and those involving value are among the most vexing to the young artist. These are more easily recognized

and solved in tonal drawing than in painting, where value, like hue and intensity, is a property of color and harder to isolate for consideration.

It is no coincidence that Rembrandt was not only a great painter, but also a prolific and brilliant draughtsman from his earliest days as a young aspiring artist until the end of his life. Rembrandt's mastery of value (Plate 4.20) enabled him to convey light, volume, gesture, and profound expressive meaning, with an economy, power, and eloquence rarely equalled. His penetrating knowledge and inventive use of value is amply evident in his paintings (Plate 4.21).

For the student, the development of graphic freedom—the ability to pursue his drawing interests in *any* direction for *any* purpose—depends on his comprehension and control of value's potential for contributing to expressive order. Whatever uses value will have for the student later on, now the study of the several functions of value is essential to his development as a perceptually sensitive and knowledgeable artist.

A

B

*Illustration 4.17*

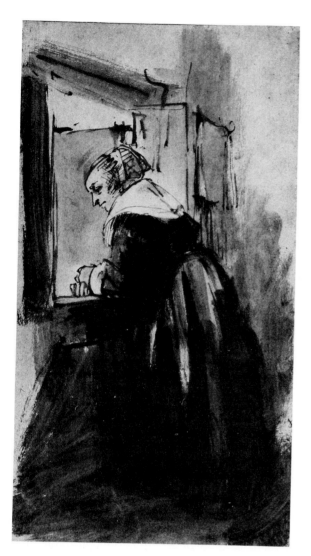

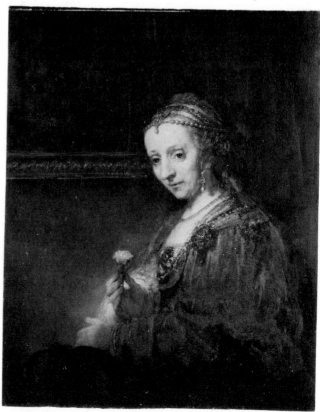

Plate 4.20

*Rembrandt van Rijn* (1606–69).
WOMAN LOOKING THROUGH WINDOW.
Pen, brush and ink.
COLLECTION, EDMOND DE ROTHSCHILD, MUSÉE DU LOUVRE.

Plate 4.21

*Rembrandt van Rijn* (1606–1669). LADY WITH A PINK.
Oil on canvas.
THE METROPOLITAN MUSEUM OF ART,
BEQUEST OF BENJAMIN ALTMAN, 1914.

5

# Perspective

*THE*

*FORESHORTENED VIEW*

## A DEFINITION

For the responsive artist, *perspective* embraces any visual clue to volume, scale, placement, or the direction of forms in a spatial field. Using this broader meaning of perspective, we see that some of its aspects are present in all drawings that convey the impression of three-dimensional forms in space. Even primitive works show some rudimentary (though possibly unconscious) employment of perspective (Plate 5.1).

The wider interpretation of the term perspective, as the appearances of forms in space, may reassure the student who feels he is confronted with a complex, rather dry, and mechanical system. Actually, for most artists, the exact and predictable complexities that stem from the basic application of perspective hold little interest. A preoccupation with perspective generally restricts inventive freedom. In fact, the student has been using most of the basic principles, and probably sensing some of the others. Because perspective deals with appearances, the student knows more about the subject than he realizes. What he needs to do is to clarify and expand his understanding of these principles to benefit from the specific information and control they provide.

A knowledge of perspective is helpful in three ways. First, it serves as a "checklist" to uncover unintended distortions of the subject's actualities.

Second, it enables the student to draw more complex and/or interesting subjects that he might otherwise avoid. Third, it allows him to regard spatial and volume clues that he might otherwise not consider.

A number of perspective systems have been devised in the past. Ancient Egyptian, Persian, and Oriental artists developed visually lucid and aesthetically pleasing systems. There have been others. The system normally used in the Western world is called *linear perspective*. Like all other systems, it is not completely successful in projecting real volumes in real space onto a flat surface without some distortion. It differs from all other systems in being based upon what forms in space look like when observed from a fixed position with one eye closed. Naturally enough, artists, when drawing, do move about. Indeed, many artists find the act of drawing in general, and the requirements of perception in particular, demand a considerable amount of movement. In the act of drawing, an artist must look up and down, left and right, and frequently step back or otherwise change his original position relative to his subject. Thus, with its very first requirement often disregarded, linear perspective is best used in a supportative, rather than a methodological role. The artist drawing volumes based mainly

*Plate 5.1*

BUSHMAN PAINTING OF A DANCE.
(rock painting)
SOUTH AFRICAN MUSEUM, CAPETOWN, SOUTH AFRICA.

on linear perspective is limited by its nature—and his—in transposing actual volume and space into their two-dimensional equivalents.

Allied to linear perspective are some observable phenomena resulting from atmospheric conditions and particles of matter suspended in the air, called *aerial perspective*. These affect the clarity, texture, and values of subjects seen at a distance.

Together, these concepts have helped Western artists convey much observed visual fact with little intrusive distortion. But the greatest artists wisely regarded perspective as a tool, and one with definite limits. Ironically, the impression of forms in space becomes more convincing when the principles of perspective are not unselectively followed.

When applying the principles of linear perspective in a drawing, it must be remembered that in responsive drawing, results emerge from the negotiations between perception, feeling, and aesthetic attitude. The information provided by linear and aerial perspective, like all other visual perceptions, is subject to this interpretive process. Perspective is useful as a means, but has restraining tendencies as an end. When overused, perspective begins to change the purpose of a drawing from invention to imitation—which are mutually exclusive attitudes. In relinquishing inventive choice and change, we lose the means to order, expound upon, and pictorially activate the subject's random properties. Changes that

intensify the drawing's visual and expressive meaning are more important than following perspective or any other convention. Any convention that unquestioningly restricts is destructive of the freedom necessary to creativity. When used with a liberal tolerance for its adjustment to other factors in responsive drawing, perspective becomes a valuable aid.

The foreshortening of forms in space is inherent to three-dimensional drawing. We seldom see a form from a view that offers only one plane. The seasoned artist usually avoids such totally foreshortened views of objects because they hide too much of the object's mass. A line drawing of a circle, representing an end plane of a cylinder, tells us nothing of the cylinder's length. Unless we are told the circle represents a cylinder, we would have no way of deducing this from the circle itself. It could represent the base of a cone, the base of half a sphere, or any other form that resolves itself to a circular plane at its base.

Understanding the principles of perspective helps to clarify and control the effects of foreshortening. They give us a number of ways to make the impression of a foreshortened form in space more convincing. Likewise, when a drawing requires that the impression of foreshortening be subdued, these principles can assist this aim.

Perspective's more technical complexities tend to pull us away from the needs and purposes of free response. Most of these complexities can be

inferred from the principles to be examined. Here, we will concentrate on the basic principles to establish their function as general guides to perception and to show how they assist foreshortening in particular. To paraphrase Eugene Delacroix's observation on the study of anatomy, perspective should be learned—and forgotten. The residue—a sensitivity to perspective—helps perception, varying with each individual, and determined by his responsive needs.

## THE PRINCIPLES OF LINEAR AND AERIAL PERSPECTIVE

Linear perspective is based on six principles. Each of these provides space and volume-revealing clues, some of which have already been mentioned.

1. *Relative scale:*
   When forms known to be the same or a similar size differ in their scale, they indicate differences in their position in a spatial field. Thus, the decreasing scale of a row of trees or fence posts suggests near and far forms in space.

2. *Overlapping or blocking:*
   When a form is in a position that interrupts the contours of one or more other forms, partly hiding them, we have the impression of a form being behind another in space. Thus, seeing *part* of an apple's form as located behind another apple in full view suggests forms in space.

3. *Relative distance and position:*
   When forms, not overlapping, and known to be the same or a similar distance apart show a decreasing distance between them, we perceive them to be receding in space. Thus, the decreasing distance between fence posts or railroad ties suggests forms in space. Except when such forms are seen high above our eye-level, the higher a form is in our field of vision, the farther back in space it appears.

4. *Convergence:*
   When lines known to be parallel appear to converge toward each other, they give the impression of going back in space. Thus, corridors, houses, railroad tracks, or anything with parallel boundaries in any direction, appear to recede in space if these boundaries are seen as inclined toward each other.

5. *Cross-section or cage lines:*
   When forms naturally possess (or are, in a drawing, given) a linear-textured surface, as in the use of structural line-groups or crosshatching, the relative distance and changes of direction between such lines suggest volume in space. Thus, objects as different as sea shells, driftwood, cornfields, or barber poles, by their textured surface-state, convey forms in space.

6. *Light and shade:*
   When value-variations of a form known not to represent local-tones are discerned, volume is suggested. Thus, a cylinder whose value-variations gradually darken as they turn around one or both sides of its body is more easily understood to be a volume in space. When one form casts a shadow upon another, its length, position, shape, and especially its scale and value suggest the distance separating the two forms, the shape of the form casting the shadow, and the planar surface-state of the form in the area receiving the shadow.

The common denominator in these six principles is the diminution of the scale, and, in light and shade, of the value contrasts of forms as they recede in space. If all or most of these principles are invoked, forms—when uninterrupted by other forms—will appear to diminish in scale and finally disappear.

Aerial perspective is based on three principles. These apply mainly to forms in deeper space, such as distant houses and hills in a landscape. The uses of these principles decline with the decreasing distance between the artist and the subject. Generally, they have little practical application in drawing near objects, such as still-lifes.

1. *Clarity:*
   When forms grow less distinct in edge, detail, and general focus, we assume they are farther away. Thus, mountains seen at a distance appear blurred.

2. *Value range:*
   When the value contrasts between forms diminish, often becoming lighter, but always more closely related, we assume these forms to be in deep space.

3. *Relative texture:*
   When forms known to be the same or similar in physical characteristics diminish in textural activity relative to others like them, we assume the less texturally active group to be farther away. Thus, nearby grassy areas are seen as texturally active, those in the distance appear relatively less so.

The common denominator in these three principles is the decrease in definition and change—the generality—that increases with distance. Used together with linear perspective, if uninterrupted in space by other forms, aerial perspective will help cause forms to disappear.

These nine principles constitute the ways in which perspective can be helpful to develop convincing volume and space. But these are useless unless they serve *in support of* sound visual comprehension. Seeing gesture, shapes, scale, and major masses, responding to spirit and substance

Plate 5.2

*Albert Alcalay* (1917–   ). Times Square, 1959.
Pen, ink and wash.
DECORDOVA MUSEUM, LINCOLN, MASSACHUSETTS.

before detail and surface, permitting the interplay between facts and intent, are first considerations to understanding volume in space. A knowledge of perspective can serve, but not replace them.

Perspective can also help the artist subdue volume and space. Knowing what clues will convey these impressions, he has greater control over other clues that involve the beholder with the activity on the picture-plane. For example, Alcalay, in his drawing, "Times Square" (Plate 5.2), achieves an interesting fusion of two and three-dimensional space by stressing some perspective principles and subduing others.

## THE HORIZON LINE

A fundamental concept in linear perspective is the horizon line. This is determined by, and is equivalent to, the observer's eye-level. Whether visible or not, the horizon line is imagined as describing a circle around the observer at eye-level. Being equivalent to the observer's eye-level, the horizon line is as high or low as his position is above or on the ground. To someone standing on a mountain ledge, the horizon line would be very high in his field of vision, for someone lying on the ground, very low (Illustration 5.1).

Normally, obstacles such as hills, houses, walls,

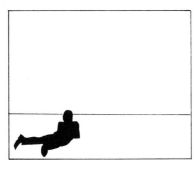

*Illustration 5.1*

or foliage block the view of actual horizon lines. They are occasionally visible, as when viewing a large body of water or an enormous stretch of flat land. Visible or not, linear perspective requires that the horizon line be established in the drawing. This can be actually drawn or simply understood as located on a particular horizontal level on the page. Knowing the location of this line helps determine quickly the general position of forms in relation to the observer. Anything above the horizon line is seen above the observer's eye-level; anything below is below the observer's eye-level. Therefore, we look at the undersides of forms located above the horizon line, and down on the tops of forms below it.

To better understand the horizon line as equivalent with the eye-level, take the example of a room with three transparent walls, through which we see the horizon of a lake (Illustration 5.2A). Our eye-level is centered between floor and ceiling, equidistant from both walls. Through an opening in the middle wall, the horizon of the lake can be seen *directly*. If now we assume the walls are not transparent, but solid and opaque, the only part of the horizon visible is the small segment seen through the window-like opening. The rest of the line that formerly represented the horizon can now be seen as a painted line on each of the three walls, exactly at eye-level. Were such lines drawn on each wall near the floor, they would not form a straight line, but would incline upwards toward the horizon line on the two side walls. If they were drawn close to the ceiling on each of the three walls, the lines on the side walls would incline downwards toward the horizon line. The horizon, or eye-level line, is that horizontal level where lines that we know to change direction in space appear to flatten into a straight line. In Illustration 5.2B, the same room is shown with several lines on the three walls. Note that extending any pair (one from each of the side walls) would cause them to meet at a point on the horizon line. This is called the *vanishing point*.

Recalling the principle of convergence, we know that lines can be made to appear to recede in space when they incline toward each other.

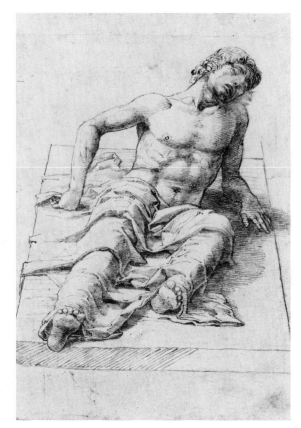

Plate 5.3

*Andrea Mantagna* (c. 1431–1506).
A MAN LYING ON A STONE SLAB.
Pen and ink.
TRUSTEES OF THE BRITISH MUSEUM, LONDON.

When such lines are horizontal, that is, parallel to the ground-plane, they will always meet at a vanishing point on the horizon line, except when seen at eye-level. This can be seen by extending the lines on the side walls in Illustration 5.2B.

In Illustration 5.2C, the same room is viewed with the observer's eye-level near the floor. Now, the next-to-the-lowest lines on the three walls have become the horizon line and appear as a straight line. Thus, we no longer see the lake through the opening in the center wall. Looking at Illustrations 5.2B and 5.2C, we sense the difference in the level at which we view the two rooms. Through perspective, the artist not only sets the stage, he controls the level and, as we shall see, the angle from which we view it.

The horizon line need not appear within the

*Illustration 5.2*

A          B          C

limits of the page. Sometimes, as in Mantagna's "Man Lying On A Stone Slab" (Plate 5.3), the horizon line is assumed to lie above the page. Here, we know it is far above the page, because the degree of inclination of the lines representing the slab's left and right sides, would make it impossible for them to meet until they had traversed several inches beyond the upper limits of the drawing. Less frequently, the horizon line may be known to lie below the limits of the drawing (Plate 5.4).

## ONE, TWO, AND THREE POINT PERSPECTIVE

As mentioned earlier, all linear perspective principles are based on the assumption that the artist maintains a stationary position before his subject. This is, of course, nearly impossible. If the subject is a figure, or anything else capable of movement, it also does not remain completely immobile. But assuming a minimum of movement between the artist and his subject, he can view any subject in one of three ways. He can center himself before its horizontal limits, as Mantagna did before the stone slab in his drawing; he can stand to either side of his subject, as Mantagna did before the figure of the man; or he can view his subject from a point very much above or below it. Any other view is comprised of combinations of these basic positions. In Plate 5.4, it is clear that the artist's position is near the base of the building. In each case, he gains helpful information by regarding the general behavior of the parallel lines (in discussing perspective, the term *line* often replaces *edge,* for purposes of clarity).

When the artist is centered and parallel to his subject, those lines he perceives as *actually* horizontal or vertical, i.e., literally and measurably parallel, do not meet at any vanishing point, for there is no convergence. Only those lines the artist sees as *diagonals,* as moving away from him, incline toward each other and meet at a vanishing point on the horizon line, as in the converging lines of the slab in the Mantagna drawing. Note that the lines of the slab parallel to the page do not converge.

Drawings in which the artist is centered on his subject are called *one-point perspective* drawings because all the converging lines meet at the same vanishing point (Plate 5.5). This meeting of all the converging lines will occur whether the forms are above, on, or below the horizon line, so long as the forms are parallel with the ground-plane,

as in Illustration 5.3A. Note that the middle box, observed at eyelevel, shows only one plane. This is the one parallel to the observer's face (or at a right angle to his line of sight), and it is comprized of four right angles. The other boxes show the same plane, but because these boxes are above and below the horizon line we see the underside of the one above and the top of the one below.

But one-point perspective has an immediate limitation. If we wish now to surround the central box with two others—one far to the left and one far to the right and parallel with it—a

Plate 5.4

*Charles Sheeler* (1883–1965). Delmonico Building. Lithograph.
COURTESY OF THE FOGG ART MUSEUM, HARVARD UNIVERSITY.
GIFT OF PAUL J. SACHS.

A

B

C

*Illustration 5.3*

dilemma arises. Indeed, it already exists in Illustration 5.3A, but because the three boxes are so close together, it is hardly noticeable. Assuming all the boxes to be made of rectangular planes, there is only one position that will show a plane with four right angles: the eye-level position of one-point perspective. This is the only position that will not show any of the sides of the boxes. But, seeing the sides of the two new boxes in Illustration 5.3B, we recognize that the observer seems no longer to be right in front of them, but views them from oblique angles. But if the new boxes are turned enough to show a foreshortened view of their side plane, their front planes should no longer be seen straight on. The boxes cannot show a three-quarter view of their *side* planes without similarly changing their *front* planes. If, then, the front planes of these two boxes are no longer parallel to the observer, they must conform to the principle of convergence and show the horizontal lines of their (former) front planes to incline toward vanishing points on the horizon line. The lines of the former front plane of the box on the left will converge to meet at a vanishing point to the left, those of the former front plane of the box to the right, far to the right. The left and right vanishing points will be distant, because the degree of in-

clination of the former front planes' lines is slight, requiring them to traverse a considerable distance before they can meet.

In Illustration 5.3C, this correction has been made. The boxes on either side of the center one are no longer distorted. They are now "in perspective" but their alignment with the center box has been destroyed. The original intention was to have these three boxes line up in a row parallel with the observer. This was achieved in Illustration 5.3B at the cost of distorting the side boxes, but corrected in Illustration 5.3C at the cost of destroying their alignment. Here, the limits of projecting real volume and space onto a flat surface becomes apparent.

Looking again at Illustration 5.3C, we see that the side boxes, no longer centered on the observer, each possess *two* sets of converging lines that meet at two widely separated vanishing points on the horizon line. These boxes, unlike the center one or their counter-parts in Illustration 5.3B, are drawn in *two-point perspective*.

Whenever forms are parallel to the ground-plane but not to the observer, as, for example, when we stand facing a corner, not a side of a square table, their parallel lines will appear to meet at two vanishing points on the horizon line. Any number of forms, when parallel to the

98

*Illustration 5.4*

ground-plane but differing in their alignment to each other, as, for example, a floor strewn with boxes, all upright but at various angles to each other, will each have its own two vanishing points. Though an object like the folding screen in Illustration 5.4 may have many parallel lines converging upon many vanishing points, it is still regarded as being drawn in two-point perspective.

When forms are seen as floating at an angle to the ground-plane, their vanishing points will be above or below the horizon line, as in Illustration 5.4. Note that the lines of the folding screen and the boxes denoting their verticality, whether or not they are actually at a right angle to the ground-plane, do not converge. In two-point perspective, lines observed to be measurably parallel, as mentioned earlier, are drawn as true parallels.

When we look down upon a subject from a great height or look up from a low observation point to see a towering form such as a skyscraper, the subject's vertical lines will appear to converge toward a vanishing point. When this is observed, a *three-point perspective* situation exists, as can be seen in Illustration 5.5 and Plate 5.4.

*Illustration 5.5*

99

Plate 5.5

*Annibale Carracci or Studio* (1560–1609).
FRONTISPIECE, FROM THE ILLUSTRATIONS OF THE
LIFE OF ST. PAUL.
Pen and ink, brown and gray washes.
THE PIERPONT MORGAN LIBRARY, NEW YORK.

Plate 5.6

*Charles Meryon* (1821–68).
STUDY FOR THE ETCHING, LA POMPE NOTRE DAME.
Pencil.
COURTESY, MUSEUM OF FINE ARTS, BOSTON.

*Illustration 5.6*

In both two and three-point perspective, the vanishing points should not be placed too close together. Crowding them produces forced and distorted forms, such as those in Illustration 5.6. Because of the unavoidable distortions in transposing real volume and space to a flat surface, most artists will make subtle adjustments between conflicting perspective views such as in Illustrations 5.3B and 5.3C, thereby reducing and obscuring the evidence of distortion (Plate 5.6). Many artists intentionally "go against" the convergence effect, to reduce the camera-like distortions that a strict adherence to perspective can cause. Here, the vanishing points may be extremely far apart, giving a broad "frontality" to forms, that emphasizes attention upon the picture-plane (Plate 5.7).

In the following exercise, try to select views that will test your understanding of one, two, and three-point perspective.

EXERCISE | 5A

Draw in pencil on any suitable surface. Use a ruler and eraser freely on all but the last of the three drawings you will make.

*Drawing 1.* Use two simple, block forms as models. Gift boxes, cartons, or children's large pasteboard building blocks are excellent, but any block-like object will serve. These need not be cubes, but do avoid very long block forms. If possible, one or both of the forms should be open at one or even both ends, permitting you to see inside. You will be drawing both forms as if they were semi-transparent. It is helpful to see the angles of inside lines. These forms may be the same or they may differ in size, with neither being

smaller than five, nor larger than twelve inches in any direction. Avoid broken or otherwise misshapen forms and those that do not offer right angles abutments of all planes.

Plan to cover a sheet of 18″ × 24″ paper with as many views of these two forms together, in varying positions, as will conveniently fit on the page. Draw these considerably smaller than actual size, but avoid tiny drawings.

Arrange these forms in any way that offers a new combination for each sketch. Or, leaving the blocks in some arrangement, draw the different views you see as you move around them. You can place them next to each other at different angles, place one atop the other, or lean them against a wall, balancing them on their corners. Draw them as they appear above, at, and below your eye-level. If the forms are light enough, they can be taped to hang from a doorjamb or can be otherwise suspended above eye-level.

Begin your drawing of each view in a free manner. Note, first, where each form is in relation to your eye-level. Look for the shape-state of the planes. In doing so, you will see planes more objectively and, thus, be more aware of the direction of their lines. Here, a diagrammatic use of line will help you concentrate on analysis, rather than exposition. When your drawing has some rough relationship to the shape, scale, and location of the two forms, use a ruler to establish the right relationship of inclination between the lines. Allow the lines to extend beyond the point of intersection with other lines when you see them as converging toward a vanishing point. As there are no visible horizon lines to be drawn on this page, extend such lines only slightly beyond the form itself. These extensions help you to see their inclination better, as in Illustration 5.7. Notice that many of the lines of the lower

form are visible through the upper one. Assume that the forms you are drawing are semi-transparent, allowing you to draw most of the unseen lines. Should a profusion of lines become confusing, draw those you do not actually see as lighter or occasionally allow some of these lines to disappear for a little distance along their paths. Use your eraser to clarify the drawing in general, and to lighten the imagined lines still further where you feel them to be confused with observed lines. Drawing the lines you *do* see in heavier strokes also helps to explain which are actually perceived and which imagined.

In Illustration 5.7, the two forms each show three groups of lines. Those marked *P* are parallel to the observer, despite the tilt to the left of those in the upper block. Lines *A* and *B* of the lower block and lines *C* and *D* of the upper one are not parallel to the observer and are, therefore, drawn in two-point perspective.

There is no time limit for the various views you will draw on this page. When you have filled the entire page, go over each sketch to see if any lines diverge or remain parallel when their position requires them to converge. Check to see if any of the forms seem distorted because the inclination of the lines was too extreme. Look at these drawings again in a few days to see if you can locate the observer's position for each sketch, and if they "feel" right.

***Drawing 2.*** This drawing is to be completely imaginative. Again, draw in pencil on a sheet of 18″ × 24″ paper. Turning the sheet vertically, divide it into three even sections. Starting with

the topmost section, draw a horizontal line four inches from its base, dividing it in half. In the second section, draw a similar line two inches from its top. In the third section, draw a horizontal line two inches from its base. These three lines will represent, in each drawing, the horizon-eye-level line.

Starting with the *middle* section, draw three block-like forms that appear to "sit" on the ground-plane. Each should be drawn in two-point perspective at an angle differing from the other two. This will result in six different vanishing points. We saw in Illustration 5.4 that forms parallel to the ground-plane, but not to each other, have their own vanishing points on the horizon line.

Again, assume the forms are semi-transparent, and let the converging lines extend beyond the forms, this time all the way to their various vanishing points. You may find that a block's placement has resulted in a vanishing point being located beyond the limits of your page. When this is the case, temporarily place a sheet of paper alongside your drawing, extend the horizon line, and, using a ruler, draw the converging lines onto this sheet of paper until they meet at the horizon line. Be sure to keep each block's vanishing points well apart.

There is a second way by which you can establish the three blocks. Instead of drawing the forms and adjusting their lines until they meet at their appropriate points on the horizon line, you can begin by selecting a block's two vanishing points and draw two radiating lines from each in the general direction of your de-

*Illustration 5.7*

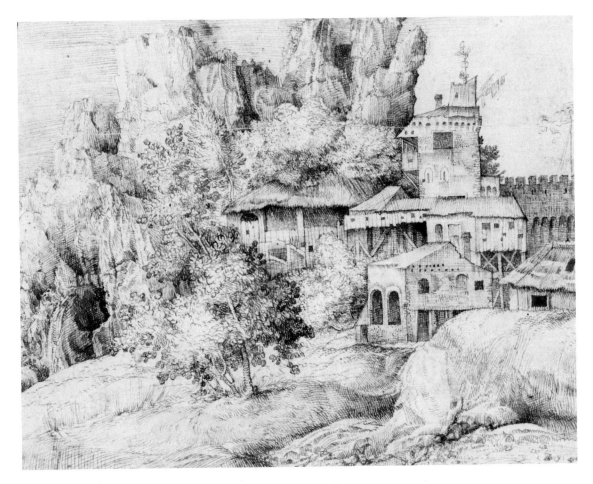

*Plate 5.7*

*Domenico Campagnola* (c. 1500–52).
BUILDINGS IN A ROCKY LANDSCAPE.
Pen and ink.
THE PIERPONT MORGAN LIBRARY, NEW YORK.

sired location for the block. Where the four lines intersect, the bottom plane of the block will be located. Elevating four vertical lines at each point of intersection, raises the four walls of the block. To locate the top plane of the form, again draw diverging lines from both vanishing points until they intersect, this time at a higher elevation than the first set of lines.

Whichever way you draw the three blocks, place them well away from the horizon line. They may, however, vary in their nearness to the observer. These blocks, when completed, will be your models for the two remaining sections.

Using a ruler held vertically, locate the six vanishing points on the horizon lines of the first and third sections. In both sections, draw the three forms in the same relationship to the ground-plane as established in the middle section.

The differences in the location of the horizon line will make the blocks appear farther below the observer's position in the first section than in the third section. Depending on their height

and position on the ground-plane, the upper portions of the blocks in the third section may rise above the horizon line.

When you have completed drawing these three views, return to the center section and continue to develop it as if the blocks represented the geometrically "pure" state of houses. Add windows, roofs, and anything else that would convert the original forms into houses. Place them in a simple landscape setting that may include streets, lampposts, trees, and fences. Keep these additions quite simple. Use converging lines to align windows, streets, etc., as in Illustration 5.8. Then try to show how this landscape would look from a different elevation, by drawing the same objects in the same positions in the first section, and how it would look from a low eye-level view, by developing the third section in the same way. When completed, the three landscapes should show each component in a correct position in relation to its ground-plane and horizon line.

You may find yourself faced with perspective

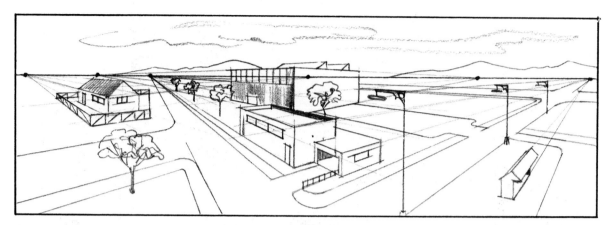

*Illustration 5.8*

matters not yet discussed. If so, return to this drawing at the completion of the chapter to see what new information you can use to complete the three views of this imaginary landscape.

***Drawing 3.*** Sit about two feet away from a small table upon which you have arranged some eight or nine books of various shapes and sizes. Several should be stacked on their sides at different angles, one or two can lean against the stacked books, while others can be placed at various angles upon the tabletop and may overhang it. Study the subject to determine your horizon-eye-level line and lightly indicate this on a sheet of 18″ × 24″ paper, to be used horizontally. Do not use a ruler for this drawing.

Your attitude here should be to use perspective as an aid to sound perception, not as a method. Your goal is to accurately depict the position of the subject's forms.

Begin gesturally, and develop the drawing in line, value, or both. Search for positive and negative shape, scale, and general location of the books and tabletop (you do not need to include all of the table). As you do, refer to the eye-level line to help you locate a part's position in space relative to your position. Note the angles of convergence of the edges of your subject and where any parts seem not to lie at the correct angle, extend some light lines from their diagonal edges to see whether or not they fall on the horizon line. Use, but do not merely rely on, perspective to assist your understanding of these forms as masses in space.

We have seen that linear perspective can distort. Exercise great freedom in the way you wish to develop this drawing, but insist on conveying the positions of the forms to each other, and to you the observer-artist.

## SOME PERSPECTIVE CLUES TO EXACT LOCATION

Occasionally, it is necessary to locate the middle of a square or rectangular plane turned away in some direction from the observer. In Illustration 5.9, a square and rectangle are shown in a position parallel to the observer (a). Diagonal lines drawn from corner to corner in each cause them to intersect in the exact center, thus locat-

*Illustration 5.9*

*Illustration 5.10*

ing the window in each as being centered on it. Placing these planes at an angle to the observer, we find that drawing diagonal lines from corner to corner gives us the exact *perspective* center and locates the position of the centrally placed window (Illustration 5.9B).

Perspective provides a simple system to locate the position of evenly spaced forms such as fenceposts, telephone poles, or soldiers in a row. To locate them, draw the first member of a row of forms, and, extending lines from its tip and base, incline these lines to meet at the desired vanishing point on the horizon line. Based on these lines, draw the second member at the desired distance from the first. This first space interval establishes the size of all the spaces between the rest of the forms. Recall that according to the principle of relative distance, spaces must diminish between each pair of forms to help achieve the impression of the forms as receding in space. To locate the correct placement of the third member, first draw a line from the established vanishing point to the center of the first member, dividing it in half. Then draw a diagonal line from the top of the first member through the point of intersection between the second member and the dividing line, continuing until it strikes the base-line, as in Illustration 5.10A. Draw the third member at the point at which the diagonal line strikes the base-line. Repeat this procedure to locate all subsequent members, as in Illustration 5.10B.

There are many sophisticated extensions of these two suggestions for locating forms in space that provide exact mathematical and geometric results. But these tend to expand the role of perspective (usually at the cost of creative freedom) beyond its serviceable role as a tool. For those who wish to pursue this absorbing subject further, several source-books are listed in the bibliography.

## THE CIRCLE IN PERSPECTIVE

To see a circular shape, the observer must be positioned parallel to its surface and centered on its limit. When its surface is parallel to the observer's line of sight, that is, totally foreshortened, it appears as a line. Viewed from any other angle, it appears as an ellipse-like shape, as in Illustration 5.11.

*Illustration 5.11*

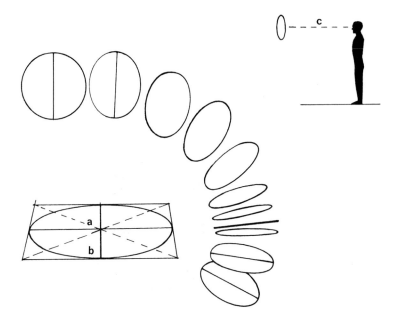

If we bisect a true ellipse along its longest axis, it produces two equal halves. Bisecting a circle seen in perspective in this way produces a fuller curve in the half nearest the observer (Illustration 5.11). In drawing foreshortened circular forms, it is important to remember that they are not seen as true ellipses—though sometimes referred to as such in this chapter.

Illustration 5.12 shows a circle put into perspective. Although somewhat mechanical, this drawing aid is sometimes required by certain subjects (and artists) to achieve a convincing representation of foreshortened circles. For example, in making a closely observed study of a large circular form, whose dimensions are basic to the placement of smaller forms upon its body, as in a large, decorative fountain or pool, an accurate perception of its actual shape is important.

To help see this, the changes that occur from circle to ellipse-like shape must first be understood. The circle's center is first established by drawing a square and dividing it horizontally and vertically into four equal parts. The circle is then drawn by making a line that—without changing its degree of curvature—strikes the center of each of the square's four "walls."

To place the circle in perspective, redivide the square by diagonal lines going from corner to corner, making eight sections, as shown. Two vertical lines are now elevated from the base-line (A) to run through the intersections of the circular line and diagonal lines. The necessary vanishing point need not be centered on the square

as shown, but may lie to either side of the square's horizontal dimensions.

To draw the foreshortened view of the circle, extend the five vertical lines of the square to the desired vanishing point. Place a horizontal line (X) at a level estimated to establish the foreshortened width of the original square. Although there is a complex geometric means to determine the exact location of line X, the artist's "feel" is often as dependable and, because of the alien nature of such a mechanical procedure to responsive drawing, always preferable. Dividing the foreshortened square (B) in the same way as A, establishes eight points, as shown, to help draw the foreshortened circle. Note that the actual, mathematical bisection of the ellipse in B is nearer to the observer than the perspective mid-line.

Although most artists do not engage in such mechanical procedures, examining the changes that occur in circles in different degrees of foreshortening is a useful sketchbook practice.

The angle of any foreshortened circle is determined by the perception of its longest axis. When such an elliptical shape is upright, its long axis will be vertical. When it is parallel with the ground-plane and centered on the observer, it is horizontal. All other positions in space will show the long axis of an ellipse as inclined to some degree.

In Illustration 5.13, the long axis in each of the four ellipses is different. In *a* it is horizontal because, unlike *b*, it is centered on the observer. But both are parallel with the ground-plane. In *c*, it tilts away from a vertical position, matching the tilt of the box-like container. Many artists find it easier to place an ellipse at the desired angle by first drawing such boxes in the required position and drawing the ellipse by making a curved line strike the center of each side, as in Illustration 5.12. Though *d*, like *c*, turns away from the observer, its long axis remains vertical. Note in *e* that the long axis of each ellipse is at a right angle to the line running through them all. This curved line running the length of the cylinder represents the short axis of each ellipse. Note that the short axes of ellipses *a,b,c,* and *d* above, are also at a right angle to the long axes in each ellipse.

To help establish the desired angle of an observed ellipse at one end of a cylinder form such as a column or wheel, begin by drawing the box-like container, as shown in Illustration 5.14. Running a line through its center, parallel with its tilt in space establishes the short axis of the ellipse to be located at the end of the box.

*Illustration 5.12*

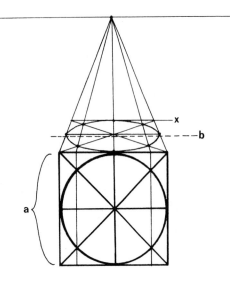

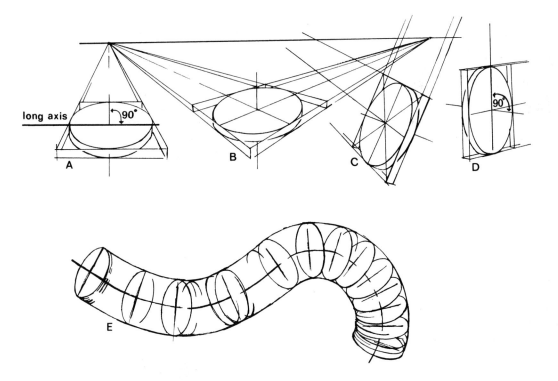

long axis    90°

A      B      C      90°    D

E

*Illustration 5.13*

Drawing a line at a right angle to the short axis establishes the long axis, and consequently the required angle of the ellipse. Circles in perspective offer no view from which sharp corners are visible (Illustration 5.15).

## CAST SHADOWS

Linear perspective affects the shape and scale of cast shadows (Plate 5.8). When forms are illuminated by a nearby source of light such as a candle (Illustration 5.16), their cast shadows will radiate from a point at the base of the light source. To establish the length of a cast shadow, draw a line from the top of the light source that touches the top of the form and ends at a point where it meets with lines drawn from the base of the light source. These lines from the base of the light source represent the shape of the cast shadow.

When forms are illuminated by sunlight, the radiating effect of the light rays is far less evident because of the great distance separating them from the sun. To establish the shape of a shadow cast by a vertical plane in sunlight, drop a vertical line from the position of the sun to the horizon line. This creates a vanishing point for

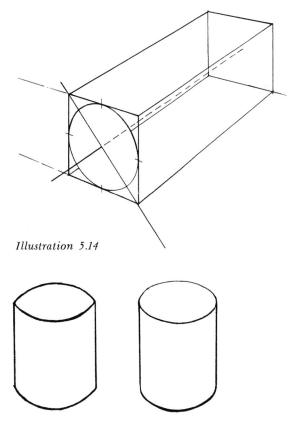

*Illustration 5.14*

*Illustration 5.15*

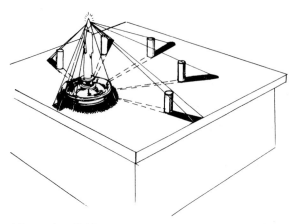

Illustration 5.16

.the same general procedure. However, as shown in Illustration 5.18, there are now *three* vanishing points that affect the cast shadow. The vanishing point of the shadow's lines dictates the direction of the block's shadow; the other two vanishing points and the sun's height, its shape, and scale. The irregular shape of the cast shadow in this illustration results from the block's position in relation to the sun.

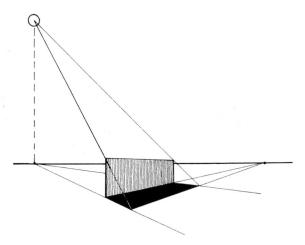

Illustration 5.17

the lines of the shadow (Illustration 5.17). Two lines, drawn from the sun at an angle that touches the top corners of the plane and continue farther to intersect the radiating lines of the cast shadow, establish the shape, scale, and direction of the cast shadow. To use the plane's vanishing point to draw a line that touches both of these intersections "proves" the angle of the leading edge of the cast shadow.

To establish the shape of a shadow cast by a three-dimensional solid such as a block, follow

*Plate 5.8*

*Anonymous* (Italian, 16th century).
SHADOWS CAST BY ARTIFICIAL LIGHT.
Ink and chalk.
THE PIERPONT MORGAN LIBRARY.

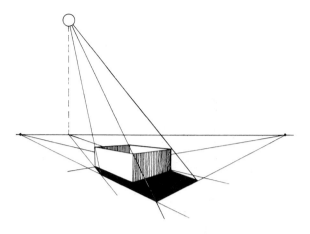

*Illustration 5.18*

## FORESHORTENING

To repeat: *foreshortening is the real theme of this chapter*. We have been discussing it all along. Because we can only see one view of a volume at any one time, any position we take that places us parallel with one or more of its planes, places us at an angle to the others. Foreshortening is a given condition of three-dimensional drawing. The beginning student who prefers to draw the "easier" side view of a model's head because the front view seems too difficult, must then draw the front view from a severely foreshortened angle as well as the full, parallel view of the side of the head. Not much has been gained. Though some subjects *do* offer a view from one position that is far more complex than other views, moving to a right angle position of a complicated view only foreshortens, and, often, further complicates it.

Those parts of a three-dimensional form that recede into space at angles that permit us to see them always undergo two major changes. The length and the width of such parts are both diminished to some degree. Usually, they do not diminish at the same rate. As a form approaches a parallel relation to the observer's line of sight, its length diminishes at a faster rate than its width. Only with severely foreshortened views of subjects of enormous length does the reduction in width keep pace with that of length. This difference in the rate of reduction is important. As an example, if we draw a foreshortened view of a leg (Illustration 5.19), it is necessary to distinguish between the rapid "telescoping" of its length and the relatively minor reduction of its width, as in *A*. Many students, perhaps subconsciously influenced by the sharp reduction of a form's length, reduce its width far too much, as in *B*.

But some beginning students, like the general, untrained adult, avoid such views, and prefer, instead, straight on, or frontal views. Seeing a subject from an oblique angle is at first confusing. By placing themselves parallel to a desired view of a subject, as in the example of the model's head, beginning students hope to avoid foreshortening. This, as we have seen, is impossible. Such an attitude usually makes the student substitute remembered notions of a subject for what he sees. He may *see* a foreshortened leg, but will draw it as if he were in a position hovering above it. Indeed, he is more likely to diminish its width than its length, because seeing

*Illustration 5.19*

A                                                B

the reduction in the overall scale of a form's shape is easier than analysing the form's shape-state. Sometimes, the entire leg or part of it will be drawn to a smaller scale than the rest of the forms of the figure, but it will still look like a frontal view. This tendency toward unintended frontality subsides as the student begins to shift from preconceived notions to perceptual comprehensions.

Learning to see gestural expression and shapes is a crucial first step in perceptual comprehension. Seeing the measurable actualities of forms in space from one observation point is another. These are not separate issues. We have seen that gesture and shape contribute to volume. Here, we are examining perspective principles that assist in sensitizing us to volume. Because gestural action and shape are both concerned with the behavior of volumes in space, perspective's contribution to these fundamental aspects of perceptual comprehension is useful.

Perspective more immediately applies to simple geometric forms. Applying its principles to a house or a fence seems logical and manageable. But its presence in organic forms such as trees or the human figure is less evident and is often disregarded. However, disregarding perspective's clarifying uses risks losing the sense of the artist's fixed position in relation to the subject, and increases the likelihood of perceptual errors going undetected. For example, it is helpful to know that, if we are seated before a standing figure, we look *down* upon the tops of the feet, but *up* at the underside of the chin and nose (Illustration 5.20). Knowing that our eye-level falls approximately at the figure's hips alerts our perceptual sensibilities to what the figure's general position in space is from our view of it, and helps us to understand the volumes better. A knowledge of perspective, then, helps us to organize complex organic subjects by helping us understand their disposition in space. It also makes it easier to make desired changes in the location of forms that will be visually consistent with the perspective of the rest of the forms.

But the irregularities of a complex subject such as the figure make it difficult to apply perspective principles. Simplifying its parts in the direction of basic geometric solids helps locate them in space. These geometric forms can be actually drawn (Plate 5.9), or only held in the mind's eye. To recognize that the head can be regarded as essentially egg-like or block-like, that an arm or leg can be viewed as cylinders, helps us understand their basic volume character, and thus more easily places them in space in what-

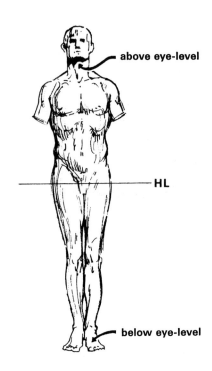

*Illustration 5.20*

ever foreshortened view is required. Once the geometrically simple "stand in" has taken its position, and its scale, shape, and converging edges have been noted, the development of its forms, based on perceptions, can more easily be made.

In Ruben's drawing of arms and legs (Plate 5.10), the limbs have been drawn in a way that echo their geometric core. Especially in the foreshortened right lower leg, we sense the cylinder that underlies the surface variations. Note how Rubens draws smaller volumes, formed by the bulging muscles. These, too, are sensed to be hinting at a simpler state of volume. The details we know to be present in arms and legs are here made subordinate to the bigger, simpler forms, or omitted altogether.

Depending on the organic form, overlapping of one part by another can play a role in conveying the foreshortened state of a part. If the subject is an arm, as in Illustration 5.21A, the muscles nearer to the observer will overlap those farther away, providing a strong clue to their position in space.

When forms overlap, the nearer, or dominant one often casts a weak shadow or causes a lessening of light upon the farther, or subordinate one, on that segment nearest to the dominant form, as in Illustration 5.21A. The impression of vol-

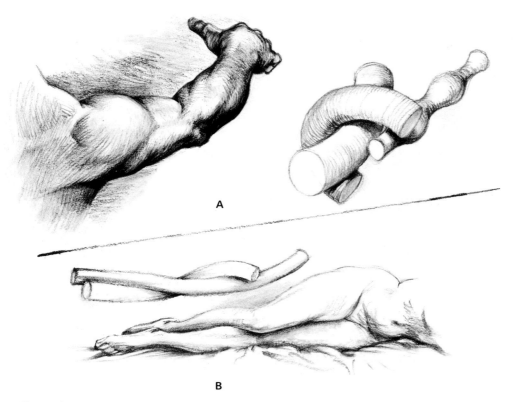

A

B

*Illustration 5.21*

ume is increased when values are used to "underscore" the blocking of one form by another in this way. When forms lie close together on a plane in a way that does not make it clear which one is dominant at any one point, the use of value to darken the subordinate form near its neighbor helps to clarify their placement as in Illustration 5.21B. As with any device, unselectively used, this solution can quickly degenerate into gimmickry. Employed when other clues cannot convey the dominance of one volume over another,

or to lend emphasis to others, it is a helpful tactic.

The use of cross-section or cage lines or of structural line groups is another means of providing clues about foreshortened form. In Illustration 5.22, the lines convey the surface-state of the volume, and their increasing closeness and delicacy, the sense of receding in space.

Even aerial perspective, generally reserved for subjects in which deep space occurs, as in Plate 5.11, can assist in conveying the spatial behavior

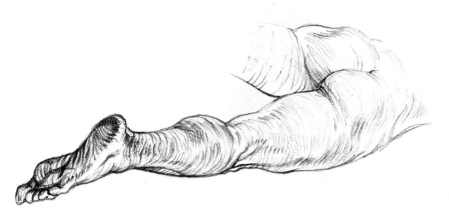

*Illustration 5.22*

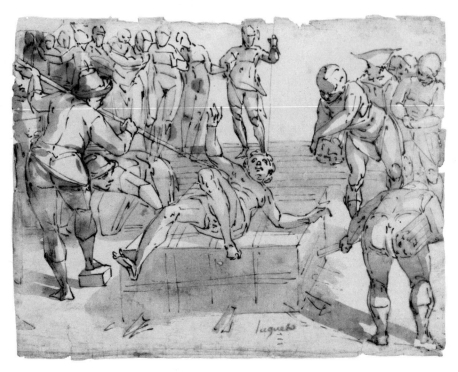

Plate 5.9

*Luca Cambiaso* (1527–85).
THE MARTYRDOM OF ST. LAWRENCE.
Pen and brown wash.
THE NATIONAL GALLERY OF CANADA, OTTAWA.

of nearby organic forms—if used with great subtlety. In Plate 3.3, da Vinci just barely suggests the second head from the right as less defined, that the value range has lessened, and that there is less textural activity. In general, he makes the nearer forms of the drawing sharper in focus, bolder in value contrasts, and richer in textural activity. Note all the clues used to tell us that the second head from the left is severely foreshortened.

Relative distance and position can also help convey foreshortened views of independent organic forms. The decreasing space between trees, flowers, or figures in some orderly pattern suggests space. The farther back in space such separations are between forms, the more critical their position becomes. Misjudging the distance between two nearby forms to a small degree, is generally of little importance. But the same degree of misjudgment between forms a mile or so away becomes a serious change in the scale of the distance between them. Thus, in a drawing showing a foreshortened view of a row of trees intended as equidistant, enlarging, or even only

failing to reduce the distance between the last two trees, might show the last one as being a full city block away from its neighbor, when only a fraction of that distance was intended.

Thus, all nine perspective clues can participate in foreshortening any kind of form. The more complex the form, the more useful perspective becomes as a tool for clarifying its direction, scale, location, and essential mass.

Because volume and space are inseparable issues, the drawing of a foreshortened form should be made believing that the flat surface of the page does not exist—that we can reach in and touch, with our drawing instrument, a form that is located far away in space. Many artists, therefore, simultaneously develop the volume and the spatial cavity in which it exists. Leaving the space around a form (or between forms) as just the white of the paper sometimes tends to have a flattening effect on their sense of mass. The forms appear somewhat pressed upon the page. Or, it may make the forms appear to lift off the page and hover above it. Both of these problems are solved by establishing a spatial

cavity to receive them. Where such spatial "receptacles" are limited by other masses or the horizon line, perspective can assist in shaping them.

In the next exercise, you will draw some foreshortened forms. As you go from simple forms to more complex ones, remember the nine ways in which perspective can help.

EXERCISE | 5 B

There are four drawings in this exercise. There is no time limit on any of them. The first consists of invented forms, the remaining three will be drawn from observed subject mat-

ter. For these, use the human figure, either draped or nude, as your subject. If no model is available, make a still-life arrangement consisting of some of the following: pillows, fruits, purses, hats, boots, dolls, and vases. Here, the idea is to simulate some of the characteristics of organic forms. Any other objects that you feel would be consistent with this theme may, of course, be used. The still-life should be fairly simple and should avoid angular or mechanical objects. However, if a choice of subjects is possible, use the figure, preferably nude.

In all four drawings use any erasable medium. You will be making many adjustments in the search for scale, direction, shape, etc., and should use a medium and paper that permits changes. All four drawings should be made on paper no smaller than 18″ × 24″.

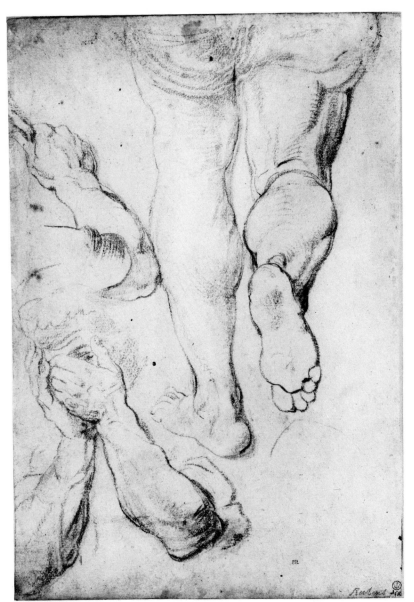

*Plate 5.10*

*Peter Paul Rubens* (1577–1640).
STUDIES OF ARMS AND LEGS.
MUSEUM BOYMANS-VAN BEUNINGEN,
ROTTERDAM, THE NETHERLANDS.

***Drawing 1.*** Fill one-half of the page with simple geometric forms such as cylinders, cones, half-spheres, and any other variations of such basically rounded forms. Use your imagination freely, but avoid complex forms. The cylinders may bend, interlock, or develop variations in their thickness. However, try to show the elliptical end-planes of these cylinders at right angles to the bodies of the cylinders. Other forms may consist of several joined volumes. For example, a cylinder may have a mushroom-like cap at either end, or a tire-like ring around its body. Except where forms are made of such combinations of smaller forms, avoid having one form blocked by another. In general, they should float free of each other, as in Illustration 5.23A. These should be drawn in line, using structural line-groups wherever you feel the volumes need clarification, or to indicate the subordinate form where overlapping does occur. Make all the changes and corrections needed to produce clearly stated volumes floating in space.

When you have completed the half-page, draw each of the objects again on the other half of the page—as if you have moved a few feet to your right. Imagine how each of these would look if you changed your position in this way, and draw their new view (Illustration 5.23B). Although each is now "seen" from this new angle, avoid any blocking of independent forms that would occur in such a shift of position. Draw them again, as floating free of each other. Thus, in drawing each volume as you imagine it from this new view, disregard the spatial relationships between them (except, of course, those made up of joined forms) allowing each form to be fully visible. If you find it difficult to imagine these rounded forms in their new positions, "en-

A

B

*Illustration 5.23*

*Illustration 5.24*

case" them in block-like containers, as in Illustration 5.24 to help clarify their direction and summarize the degree of foreshortening. It also helps to think of the rounded forms as transparent, because seeing through a form makes its proportions and position easier to establish.

***Drawing 2.*** The model or still-life will keep the same pose for the next three drawings. The subject should be placed atop a tall stool, desktop, or other support higher than a household chair. If the figure is used, the pose should include crossed arms or legs, or any position that creates a variety of directions of the limbs. If

you are drawing from the still-life, arrange the components to offer a similar variety of directions. For this drawing, stand at an easel or any comparable support.

Study the subject until you feel you understand the various directions of its parts. Before you begin to draw, lightly indicate the horizon-eye-level line on the page. Begin freely, drawing the forms of your subject as if they are simple geometric solids. Do not draw them as they actually appear. In Illustration 5.25, the arms and legs are cylinder-like, the head is shown as block-like, the throat is seen as cone-like, etc. Draw the forms of your subject in equally severe, geometric terms. Drawn in this simplified way, it is easier to place them in their various foreshortened directions, recognize converging edges, and see changes in the dimensions of their bodies and in the scale of their parts.

Note that some cylinders were drawn as floating free. Take any similar liberties you feel will help you control the direction and placement of the forms in space. As in the first drawing, use some structural line-groups to clarify the volumetric character of the forms. The resulting drawing will, of course, look manikin-like, but should show these forms clearly turning toward and away from the viewer. Use some tones in the background to help create a sense of space for the subject. Where possible, indicate the stool or other support, and perhaps some corner of the

*Illustration 5.25*

room. Any clues you can provide to strengthen the sense of a spatial cavity will help you to better locate the forms within it.

***Drawing 3.*** In this drawing, work from the same position, but this time you should be seated in a chair, upon a low stool, or even on the floor. Begin as you did the second drawing. Again, locate the horizon-eye-level line. Though the pose has not changed, your position is lowered and all the relationships are changed. Noting these differences, again draw each form as reduced to a simple geometric state. But this time, do so lightly, using as few lines as possible. Once you have established the direction, scale, and overlapping of these forms (which should be thought of as transparent), continue by drawing upon these geometric forms what you *do* see of the subject's actualities. That is, using the geometric forms as indicators of each part's essential mass and direction, develop the forms of your subject. If you find that some of these severely simplified forms are too remote in volumetric character from the parts they represent in the

subject, develop such geometric forms by stages. For example, instead of drawing the observed forms of the head upon the block that represents it, "carve" the block to make a few more broad planes that more nearly represent the volume actualities of the observed head. This will help you locate some of the smaller forms upon the simplified form. Normally, it is not necessary to use such severely reduced volumes as a basis for drawings in which structural volume is to be stressed (*see* Chapter Six), but here it helps to more easily control the subject's perspective.

As you develop the simple forms, do not bury them under many details, but keep an echo of the geometric "parent" evident in all the final forms of your drawing, as in Plate 5.10. The rule here can be "when in doubt, leave it out."

As the drawing develops, resist any tendency to make a foreshortened part turn frontally. This sometimes happens when the attention shifts from a part's placement in space to its specific characteristics.

Your goal here is to produce a drawing modelled mainly by structural line that shows con-

*Plate 5.11*

*Chou Ch'ên* (1st half 16th cent.) THE NORTHERN SEA. Ink and slight color on silk.
NELSON GALLERY–ATKINS MUSEUM, KANSAS CITY, MISSOURI
(NELSON FUND)

Plate 5.12

*Giovanni Batista Piranesi* (1720–78).
FANTASTIC INTERIOR.
Pen and brown wash over chalk.
THE NATIONAL GALLERY OF CANADA, OTTAWA.

Plate 5.13

*Winslow Homer* (1836–1910).
CHILD SEATED IN A WICKER CHAIR.
Black crayon and white gouache,
with touches of pencil on light gray paper.
STERLING AND FRANCINE CLARK ART INSTITUTE,
WILLIAMSTOWN, MASSACHUSETTS.

vincing, foreshortened volumes that collectively reflect the subject as you saw it from your position in space.

***Drawing 4.*** The fourth drawing is to be done exactly as the third. But this time, move to a position that is approximately at a right angle to the one you held for the second and third drawings. You may stand or sit for this drawing. Seeing the same forms from this new view, you will have a completely new set of relationships, but the experience of the previous drawings should help you represent them with greater economy and control.

## PERSPECTIVE AS
## AN AGENT OF EXPRESSION

A knowledge of perspective can contribute to expressive meaning by enabling the artist to draw a subject from that angle most evocative of his feelings and intent. In Plates 5.4, 5.11 and 5.12, the views given stimulate emotions about the subject. The use of three-point perspective in the Sheeler drawing helps us to feel the towering elegance of the building. The Piranesi drawing, which is almost certainly a work largely of the imagination (as the title suggests), shows a view that permits us to share his excitement in the quick sweep of the forms and in the emotional impact of the spatial cavities they create. Here, as in Plate 3.13, Piranesi proves that perspective can be a tool of exciting expressive possibilities. Less evident, Homer uses perspective to subtly convey a child's feeling of elevation in a common, household chair. From the view he presents, we see the child's right foot well off the ground. Note how Homer has "spread" the eye-level to extend from the child's legs to the curves of the armrests. This has the effect of suggesting a broader band of horizontal mass which in turn implies that the child is solidly seated.

We have seen that perspective, in its broader sense, is a given condition of three-dimensional drawing. It helps provide important information about volume and space, and provides a number of ways in which these qualities can be clarified and emphasized. Although sensitive visual perception would seem to make perspective almost unnecessary, understanding its principles provides a drawing with that extra measure of authority and economy that the sensitive beholder recognizes as issuing from knowledge, not bravado. Also, because responsive drawing may, for some artists, require considerable changes in what is observed, when such changes concern the relocation of volumes, perspective is immediately involved. While linear perspective has its limits, it has important virtues—especially as a tool in helping us to understand the state of a foreshortened form. Its general influence helps us to know and control the behavior of volumes in space and thus, is necessary to the development of a mature understanding of the physical world.

CHAPTER

# Volume

*THE*

*SCULPTURAL SENSE*

*A DEFINITION*

The previous chapters centered on a subject's physical actualities and emotive character so that the student could better select, alter and control them in forming responsive drawings. Thus, a major consideration in each chapter was the fact of a subject's existence as volume in space. We saw, in examining gestural expression, shape, line, value, and perspective, that understanding each contributed to our understanding of a subject's physical and behavioral nature in space. Such perceptions were shown to be fundamental to responsive drawing. This is not to suggest that responsive drawing need be primarily concerned with the impression of volumes in space; our perceptual sensitivity, and aesthetic inclination, wherever they may lead, decide what role volume-building will play. Rather, it is the severe restrictions on graphic freedom that result from an inability to create convincing impressions of volume in space that make it necessary to develop the skills and insights to convey that impression.

In this chapter we will explore, and occasionally review, the various factors that can participate in conveying volume—not the outlining of observed volumes, not their surface effects, not vague suggestions of volumes, but the convincing impression of solid masses that have weight and occupy space.

Volumes can be represented in two ways. A drawing can describe a subject's outsides—its tonal and textural surface-state—in a reportorial manner. When such observations are accurately perceived and carefully recorded, a sense of volume similar to that in a photograph of the subject can result. But emphasizing the subject's external characteristics tends to limit the impression of volume in the same way that the photograph does. In both, the results depend on, and are confined to, the nature of the light's accidental behavior as well as the subject's superficial, and occasionally volume-denying details.

Another way of presenting volume utilizes responses that convey a subject's *structure*—that is, the way it is put together. In this way, its constructional nature and the tensions and pressures contained within it, its weight—in the literal sense of the subject's lightness or heaviness, or in a complex subject the differences in weight between its component parts, and the subject's

119

design in space—the ordering of its parts into some system, flow, or continuity, can all be expressed.

The human figure, because it clearly demonstrates the concepts being discussed, is heavily relied on here. These concepts and the processes they lead to are, of course, applicable to any solid mass in space.

## THREE BASIC APPROACHES TO STRUCTURAL VOLUME

All volumes, as we saw in Chapter Two, can be translated into flat or curved planes. Some subjects—jagged rocks, tables, books, or bananas—clearly reveal their planar construction. Whether simple or complex, their surface-states are resolved into explicit planar divisions that give such subjects structural clarity. Other subjects—

bottles, apples, boulders, or animal and human forms, being less angular, show less clearly defined surface facets. The more smoothly rounded a subject's surfaces, the more arbitrarily intrusive it usually seems to translate them into planar divisions. The sphere, for example, would seem to defy planar analysis. But in drawings showing volume with emphatic clarity, evenly rounded forms are sometimes shown as less smoothly rounded by flat or curved planes that abut at subtle angles, as in Jacques de Gheyn's drawing of some Gypsies (Plate 6.1). Another approach to explaining a subject's planar structure relies less on clearly defined abutments. Instead, the planar-state of forms, especially organic and curvasive ones, is shown by sensitive-graduations of value as in Jacobo da Empoli's drawing, "Young Man Seen From the Back" (Plate 6.2). Here, the planes are drawn more realistically, their clarity conveyed by tonal, rather than

*Plate 6.1*

*Jacques de Gheyn* (1565–1629). THREE GYPSIES.
Pen and ink.
COURTESY OF THE ART INSTITUTE OF CHICAGO.
GIFT OF MRS. TIFFANY BLAKE.

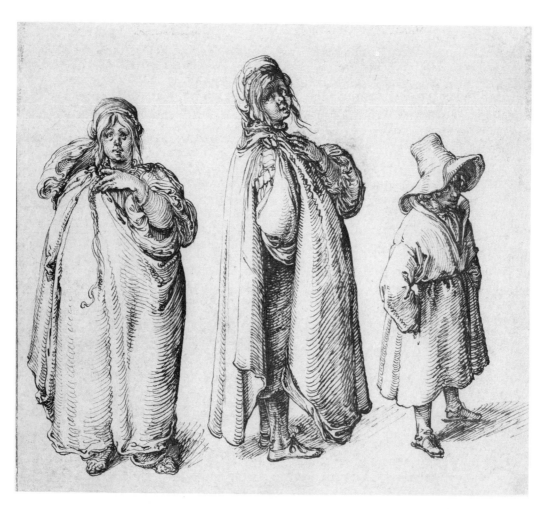

linear modelling. A third approach combines both tonal and linear drawing, as in Rembrandt's "Standing Male Nude" (Plate 6.3), and in Carpeaux's "Study for Ugolina" (Plate 6.4).

De Gheyn draws the folds of the robes as long convex or concave planes that abut with each other somewhat abruptly to suggest pronounced changes in their direction. Despite these angularities, the forms of the figures are not stiff or mechanical, but flow in a decidedly curvilinear way. The broad planes by which de Gheyn models the volumes are made entirely of structural line-groups.

In da Empoli's drawing, gradual transitions of value explain the fusing of planes to create gently undulating surfaces. But, unlike de Gheyn, who permits unexplained (but implied) planes to be represented by the white of the paper, da Empoli insists on value-variations that show every subtle change in the surface-state of the figure's upper body. However, in the man's drape, the values become less blended, more the result of massed lines. This change in tactics from the smoother values of the body to the directional line-groups of the drape reflect da Empoli's interest in conveying the differences in the visual and textural character of these forms. Although there are some structural lines in the body and some broad tones in the drape, da Empoli explains the volume of both without violating the dominant visual and textural differences of either. Although both artists primarily use an illiminating source to explain volume, neither permit any part of their subject to be lost in shadow. Even though, in da Empoli's drawing the man's back is in shadow, every part is volumetrically clear. Likewise, the planar surfaces of the center figure in de Gheyn's drawing are visible even when they are shaded by the robe and arm.

Notice how both artists create a sense of spatial depth. Da Empoli uses a series of light curved lines to imply a large "container" of space for the figure to occupy. When we look at the figure we are not immediately aware that the background is comprised of lines, but we do sense space around and behind the figure. The collective tone of these lines appears to go back in space for two reasons: first, because their alignment continues to the figure's left and right, we assume that they are the same lines, having passed behind the figure; second, because their collective tone, being darker than the figure's lightest areas of tone, seems to drop behind these lighter, advancing ones. Here, the light tones appear to advance because we tend to regard light tones

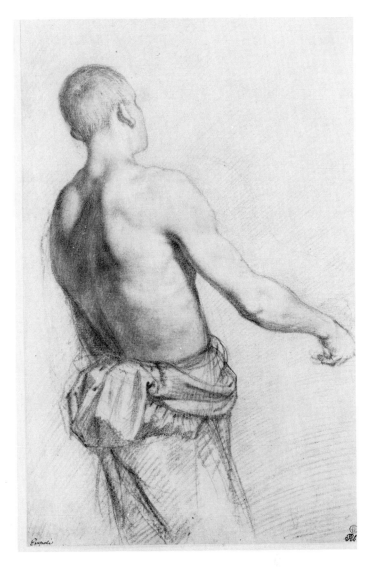

*Plate 6.2*

*Jacobo da Empoli* (1551–1640).
Young Man Seen from the Back.
Red chalk.
the pierpont morgan library.

upon a darker field to be in front of the darker field. Usually we assume forms turning away from our line of sight and planes located farther from the illuminated forms, to be darker in value.

De Gheyn's solution for establishing spatial depth for his figures is simply to draw small, vague, cast shadows near and slightly behind each figure. This suggests a ground plane that extends behind the group.

Rembrandt, as mentioned earlier, uses both line and value to explore his subject's structural character. In the broad and vigorous handling of the background, he relies mainly on line to establish the boundaries of planes, and to suggest

*Plate 6.3*

*Rembrandt van Rijn* (1606–69).
STANDING MALE FIGURE.
Pen and brown ink, wash, heightened with white.
TRUSTEES OF THE BRITISH MUSEUM, LONDON.

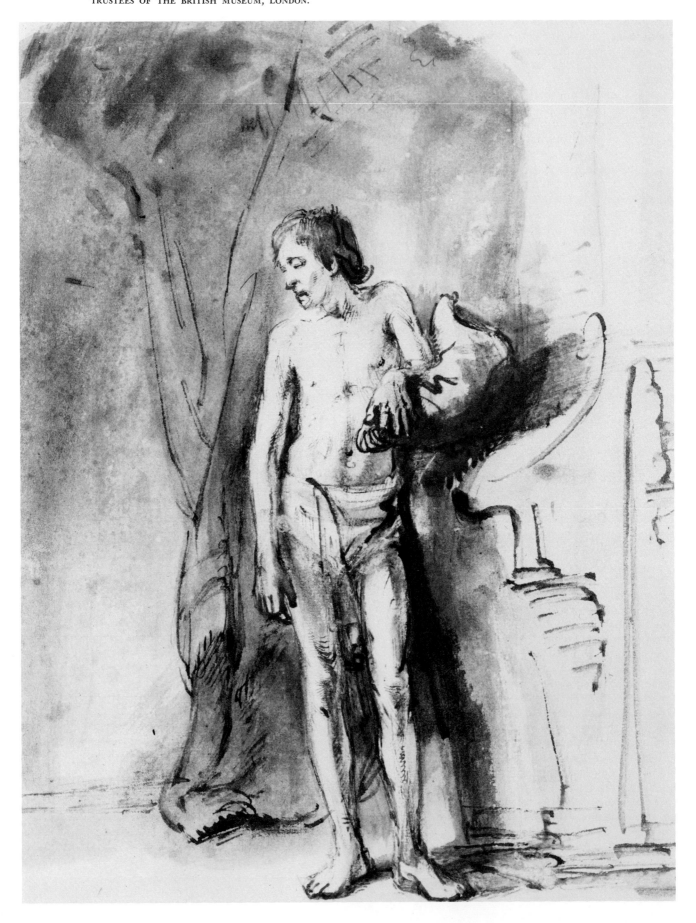

some folds in the drape behind the figure's right side. A light tone that envelopes over two-thirds of the background serves to push forms back, and creates the spatial cavity occupied by the figure. On the drawing's right side, very bold cast shadows explain the masses of the supporting pillow and the surface against which the figure stands. As the cast shadow descends, it "measures" the increasing divergence and advance of the figure's left leg from the nearby wall. In drawing the forms that make up the young man's figure, Rembrandt more evenly divides the roles of value and line to develop the volumes. Usually, short, structural line-groups define sudden changes in direction between planes, and washes of tone explain the more gradual changes. Here,

as in the de Gheyn and da Empoli drawings, illumination is used mainly to explain the figure's structural character. Notice that Rembrandt relies on broad planes that stand as summaries of several smaller ones to convey volume. For example, a single tone describes a broad plane along the side of the head that shows the change in the surface direction along the ridge of the cheekbone. To summarize the planar actualities of this part of the head, Rembrandt had to find the strongest over-all directional grouping of the observed planes. Because no other over-all changes in direction were as strongly evident as that forming the ridge of the cheek-bone, he chose this change as the demarcation "line" between those planes above and below it. Such bold, broad

*Plate 6.4*

*Jean Baptiste Carpeaux* (1827–75).
STUDY FOR UGOLINO.
Pen and gouache on brown paper.
COURTESY OF THE ART INSTITUTE OF CHICAGO.
JOSEPH AND HELEN REGENSTEIN FOUNDATION.

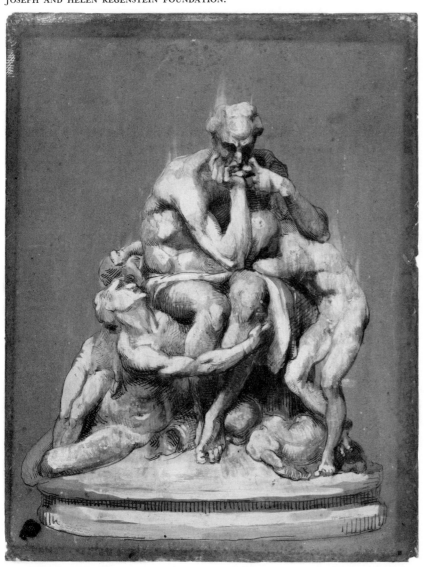

carving can give drawing a strength and clarity that is often lost in more detailed approaches.

Carpeaux's drawing, a study for a sculptural work, also combines tonal washes of grays and those formed by line-groups to explore more fully his subject's volumes. Here, there is the need to understand each part's structural character, and the over-all structural behavior of five interwoven figures in space. This makes the relatively less probing approach of de Gheyn's brief drawing, or da Empoli's somewhat naturalistic and thus not so aggressively analytical approach, unsuited to Carpeaux's purposes. These aim at understanding the major planes that form the parts of each figure: the spaces—the negative "masses"—that result from the placement of the figures; the organizational and expressive character of the group; and the way light plays across the forms from this view. The results of such analytical approaches to volume as Rembrandt and Carpeaux utilize in these two drawings enable us to see structural, spatial, and even expressive qualities that would otherwise be lost.

To disregard the interlocking, directional behavior of a subject's planes and that of the masses they form, that is, their explicit structural nature, weakens the impression of volume. Trying to produce the impression of volume by making a faithful copy of externals not only *re-presents* the subject's superficial and random properties—some of which actually limit the development of the volume—but also records the subject's structural and expressive clues and possibilities in their original state *as undeveloped potentialities*. The raw material is not interpreted and ordered but only re-presented as raw material.

As we have seen, there are many graphic concepts that create the impression of volume in space. Whether it is general information about masses in space that result from the search for gestural expression, or the more specific infor-

mation provided by the nine principles of perspective, or any of the other volume-revealing concepts already discussed, the sense of solid, structural mass results from the *choices and changes* such concepts make possible. To convey volume, it is always necessary to extract and stress the visual and expressive qualities that evoke it and subdue or omit observations that would weaken or obscure it.

In the energetic drawing by Delacroix, "Studies After Rubens' 'Crucifixion'" (Plate 6.5), there are just such extracts from some forms in the Rubens painting that interested Delacroix. We see these forms as weighty and animated because Delacroix stresses these qualities. In making this sketch, he knew what his interests and intentions were, and, consequently, so do we.

This drawing, made not from nature but from a work of art in which the volumes of the original subject have already been extracted and translated into visual terms, is, then, a kind of double extraction. Perhaps that is what makes Delacroix's brief sketch appear to seize the very essence of the structural character of these human forms. Although Delacroix is quite different from Rubens in his approach (Plates 2.7, 2.11, and 5.10), each in their own way builds powerful volumes from an excited involvement with the experiences, processes, and goals of volume-making.

## DIRECTION
## AND GEOMETRIC SUMMARY

Volume, like most other goals of drawing, is usually arrived at by working from generalities to specifics. The draughtsman, like the sculptor, generally states the broader planes of his subject before the smaller ones. Indeed, neither one can know with any certainty where smaller planes are to be located until the broad "parent" plane is

A

B

*Illustration 6.1*

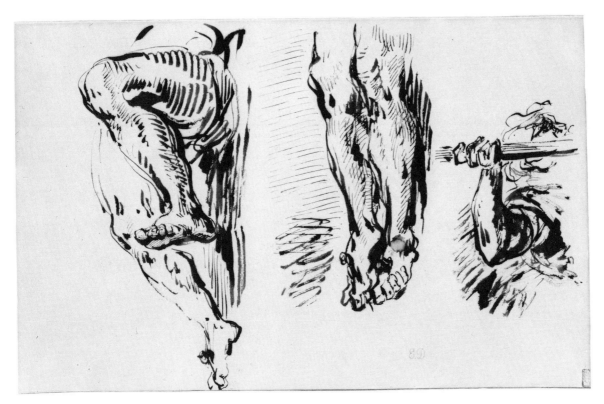

*Plate 6.5*

*Eugene Delacroix* (1798–1863).
STUDIES OF ARMS AND LEGS.
After, *The Crucifixion* by Rubens.
Pen and sepia ink on buff paper.
COURTESY OF THE ART INSTITUTE OF CHICAGO.

established, because, as we saw in Chapter Five, the smaller ones are always variations on the direction of the parent plane and depend on its position for their own. This is evident when drawing subjects that are naturally almost pure geometric volumes.

Few students are likely to be diverted from seeing the basic direction of a simple plaster wall by any minor variations in its surface-state due to aging or an uneven application of plaster. However, as such variations increase in scale and frequency, the likelihood of disregarding the wall's position in space, as well as the major planes of which it is constructed, increases (Illustration 6.1). When we consider the many volumetric complexities of a subject such as the human figure, the need to understand a part's basic direction and those of its major planes becomes apparent. In complex subjects, the superficial details of volume and texture can easily divert the unwary student from perceiving the directions of masses and major planes.

There are generally two unfortunate results when a concern for such details precedes the establishment of a subject's over-all position in space. First, because what is not perceived is only accidentally (and rarely) drawn in accordance with the subject's actualities, the probability of error in a part's direction is very high. Second, beginning with details and permitting them to determine the whole, is, as we saw in Chapter One, a sequential, additive process in which superficial details dictate the essential issues. It is the tail wagging the dog. It violates the way forms in nature are seen.

A form's volumetric character is not perceived by adding up its details. Rather, the details are seen as particular facts belonging to a volume. Usually, they are seen *after* a general perception about the form has been made. If, for example, we are asked to identify an object flashed on a screen for one-tenth of a second, we may recognize its general shape and volume, but we will not have seen its details.

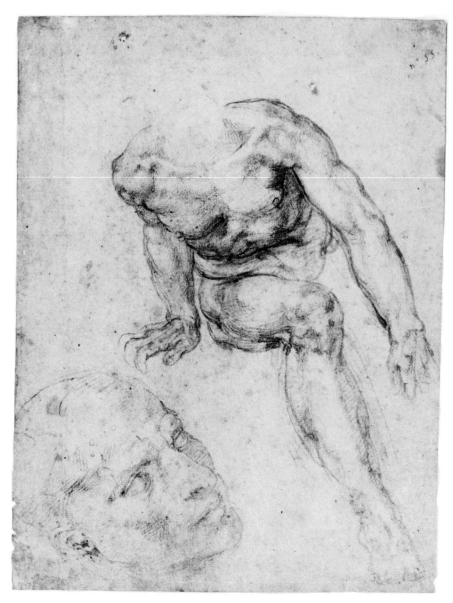

Plate 6.6

*Michelangelo Buonarroti* (1475–1564).
SEATED NUDE AND HEAD STUDY.
Black chalk.
TEYLERS MUSEUM, HAARLEM, HOLLAND.

In drawings that include a considerable amount of detailed volume, the major planes and masses must maintain dominance over smaller ones. When their influence as basic planes or masses is neutralized by minor embellishments upon them, both the structure and the unity of the forms are weakened.

The persistent influence of major planes and masses seen "through" the details is readily sensed in Michelangelo's imposing study of a figure and a head (Plate 6.6), and in an early Degas drawing of a standing figure (Plate 6.7). In these drawings, otherwise so different in mood and manner of execution, there are many similarities. But in neither do the parts, limbs, i.e., torso, etc., "add up"

to become the figure. Nor, in either drawing, do such parts result from an accumulation of details. Instead, the details are seen as subtle, flat or curved planar variations on the basic geometrical and directional behavior of these forms. They "well up" from the forms and "belong" to them. Likewise, the position in space of the figures themselves do not result from their parts having been drawn separately. Seeing the figure's over-all direction in space (note the search for the entire figure's direction in the beginning few lines of a second nude in the Degas drawing) each artist was better able to locate the direction of arms, legs, etc. to it, and relate these parts to each other. In both drawings, the parts are subordinate to

126

the whole. Each part contributes to the unity of the whole. In both, we sense the "echo" of the basic geometric volume that underlies each part of the figure. And each part is a convincing, structural volume that has weight and occupies a specific direction in space. Note that neither artist uses smudges of tone to model the forms, but establishes the sense of volume by cross-hatched line-groups. These are more involved with a tactile experiencing of the subject's terrain than with the effects of illumination. In these drawings, light's ability to reveal volume is integrated with, but subordinate to modelling based on structural clarity.

When a subject is comprised of many *independent* volumes, the danger of disregarding its over-all mass is increased. If the earlier example of a wall were made of casually heaped fieldstone instead of plaster, a greater analytical effort would be required to conceive its overall mass as reducible to a simple, geometric volume, or *volume-summary*. The more the independent volumes that form a greater one are scattered, the more difficult it is to see their collective

*Plate 6.7*

*Edgar Degas* (1834–1917). STANDING NUDE.
Pencil.
STERLING AND FRANCINE CLARK ART INSTITUTE,
WILLIAMSTOWN, MASS.

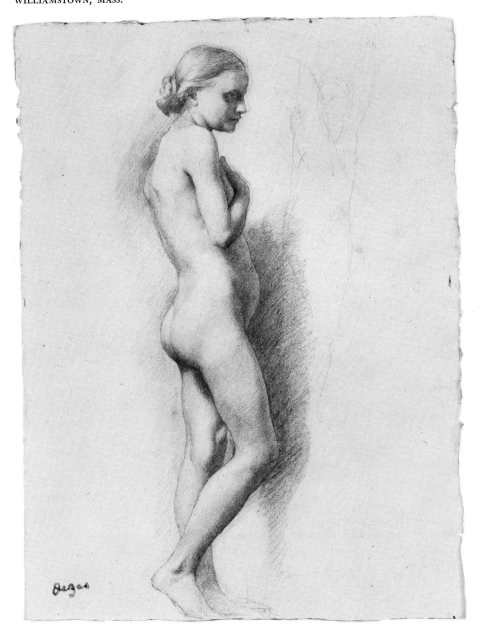

*Illustration 6.2*

volume-summary. The clarity of direction and volume-summary of the tightly constructed wall (a) in Illustration 6.2, is easier to see than in the wall formed by loosely piled stones (b).

Unlike the walls in Illustration 6.1, which are both reducible to slender, vertical slabs, inclined toward the horizon to the observer's right, only the tightly constructed wall in Illustration 6.2 approximates a similar volume-summary. Although both walls in Illustration 6.2 go in the same direction as those of Illustration 6.1, the loosely constructed wall (b) is more accurately analysed as a half-cylinder. Discerning a form's volume-summary is basic to its more specific development. Da Vinci's drawing of stratified rocks (Plate 6.8) clearly shows his grasp of the volume-summaries that unite the subject's many independent volumes. Indeed, it seems that conveying such summaries is part of this striking drawing's visual and expressive theme.

Thus, the two basic perceptions of a subject's mass in space are its overall direction and volume-summary, and those of its parts. Both require an effort to temporarily bypass lesser planes and volumes to be seen—and much of the impression of convincing volume in space depends on their being seen. Disregarding such fundamental generalities will almost certainly compromise a volume's specifics.

The more organic or convoluted a subject is, and the more independent or overlapped its parts are, the greater the need to see such generalities first. There are three basic ways of approaching these simplifications.

Some artists begin by actually drawing the subject as made up of volume-summaries, as you did in Exercise 5B. However, the severely summarized volumes used in that exercise, or as seen in the Cambioso drawing (Plate 5.9), are often felt to be too mechanical and too removed from the overall character of most subjects. Therefore, many artists who begin by showing the simplified volume-summaries of a subject arrive at summaries that are less extreme. They search for those which clarify perspective, but still retain the major, and even some of the secondary structural features, as well as something of the subject's character. Unencumbered by many small, planar surface changes, perceptions concerning scale, shape, and space can be more easily established. Making such adjustments before the volumes are developed further frequently avoids the later, more difficult changes that are so injurious to a drawing's spontaneity and strength.

Other artists, like Cezanne (Plate 6.9), start by drawing only a few, abbreviated hints about a subject's volumes in space, again simplified for the sake of clarity. This second approach is preferred by those who feel it too restricting to divide the act of drawing into separate stages, or, that it is too strong and isolated an emphasis on volume outside the context of the subject's other potentialities for compositional and expressive activity. Also, the nature of some drawing media, such as pen and ink, make any extensive underdrawing impractical.

Still other artists begin a drawing in the charged spirit of a direct attack—intending each

*Plate 6.8*

*Leonardo da Vinci* (1452–1519).
OUTCROP OF STRATIFIED ROCK.
Pen over chalk.
WINDSOR CASTLE, ROYAL COLLECTION,
COPYRIGHT RESERVED.

*Plate 6.9*

*Paul Cezanne* (1839–1906). STUDY OF A NUDE FIGURE.
Pencil and wash.
COURTESY OF THE FOGG ART MUSEUM,
HARVARD UNIVERSITY.
GIFT—MR. AND MRS. JUSTIN K. THANNHAUSER
IN MEMORY OF THEIR SON,
HEINZ H. THANNHAUSER, M. A. '41.

*Plate 6.10*

*Jean-Francois Millet* (1814–75).
YOUNG MOTHER PREPARING THE EVENING MEAL.
Pen and brown ink.
THE NATIONAL GALLERY OF CANADA, OTTAWA.

phatic planar construction of a subject. In such drawings, volume-summaries, with some few modifications, become final structural statements. Only when the structure of a form is fully comprehended, can it be reduced to those few broad planes and masses that convey the essence of a subject's volumetric character. This kind of bold modelling often suggests a carved, sculptural quality. Villon's etching is, in fact, a work based on a sculpture by his brother, Raymond Duchamp Villon. Jacques Villon's reduction of the forms is very incisive and convincing. In this etching, the chin, a block-like form jutting out at almost a right angle to the thin, clearly defined plane under the lower lip, is typical of the simple, strong carving of the rest of the head. Note how the planar clarity of the nose, ear, forehead, and cheek rule out any misreading of the volume.

This work illustrates another helpful device for conveying volumes in space: "stacking" volumes, one upon the other, to emphasize their

*Plate 6.11*

*Eugene Delacroix* (1798–1863). NUDE WOMAN.
Pen and brown ink.
STERLING AND FRANCINE CLARK ART INSTITUTE,
WILLIAMSTOWN, MASS.

line and tone as final. Although some changes and developments upon the initial drawing usually occur, the intention, at least, is to state the total interpretation of their subject in one spontaneous effort, responding to all of the visual and expressive motives and stimuli simultaneously (Plate 6.5, 6.10).

Although some artists, like da Empoli, sometimes prefer to lessen attention to a subject's analytical and schematic aspects in favor of a fuller exploration of light, local-tone, and texture, others, like Delacroix (Plate 6.11) and Jacques Villon (Plate 6.12) emphasize simplification of volume to stress a sculptural interpretation of a subject. In such drawings, volume-summaries are not only foundations for subsequent development, but are, because of their bold simplification, influences on such developments. These tend to intensify rather than weaken the em-

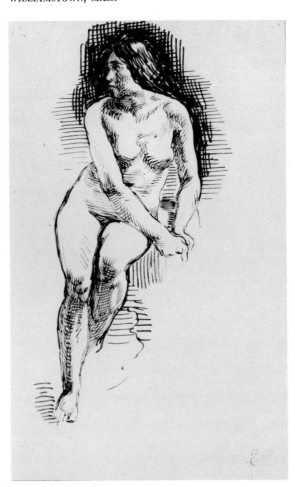

existence in space. By drawing the head set upon a pedestal, which, in turn, is placed upon a flat surface, Villon creates two simple volumes in space—the pedestal and the flat surface—that prepare us to accept the head's position in a spatial field. Thus, part of our understanding of the head as a volume existing in space is conditioned by the masses around and below it. Here, as in the da Empoli drawing, the lines of the background tone appear to pass behind the head, adding to the impression of its existence in a spatial field.

Delacroix, using more curved than flat planes, draws the figure's forms as simplified volumes that occupy precise and readable positions in space. Note the subtle difference in elevation between the left and right legs. As in the Villon etching, Delacroix explains the form's structural nature with great clarity. But his more inferential approach to volume sharply contrasts with Villon's more schematic one.

Later in this chapter we will examine the expressive aspects of volumetric drawing, but it is worth noting here that both of these works are energetic, felt responses to the forms—to the ways in which their parts join, flow, and resist each other. Both artists invest the volumes with strong, animated meaning.

A brief summary of the order in which we perceive volumes would be helpful here. A subject's overall direction, or the direction of its several components, for example, the various directions of a group of trees (Plate 6.13), and some gestural and analytical response to its overall mass or major masses, are best established before any smaller subdivisions. There are two important reasons for this.

First, any greater form, if it is to retain a sense of its basic volume-character and unity, requires its components, large and small, to be subordinate to it. Many otherwise admirable student drawings have suffered because a part "broke away" from a major form, as in a figure drawing when a muscle is shown as a self-contained unit, isolated, and as visually attracting as its parent plane. Or, when a few folds of a jacket sleeve appear more important than, and compete with, the arm inside.

Second, locating the direction of the greater volume guides us in locating all smaller ones. If the subject is, for example, a hand, its mitten-like mass should be known before the structural nature of its major subdivisions is considered. Seeing these should, in turn, precede the drawing of specifics—fingernails and skin-folds (Illustration 6.3). To reverse the visual order of showing smaller parts as belonging to larger ones isolates the specifics as ends in themselves, obscures the character of the greater volume, and destroys the unity of the drawing.

## THE JOINING OF PLANES AND VOLUMES

Any ambiguity of the direction of planes, or in their manner of uniting to form volumes, creates ruptures in the continuity of the structural and spatial clarity of volumetric drawings. Although some structurally unexplained passages are often found in drawings by the masters (Plates 6.1, 6.6, 6.10), they are never the results of indecision or

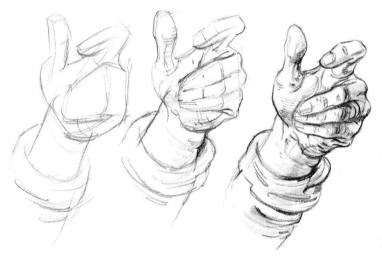

*Illustration 6.3*

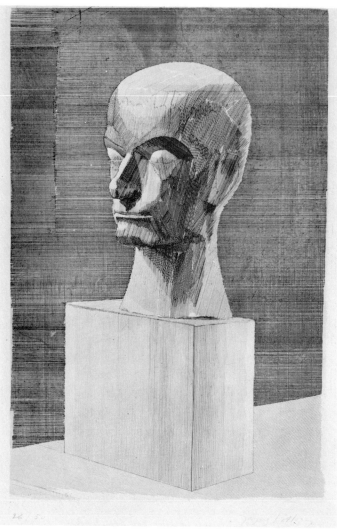

*Plate 6.12*

*Jacques Villon* (1875–1963). PORTRAIT OF BAUDELAIRE. Etching.

COLLECTION, THE MUSEUM OF MODERN ART, NEW YORK. GIFT OF VICTOR S. RIESENFELD.

innocence. Sometimes such drawings are preparatory studies for works in other media, and the artist develops only those areas of a subject he wishes to study more fully. Often, undeveloped passages serve compositional or expressive interests. The relative directness of drawing compared to painting and sculpture, and the relative simplicity of means, makes it far more suited to spontaneous, bold, and brief explorations or graphic declarations. The results of such investigatory drawings are sometimes more intimate and revealing of an artist's perceptions, feelings, and intent, than those of his more formal works. Also, they are often refreshingly free of the dead-

ening effects of a completeness that conveys the "polished" at the expense of the spontaneous.

In master drawings that stress volume in space, undeveloped areas often serve as passive foils for other areas that stand out as "crescendos" of volumetric emphasis. In this way, the weight and sculptural strength of stressed areas take on greater visual and expressive meaning. In such master drawings, unexplained passages, when consciously left, are intended; when subconsciously left, are necessary. But they are never perceptual failings or oversights.

Nor are such unexplained areas *wholly* without some volume clues. In Plate 6.10, Millet provides strong hints about the surface-state of the woman's arms, back, and skirt by the shapes of the planes and the nature of the contours surrounding the "empty" passages in these places. In Delacroix's drawing (Plate 6.11), the difference in direction between the figure's right thigh and hip is clear, though no line or tone marks the end of one part and the beginning of the other. The change in direction is suggested, as in the Millet drawing, by the structural lines explaining the tilt and shape of the nearby planes. Some of the appeal of these two drawings comes from our realization that so much is being conveyed by so little. Both are good examples of how much economy is possible in structural drawing.

But for the student, the sculptural attitude toward forms should be tested through the experience of working from the broader planes and masses that summarize a subject's essential structural character, to those smaller planar features that clarify specific characteristics of its parts. In doing so, care must be taken to select only those small planar surface-changes that are most informing of a subject's smaller volume characteristics. Here, as in drawing broad planes forming large masses, small ones are also clarified by seeing their direction, summarizing the volume, and explaining the way they join.

The scale of a part or plane, then, should not affect the way it is developed. The planes of a pebble, blossom, or eyelid are as deserving of structural analysis as those of a mountain, tree, or man.

It is helpful to think of every union of planes or volumes, large or small, as interlocking, clasping, impacting, or fusing. The clarity and conviction with which such uinons are drawn requires more than sensitive perceptual skill. It demands *felt* responses to the ways they join. Although the drawings reproduced in this chapter are highly individual in temperament, approach, intent, and order, in other words, in their point

of view—their *style*—they all reveal the artist's feelings about the nature of the unions between planes and between masses. Although perceiving the directions and summaries of planes and masses is necessary to the *clarity* of their interplay, the response to, and the intensification of, their suggestions of movement and energy invests a drawing with the emotive *character* of their interplay.

Therefore, the artist intending structural mass cannot regard such joinings as only a matter of perspective, shape, or any other measurable perception. He must feel their potential for meaning—must be able to *empathize* with the inferred character of the unions. That is, he must interpret their suggestions of action and energy according to his perceptual comprehension *and* his ability to feel their behavior—his empathic temperament.

The gestural characteristics of such unions are limitless. They may infer slow, subtle, movement, as in the way the column of the young man's neck in da Empoli's drawing (Plate 6.2) seems to lift gracefully from deep between the

shoulder masses that appear to part and allow its rise. Or they may be fast and active, as in the interlaced race of folds around the young man's waist. They may be given to variously gradual fusions, as in Degas' figure drawing (Plate 6.7), or to sudden, crisp, abutments of planes and wedge-like interlockings, as in Carpeaux's drawing (Plate 6.4), and Villon's etching (Plate 6.12). They may be frenzied couplings, as in Delacroix's drawing (Plate 6.5), or rhythmic, as in da Vinci's (Plate 6.8). Their nature may often elude any verbal description.

Here, another aspect of expressive response should be considered. As demonstrated in any of the previous plates in this chapter, in others throughout the book, and especially well in the drawings of Michelangelo (Plate 6.6) and Delacroix (Plate 6.5), some subjects are constructed of parts which support, and others of parts that are supported. These actions cause tensions and pressures between the parts of such subjects. Some of these forces are actual, some are inferred. When a subject's forms are supported by, suspended from, and attached to an inner skeletal

*Plate 6.13*

*Titian* (1477?–1576). STUDY OF TREES.
Pen and bistre.
THE METROPOLITAN MUSEUM OF ART.
ROGERS FUND, 1908.

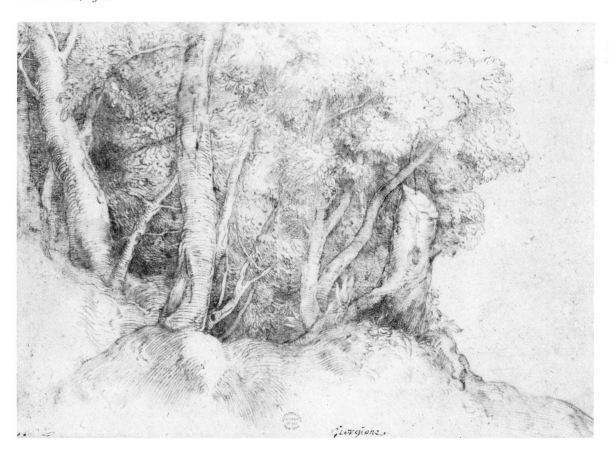

framework such as a human (or other) skeleton, or when naturally limp materials like cloth or leather are supported by solid masses beneath them, there is real tension and pressure between the visibly "held" and the inner "holder." In such constructions, the supporting structure, whether skeletal or solid, is sometimes stable, as when a cube supports a cloth draped over it. Removing the cloth does not affect the cube's behavior. Other constructions depend on mutual support. Two poles holding up a pup tent are themselves held in place by the balanced weight and tensions of its canvas cover, stretched taut when short stakes are driven into the ground at each of its four corners. Removing any of these stakes affects the balance of forces and collapses the tent's shape. Both the cloth-covered cube and the tent's framework prevent the collapse of the covering material. But in the case of the tent, the elastic nature of the covering material and the balanced tensions upon it, help to contain and support the framework (Illustration 6.4); they hold each other up.

In such subjects, the forces of weight and tension—the burdens of support and containment—create folds, bulges, and sags that reveal the strain, resistance, and pressure between the holder and the held. To infuse a drawing with the power to convey the *feel* as well as the *look* of such force and counter-force, the artist must empathize with the struggle between the inner and outer parts of his subject, and feel their weight. The force of gravity is an important participant in the struggle between the parts. Supporting frameworks, in addition to creating tensions and pressures between themselves and the material they support, also resist the force of gravity

pulling at themselves and the supported material. The sagging and taut folds, the bulges and hollows of inner supported subjects, and the folds and bulges resulting from parts pressed against each other express the struggle between the holder and the held, and between both of these and gravitational pull.

The pressure upon the right shoulder of the figure in Michelangelo's drawing, the straining of the bones and muscles of the shoulder and chest against the thin container of skin, the pressure of the heavy upper body upon the figure's midsection—these are more than visual observations. They are deeply felt responses to the actualities of the figure's structural character—intensified to convey the artist's feelings about the powerful struggle of physical forces within and upon the figure. Likewise, in Delacroix's drawing, bone, muscle, and skin all strain, press, and resist each other to achieve a balance of forces. The knee-bone of the figure's raised left leg, at the far left of the drawing, is barely constrained by the taut skin covering it. The lower leg drives up hard against the upper, which swells with bulging muscles that infer the pressure upon it. At the far right of the drawing, the bone at the elbow shows the strain of the arm's burden—of its being forced down while it strains to support its load. These actions appear highly charged because Delacroix felt their force, and intensified it.

These empathic responses to the ways in which planes and masses join, and to those generated by a subject's inner and outer structure and weight, endow a drawing with a "life" that is the graphic equivalent to those qualities seen and felt in the subject. But such responses are not

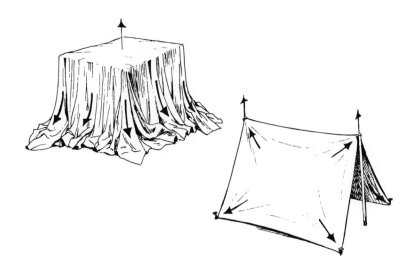

*Illustration 6.4*

restricted to organic forms only. Rock and ice formations, bridges, furniture, utensils, tools of various kinds, and numerous other inorganic subjects often suggest some or all of these energies to some degree. Although some of these subjects have inner supports and others do not, the character of their masses can suggest the kinds of union, tension, resistance, and pressure conveyed by living things, as in the rocks and clouds in Plate 6.8, or in the chair and plant holder in Plate 6.14.

Whether the subject is the human figure or some rock slabs, and whether the energies are actual or inferred, the artist must feel the force of their structural activities as "meant," or necessary—as obligatory actions inherent in the subject. To the extent that we can empathize with these actions, our expressive involvement deepens, urging more incisive and direct drawing activity. Again, responses limited to the measurable actualities of shape, direction, scale, etc., record a subject's physical facts, but a sensitivity to the forces of union, support, containment and gravity that issue from, or affect it convey the pulsating energies of its structural character.

Pontormo's drawing, "Striding Nude" (Plate

6.15), suggests the energies that drive planes and volumes into strong unions, and also those issuing from pressures and stresses between the holder and the held. Note how the volumes around the shoulders, knees, and ankles insert and clasp each other with hard intent. The planes abut with vigorous certainty. These not only produce, they enact the forceful energy of the interlockings of the volumes they form. The skeletal framework emerges from deep within the forms to press against the containing surfaces at the ankles,

*Plate 6.15*

*Jacopo Pontormo* (1494–1556). STRIDING NUDE.
Red and black chalk, heightened with white chalk.
THE PIERPONT MORGAN LIBRARY.

knees, elbows, and at several places on the torso, creating firm anchors against which the muscles strain. The entire figure seems to vibrate with the activity of volumes pressing, straining, and resisting.

Pontormo's interest in such forces is apparent in the way he suggests gestural "ripples" of action that course through the figure, and lesser ones that move between the parts. These suggestions are further strengthened by showing some volumes as elongated—as if they are being stretched between fixed points. These attenuations serve to exaggerate the graceful flow of their form. This results in many of the figure's volumes enacting a rhythmic pattern of growth and diminution of mass. Just as small volumes rise from, swell, and subside back into major ones, so major volumes, like the torso, right arm, and right leg, are seen as increasing and diminishing in bulk. In the right leg, for example, the volume begins at the ankle, swells at the calf, and, beginning to subside, is overtaken by the clasping tendons of the upper leg. These, in turn, expand, interlace with other volumes, and merge with them to form one swelling, tubular volume which suddenly erupts into a still greater volume by the addition of the buttock, part of the pelvic area, and some muscles of the lower torso. We see the right leg and hip as one volume that seems to spring up from the ankle with some velocity, swelling, subsiding, and finally implanting itself deep within the torso. Its last identifiable ripples reach as far as the figure's rib cage.

## THE DESIGN
## OF VOLUMES IN SPACE

Pontormo's interest in structural energy does more than make good use of a subject's clues for its gesturally expressive potentialities. By intensifying them, he clarifies another important category of response to observed volumes: the sense of volumes as related by a comprehensible order or plan—a system of abstract and structural affinities. Chapter Eight will further explore the design of volumes, but here it is necessary to grasp something of the basic nature of the order between volumes, and of its role in responsive drawing. There are a number of factors that can help form this sense of order between separate volumes or between the parts of a complex one such as the figure.

Similarities and contrasts of scale, direction, shape, texture, value, and manner of union, as

well as the physical proximity of parts, can all contribute to our comprehension of volumes as belonging to some system of order. The location of masses in a spatial field—their manner of distribution—and the various ways they overlap and join, provides some strong relationships in the design of volumes. Thus, when Pontormo stresses structural energies coursing through the figure, he also contributes to the sense of its abstract plastic energies. This is so because sensitivity to a subject's structural character includes seeing similarities and contrast of scale, direction, and shape. The rhythms and affinities these similarities create help convey the subject's volume-design. To the extent that the artist desires to strengthen the sense of volumes as unified by an overall system of relationships and movements, he will stress the visual similarities between the parts of his subject—the "alikeness" between unlike things—and their collective gestural actions. Conversely, sensitivity to a subject's volume-design helps discover structural facts. Did Pontormo first see the design or the structural aspects of the right leg—or both simultaneously? It is impossible to say. What is evident in his drawing, however, is his interest in both. These two considerations, the mechanics and dynamics of a subject's volumetric structure, and the design of such structures, are interlaced considerations. Both are necessary in apprehending the potentialities for expressive order in nature.

Degas, in his drawing "After The Bath" (Plate 6.16), shows a strong interest in the design of volumes. Although the model's forms must have described something like the action of the drawing's forms, it is evident that Degas extracted and strengthened the continuity of their flow. They rise from the bottom of the page as three simple shapes that become three volumes which collectively suggest a greater columnar volume, inclined to the left. The movement they generate is continued and intensified by the forms of the upper body. These unite to perform a sweeping movement to the right. Their energy seems to have some "escape" in the hair that ripples down in a way that answers the rising of the lower limbs and the towel.

Degas' responses to his subject's volumes, united in a curving motion, is conveyed by virtually every available means. He accents the similarity between the shape and scale of the figure's left leg and the two parts of the nearby towel. Note that the lighter of the two shapes of the towel strongly resembles the left leg upside-down, while the other shape imitates the movement and direction of the leg and **the** contour of its right

side. Degas' use of structural line-groups made of thick, bold, charcoal strokes, introduces a texture that unites volumes throughout the drawing. He holds his darkest values in reserve while the curving action mounts, and commits them in the curve's "crescendo" in the head and hair—the two forms that appear to descend, and are in contrast with the rising of the others. Thus, values also help explain the plastic action of the whole figure. Degas' stressing of the back's twin halves, and his treatment of all the volumes as somewhat tubular, help to unite the figure and to increase the force of its gesture. Note how emphatically he overlaps the lower part of the head with the right shoulder, and how powerfully the right hand is forced into the towel.

Although Pontormo's drawing seems to emphasize the structure of volumes, and Degas's drawing accents their designed flow, both

*Plate 6.16*

*Edgar Degas* (1834–1917). AFTER THE BATH. Charcoal.
STERLING AND FRANCINE CLARK ART INSTITUTE, WILLIAMSTOWN, MASS.

artists respond to both considerations. When studying the drawings reproduced in this chapter, notice that each conveys both structural and plastic energies. Without the energies of structural volume, forms are dead bulk; without the energies of design, they are discomposed as well.

In the following exercise, a series of drawings will stress the material discussed in this chapter. As you first look at your subject, most of its perspective, its planes, its system of support, the forces that drive them, and the subject's overall design potentialities may not be readily apparent. Their presence is discovered by only perceptions that trigger both analysis and empathy.

### EXERCISE | 6A

There are six drawings in this exercise. For each one, use an easily erasable medium such as vine charcoal sticks or a 5B graphite pencil, on any suitable surface. These drawings may be any size but avoid tiny ones, as they tend toward a timid fussiness. Here, your attention should focus on the structural facts and forces of your subject, and on the design of its parts. In fact, your in-

volvement in analysis and empathy should be so exclusive that the resulting drawings will be something of a surprising byproduct of your experience in responding to the constructional, gestural, and design aspects of observed volumes. The real value of these drawings is more in the quality of the realizations and insights they provide than in their successful accomplishment. In responsive drawing, as in the development of any other ability, concept and experience precede successful usage.

***Drawing. 1.*** Collect seven or eight small objects of a simple volumetric nature. Books, boxes, cups, bowls, or any other objects that are basically box-like, cylindrical, etc., are usable, but these need not be severely geometrical forms. Fruits, vegetables, shoes, even rocks, will do. Cover some of these with a thin fabric such as cotton or jersey. Some of the objects may be partially uncovered. Place the remaining objects upon the fabric, amongst the fully or partially hidden objects beneath it. Arrange all the objects in ways that reveal something of the forms of the hidden ones and that create strong protrusions, hollows, sagging and taut folds, and overlaps. The ten-

*Illustration 6.5*

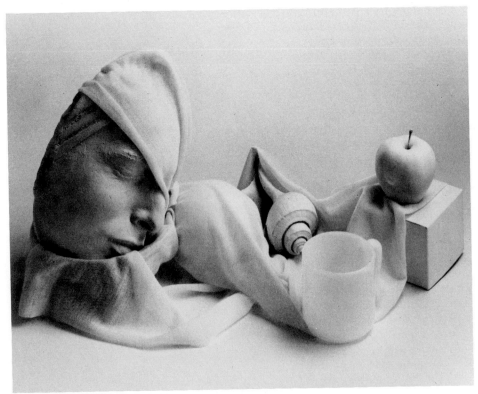

sions and pressures produced will be roughly similar to those on the surfaces of subjects formed around skeletal frames. The over-all arrangement should not be an extended, rambling one, but somewhat compacted in character (Illustration 6.5).

This is a twenty-five minute drawing. In the first five minutes draw in an analytical, investigatory way. That is, broaden your gestural approach to include a greater than usual emphasis on the search for the subject's main directions, scale relationships, and volume summaries. To do this, you must disregard all surface details, *including minor planar changes.* Avoid making this a contour drawing. Here, you will use only some of the actual contours—those which happen to fall on a line that describes the limits of a generalized volume. Even then, draw such edges in a simplified way. This five-minute phase has the general character and goal of gesture drawing, but it attempts to analyze, in broad terms, the subject's major structural actualities. It is somewhat similar in concept to that of Exercise 5B in the previous chapter. Then, the need to clarify and stress foreshortening, overlap, convergence, etc., led us to draw the simplest available geo-

metric volume a part could be reduced to without losing its basic volume character. Thus, a head became a block *or* cylinder, because a case could be made for either as an acceptable geometric core. Here, such extreme generality is not desirable. Although the clarity of the subject's foreshortenings, overlaps, etc., is just as important in this drawing as it was in Exercise 5B, clarity in these matters should not be gained at the expense of the general structural character of the subject's parts. Grasping the essentials of the subject's structure in the first five minutes is important to the development of the volumes in the remaining twenty minutes.

Illustration 6.6 suggests a degree of summary and stress of direction that the arrangement in Illustration 6.5 could be reduced to. Note the use of structural line-groups to suggest some major planes, and the searching, diagrammatic lines feeling out both solid mass and spatial areas. Note, too, the emphasis on pressures, tensions, weight, and design.

Illustration 6.6 should not influence you to emulate its particular characteristics—its handwriting. It is not intended in a how-to-do-it sense, but to show a serviceable degree of development

*Illustration 6.6*

of the subject's forms in the five-minute phase. It *is* intended to suggest a degree of emphasis on direction, volume summary, and the energies of structural and plastic forces, specific enough to establish these important aspects of the subject's major masses, and general enough to be free of lesser—and for the moment—complicating ones. To summarize in a more sweeping way produces generalities too removed from measurable actualities and restricts responses to the structural and plastic energies. To draw the arrangement in a much less generalized way than that suggested in Illustration 6.6 risks missing some important fundamental perceptions about direction and general mass, as well as relationships of scale and location, and the energies that flow between the parts. Drawings that do not grasp the subject's total disposition of volumes in space cannot —except by chance—become totally organized.

In this five-minute phase, your goal is to extract from the arrangement the simplified nature of its various volumes and their relationship to each other in space, and to convey the expressive and visual forces that move among them. Your attention, then, should focus as much on seeing and feeling the relationships between the parts as on analyzing them separately. Look for independent parts that may share a common direction or scale by comparing such angles and sizes with those of parts placed far from, as well as near to each other. Locate and stress the strongest pressures and tensions, and establish the subject's overall design theme—the related order of its parts.

This phase of the drawing is limited to five minutes for the same reason that the gestural drawings in Chapter One were held to even briefer limits. It encourages a search for essentials before particulars.

In the second part of this drawing, the emphasis should shift to an analysis of the shape, scale, angle, and location of the smaller planes— those which explain the various surface irregularities of the subject's components and any substantial volume-variations formed by their unions. Even here, however, you should distinguish between those smaller, or *secondary planes* that advance your explanation of a part's structure, and those which, because of their tiny scale or "busy" nature—such as the hundreds of small planes in an extremely wrinkled cloth—merely crowd the drawing with unimportant details. Even when an object's surface is made of such tiny planar-variations, most artist's state only a few here and there to imply their presence throughout the object. Drawing them all often weakens a form's structural clarity, which is con-

veyed by the primary and secondary planes, not the multitude of tiny ones. The remaining twenty minutes should provide enough time to develop those secondary planes that help explain the subject's sculptural character, and should prevent the tendency toward an involvement with details.

Beginning anywhere on the drawing, compare any generalized volume with its original in the arrangement. If the generalized volume represents a rather geometrically simple object, such as a book or a cup, you may find little to add to your initial observations. Instead, you may want to adjust its direction, scale, and the expressive nature of its planar joinings, and develop its contours. If it represents a complex and irregular object, such as a pillow (Illustration 6.7A), it will require the addition of its secondary planes to convey its unique structural and expressive character (Illustration 6.7B).

*Illustration 6.7*

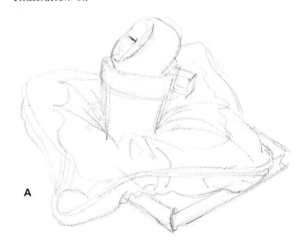

A

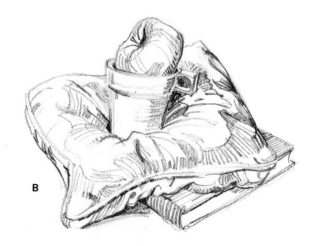

B

In the case of a volume formed around and enclosing a space, as, for example, a cup, consider this isolated space as a "negative" volume. Thus, instead of its resulting from observation of the cup's solid parts, the space itself is observed as one more measurable component of the cup. Seen directly, its direction, scale, and shape requirements may warrant changes in your drawing of the cup's solid parts.

Now you are clarifying the subject's physical facts, expressive energies, and overall system of order. Try to keep a balanced attitude to all three considerations. Becoming too intellectually engrossed in the technicalities of a complex union of planes may result in correct but cold passages in the drawing. Conversely, over-reacting to the gestural character of such a union, to the pressures and strains between the parts, may produce frenzied ambiguities. Considering both the visual and expressive behavior of a particular union to the exclusion of its role in the design of the drawing's volumes may break the continuity of the design.

Here, we should consider a common error in placement. Sometimes, two adjacent objects are drawn so close that an overhead view would reveal them to be interpenetrated. Be sure that you allow enough room for the bodies of closely placed objects. Although your drawing of any volume stops at its physical boundaries, your ability to "believe" in the existence of its unseen back must be strong enough to prevent the invasion of one solid by another.

As you draw, try to feel the heaviness of the objects and the "determined" resistance of the fabric-supporting solids. Think of the fabric as sopping wet to help you respond to its inability in resisting the tug of gravity. This will also help you explain the volume of the objects covered by the fabric.

As the drawing nears completion, refer to the principles of perspective to prove or help clarify any part of the drawing that seems troublesome. Although perspective principles cannot displace perception, it is, as we saw in Chapter Five, a helpful support for it. In fact, its influence has been present throughout the drawing. Now, a brief examination of relative scale, convergence, and other considerations of perspective dealt with in Chapter Five can help you adjust some faulty or confusing passages.

*Drawing 2.* You have thirty-five minutes for the second drawing. This time, select three or four of the objects used in the first drawing and place them inside a cloth container, such as a laundry bag or pillowcase. Tie the container at

the top with a rope long enough to tie onto some overhead support such as a beam, pipe, or rafter, enabling the container to hang free. As you draw, notice the folds caused by the weight of the container pulling against its restraining rope. At the top of the container, they will be extremely pronounced. Lower down, the objects inside it will press against the fabric, revealing parts of their form. Try to stress this struggle between the container and its restrainer, and between the container and the objects inside.

Again, begin the drawing with a five-minute analytical-gestural search for direction, scale, location, etc. Again, the reduction of the subject's forms, although less severe than those in Exercise 5B, should be summarized enough to enable you to see its basic volume character.

In the remaining thirty minutes, spread your attention over the entire subject, advancing it together. Here, be especially insistent on showing the pressures and tensions between the parts of the subject. Do not hesitate to make moderate adjustments to help intensify these forces—to exaggerate the weight of the objects and the pliancy of the container.

Here, too, search for the abstract energies—the rhythms and movements—that organize the subject into a related system of volumes, each of which participates in the structural *and* design action.

*Drawing 3.* This, too, is a thirty-five minute drawing. This time, the human figure, preferably nude, should be used as your subject. If a draped figure is used, the attire should be simple and should not cause complex folds or billowing shapes. Again, begin with a five-minute analytical-gestural drawing. The forms should be simplified enough to help you see the foreshortening of forms with some ease.

In the first drawing of this exercise, the independent nature of the objects helped you to understand their volumes better. Then, the objects were rather simple in their construction, and establishing their generalized volume-state was correspondingly simple. Now, the subject is composed of complex organic forms, rooted in the central form of the torso—a single, extended system of inner-supported masses. Pose the model to avoid complex overlapping of the limbs. This helps maintain your awareness of its continuity— its oneness. Therefore, a simple standing or reclining pose is most suitable here.

In less compacted poses the forms are seen as flowing into one another. For example, there is no one place on a leg where we can see the ankle as ending and the lower-leg beginning with

sausage-link clarity. Instead, there is an inter-laced, almost braided system of bone, tendon, and muscle that forms transitional, planar passages. Sometimes these planes are subtle and fluid (Plate 6.7); sometimes they erupt from the surface forming clearly carved volume-variations (Plate 6.6). Often, these transitional, planar "avenues" can be traced for long distances above and below a joining of parts, thus adding to the flow of the forms. As your drawing continues beyond the five-minute phase, try to see the several planes, and the volumes they form, that explain these transitions. Their visibility is partly due to the yielding, pliant character of the skin, which, like fabric, will collapse unless supported by a frame-work. As the supporting and supported inner system of bone, tendon, muscle, and fatty tissue interact, their forms, pressed against the elastic skin, like the objects in the suspended container, reveal planar transitions, support-function, and some of their volume by the amount of stress or pressure they exert on the figure's surfaces. In the remaining thirty minutes, try to see and feel the subject's structural behavior as having its

origins deep inside, the result of forms and forces that press against the interior walls of its surfaces.

As before, first establish the secondary planes and then consider the smaller ones. Use only those smaller planes necessary to explain the basic volumetric character of the major forms. This usually reveals how much the impression of three-dimensional mass is carried by the primary and secondary planes. Often, very few smaller planes are required, or, as in the Dela-croix drawing "Nude Woman" (Plate 6.11), de-sired. Looking at this drawing we know that the artist has omitted many of the planes of the female figure, but nowhere are we left with blank, flat areas. Nor are there areas where many small planes indicate the many minor surface changes. Here, the volumes owe much of their sculptural solidity to Delacroix's emphasis upon those larger planes that denote important changes in the direction of a volume's surface. This bold, selective, carving of large forms by large planes— this economy of the means—itself gives the vol-ume power and impact. It *is* impressive when so little can express so much. This is not to suggest

*Plate 6.17*

*Bartolomeo Passarotti* (1529–92). STUDIES OF AN ARM. Chalk.
COURTESY, MUSEUM OF FINE ARTS, BOSTON.
GIFT. HENRY P. ROSSITER.

Plate 6.18

*Follower of Leonardo da Vinci.* HEAD OF A WOMAN.
Metalpoint on greenish prepared paper.
STERLING AND FRANCINE CLARK ART INSTITUTE,
WILLIAMSTOWN, MASS.

that your drawing should stop at this degree of volume-revealing information. Delacroix did because he felt this drawing was unified and expressive of his interests at its present stage. His goals were realized. What *is* suggested by the example of this drawing is the inadvisability of stopping short of this degree of volume-building, to build such volumes by their larger planes, and to avoid the enticements of tiny details as ends in themselves.

*Drawing 4.* This drawing will take one hour. Use only a segment of the figure for your subject. It can be an arm, leg, torso, or head, from any interesting and challenging view of the form (Plates 6.17, 6.18). Draw large—a little over actual size. Again, begin with an analytical-gestural search for the volume fundamentals described earlier. This time, however, take as much time

as you need to establish these broad generalities. Now, you have about twice as much time as you had for the previous drawing in which to draw considerably less of the figure. This will permit you to include many of the smaller planar changes that would ordinarily be omitted in drawings limited to less time, or in drawings of the entire figure. In closing in on a part of the former whole, you will find that what are small planes in drawings of the segment as part of the entire figure, here are elevated to the status of primary and secondary planes. As in the previous drawings, these should, of course, be developed first.

The longer drawing time allows you to make a more probing study of quite small structural details. As you begin to include these, be sure to keep them subordinate to the larger planes and masses. You may want to explain all the small

volumetric activity, as in Plate 6.17, or show it as all but absorbed by the major mass, as in Plate 6.18. Whichever way you develop the drawing, remember to search for the structural volume by working from the general to the specific, and to show the unity of a major mass regardless of the amount of planar change in its terrain. Here, as in the previous three drawings, look for the pressures and tensions between the holder and the held, for the way in which parts join, and for the design of the segment of the figure. Avoid involvements with the impression of illumination where it does not help explain volume, and use direction-informing line-groups to show the various tilts of the planes, as in Plate 6.17. Notice that the line-groups in Plate 6.18 all go in the same direction. Here, surface changes are conveyed by the variations in their density and in their value. Although such variations do explain the subject's terrain, changing the direction of lines to correspond to the direction of the planes they describe is an important aid in explaining the subject's surface-state.

Your goal here is to develop a drawing so structurally clear and convincing that a sculptor could use it as a guide for a free-standing sculptural work and never be confused in understanding the general structural volume or the various planar changes on its surfaces.

**Drawing 5.** This drawing is limited to fifteen minutes. Pose the model in some rhythmic, "animated" position. There is no specific time-limit for establishing the broad volume generalities. You may, if you choose, "attack" directly, intending each mark as part of your final statement. In this case, begin in a gestural way, as described in Chapter One. Whether or not you employ an underdrawing stage, continue to stress the major planes and masses first.

In the previous four drawings, the analytical-gestural phase permitted you to concentrate on the broad, visual, and expressive characteristics of your subject in the knowledge that these early explorations were tentative—that they would largely be absorbed and altered by the drawing's later development. Now, should you choose to work directly, every mark must respond to the subject with feeling and decisiveness. Instead of emphasizing analysis first and "conclusions" later, in direct drawing these considerations are parts of the same action.

You may find that the reduced time demands a more energetic and broader approach to your

subject. This can assist, rather than restrict, your grasp of the essentials of the figure's forms. Degas' drawing (Plate 6.16) shows the kind of energy and excitement such a spontaneous and forceful approach can convey. This is knowledgeable simplicity, not empty flourish. The drawing's designed flow, discussed earlier, gets some of its force and clarity from Degas' bold, direct attack.

Your drawing, too, should aim for volume in simple, broad terms. And it should convey the expressive and plastic energies that make it more than just bulk.

**Drawing 6.** This drawing allows you a great deal of free choice. *You* will set the time-limit, determine how much time, if any, to use for a preparatory stage, and select the subject. Although the figure is an excellent subject for this largely self-directed drawing, you may want to apply the concepts and processses you have been practicing in this exercise to a landscape, animal form, interior, etc.

Here, you will even decide whether constructing volume is to be a dominant or supporting theme of the drawing. Your goal is to regard what you now know about volume-building as one more tool, albeit an important one, of responsive drawing, and use it as your interests require. Whether it will be central to your interests or subdued by other interests, should now depend on your visual and expressive responses to the nature of your subject—let the subject suggest the means.

We have seen that creating the impression of convincing structural volume is both a demanding perceptual challenge and an emotional experience. It calls for an understanding of gesture, line, shape, value, perspective, and the ability to feel a subject's structural and plastic energies. It is the quality of the negotiations among these concepts and processes that determines the degree and quality of convincing volume. By knowing what is involved in creating the impression of convincing volume, we also know what is involved in subduing it. In this way, our control of the images we make is expanded.

The necessity for, and logic of, the concepts and processes discussed in this chapter, become more evident the more you confront the challenges of volume. Not because they convince as a *system*, but as an *approach*. These concepts and processes require and deserve your commitment, patience, and tireless efforts to see, feel, and know volume.

# 7

# Media
# and
# Materials

## A DEFINITION

For the responsive artist, the substances that produce the lines and tones of drawing, the *media,* and the papers and boards that receive them, the *surfaces* or *supports,* simultaneoulsy carry and influence his responses and thus are important in the forming of his works.

The beginning student may be amazed at the number of kinds of drawing media available at the larger art stores. Much of the apparent variety is often the same media, stocked in several brands. Fifteen or more different India-inks may be displayed, representing no more than three or four distinctly different kinds, by as many manufacturers. Also, there are the various specialized media and materials for the advertising artist. Although some of these can be used for any kind of drawing, the student can disregard the more exotic media and paraphernalia of the commercial artist.

But this still leaves a wide variety of drawing media. The student need not immediately experiment with many. Nor, considering the virtually endless combinations of media possible, with differing behavior on different supports, is it possible to explore the entire range of available drawing supplies. For the first several months, the beginning student should work with no more than three or four media. Between an

indifference to media and a compulsive search for "the right one," the student's own needs and curiosity are his best guide in the investigation of additional media as his studies progress.

Some order can be made of the varieties of drawing media by recognizing that all media are applied to a surface either by adhesion or intromission. The adhesive media are the dry, or *abrasive media*—applied by rubbing off particles onto the grain, or *tooth* of the surface. The intromissive media are the wet, or *absorbent media.* Here, pigment particles are suspended in a holding agent, or *binder,* and water. Applied in this liquid state, the pigment, binder, and water are absorbed in quantities that depend on the nature of the support. The water evaporates, but the binder dries within and upon the fibers of the support, holding the pigment particles in place.

Every media has its intrinsic characteristics and technical limits. Some, such as a hard graphite pencil, have pronounced characteristics and definite limits. Others, like brush and ink, have an almost limitless ability to change character, and answer virtually every graphic demand.

Although every medium is distinct in its character and range of usage, the graphic possibilities of each can never be fully exhausted. In an age

of media proliferation that includes plastics, film, neon, and power-driven works, the common "lead," or graphite pencil is still capable of new uses. Because every medium reflects the user's level of sensitivity to it, as well as his judgments about its graphic role, some new accents of usage are always possible. If the user is "blind" to a medium's nature and range, or influenced by the way others have used it, his responses will be poorly or derivatively expressed. But if he finds the medium compatible with his intent, and if his creative interests are original, that is, *genuinely personal,* his rapport with the medium can create still another unique use of it. There can be as many original uses of a medium as there are inventive artists for whom its nature is congenial and stimulating. Although the technical limits of a medium cannot be appealed, the scope of its behavior within these limits is bounded only by the artist's sensitivity to the medium and by his creative wit.

The first time we manipulate a new tool or medium, we experiment with its performance in various ways that interest us. If we are given to slow, deliberate statements, or fast, impulsive ones, we want to know if it is responsive to such demands. By such exploration we learn how the medium *feels*—literally. The heft of the instrument, the drag or flow of dry or wet media, the overall tactile nature of its properties are important considerations. We test its behavior in maneuvers we have required of other media to make comparisons. We try to learn its characteristics and consider its potentialities. These manipulations are instructive. They not only tell us what a medium or tool is like, they tell us something about our overall attitude and interests—what we are looking for in a medium or tool is a clue to what we want to do.

A medium's characteristics and limits can influence the artist's tactics. He is not likely to draw a cloud formation with pen and ink in the same way he would with charcoal. Artists tend to use a medium's strengths and avoid forcing it to do what it cannot do well. In this regard, the choice of media is important. Selecting pen and ink, the artist drawing a cloud formation would probably forego the smooth graduations of tone easily produced by charcoal, to obtain other qualities in the subject that he feels pen and ink can best state.

Thus, the medium can influence, but should never dominate a drawing's direction. Congenial media help stimulate and extend our range of responses, but do not determine them.

A sensitive versatility with a wide number of media is convenient and helpful, but such a pursuit should not be over-stressed. Picasso is equally at home with pen and ink, chalk, crayon, and a number of other media. But Holbein, Ingres, and many others used only one or two media to produce most of their drawings. What is important is how well a medium can assist the expression of our responses. Good drawing invariably depends on a sympathetic union of intent and tools. The medium used in every instance should be one that the artist feels a rapport with for its aptness—an intuitive sense of its compatibility—with his intent, and with the nature of the subject.

But a word of caution. Any new medium deserves more than a brief trial. All media require time and repeated use to comprehend and control. During a period of exploration, it *is* helpful to see how others have used a medium, to gain some idea of its range. In the case of the graphite pencil, one can look at drawings by artists as different in temperament and approach as Ingres (Plate 3.18), Degas (Plate 6.7), Cezanne (Plate 6.9), Eilshemius (Plate 7.1), and Klee (Plate 7.2), to see how flexible a tool it is.

Sometimes, a medium may work poorly on one kind of surface and should not be rejected until several other kinds of paper have been tried. At times, the problems with a medium are traceable to the scale of the drawings. Sometimes, pen and ink appears weak in a drawing of large dimensions, just as charcoal seems too thick and unwieldy in a small drawing area. In general, the student should experiment freely for at least a few months, with the several media he selects before coming to some decision about their aptness for him. He should occasionally combine them, and should work with as well as "go against" their characteristics. He should use them on different supports of various sizes, for various purposes.

Our first, unfavorable reactions to a material may survive the period of exploration—but they may not. It is not uncommon for many beginning students to prefer "neat" media such as graphite or charcoal pencils, which have the additional "advantage" of being more or less erasable. Other media, such as conté crayons, or brush and ink, are bolder, broader media—and cannot be erased. Do not reject an unfamiliar medium because of its bold or permanent nature. A bolder medium helps guide the student away from minor niceties, and toward the essentials. Usually, the stronger, more animated results of such media are soon recognized by the student

*Plate 7.1*

*Louis M. Eilshemius* (1864–1942). OLD SAW MILL.
Pencil.
COURTESY OF AMHERST COLLEGE, AMHERST, MASS.
GIFT OF MR. ROY R. NEUBERGER.

*Plate 7.2*

*Paul Klee* (1879–1940). TREES BEHIND ROCKS, K.6.
Pencil.
THE SOLOMON R. GUGGENHEIM MUSEUM.

concerned with analysis and expression, rather than exposition and polish.

We should recognize that the medium has too often been blamed for shortcomings of perception *and* conception. Although, after an adequate period of trial, we may wisely set aside a particular medium, we should always guard against rejecting it because it has not solved creative problems in general, and perceptual ones in particular. The "right" medium *will* stimulate invention—*will* ease and enhance expression—but cannot itself *make* perceptions or directly contribute concepts. The medium is an integral part of the graphic message, not the message itself.

Beginning with the cave artists, who discovered the possibilities in natural chalks and clay, artists have always shown ingenuity in adapting any material that suggested possibilities as a medium or a tool. The need to create certain images, to produce a certain texture, or to improvise when art supplies were unavailable, has stimulated the invention of many tools and materials in use today. The first painting knife may well have been an artist's palette scraper, used in a moment when a heavy impasto was needed. For years, soft bread was used as a charcoal eraser, and crumpled paper dabbed upon ink, watercolor, or opaque paint produced interesting results and is now a common practice. Fingers were probably man's first "brushes," and there are few artists who do not add or adjust a tone or line in this way.

Finding himself without a pen or brush, an artist may apply ink or paint with a twig, a cotton swab, sponge, matchstick, or any one of a score or more of adaptable applicators. When the medium itself is unavailable, instant coffee or tea have been used, as has food coloring, iodine, and similar staining liquids. Almost any substance that can make a mark, and any surface that can receive it may serve as drawing materials. Sometimes, tools and materials discovered in an emergency situation, or in free experimentation, have become favored media for some artists. One contemporary artist of note for years regularly used mercurochrome with his inks, applied to common shelf paper. Too often, however, as in this case, such innovations lack permanence or adequate control.

The abrasive media in common usage today can be grouped into four general divisions: the several kinds of charcoal-based media; graphite, with clay or carbon mixtures; the several kinds of chalks; and the fatty-based crayons. The absorbent media include: waterproof and washable inks; transparent watercolors; and the several more or less opaque, water-based paints. Less frequently, but a practice of long standing, thinned oil paint is also used as a drawing medium.

Often, abrasive and absorbent media are intermixed. In Daumier's drawing (Plate 7.3), graphite pencil, charcoal, and watercolor washes are used. Often, mixed media drawings result from the graphic and expressive needs of the moment. If, as a drawing develops, the artist finds new creative possibilities suggested by the subject and/or the drawing warrant a change in the general handling, he will use whatever additional media are required.

Sometimes, an artist envisions a drawing strategy that must necessarily include several media. Daumier's drawing seems to be one of these. Here, the soft, vague charcoal lines appear as a first, gestural underdrawing, as can be seen by the preliminary indications of a figure on the far left. Pencil lines establish the more specific delineations of the forms, and the watercolor washes, the local-tones, and broad modelling of the forms. Note the integration of charcoal, graphite, and wet tones. The drawing has no sizable segment expressed by only one medium. Each is active everywhere.

Unless media and materials are technically or chemically incompatible, they can be combined in any way that seems to offer a solution to our desired goals. "Rules" for using the various media have often presented unnecessary barriers to the student's free response to his subject—and to his free exploration of media. Many of these prescriptions for usage grew up around those procedures that direct the user toward a medium's most typical and natural characteristics. For example, some artists still strongly insist that the use of watercolors must be limited to transparent washes. To include opaque passages is considered a kind of illegitimate or impure use of the medium. But such a peremptory view stands in the way of an objective evaluation of works that disregard this "rule." Whether opaque passages help or hurt a watercolor drawing must be decided on its merits as a system of expressive order, not on its conformity to established codes of usage. Such codes, begun as well-intentioned suggestions to students, sometimes have, over the years, hardened into unquestioned policies that are often limiting. The justification for the use of any medium or combination of media can only be found in the artistic worth of the drawing in question.

Because, as suggested earlier, successful draw-

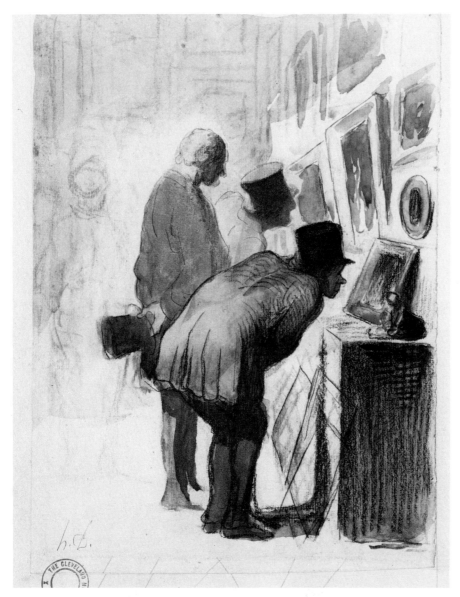

*Plate 7.3*

*Honoré Daumier* (1808–79). Connoisseurs.
Watercolor, charcoal and pencil.
THE CLEVELAND MUSEUM OF ART,
DUDLEY P. ALLEN FUND.

ing depends on the union of its meaning and the means used, every great drawing is a virtuoso performance of the media used. But placing the emphasis on display of technical facility with media, shifts the emphasis of drawing from analysis and expression to performance. The drawing then becomes not the result of an artist's interpretation of nature, but a show of skill in manipulating tools. When such technical skill becomes the primary goal, then the subject has become the medium for this display of virtuosity.

## THE ABRASIVE MEDIA

The common *stick charcoal* (Illustration 7.1), possibly used in prehistoric times, continues to be a popular medium with students and professionals. Stick charcoal, sometimes called vine charcoal, is simply carbonized wood. The longer the sticks (usually of willow, beech, or vine branches) are allowed to carbonize in a sealed chamber, the softer and darker the charcoal sticks become, enabling them to produce darker tones.

149

*Illustration 7.1*

*Charcoal and chalk media. From left to right: compressed charcoal stick, soft chalk, conté crayon, hard chalk, sanguine red conté crayon, soft charcoal block, and white conté crayon, at bottom, stick charcoal.*

*Illustration 7.2*

*Bold, heavy strokes drive charcoal stick particles into the "valleys" of a paper's surface texture. Light strokes deposit the particles only on the "hilltops."*

Charcoal has no holding, or adhesive agent—no binder—and, therefore, is an especially *friable* material; that is, it can be very easily crushed into a powder. It depends, as do most abrasive media, on a surface that has, however fine or rough, a tooth. By rubbing any abrasive medium across such a roughened surface, minute particles are filed away and lodge among the hills and valleys of the paper's surface (Illustration 7.2). Because of its extreme friability, stick charcoal needs only light pressure to mark a surface. Its particles are not usually embedded very deeply into a paper's grain, and are very easy to erase or dust off.

Charcoal can be repeatedly erased and reworked. It can, when sharpened on a sandpaper block, produce quite delicate lines. When used on its side, stick charcoal makes bold, broad tones. Because of its easy application and removal, and its range of expression, it has been

used for centuries to make preparatory drawings for both small and large paintings. Such drawings are developed to the desired degree with the certainty that they will in no way intrude on the subsequent painting. They can easily be isolated by spraying with a weak solution of shellac or lacquer, called *fixative,* or the drawing can simply be dusted away as the painting develops. For all these reasons, too, it became, around the beginning of the nineteenth century, the standard drawing medium in the European academies. Its easy handling made stick charcoal an especially popular medium for the development of sustained, closely observed studies.

Although charcoal was, and continues to be used for final drawings, its fragile hold on the paper, until fixed, sometimes makes it difficult to retain dark tones upon the page, or avoid smearing developed passages. The unwary student who sneezes toward a drawing heavily laden with charcoal, may find his drawing suddenly faded, the particles "exploded" upon the page. Fixing the drawing prevents this, but then erasure becomes almost impossible. One solution to the fragility of a charcoal drawing in progress is to fix the drawing at several stages, when there is not likely to be any subsequent erasures of established tones or lines. Fixative does not prevent additional drawing over fixed areas. In some instances, fixing helps produce deeper charcoal tones because the earlier charcoal deposits, now encased in the fixing material, form a new, firm tooth and can hold new charcoal particles better. Fixative can be purchased in bottles and applied with a mouth blower, but using the pressurized fixative spray can allows for a more even, controlled spray.

Although stick charcoal's range does not extend as far into the rich blacks possible with chalks and crayons, it permits a wide enough range of value for most drawing purposes and styles. It can be used for subtle tonal and line drawing, as in Plates 7.4 and 7.5, or for bold, brooding ones, such as Hopper's study (Plate 7.6), especially when a good quality of soft charcoal is used on an intensely white surface with a moderate tooth. Unlike most of the other abrasive media, which can hold on surfaces with a very fine grain, stick charcoal's weak holding power will fail on such smooth surfaces. Even some of the smoother types of newsprint paper will not take charcoal well.

*Compressed charcoal,* made by pulverizing charcoal, adding a binding agent, and compressing it into small cylinders or square-sided sticks,

Plate 7.4

*Piet Mondrian* (1872–1944). CHRYSANTHEMUM. Charcoal.
SMITH COLLEGE MUSEUM OF ART.

produces richer blacks, has good holding power on a wider variety of surfaces, and is less easily erased than stick charcoal. Charcoal in this form is sometimes regarded as black chalk. Manufactured in varying degrees of softness, its character is controlled by the amount of binder added. The hardest compressed charcoal sticks have some of the characteristics of the natural black chalks, which were in popular use from the fifteenth century until the nineteenth century, when good quality natural black chalks became less available. Made of various colored earths, minerals, and carbon mixtures, natural chalks

Plate 7.5
*Henri de Toulouse-Lautrec* (1864–1901).
THE MODEL NIZZAVONA.
Charcoal.
COURTESY OF THE ART INSTITUTE OF CHICAGO.

Plate 7.6
*Edward Hopper* (1882–1967).
Sketch for MANHATTAN BRIDGE LOOP.
Charcoal.
ADDISON GALLERY OF AMERICAN ART, ANDOVER, MASS.

*Illustration 7.3*

*Chalks in pencil form. From left to right: white conté crayon pencil, compressed charcoal pencil with string for exposing additional chalk, sanguine red conté crayon pencil, mechanical holder with thin chalk sticks, hard compressed charcoal pencil, mechanical holder with broad chalk stick.*

were available in black and several shades of brown and earth red. Most natural black chalks (Plate 7.7) seem to smear less and allow for a precision not as easily attainable with the softer contemporary, manufactured black chalks.

Compressed charcoal, usually available in four degrees of softness, is also manufactured in pencil form, and referred to as *charcoal* or *carbon pencils* (Illustration 7.3). Fashioned into slender "leads" and encased in wood or paper shafts, these are also sold in packets, for use in holders. The softer charcoal pencils must be carefully sharpened, as their composition does not permit rough handling. When used with a holder, only a short stump, no more than one fourth of an inch, should be allowed to protrude to avoid its breaking off during energetic drawing actions.

The thin lines possible with a charcoal pencil allow for a more linear use. Although this can provide handsome results (Plate 7.8), it can have inhibiting effects on the handling of large drawings. It is generally used for works of a small scale, or in conjunction with the broader charcoal media when more precise statements require a medium capable of fine lines and tonal nuance, as in Illustration 7.4.

All members of the charcoal family are intermixable and frequently used together. Compressed charcoal is often used to deepen values and add accents to stick charcoal drawings. Charcoal media work well with water-based ones in mixed media combinations, as in Plate 7.3.

The term *chalk* has been freely applied to a wide variety of friable media, including those of a fatty-based composition. Originally, the term referred to the natural chalks, now rarely available. Today, the differences between various types of manufactured chalks that are a mixture

*Illustration 7.4*

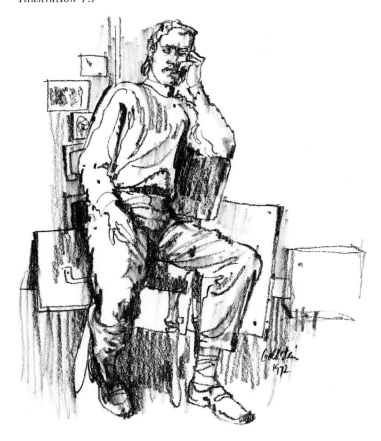

Plate 7.7

*Hans Holbein, the Younger* (1497/8–1543).
Cécily Heron.
Natural black chalk.
ROYAL COLLECTION, WINDSOR CASTLE, COPYRIGHT
RESERVED.

Plate 7.8

*Pablo Picasso* (1881–    ). The Donkey Driver.
Carbon pencil.
THE CLEVELAND MUSEUM OF ART,
LEONARD C. HANNA, JR. COLLECTION.

of dry pigments and nonfatty binders, are hard to define. With black chalks, even the line dividing them from compressed charcoal is hardly discernable—or warranted. Pulverized charcoal is just one of several dry pigments used in the manufacture of some chalks. It is difficult to group types of chalks because of the many possible combinations of pigments, binders, and, sometimes, other additives, and the particular formulas of the various manufacturers. The term *pastel* has come to be associated with the great variety of colored chalks; but black pastel is generally made of ivory-black pigment and gum arabic, ball clay, or other materials often found in other types of black chalk. Adding to the difficulty of defining the realm of chalk media are those media that possess a slightly waxy binder, but are, in use, far closer to the more friable chalks than to crayons. All chalks can be erased to some degree, but those having a waxy base are far less erasable. The popular conté crayon is such a medium. Its slightly fatty, smooth flow (especially pronounced in the sanguine, or earth red, color), still retains some of the look and feel of the more erasable, drier chalks. Conté crayon (Plates 4.8, 4.12) seems to bridge the division between chalks and the family of waxy-based media, called *crayons*.

Chalks range from the very soft and easily friable ones to those of a quite hard consistency that require some pressure to produce dark tones. The harder ones are capable of greater precision than the soft chalks, and do not require a surface with as pronounced a tooth. Because of the various types and colors of chalks available, the student should experiment with several. Their differences in behavior are often subtle. Today, an excellent choice of blacks, grays, browns, earth reds, and white is available, as are other colors.

Fragonard's drawing (Plate 7.9) in red chalk shows a sensitive understanding of the broad, painterly qualities that most softer chalks are capable of. Note, too, the calligraphic lines, well integrated with the broader chalk lines and tones. Fragonard utilizes chalk's capacity for tonal nuance to convey his sensitive energetic responses. The rich texture of the softer, manufactured chalks is apparent in Degas' "Jockey on a Rearing Horse" (Plate 7.10). The rugged power of the softer chalks lends itself well to such bold statements. Whistler's study for an etching (Plate 7.11) shows the resonant, mellow dark tones that chalk can produce.

Chalks are often used in combination with other media. Henry Moore's drawing of miners

Plate 7.9

*Jean Honoré Fragonard* (1732–1806).
A WOMAN STANDING WITH HAND ON HIP.
Red chalk.
COURTESY OF THE FOGG ART MUSEUM, HARVARD UNIVERSITY.
BEQUEST OF META AND PAUL J. SACHS.

(Plate 7.12) is a mixed media work in black, brown, tan, yellow, and white chalk, pen and ink, gray washes, and with some surface scratching to reveal lower layers of tone. Here, the chalk's texture is revealed by the rough tooth of the paper, the repeated applications of chalk, scratching through, and the use of washes, which settle in the valleys of the surface, darkening them and leaving the hills lighter.

As in the case of chalks, there is a wide range of wax, or other fatty-based crayons available, from those of a rather dry, chalk-like nature to the greasy and viscous ones, not unlike children's crayons. The type of binder used in the manufacture of crayon media determines the degree of viscosity. Those, like conté crayon, that retain

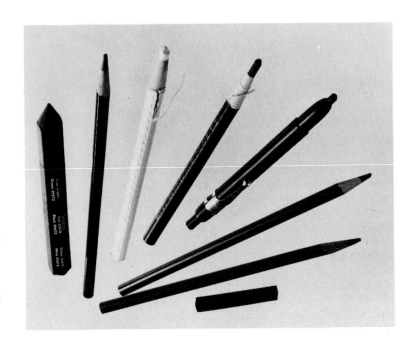

*Illustration 7.5*

*Crayon media. Left to right: carpenter's marking crayon, black crayon pencil, white crayon pencil with string for exposing additional crayon, black litho crayon pencil with string for exposing additional crayon, mechanical holder with soft crayon "lead," sanguine red crayon pencil, sepia crayon pencil, and square stick of litho crayon.*

some chalk-like characteristics, usually contain soap, ball clay, and sometimes, very small amounts of beeswax. The most greasy ones contain high amounts of wax and tallow. Most crayon media are available in stick and pencil form (Illustration 7.5), and are available in a wide assortment of colors.

Lautrec's drawing (Plate 1.5), well illustrates the flowing, linear freedom possible with crayon. Picasso's drawing of a young man (Plate 7.13) shows the rich blacks and the sharp focus of crayon lines. These tend to exceed the depth and clarity of chalk lines. Because of the adhesive strength of the binder, particles of crayon, unlike chalk, do not easily come off of a drawing. The more viscous ones are not at all erasable. Because of their permanent nature, the blending of tones is extremely limited, and must be optically achieved by line-groups. Note that the value-variations in Picasso's drawing result from cross-hatching. Because of this restriction, crayons are more frequently used by artists who draw

*Plate 7.10*

*Edgar Degas* (1834–1917).
JOCKEY ON A REARING HORSE.
Black, olive and light green chalk.
STERLING AND FRANCINE CLARK ART INSTITUTE,
WILLIAMSTOWN, MASS.

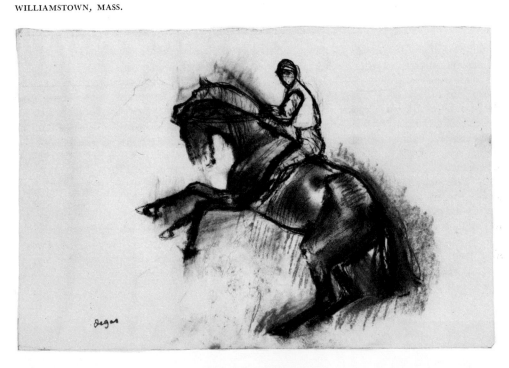

in a linear, rather than a tonal way. Many artists are attracted to crayon's sharp, rich lines, and to the challenge of its permanence, which, like pen and ink, demands a resolute handling.

One group of fatty-based crayons in stick and pencil form was developed for use in the graphic process of lithography (Plate 2.5). Black lithography crayons and pencils come in varying degrees of softness, but are, as a group, more fatty than most other crayons. In addition to their use in lithography, they are a versatile and popular medium for both short and sustained drawing.

Because the fatty-based media do not require fixative and do not smear in the sketchbook, they are a popular medium for drawing out-of-doors. But the presence of wax or other water-resisting binders makes them less compatible in certain mixed-media combinations.

There is another method of making a crayon-like medium. Unavailable in the art stores, it can be easily prepared in the studio. Stick charcoal or the more friable chalks, when immersed in olive-oil or a comparable nondrying oil for a day, absorbs the oil and imparts to the medium a somewhat fatty, crayon-like character. Like crayon, it blends poorly and cannot be erased. In the case of charcoal, the lines become darker, will not dust off, and take on a smooth, flowing character that is rather unique.

Perhaps the most familiar writing and drawing tool in use today is the *graphite* pencil (Illustration 7.6) erroneously called a lead pencil. The confusion in terms probably resulted from the common, earlier use of the various metallic styluses, of which lead and lead-alloy metals were the most popular among the general public.

The use of lead, and lead and tin mixtures had the important advantage of not requiring a prepared surface, usually a white lead base, as was necessary for the use of silver, gold, brass, and other metals. This made lead a more popular medium for writing and record-keeping purposes. But many artists often used the other metals, especially silver, because of the darker lines that resulted through oxidization (Plate 6.18).

Compared to graphite lines, metalpoint lines are lighter, finer, and cannot vary in width or value. Although excellent for delicate, small drawings that do not depend on the variety of width, or value of line, metalpoint drawing has been largely superceded by the modern graphite pencil.

The graphite pencil is available in some twenty different degrees of softness. The harder pencils usually carry an *H* designation, plus a number indicating the degree of hardness. The 1H pencil is the least hard of this group, the 9H, the hardest. The softer pencils are marked *B*, and the higher the number, the softer the pencil. These extend up to 8B. There are three pencil grades between the two categories, usually marked (from softer to harder), *F, HB,* and *H*. All the H pencils can produce lines similar to the sharp, fine lines of the metalpoint instru-

*Illustration 7.6*

*Graphite media. From top, counter-clockwise: graphite pencil in pencil extender, thick graphite "lead" in double-ended extender made to hold any wide abrasive medium, an 8B graphite pencil, mechanical pencil holder for thin "leads," pencil made of graphite-carbon mixture (for very dense, black lines), flat graphite pencil, and broad, square-sided graphite block.*

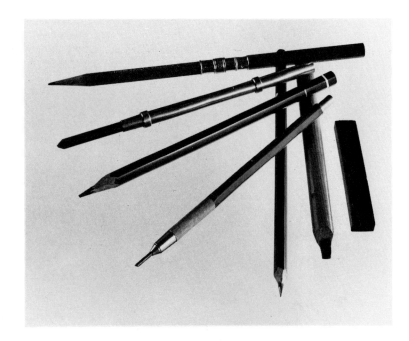

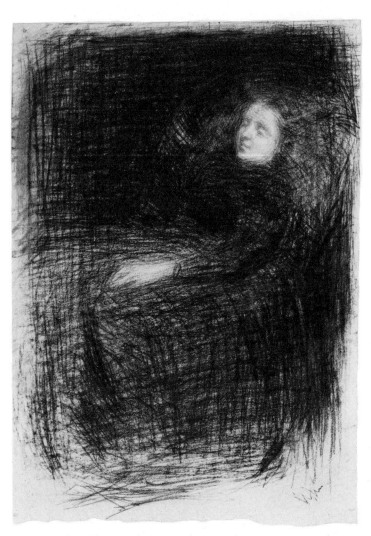

Plate 7.11

*James Abbott McNeill Whistler* (1834–1903).
STUDY FOR WEARY.
Black chalk.
STERLING AND FRANCINE CLARK ART INSTITUTE,
WILLIAMSTOWN, MASS.

Plate 7.12

*Henry Moore* (1898– ).
MINERS AT WORK ON THE COAL FACE.
Black chalk, pen and ink with gray wash,
heightened with white chalk and body color.
Surface scratching and yellow and brown chalk.
WHITWORTH ART GALLERY, UNIVERSITY OF MANCHESTER.

ments. The various degrees are determined by mixtures of graphite and clay. The softest and blackest pencils contain some carbon. The more clay present in the mixture, the harder and lighter the line. The more carbon present, the darker the lines.

Like the slender compressed charcoal sticks, graphite "leads" are available for use in mechanical holders, and in flat-sided sticks or blocks which can produce wide bands of tone (Illustration 7.5). Among the wide range of graphite pencils available, almost every artist will find some that are suited to his drawing needs. The beginning student too often strains the range of a single pencil. It is unnecessary to have the entire range of graphite pencils, but some four or five degrees of softness are often needed in extended tonal drawings (Plate 7.14). A good, all purpose selection might be 3H, HB, 2B, 5B, and 8B. Although the harder degrees are here omitted, some surfaces (and styles) may require their use. In general though, their limited value-range and hard, fine lines too often promote a tight, timid result. The softer graphite pencils can still give great exactitude, and

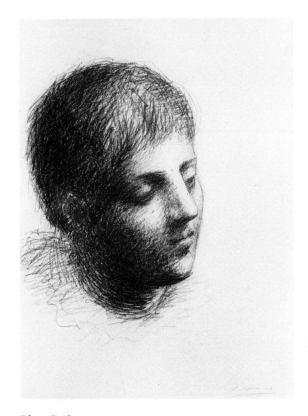

*Plate 7.14*

*Andrew Wyeth* (1917–  ). BECKIE KING. Pencil, 28½" x 34".
COURTESY OF THE DALLAS MUSEUM OF FINE ARTS.
GIFT OF MR. EVERETT L. DEGOLYER.

*Plate 7.13*

*Pablo Picasso* (1881–  ). HEAD OF A YOUNG MAN. Grease crayon.
COURTESY OF THE BROOKLYN MUSEUM.

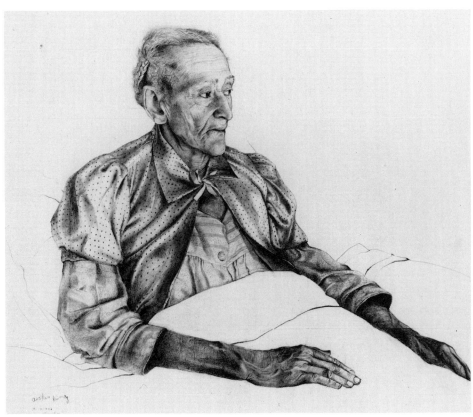

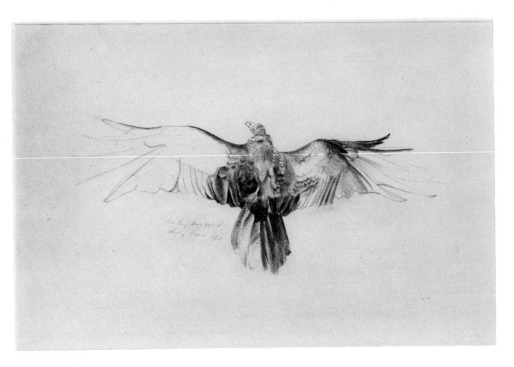

Plate 7.15

*Andrew Wyeth* (1917– ). Turkey Buzzard.
Pencil.
COURTESY, MUSEUM OF FINE ARTS, BOSTON.
BEQUEST OF MAXIM KAROLIK.

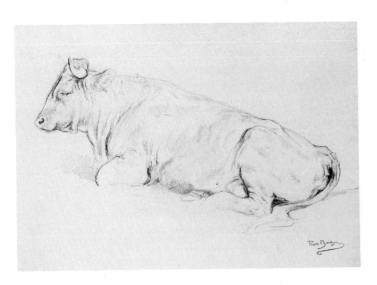

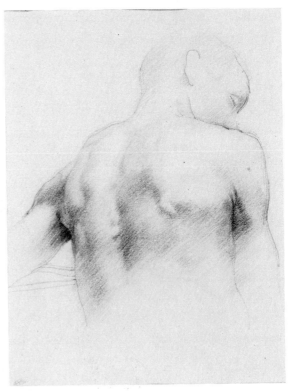

Plate 7.16

*Rosa Bonheur* (1822–99). Bull Resting.
Pencil.
STERLING AND FRANCINE CLARK ART INSTITUTE,
WILLIAMSTOWN, MASS.

Plate 7.17

*Rachel Carnegie* (1901– ).
Study of Back and Shoulders.
Pencil.
COURTESY, MUSEUM OF FINE ARTS, BOSTON.
GIFT OF GEORGE P. GARDNER.

160

much more tonal power than the hard pencils (Plate 7.15). If one *were* to be limited to the choice of a single pencil, a 3B or 4B pencil would serve most needs the best. Rosa Bonheur (Plate 7.16) uses a single soft pencil to establish the delicate nuances and bold accents of her subject. Note the range of fine to heavy lines.

As with charcoal and chalk media, graphite can be blended, but most artists prefer the texture and freshness of massed graphite lines (Plate 7.17). Graphite's easy erasability (less so in the very hardest *and* softest degrees) leads many students to overwork their drawings. Graphite's freshness is fragile and easily lost. Extensive erasures, blending, and reworking of graphite causes an unpleasant shiny and scarred surface.

Graphite, too, is a popular medium in mixed-media works (Plates 6.9 and 7.3). Its ability to be used in faint wisps or powerful accents, its easy application over layers of almost any other medium, and its pleasing character as a dry "counterpoint" to wet media, make it a versatile member of almost any combination of media.

## THE ABSORBENT MEDIA

The designation *pen and ink* is sometimes freely applied to drawings made with tools other than, or in addition to, the pen. Twigs, or sticks of various kinds, especially balsa wood, feathers used as brushes, sponges, rolled paper, even cocktail skewers or eye droppers, and other unlikely objects have been used to produce certain textures and linear characteristics in a drawing. Such improvisations extend the range of ink's uses. The wide selection of available pens and brushes meets nearly every kind of graphic demand, but it is instructive to explore new means of using ink.

Some of these innovations, such as string dipped in ink, may lack the control necessary to keep the tool from dominating a drawing's direction, and harm rather than help it. Others, such as raking the thumbnail or a stick across a toothbrush dipped in ink, while difficult to control, are sometimes usable tools. Any drawing instrument can lead to mannered habits and a fascination with unusual or superficial effects. The user must decide whether a particular tool serves or masters him.

Ink, applied with brush or pen, was used as a drawing and writing medium in many ancient cultures. It retained its popularity in the West even after the introduction of manufactured chalks, crayons, and graphite, and is still one of the most appealing of drawing media. Its ability to state dramatic or subtle contrasts in value, to be used with broad, painterly force or delicate finesse, its virtually endless range of line and value characteristics, in short, its great versatility, has made it a favorite drawing medium in every age and culture for any visual, expressive, or stylistic purpose.

Today, there are many kinds of inks, in many colors (including white), available for many uses. There are inks made of dye solution for use in ball-point pens, the traditional fountain-pen ink, and inks made especially for etching, lithography, and for the commercial printing industry, as well as the several kinds of inks used for drawing. Inks may be transparent or opaque, waterproof or water-soluble, and are available in liquid, paste, or solid forms.

One of the oldest and most versatile inks is the Oriental *sumi* ink. Made of carbon and a water-soluble binder, it is formed into small blocks or cakes which are rubbed on a slate inkstone containing a small amount of water, to produce either an ink paste or liquid, depending on the ratio of pigment to water. Sumi ink is now also available in liquid and paste form, as well as the traditional cake form. In a liquid state comparable to that of contemporary black drawing inks, it produces a rich, black line as good as the best of the contemporary ones (whether water-soluble or waterproof) and better than some (Plate 7.18).

Another early drawing ink, *sepia,* is a dark, olive-brown ink, made of the inky substance from the sacs of squid and cuttlefish. An ink called sepia is available today, but most manufacturers do not use the original material. One brand, Pelikan Drawing Inks, makes a particularly handsome waterproof sepia ink that is a blackish-brown at full strength, produces various shades of olive-brown through the middle values, and golden-tans in the light washes. It is transparent in the lighter values, making it especially desirable for wash drawings. Like another early ink, called *bistre,* a yellowish-brown ink, sepia ink was, and is favored for its suggestions of color, and being a darker ink than bistre, offers a wider range of color. Bistre ink is not available commercially.[1]

*India ink* is a generic term for a contemporary

[1] For those interested in making bistre, and other inks, see *The Craft of Old Master Drawings,* James Watrous (Madison: University of Wisconsin Press, 1957).

*Plate 7.18*

Late Kamakura period.
WHITE-ROBED KANNON FROM KOZAN-JI TEMPLE.
Brush and ink.
THE CLEVELAND MUSEUM OF ART,
PURCHASE, JOHN L. SEVERANCE FUND.

mulates during usage. At the end of a drawing session, all instruments that have been in contact with India ink must be thoroughly washed with soap and water. Should it be necessary, India ink solvents are available. A wide selection of brands offers several densities of India ink for various purposes. All produce dense blacks and are excellent drawing inks.

Although India ink can be diluted for washes of tone, such washes usually appear granular when compared to similar sumi ink washes. Also, India ink washes often end in a rather abrupt way, when compared to the more feathered edges of a sumi ink wash. However, the paper used, the manner of application, the density of the wash, even the hard or soft nature of the water used, are all factors in determining the appearance of any ink wash.

Less typically associated with drawing are transparent *watercolors,* in cake, tube, or liquid form. Of particular interest to the draughtsman are the blacks, the many browns (including bistre and sepia), and the various earth reds. Although other colors are sometimes used, these are more compatible with the inks described above. Watercolors are used for wash drawings, for linear drawing with brushes, or in conjunction with other media.

Watercolors are made of dry pigment, gum arabic, and, in tube form, an ingredient such as glycerin, to retard their drying in the tube, and to more easily dissolve the paint in water. Liquid watercolors are usually made of dyes, or dyes added to pigment. Often they are described as concentrates, and the colors *do* have strong tinting power. But the permanence of many colors is doubtful. Some of those in cake form contain a retarding agent, others (usually the less expensive brands) do not.

The composition of watercolors does not easily permit their application in heavy layers—at least not over large areas. Watercolors can be made opaque by the addition of a white paint, usually called *Chinese white.* Sometimes, when watercolors are used in this way, the medium is referred to as *gouache.*

Lampblack (Plate 4.10) watercolor is similar to sumi ink in hue and compatible with it and the other carbon inks. Often it is used to lay in washes of tone over India ink lines, which unlike water-soluble ink lines will not dissolve and spread on the page. *Ivory black* is a cooler, bluish-black, and when used alongside warmer blacks, imparts a subtle note of color to a drawing's tones.

Although the liquid watercolors can be used for pen drawing, the tube and cake forms are

drawing ink, usually made of carbon or lamp black pigment, and a shellac binder which renders the finished drawing waterproof It tends to have a somewhat heavier consistency, a more velvety feel, than most black water-soluble inks on the market because of the solids in its composition. Because of these solids and the shellac, the user must, from time to time, scrape or wash from his instruments the dried ink which accu-

not normally thinned out for use in this way. The process of diluting them is a tedious one, and their faster drying properties make their use with pens difficult. When strong, colorful lines are desired, colored inks (though many are of questionable permanence) produce crisper lines of richer hues. When heavy layers of paint are desired, opaque, water-based media such as *casein, tempera,* and *acrylic* paints should be used.

Casein is a strong binder made of the curd of milk. Because of its brittleness, gums and other additives are combined with it and dry pigments to produce a softer paint film. Even so, casein is too brittle to use on any but the heaviest of paper supports. When used transparently, it handles poorly and produces washes of a rather mottled, unclear appearance. Even the thinnest washes retain a slightly clouded look. Casein paint is perhaps the most opaque water-based paint available and surrenders this quality with reluctance. As an opaque paint, its handsome matte finish and excellent brushing properties are suited to large, bold drawing, and make it a desirable component in mixed-media combinations with the drier abrasive media and others of a matte nature. When dry, the paint film is insoluble. Because of its powerful opacity, casein white is sometimes used to cover over unwanted lines and tones in other media. If subsequent drawing is to be applied over thin washes of casein, the clouded quality of such washes may matter far less than the rather pleasant tooth and good receptivity to both abrasive and absorbent media that casein offers.

The term *tempera* has been freely applied to many water-based paints. Today, it is often used to describe poster-paint, but some manufacturers offer a tubed tempera paint that behaves somewhat like casein, but has the advantage of producing clearer thin washes. On the palette, dry tempera paint is resoluble, but loses too much of its tinting and adhesive strength to be reused. However, rewetting areas of tempera paint in a drawing does permit some adjustments to be made. Manufactured temperas should not be confused with egg-tempera, a medium popular between the twelfth and fifteenth centuries, which used raw eggyolk as a binder with dry pigments. Because it spoils quickly, egg tempera is not available commercially.

Acrylic paints, a fairly recent addition to the media now available, uses a synthetic resin as a binder. This imparts a remarkable pliancy to the paint film that prevents cracking. Somewhat less opaque than casein and tempera, it nevertheless can be applied heavily enough to achieve total opacity. Acrylic paint is extremely fast drying. This makes it necessary, while working, to place brushes that are temporarily not in use in a container of water. Left lying on the palette, the paint would dry on the brush within minutes. Dried acrylic paint is not soluble in water, and cannot be removed easily from the palette. Its stubborn resistance to soap and water makes it necessary to thoroughly wash any instruments —especially brushes—immediately after use. Should the need arise, an acrylic solvent is now available. Most manufacturers also offer an acrylic extender for thinning the paint. This is available in either a matte or glossy form, allowing the artist to control the degree of reflectivity of the painted surface. This material can, when added to casein or tempera paint, impart some additional pliancy to these paints, broadening their range of use and character.

Acrylics can be applied more heavily than either casein or tempera paints with little danger of their cracking or peeling. Unlike any other water-based paint, acrylic paint films can be drawn upon with pen and ink without the ink spreading, blotting, or mixing with the paint, and with no danger of the paint chipping off. This is so because the synthetic binder forms an impenetrable shield that permits no other absorbent medium to enter. However, for the same reason, no other wet medium, including oil paint, can physically bond with an acrylic paint film. They can adhere to its surface but cannot penetrate it for a firm hold. Acrylic paints, like casein and tempera, are available in a wide range of colors.

Because of the listing here of media generally associated with painting, we may seem to have drifted from listing drawing media. But it is impossible to say just where drawing ends and painting begins. Cezanne's "Standing Nude" (Plate 6.9) is clearly a drawing, although it has transparent washes in several colors. Nor is color the only criterion. Constable's wash-drawing (Plate 7.19) in sepia ink is monochromatic, but seems to possess painterly qualities.

It is often impossible to say whether a particular work is a drawing or a painting because no clear demarcation line between these two broad categories can be found. It is not surprising. This is a natural result of the imperative of freedom in creativity. The freedom to pursue any system of expressive order, extends to the free choice of tactical means. When the responsive demands of an artist require that he use materials and processes usually associated with painting (Plate 7.20) in a work which, in other respects, appears to be a drawing, no particular

*Plate 7.19*

*John Constable* (1776–1837). Stoke by Nayland.
Brush and sepia ink.
VICTORIA AND ALBERT MUSEUM, LONDON.

*Plate 7.20*

*Henri de Toulouse-Lautrec* (1864–1901). The Dog.
Oil on cardboard.
MUSÉE TOULOUSE-LAUTREC, ALBI, FRANCE.

164

rule has been violated. To insist on precise boundaries to keep these major media categories from overlapping would be as partisan and limiting as those codes which proscribe a medium's usage. Although most drawings *do* omit color, *are* small in scale, *are* made on paper supports, and *do* tend to emphasize line, there are no compelling reasons for accepting these traditional characteristics as fixed barriers.

Thus, the several paints discussed here should be considered as additional ways to increase our options in drawing. Oil paints are omitted here only because the addition of a medium requiring its own thinner, varnishes, oils, etc., would complicate the mixed-media possibilities and restrictions. But drawing in oils is a not uncommon practice of long standing. The use of paints in drawing tends to influence a broader, often more daring approach, on a larger scale, that can act as a healthy corrective for those who tend to make tiny drawings in a timid manner.

## THE DRAWING INSTRUMENTS

Most of the abrasive media, except for the thin and fragile compressed charcoal, crayon, and graphite leads, do not normally require any mechanical implements or holders. However, some artists prefer holders or extenders for all the abrasive media to permit them to stand further back from large drawings, or to extend the drawing life of a medium worn too short to be comfortably held in the hand (Illustration 7.7).

Some mention has already been made of the many improvised drawing tools that can be used with inks or paints. Here, we will examine the various pens and brushes designed for use with these media.

## PENS

Probably the oldest instrument for applying ink is the *reed pen*. Found at many river banks and marshes, the stronger, tubular reeds are cut to a comfortable length, and sharpened to a point at one or both ends. Splitting the shaft at the point produces a steadier ink flow and a slightly more flexible point (Illustration 7.9). The reed pen, with its thick, tubular body, naturally produces broad, resolute and "plain spoken" lines. Its fibrous composition and its thick wall prevent making a fine point. When sharpened too

*Illustration 7.7*

*Some pens. Clockwise, starting at bottom: goose-quill pen, crow-quill steel pen, Japanese reed pen with squirrel-hair brush at opposite end (brush reverses into handle when not in use), felt-tip pen, stylus type fountain pen for use with washable inks, all-purpose drawing fountain pen for use with washable inks, and India ink fountain pen with nib that lowers into barrel when not in use.*

*Illustration 7.8*

*Some brushes. Clockwise, starting at bottom of photo: portable sable brush with cover which serves to extend handle when in use, French quill brush taped to a stick, number 2 round bristle, flat red sable, number 5 filbert bristle, Japanese squirrel-hair brush, portable fountain brush, number 4 round red sable, large flat red sable with a beveled handle tip for incising lines and removing paint, common paste brush of nylon "hairs."*

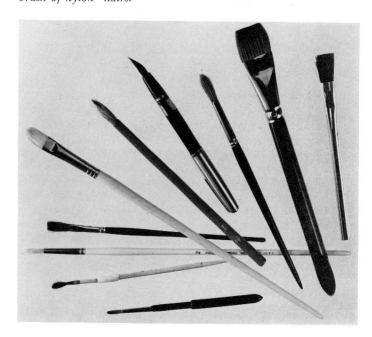

*Illustration 7.9*

*Cutting a reed pen. Using a sharp blade, make a 45-degree cut (A). A second cut (B) should be made at a more oblique angle than the first. Sharpen to a dull point, as in C. Using a nail or pin, drive a hole through the wall of the reed. Using a knife blade, slit from hole down to the end of the reed, as in D.*

fine, the fibers quickly wear away or break down. Even the necessary blunt point wears away after a short period of drawing and needs to be recut. Also, some ink is taken up into the pen's tip through capillary action in the fibers. This makes the point fairly spongy after about twenty minutes of drawing. It should be set aside to dry. Many artists use two or three reed pens, in rotation.

But the reed's ability to take up ink in its fibers has one advantage. When the pen is fully charged with ink, the lines will, of course, be dark and dense. But as the ink is used up, it is forced from the fibers by pressure on the pen, and produces various tones of line (Plate 1.6). These can be extremely light and dry-looking, making possible very delicate tonal nuances.

Reed pens do not often work well for long or complex curvasive lines. Their ink flow is usually too heavy to sustain such lines. Nor do they, except when fully charged, glide along the surface easily. The user feels a decided friction between the pen and paper, and may tend to make slower, shorter lines with a reed pen than with any other. But many artists consider these apparent limitations challenging and even desirable characteristics that encourage a concise, analytical, and bold approach to drawing. The reed pen discourages clever facility (Plate 7.21).

Some localities provide sturdy reeds from which pens can be easily made. Art stores offer bamboo reed pens, sometimes with a brush at

one end. Reed pens work well on most surfaces, but their character is best revealed on surfaces with a moderate to rough tooth. Very smooth papers may cause a heavy flow of ink that is hard to control.

The *quill* pen, in popular usage until the introduction of the steel pen, is made from the heavier pinion feathers of the goose, crow, and swan. Almost the opposite of the reed pen, it is light to hold and requires almost no pressure to use. The thin tubular wall of a horn-like substance allows a much finer and more flexible point. Because it glides easily over even the roughest grained paper, the point does not wear away as fast as the reed's. Like the reed pen— and for the same reasons—the quill pen is split up the middle, shown in Illustration 7.10.

The quill pen responds to the slightest movements of the hand. It produces extended fine lines, or lines that, by increasing and decreasing the pressure on the pen, will vary in width. The quill's flexible point can ride the hills and valleys of a rough-toothed paper better than the modern steel pen, which is more likely to tear through the paper, causing the ink to spatter. The quill's tip can be shaped to suit the user. Cut at an oblique angle, it produces a script-like

*Illustration 7.10*

*Cutting a quill pen. Make the same two angled cuts as for a reed pen. To split the point, press thumbnail down hard at the point where slit is to end (about ¾" from tip of quill), and forcing a brush handle into quill opening, press upward, toward the thumb (D). The quill will not split beyond the point where the thumbnail presses against the quill. Sharpen the point to the desired angle and degree of fineness (E).*

Plate 7.21

*Vincent Van Gogh* (1853–90). TREE IN A MEADOW.
Charcoal under ink with reed pen.
COURTESY OF THE ART INSTITUTE OF CHICAGO.

line as the pen is turned in different ways. Cut with a blunt point, it can produce some of the effects of the reed pen (Plate 7.22). Uncommon in most art stores, goose quills can be obtained from meat markets, farms, and some novelty shops. Crow and swan quills perform about as well, but are much harder to obtain.

The quill pen provides a delicate and ornamental counterpoint to the reed's blunt, terse statements. In Rembrandt's "Cottage Beside Canal" (Plate 7.23), the bolder reed pen lines can be seen in the drawing of the boat, deck, and in parts of the buildings. It also seems to have been used—in the lighter, drier state—to suggest the thatched roofs. The quill pen lines appear in the drawing of the foliage, the contour of the rise in front of the central house, and dart around in curvilinear sweeps on various descriptive "duties."

The steel pen appeared in the early 1800's. The several degrees of flexibility and styles for use in a holder quickly superceded the reed and quill pens because of several obvious advantages. Their uniform manufacture insures the availability of a particular type; they usually hold more ink; they never need sharpening; and they

can produce sharper, cleaner lines than either of their precursers as Plate 7.24 shows.

Today, the wide assortment available ranges from extremely flexible pens that produce lines varying in width from an almost invisible thread of ink to over one eighth of an inch thick, to stiff pens that make uniform lines of mechanical exactness. Some pens are made for use with a holder, others are made to fit into a fountain pen (Illustration 7.7).

Even so, many lack the lively and warm character of the reed and quill pens. Few will function as well on the rough-grained, handsome papers that so well suit the reed and quill pens. These older instruments make a more sensitive union with such surfaces. That is, they are more affected by, and accommodate themselves to, the paper's terrain than most steel pens. The stiffer steel pens make their own flat road on rough paper, denting it as they move, thus losing the tactile and visual benefits of interplay between the tool and the terrain. The flexible steel pens are more apt to become entangled in the fibers of such papers and splatter (Illustration 7.11).

The wide selection of steel pens and types of papers, and the differing needs of the user, make

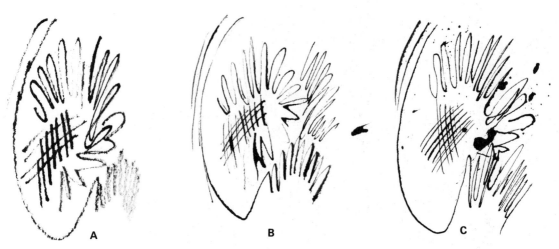

*Illustration 7.11*

*Differences in pen lines on a rough surfaced paper. Those in A were made with a reed pen; those in B, with a quill pen; and those in C with a steel crow-quill pen. Note the splatters in C, when the steel pen is used to make the same kinds of lines as those in A and B.*

it impossible to recommend specific combinations of pen and paper. In general, moderately flexible steel pens—on papers of a moderate tooth and absorbency—can approximate much of the character of the earlier quill drawings. On harder surfaced, smooth papers, the steel pen's free-flowing, incisive character has no equal (Plates 3.13, 7.24).

The several kinds of fountain pens designed to use drawing inks, because they hold a generous ink supply and can be easily carried about, are a most convenient drawing tool (Illustration 7.7). Many are made to take a wide assortment of treaded nibs—which allows the user to change the kind of point being used. Those used with water-soluble inks work quite well if thoroughly washed every few weeks. Another type of drawing pen, used with India ink, is more prone to clogging, but again, thorough, periodic cleaning will keep them functioning. A completely trouble-free India ink pen may not exist because of the drying properties of the ink, but among the most durable and versatile are the Ultraflex India ink pen and the Higgins Pengraphic Universal India ink pen. The latter has the helpful feature of the interchangeable nib, and offers a wide assortment of drawing and technical drawing nibs.

Still another type of fountain pen is often used for technical or mechanical drawing purposes, or where a line's width must be unchanging. These have stylus-like nibs that are made for use with water-soluble inks. The near uniformity of the lines has an etching-like quality, unlike any other kind of pen line (Illustra-

tion 7.12). These instruments also take interchangeable nibs in several line widths.

The ball-point pen is another serviceable addition to the range of drawing media. Its very limited line variation and the relative weakness of the black ink, compared to the carbon blacks, are considered as drawbacks by some. On hard surfaces its easy flow and maneuverability are

*Illustration 7.12*

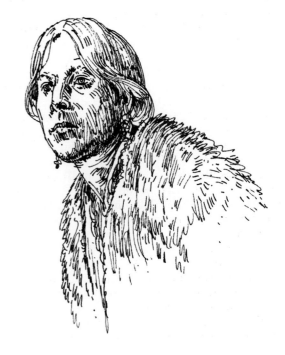

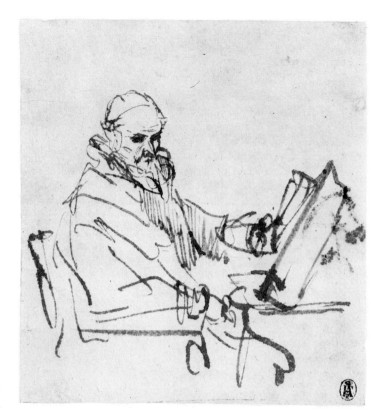

Plate 7.22

*Rembrandt van Rijn* (1606–69).
JAN CORNELIUS SYLVIUS, PREACHER:
POSTHUMOUS PORTRAIT.
Reed and quill pens and ink.
NATIONAL GALLERY OF ART, WASHINGTON, D.C.,
ROSENWALD COLLECTION.

Plate 7.23

*Rembrandt van Rijn* (1606–69).
COTTAGE BESIDE A CANAL.
Pen and wash drawing.
COURTESY OF THE ART INSTITUTE OF CHICAGO.

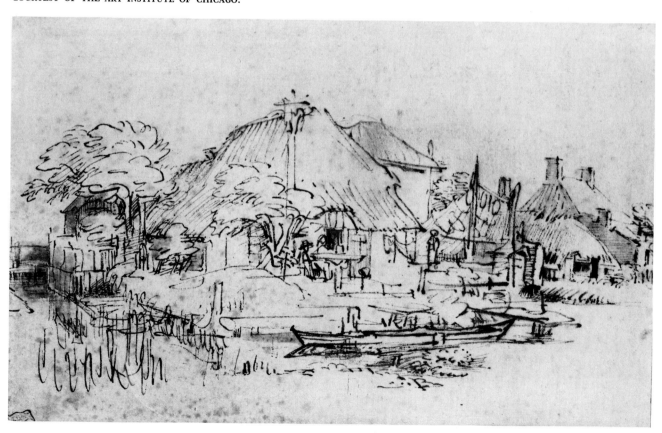

excellent, and those producing the finest lines have a remarkable delicacy.

The artist's felt-tipped fountain pen, a recent development, allows for the interchange of nibs from moderately fine to extremely wide, brush-like strokes. Special dye-based inks in several colors are available for their use. The best pens allow the artist to continue the feed of ink, or to let it run dry. This produces a lighter, rough line, similar to that of the reed pen when its ink is almost expended (Plate 3.20).

The nylon-tipped pens are useful for some drawing purposes and are favored by those who like a bold, quick-maneuvering line. Their line variety is quite limited and is incapable of the fineness possible with most other pens. Even those claimed to make fine lines are heavy compared to all but the felt-tipped pens.

*Plate 7.24*

*Auguste Rodin* (1840–1917). St. John the Baptist. Pen and ink.
COURTESY OF THE FOGG ART MUSEUM, HARVARD UNIVERSITY.
GRENVILLE L. WINTHROP BEQUEST.

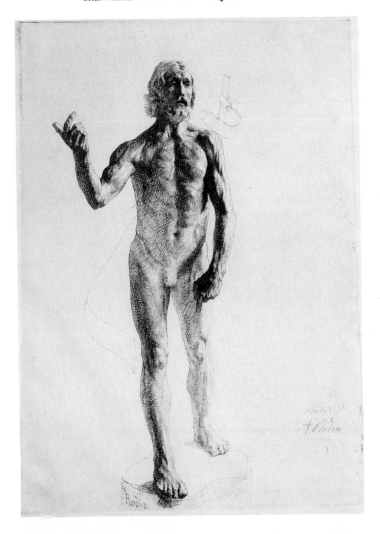

## BRUSHES

There are two basic types of artist's brushes: the stiff, coarse-haired *bristle* brush—generally hog bristles, but also of nylon "hairs" (for painting in acrylics); and the soft-haired brush made of various animal furs—especially sable and squirrel (*see* Illustration 7.8).

The term *sable* is sometimes applied to any soft-haired brush, which can be confusing. When selecting a sable brush, be sure it *is* sable. The best sable brushes, sometimes called *red sable,* have a golden-reddish color and are very springy and resilient. Less expensive "sable" brushes may contain squirrel hair, which is not as reddish in color, or as springy in use.

Bristle brushes are used for painting and drawing with any wet medium, but its use with watercolor is rare. Avoid vigorous scrubbing movements with a bristle brush on paper, because the bristles' stiff, scratching nature damages its surface—unless the paper has been previously prepared with a foundation coat of paint, called a *priming.*

There are several classifications of bristle brushes, determined by shape. *Flats* and *brights* are square-ended brushes, usually available in eighteen sizes, differing only in the somewhat greater length of the flats. *Filberts* are rounded at the ends, and somewhat fuller in body. *Rounds,* of any size, are rather long, have pointed tips, and round bodies. Filberts and rounds are usually available in twelve sizes. Bristle brushes are sized according to a scale with *1* as the smallest brush, and 18 or 12, depending on the classification, the largest. Other stiff-haired brushes sometimes used include the stencil brush, helpful in producing certain textural effects, and the common house-painting brush, for preparing surfaces, and for very broad washes.

When used with opaque paints, bristle brushes are stiff enough to push, spread, and pass through heavy concentrations of paints without splaying out, becoming bogged down, or wearing away quickly, as any soft-haired brush will. The round bristle brush works well as a line instrument when used with thinned paint or ink.

But the soft-haired brushes have always been preferred in drawing. Made from hairs of various animals, these come in various shapes and sizes. In the Orient, where the brush is also a writing tool, the hairs commonly used are goat, rabbit, and badger. Wolf and horse hair is also used for larger brushes, as is hog bristle. For writing and drawing purposes, the hairs are set into a bamboo shaft, the hairs coming to a point when wetted.

Some larger brushes are set into wooden handles. The beautiful calligraphic results possible with the Oriental brushes have long attracted Western artists. Softer and somewhat less springy than the sable brush, they work best when held at a right angle to the paper. Very slight pressure is required for the release of ink. The variety of line possible with the Oriental brush ranges from one at least as delicate as a fine pen line to very wide, painterly strokes. In this respect, Oriental brushes rival the best round sable brushes. Both their softness and quick release of ink discourage re-working of a line, and call for a concise and resolute approach.

The round sable brush is one of the most versatile and popular instruments for drawing in brush and ink or watercolor. It also works well with casein or tempera, when these are slightly thinned, but like all soft-haired brushes, it performs poorly with acrylics. This medium must be applied with a stiff-haired brush, preferably nylon.

All sable brushes come with short handles, more often used for drawing with ink or watercolor, and long handles, for use in easel painting. Their sizes commonly range from the tiny *0*, about $\frac{1}{32}$ of an inch wide, to size *12*, which is almost $\frac{1}{2}$ inch wide. Some manufacturers offer even larger sizes. Because the larger round sable brushes ably do any work the smaller ones can—sometimes better—it is best to buy fewer, but larger brushes, than the other way around. A good, all purpose selection might be sizes 2, 4, 6, 9, and 12.

Good quality round sable brushes—even the larger ones—can produce lines finer than those of any pen. Like the Oriental brushes, a single brushstroke can vary widely in width.

Besides the round sable, there are full-bodied oval shaped sables, and another group of flat, square-ended ones. Both are designed for broader handling—the largest one for brushing in large washes of tone, or for wetting the surface.

Brushes of the same shapes and sizes are available in squirrel hair, or in mixtures of various hairs that possess some of the qualities of the sable ones. Other soft-haired brushes used in drawing are the group call quill brushes. These are long, round, squirrel hair brushes designed for lettering and various decorative purposes. Their longer bodies and pointed ends allow for very delicate drawing.

This hardly exhausts the types of brushes for use in drawing. There are many more, coming in a wide selection of shapes, sizes, and materials, used for sign writing, lettering, or other special painting functions.

As brushes wear down, they can be assigned other duties. It is hard to imagine a worn brush, however battered, that cannot be used in some way. Indeed, brushes can wear down to shapes that suit an artist's needs better than new ones. Such wear and tear of usage ages a brush in a "healthy" way. But letting brushes dry without washing them thoroughly, or standing brushes, especially soft-haired ones, upright in containers of water, can damage them so they are less useful for other purposes.

Brushes are fast-moving tools that take time to learn to control. In the case of the soft brushes, especially the sable, their sensitive responses record the slightest hesitations and idiosyncratic behavior of the user's hand.

## THE SUITABLE SURFACE

The character of the paper support also helps form the drawing. As the artist transfers his responses to the paper, its submission or resistance to a particular medium—the paper's tooth, absorbency, and tactile properties—influence the artist's tactics and even the expressive nature of the work itself. The beginning student seldom reflects on a paper's physical composition, weight, absorbency, or surface character, although he is sometimes amazed at a particular paper's influence on his drawing. He may also be amazed by the many sizes and kinds of paper in the art stores. Some are permanent papers that will not yellow and crumble with age; others will begin to darken and fall apart in a few years. Some are durable and can take rough handling; others are quite fragile. Each has certain uses, some quite specialized, others adaptable to a variety of ways, and a variety of media.

The most permanent papers—usually the toughest and most capable of accepting the widest range of media—are made of linen rag. They are also the most expensive, particularly the handmade papers. The least permanent papers are made of wood pulp, untreated by any chemical preservatives.

Papers are classified according to weight and surface character. The figures designating a paper's weight refer to five hundred sheets, called a *ream*. Thus, a thirty pound paper is one whose ream weighs thirty pounds. Newsprint, the paper used in the publication of newspaper, is a thirty to thirty-five pound paper. Some of the heavier papers, those used primarily for watercolor painting, but also very well suited to drawing, can

weigh up to four hundred pounds, and are nearly as stiff as cardboard.

There are three basic classifications of rag paper surfaces:

*Hotpressed:* the hard-surfaced, smooth, and sometimes even glossy papers; best suited to pen and ink drawing, especially very exact or delicate work. It is the least absorbent of the three types.

*Coldpressed:* papers with a moderate tooth and absorbency; they accept all media well, and are the most frequently used. They vary somewhat according to the manufacturer's formula, but it is hard to find a coldpressed paper that is not an appealing surface for drawing.

*Rough:* papers with the most pronounced tooth; they are least accommodating to fine or exact pen and ink drawing, although some artists enjoy drawing on such surfaces. They give ink and watercolor washes a brilliance and sparkle not possible with other surfaces.

Rag papers are sold in single sheets and blocks. The sheets in the blocks are attached on all four sides to assure the flattening out of a paper's buckles when water-based media are used. Water, by itself, or as part of ink or thinned paint, swells the fibers, causing ripples in the paper. Although not generally noticeable in pen and ink drawings, unless the lines are densely massed on a lightweight paper, not much water is necessary to cause ripples on most papers. The heavier the paper, the more water it can tolerate before buckling. Papers lighter than 140 pounds will buckle even with a quite restricted use of water. If heavily saturated, even 140 pound papers show some rippling. Papers of 200 pounds or more will not buckle no matter how wet.

To prevent buckling, soak the paper for a few minutes. Secure it to a stiff board such as fiberboard by taping it on all four sides with gummed tape. If a second paper is similarly stretched on the back of the board, warping of the board is much less likely, and a second sheet is ready for use.

For extensive use of opaque paints, only the heaviest papers should be used. Various kinds of posterboard, cardboard, *illustration board,* or other stiff paper boards are more appropriate supports for large amounts of thick paint. Unless, like illustration board, such supports are covered with a facing of drawing or watercolor paper, they may require priming to provide a more receptive surface and to help hold the paint. An acrylic *gesso,* designed as a base for paints, makes a good surface for both wet and dry media.

Illustration board is available in the three designations for rag papers. These boards are made of an inexpensive backing of pulpboard, upon which is mounted a thin sheet of drawing or watercolor paper. Some are made with all rag surfaces. The Strathmore Paper Company markets an illustration board faced on both sides by an all rag paper. The completed drawing can be stripped from the illustration board. Thus, the Strathmore board is really two illustration boards in one.

*Oriental papers* have a distinctive absorbent character. Often called rice paper, they are actually made from the inner bark fibers of a type of mulberry plant. Oriental papers contain none of the clay additives of many Western papers that are used to reduce absorbency, and are more prone to blotting. The steel pen can become enmeshed in such soft surfaces, but the soft-haired brushes move smoothly on them (Plate 7.18).

The term *bond* refers to a wide assortment of papers often used for writing and typing purposes. Bond papers vary in weight from thirteen to thirty pounds, and in surface from the slick to the moderately grained. They may be made either of woodpulp, rag, or various mixtures of both. All are excellent for pen and ink drawing, and those manufactured for general drawing purposes are receptive to most media. But their light weight makes extensive use of water-based media impractical.

Many drawing pads and sketchbooks do not identify the papers' ingredients. Advertised as "white drawing paper," or "all-purpose drawing paper," many are like bond papers in character. Most are heavier, usually between twenty-five and forty-five pounds. Their qualities vary according to their price. At their best, they are made of 100 percent rag.

A good paper for practice drawings with dry media is the newsprint paper, mentioned earlier. It is an impermanent paper of a warm, light gray tone and can be either smooth or moderately rough. The rough-toothed paper has a more interesting character and is generally slightly heavier. Only the harder degrees of graphite do poorly on newsprint paper, appearing rather weak, and easily tearing into its surface. Here, only graphite pencils of the higher *B* designations should be used.

*Bristol* and *vellum* are heavyweight papers, often made of woodpulp, but available in 100 percent rag of postcard weight, they offer especially fine surfaces for pen and ink, brush and ink, paint, and graphite. Often sold in pads of various sizes, they are a most serviceable paper for almost any medium. These papers are usually

treated with preservatives and chemically whitened. They are tough papers; all are long-lasting, many are permanent. The bristol paper has a hard, glossy surface and may take the softer abrasive media less well than vellum, which has a subtle tooth.

*Charcoal paper,* usually between sixty and seventy pounds, is a fairly substantial paper, capable of the rough handling that drawings in charcoal, chalks, and the other dry media often entail. Its rough tooth and tough "skin" takes erasures well. These papers always have some rag content, the best ones are all rag. It is available in light colors as well as white.

*Tracing paper* is a semi-transparent, very light-weight paper used for drawing or for developing a drawing placed underneath it. It is sometimes useful to place a sheet of tracing paper over a work in progress, to experiment with drawing ideas. There are, of course, many other types of paper available. The various kinds used in the printing of etchings and lithographs, the clay-coated papers such as cameo, and more recently, papers made of spun glass, plastics, and re-cycled paper are some that artists have found useful.

At first, the student need not extensively explore paper supports or drawing media and their tools. Although a drawing's worth depends partly on the way materials are utilized, the fundamentals of perceptual understanding, and a broadened knowledge of the options of response come first. A deep concern with the materials of drawing may, in the beginning, cause an over-dependence on their powers. The more we know, the more we demand of ourselves and our materials. The exploration of new media, tools, and surfaces tends to expand as the limits of familiar materials become restrictive, and as our comprehension and curiosity expand.

For the beginning student, a serviceable selection of papers could be: an 18″ × 24″ pad of rough-toothed newsprint paper; a pad of a good grade of bond or other white drawing paper, also 18″ × 24″; a medium sized pad of bristol or vellum (11″ × 14″ or 14″ × 22″); several sheets of charcoal paper, of which one or two may be colored; a medium sized pad of tracing paper; and one or two sheets of the heavier, cold-pressed all rag paper. A sketchbook, not smaller than 8″ × 11″, but preferably larger, is also basic.

A sketchbook is more than another surface for the exploration of media. It should be, for the student, as it is for many artists, a kind of private, visual journal. It is also a portable studio-laboratory. The sketchbook is a place for private speculations and experiments. With no one look-ing on, we try things we would hesitate to try in a classroom, or on the large drawing pad which feels more public. The sketchbook is a place to experiment with whatever interests us in the subject—or in ourselves. These uses of the sketchbook help us develop a better grasp of what our strengths and susceptibilities are (Plates 7.25, and 7.26).

One useful form of the sketchbook permits the user to fill it with any combination of papers desired and remove completed drawings. Surprisingly, this kind is not usually found in the art stores, but in the larger stationary stores. These are called *spring binders* and are available in several sizes. In effect, it is really a permanent, spring operated book cover, filled and changed as needed (Illustration 7.13).

*Illustration 7.13*

*Filling spring-binder sketchbook. Any combination of drawing papers are cut to size and placed in the black folder. Covers are folded backward, as in A. Folder is inserted and covers released. This type of sketchbook has the additional advantage of lying flat when open, as in B.*

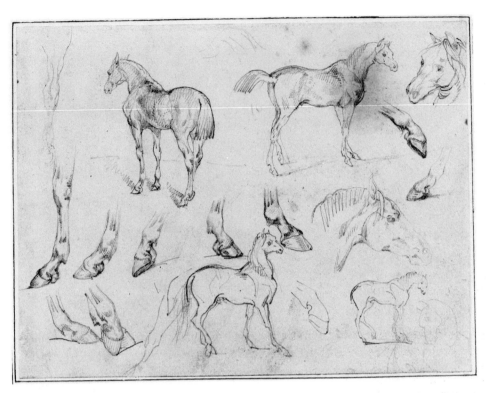

*Plate 7.25*

*Théodore Géricault* (1791–1824). STUDY OF HORSES.
Pencil.
COURTESY OF THE ART INSTITUTE OF CHICAGO.

*Plate 7.26*

*John Ruskin* (1819–1900). LEAF CLUSTER.
Pencil and watercolor.
COURTESY, MUSEUM OF FINE ARTS, BOSTON.
GIFT OF DR. E. STANLEY ABBOTT.

## MIXED MEDIA

As mentioned earlier, some mixed media drawings are planned, and some evolve from the interactions between the artist, subject, and materials. When planned, the media should be used to help convey responses and intensify the drawing's visual and expressive meaning. They should not be combined for mere caprice, or for a show of technical facility as ends in themselves. Earlier, too, it was pointed out that limitations imposed by custom or tradition on the use of media are unnecessary restrictions. These two extreme attitudes about media—freewheeling show, or unquestioning obedience to past practice—both restrict responses that extract and intensify a subject's meaning. If, in Emile Zola's words, "art is life seen through a temperament," then it is our perception, our intellect, and our intuition, not our attitudes of play with, or duty to the tools of drawing through which life— nature—is interpreted. We should use those media that help us make our responses clear, gaining from them any influences that enhance our meaning. Only when we recognize that a medium's inherent limits keeps us from realizing our goals—before or after a drawing is underway—should we turn to other media.

For some artists, a medium's limits are an exciting challenge. Some very notable artists have achieved deeply expressive work in a single medium. Such artists accept the medium's limits (not the man-made "rules" concerning media) as if they were working in a form such as a sonnet in poetry, or a sonata in music. Their interest in drawing is, to a degree concerned with seeing what a particular medium can be made to do. This is a valid and even praiseworthy goal, as long as it does not stifle responses that cannot be expressed by the medium in use.

The student should also try to explore and push each medium to its limits, and he must be slow to decide its limits have been reached. He should use it in every possible way before turning to other media. The effect the limits of a medium has on our drawing—what it will and will not do—stimulates meaningful innovations in its use. But, when certain visual, expressive, or intuitive impulses demand more than a medium can give, other media should be used to complete the drawing.

As mentioned earlier, any combinations of media and materials can be used together, except those incompatible for chemical or technical reasons. Acrylic paints cause some inks to curdle when mixed with them; casein on thin supports will promptly crack; oil-based media can rot the fibers of unprimed papers; charcoal media, and some chalks, drawn upon dense layers of graphite, will not adhere; ink lines drawn upon any dried water-based paint film except an acrylic paint, will spread and blot. There are other incompatible mixtures. Unfortunately, most are learned the hard way. Often, only two or three media are used in the same drawing. More than three are hardly ever necessary. Considering what any one medium can do, to use more than three suggests inexperience, not need.

The thick brushstrokes of tempera in John Bageris' "Infanta (After Velasquez)" (Plate 7.27), interacting with the lean, fast-moving graphite lines, are basic to the drawing's theme. Lines or paint strokes alone could not convey the overlapping, darting, "hide and seek" quality that the artist's responses to the Valesquez painting demanded. This interplay between thick and thin, fast and slow, and the drawing's overall shimmering immediacy conveys the impression of the Infanta forming and fading. The way we are teased by the forms welling-up and subsiding into the background's light values, is part of the artist's interpretive aim. Here, the choice of media and the way they are used is not arbitrary, it is essential.

Similarly, Lyonel Feininger's drawing (Plate 7.28) in chalk, and black and gold washes, conveys very economically the fusion of a group of houses with their cloud-like surroundings. Applied to a wet surface, the washes fuse into each other and into the fibers of the paper, making a soft contrast to the rough chalk lines. Here, again, the choice of media and their use intensifies the artist's interpretation.

Today, the possible combinations of media, tools, and surfaces, are almost endless. Any group exhibition of drawings shows a wide variety of mixed media. Some are unusual, such as: lithographic crayons and watercolor on colored paper; brown wax-based pencils and sepia ink; casein, graphite, and conté crayon; fatty-based crayon, turpentine (as the crayon's thinner), and ink; white chalk and white ink on black paper; white acrylic and compressed charcoal on gray paper. Others are familiar combinations, such as ink or graphite, and watercolor washes; or charcoal and ink. Some combinations are not of mixed media, but instruments, as in Whistler's gentle drawing of a seated woman (Plate 7.29). Here, the light and dark tones in the woman's head, the tone of her shawl, and the light tones in the background and on the chair, are broadly brushed in with ink washes, to contrast with the ink lines. These tones soften the figure, and they

Plate 7.27

*John Bageris* (1924–    ). INFANTA (after Velazquez).
Tempera and pencil.
COLLECTION OF LUCY G. STONE.

Plate 7.28

*Lyonel Feininger* (1871–1956). BLOCK HOUSES.
Pen and ink, black and gold wash.
COURTESY, MUSEUM OF FINE ARTS, BOSTON.
GIFT OF JOHN S. NEWBERRY, JR.

hold the drawing together. Whistler could have achieved most of these results with just the pen, but not the contrasts of wet and dry, of actual and optical grays, or the splashy treatment of the woman's left arm enabled by ink washes.

Experiencing the feel of a medium, instrument, or surface is best accomplished in the act of drawing itself, but some free exploration helps to become familiar with many of their characteristics, limits, and combinations. The following exercise is intended as a general approach to the study of these matters.

### EXERCISE | 7A

Here, you will use only a few media, surfaces, and tools. The several exercises described suggest a style of media exploration adaptable to the study of virtually any medium, tool, and surface. Even so, possibilities for extensive exploration are too numerous to examine here, but the several exercises offered should point the way to fuller experimentation.

Here are three exercises, requiring the following papers: one sheet of bristol paper (or any comparably smooth support of the same weight, or heavier) approximately 14″ × 20″; one sheet of 18″ × 24″ white charcoal paper, the heavier the weight, the better; and one cold-pressed illustration board, 20″ × 30″.

In addition, you will need:

Stick charcoal, soft or medium
6B graphite pencil
Black wax-based pencil or crayon
Black water-soluble ink
Black acrylic paint
White acrylic paint
Chinese white paint
A fine, flexible steel pen, and holder
Number 4, round soft-hair brush, preferably sable
Number 5, flat bristle or nylon brush
Number 3, round bristle brush
A graphite eraser

Before beginning the exercise, get somewhat familiar with these materials by free manipulation. On some scraps of paper, preferably of different types, draw with these media in any way that interests you. Try to *feel* their tactile nature. The kind of vibrations felt by moving a charcoal stick across any surface is clearly unlike those of graphite or of a wax-based tool. Similarly, ink applied with a brush is a very different sensation from using pen and ink. Brushing

acrylic paint around with a soft-hair brush is quite different from using a bristle or nylon brush. To fully appreciate their differences, alternate media and tools every few minutes.

Do not attempt to draw anything during this manipulation period. Just try to observe their tactile differences, and the kinds of lines and tones they produce. Draw long lines and strokes. As you do, change the pressure to feel the kind of response the tool makes. Pens and brushes will react more to changes in pressure than abrasive media, but all media show the effects of such pressure—each in a different way. Try erasing some charcoal, pencil, and crayon lines. Crosshatch with each medium. Draw the smallest circle possible with each (without filling the center hole). At this stage, it is not necessary to mix the media, but it is often hard *not* to experi-

*Plate 7.29*
*James Abbott McNeill Whistler* (1834–1903).
STUDY OF MRS. PHILIP.
Pen and wash.
COURTESY, MUSEUM OF FINE ARTS, BOSTON.
HELEN AND ALICE COLBURN FUND.

ment with one medium over another. Let your curiosity guide you.

These first few experimental efforts are important. Just playing with these materials is instructive play. You will have already made some judgments about them.

***Drawing 1.*** Divide the sheet of charcoal paper into four, even, horizontal parts, and three vertical ones, making twelve divisions as in Illustration 7.14. In box 1A, use the 6B pencil to draw an even tone of approximately a 50 percent gray. Drawing lines adjacent to each other should produce an optical gray that needs no smudging. But it will be instructive to blend one-half of the lines in the box to study the effects on value and texture. Do the same with the stick charcoal, in box 2A, also blending the lines in half of it. You may find that the blended half has become lighter. Rework the blended half until it reaches the tone of the other half.

*Illustration 7.14*

In 3A, use the wax-based medium, again establish exactly the same value as now appears in 1A and 2A. Here, you will not be able to blend or erase, and this should be borne in mind when you try to match the value of the other boxes.

When you have filled the three boxes, use these media freely to draw other lines in these boxes. For example, you should use the charcoal and crayon in 1A, and so on. These lines may mix with each other, as well as with the original lines in any given box. Some of the mixtures will work better than others. The order in which they are drawn is important. Graphite may do well over charcoal, but charcoal may do poorly over graphite. In part, it depends on how much the paper fibers have been filled. You may erase, or continue to add layers of line, in any order. You can even try to scrape some of the crayon off with a pen-knife or razor blade, and rebuild the tone of 3A with a combination of these

media. Use your imagination freely. The original medium of each box may be partially or completely covered by such additional drawing. You may wish to draw some simple volume or texture in each, or try to establish some gradual transitions in value with differing mixtures. Continue until you cannot think of any other combinations or drawing tests to put these media to.

In 1B, using graphite, start with the darkest tone the pencil can produce, and gradually lighten it as the tone moves across the box from left to right, ending just short of the box's edge, leaving a bit of the white paper on the far right side. This should be a very gradual value change. If any abrupt changes in value are visible, rework the tones until the strong dark on the left appears to fade away at an even rate and end just short of the right side of the box. Do the same in 2B, using charcoal, and in 3B, with crayon. Do not erase to establish these graduations. Notice the differences in the value and character of the three dark areas, and that each medium requires a different handling to produce these tones.

In 1C, make a tonal drawing of any simple object, such as an apple, shoe, glove, etc., using the 6B pencil. Draw the same object, from the same view, in 2C using charcoal, and again in 3C with crayon. Again, notice that each medium suggests a different handling. Because the 6B pencil cannot produce darks as easily as the crayon, more pressure is required. Because the crayon so easily produces strong blacks, less pressure must be used for lighter tones than with graphite. Because stick charcoal is a broad tool, small details are not as easily drawn as with the other two media. The crayon's resistance to erasure sets up still another condition of handling. Take advantage of what each medium offers. If crayon can produce bolder values, use this to show a more dramatic range of lights and darks. If charcoal can be manipulated on the page in ways that the other two media cannot, do so to extract from the subject qualities that charcoal can state by these manipulations. If the graphite pencil can state details more specifically than the other media, use this to explain the smaller planes and tones. Let their limits and characteristics guide your tactics.

Leave the bottom D row blank. You will complete these boxes after the next drawing.

***Drawing 2.*** Using the bristol paper or its equivalent, again divide it as in Illustration 7.14. In 1A, draw a value of about 50 percent, using pen and ink. The lines can go in any direction

or can be cross-hatched. You can use the box to try several pen and ink textures, varying the lines as you wish—so long as its overall value is maintained. In 2A, draw the same value with the sable brush and ink diluted in water to produce a dark gray, but fill only one half of the box. In the other half, use the number 5 flat bristle brush and undiluted ink. Dip just the tip of the bristle brush in the ink, and, with light back-and-forth brushing on a scrap of nonabsorbent paper, remove almost all the ink from the brush. When the brush is nearly dry, it will produce a stroke of very fine, black lines that can be brushed into the other half of 2A, producing an optical gray. This is called *dry-brush.* The wide brushstrokes of fine lines so produced, look somewhat like chalkstrokes. They allow for a gradual building up of values (Illustration 7.15). It can also be done with soft-hair brushes

*Illustration 7.15*

*Examples of drybrush. The strokes in A were made with a bristle brush; those in B, with an Oriental, squirrel-hair brush.*

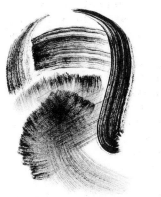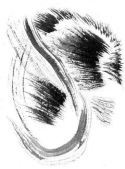

and ink, or thinly diluted paints, but acrylic is less adaptable to dry-brush than the other paints. You may wish to use this manner of application later in this second drawing. In 3A, mix ink and Chinese white with enough water to allow for easy brushing, and apply the 50 percent gray by using any or all of the three brushes. This will be an opaque layer of paint, but a quite thin one. Now, as in Drawing 1, rework these boxes in any way you wish, mixing media to produce volumes, textures, or values.

In 1B, use pen and ink to make the same kind of dark to light tonal change as in Drawing 1. Do the same with brush and ink in 2B, *after* you have wetted the box with clear water applied with a clean brush. This will make the ink

spread. The more water, the more the ink will spread—and the harder it will be to control. Therefore, do not lay in any washes until the box is only faintly damp. If an area becomes too dark, a clean brush can pick up much of the tone while it is still wet. In 3B, draw the same kind of value transition, using opaque mixtures of Chinese white and ink. This time, use only the sable brush, and draw fine lines with the thinnest opaque mixture. If the mixture is of the correct consistency, the paint should easily flow off the brush with no sense of "drag." Dry-brush will work well here.

In 1C, using pen and ink any way you wish, make a tonal drawing of any simple object. Using brush and water, draw the same object in 2C. This can be done in the wet-in-wet manner used in 2B, or in any combination of wet and dry brushstrokes. In 3C, the same subject should be drawn in any opaque manner with ink, Chinese white, and brushes. The experience of the first two rows should help you decide how you wish to handle these three drawings in the C row. Again, leave the D row blank.

Now, return to the D row of Drawing 1. In 1D, using brush and ink and Chinese white, try to *imitate* the drawing in 1C exactly. That is, your drawing in 1D should look as if it had been done with the 6B pencil. In 2D, use brush and ink (and water, if you wish) to reproduce the drawing in 2C exactly. Again, you want to imitate the medium used in 2C. In 3D, use only pen and ink to reproduce the drawing in 3C. If you are working with other students, drawings can be exchanged at this point, so that you can try to reproduce someone else's row of C drawings.

When the D row of Drawing 1 has been completed, return to the D row of Drawing 2. Again, drawings can be exchanged in this last part of Drawing 2. Now, use only the crayon to reproduce the drawing (and the medium) of 1C of Drawing 2, use only charcoal to do the same with the drawing in 2C, and the 6B pencil for the one in 3C.

In both sets of drawings in the D row, you are *straining* the media by trying to get them to imitate each other. In most cases, you can only get close to the original texture and character, but it may surprise you to see *how* close.

In Drawings 1 and 2, you experimented with the media and materials and tried to feel and recognize their character, strengths, and limits. You worked within those limits, taking advantage of their strengths, and, finally, worked *against* their limits, forcing them to "become" another medium. It is this full testing of a medium's range—what it can and cannot do—that provides

us with a sense of its nature, its range, and its potentialities, for use.

***Drawing 3.*** Turning the illustration board vertically, divide it into three horizontal sections of ten inches each. Divide it vertically in half (Illustration 7.16). Using black acrylic, the number five flat bristle brush, and water, make a gradual tonal change from black to white, allowing the white board to be visible on the far right side of 1A, as in the earlier tonal changes. Thus, as the tone lightens, you will use less paint and more water. In 2A, do the same, but use both black and white acrylics. When completed, both should be smooth graduations of tone. This will be less easily accomplished in 1A. Once they have dried, dark areas cannot be removed. Therefore, adjustments in 1A must be made before the paint dries. Here, it is better to start with the lightest tones and work toward the darks on the left. If, after drying, 1A or 2A need further tonal adjusting, use both Chinese and acrylic white, and notice the difference in the covering power. After completion, use both of these boxes for any further experiments with any of the other media.

*Illustration 7.16*

Use 1B as an area in which to experiment on this different surface with all of the media you used in Drawings 1 and 2. In 2B, wet the illustration board lightly with clean water. When just slightly damp, lay in a thin, semi-opaque wash of 50 percent gray. When this has dried, use both of your bristle brushes however you wish to draw any simple object in black and white acrylic.

In 1C, using black acrylic, any or all of your three brushes, and water, broadly lay in the volume-summary and primary planes of another observed object. This should be done within five minutes. Continue to develop the drawing in any one of the abrasive media used earlier. In 2C, using any combination of media, but omitting acrylics, and any tools except brushes, try to duplicate the drawing in 2B exactly. In place of brushes, you can use your fingers, rolled up paper, cotton swabs, sponges, etc. You may want to try duplicating 2B with abrasive media alone —perhaps using only charcoal.

Again, you have explored some materials by going with and against their character. But this still does not exhaust the possibilities. Acrylics can be used to imitate the various abrasive media, one combination can be made to duplicate the texture and character of another, different surfaces would effect the behavior of both the media and the tools, different tools would affect the media, etc. The possibilities are endless.

At the beginning, it is better to probe fewer media and materials and go deeper. Here, a suggested approach for the study of any media, tool, or surface is offered to help you when, as your studies progress, you seek them out. Although all our materials continue to unfold their nature as we use them, the few hours spent in testing, forcing, probing—in discovering—can provide an understanding that may only come in bits and pieces over a long period of time. It may be months or years before a student tries to mix— in one drawing—casein, ink, and chalks, only to find it works better than anything else he has used for conveying his meanings. But if, upon purchasing caseins, he takes the time to experiment, he can learn this sooner.

The media and other materials of drawing are the physical agents of our visual and expressive meanings. They do not themselves discover or invent. But, through their characteristics— their strengths and limits—they do suggest. To understand these suggestions, we have to learn to understand *and* respect them. One without the other will not yet produce control.

In the act of responsive drawing, materials either help or hurt our interpretive efforts—they serve us well if we know them well—but they are never neutral.

# 8

# Visual Issues

## A DEFINITION

We have seen that responsive drawing concerns *what* is drawn and *how* it is drawn, and that these concepts are complemental. Each mark on the page not only helps define our interpretation of a subject, but also, by its physical characteristics, conveys a particular kind of action, or energy. However, these lines and tones do more. They affect each other in ways that create the relationships and forces that give a drawing its own order, character, and, consequently, its worth. To expand an earlier observation about line, *all* the marks that constitute a drawing *define, act,* and *interact.* Each mark is a part of the drawing's organization and expression.

This chapter concentrates on those factors that influence a drawing's organizational aspects, that is, its composition or visual design. To separate a drawing's organization from its expression risks distorting our understanding of both. Generally, each mark simultaneously affects a drawing's visual and expressive meaning. Indeed, the best drawings are those in which design and feeling are fused. Therefore, we must recognize that this chapter's emphasis on visual matters, and the next chapter's emphasis on expressive ones are temporary stresses to help clarify our understanding of each, and deepen our realization of their interrelated nature.

Some cultures have always understood drawings as systems of design. The single Italian term, *disegno,* describes both drawing and design, as does the French, *dessin.* In fact, it is impossible to regard *any* drawing as only descriptive, even when nothing more was intended. Seeing and sensing other relationships and the forces they generate is unavoidable. Design is intrinsic to any collection of marks, and is thus, a given condition of drawing. How well integrated the marks are determines the quality of the design.

In a good design, the marks produce relationships and forces that convey a sense of balance or equilibrium between its parts, and between them and the page. Additionally, all of the design's components have strong, interacting bonds of dependence and affinity that create an overall sense of oneness, or *unity.* But both of these conditions can exist in very dull drawings. A drawing of a brick wall or a venetian-blind, unless the overall sameness is relieved by some variety, is boring. A drawing's stability and unity must emerge from the stimulating action of contrasts, as well as the union of similarities. We need diversity as an antidote to monotony. General principles in art are best approached cautiously, but it seems safe to assume that whatever else art is or may be, it will never allow disorder or bore-

dom as goals. In drawings where stability and unity are achieved by interesting contrasts, similarities, and energies, we sense that *any* change will destroy their balanced resolution.

## RELATIONSHIPS AND FORCES

The preceding chapters examined the measurable relationships of shape, volume, scale, direction, placement, line, texture, and value. These measurable relationships helped us analyse a subject's physical properties. Although compositional matters were touched on, our main concern was in learning to see the subject's actualities, to more fully respond to its volumes and its immediate spatial environment in a personal and inventive way. Now we will investigate relationships that stabilize and unify volume and space within the bounded limits of a page in ways that engage the entire page.

We have seen that all of a drawing's marks must be made of *line, value,* or both, and that these in turn form the several graphic factors of *shape, volume and space,* and *texture.* All of the visual issues that concern composition result from the behavior of these five basic factors. They are collectively called *visual elements.* In discussing the relational possibilities of visual design, we will need to examine these elements further. As we do, remember that the term "element" refers to anything from a line to the volume of a house.

In the preceding chapters we also examined some visual forces: the sense of gestural movement within a form, or between forms, *some* of the plastic activities of the elements, the actual or inferred forces of structural masses, and the sense of forms being related by some enveloping flow or plan. Our main concern, then, was the way such forces could increase our options for response to volumes in space. As we shall see, there are other kinds of forces that, like these, are powerful factors in visual design. Unlike the visible relationships between elements, the various plastic or sensory (and emotive) forces that these relationships generate are themselves invisible. We only sense or intuit them.

The possibilities for relationships of similarity or contrast between the elements are vast. In fact, in the greatest drawings, the visual activities of the elements seem capable of endless interactions. Great drawings are never "used up." Relationships can be obvious or very subtle. Each line or tone in a drawing participates in at least a few, and sometimes many different relationships, producing different visual forces. These

forces are as unlimited as the relationships that create them. Being so much a matter of intuited impressions, they elude verbal descriptions of more than their general kind of behavior.

Relationships are always based on similarities of some kind, but depend on contrasts to be effective. Where everything is bright, nothing is. We do not usually regard a white sheet of paper as being bright, we regard it as blank. Not until dark tones appear on the page does its tone have any visual meaning.

A single vertical line drawn upon a page creates a contrast. The line is unlike any other part of the paper (though it is similar in direction to the vertical borders of the page). When a second line is drawn parallel to the first, an obvious similarity is created between them. Two more lines drawn at right angles to the first pair, are like them as lines, but contrasting in their position. If the four lines form a square, the lines are related to the page and each other by the shape they make (Illustration 8.1). Thus,

*Illustration 8.1*

units can show contrast on one level of relationship and similarity on another. When, as in Illustration 8.1, similarities overpower contrasts, the result is boredom. When contrasts overpower similarities, the result is chaos. A drawing's final resolution as a successful design must avoid both of these extremes. Its contrasts may threaten, but should never succeed in destroying balance and unity. The artist must resolve the confronting contrasts into some coherent system of relationships.

We saw in Illustration 8.1 that elements can participate in several relationships simultaneously. Although unlimited in their visual interactions, relationships can be roughly grouped into ten discernably different categories. These categories of relationships and the general kinds of forces they generate are:

1.  *Direction:*
    The sense of gestural movement, when like or unlike elements relate because of a discernable continuity of their positions in the picture-plane. Such elements seem to move in various straight

or curved paths, and even suggest their speed. Elements can "amble" along or they can convey powerful velocity. The more unlike elements are, the weaker and slower the sense of movement; the greater their similarity, the stronger their directional thrust. For example, a widely varied collection of bottles and boxes unevenly placed on a shelf, because of the marked contrasts in scale, shape, and placement between the objects, suggests a slow, weak sense of movement. But identical bottles uniformly lined up on a shelf, suggest a faster, stronger force of movement (Illustration 8.2).

2. *Scale:*

The similarity or contrast of size between elements. When other factors are alike, the larger of two or more elements will dominate the smaller ones. For a sense of dominance to occur, the larger elements must relate in some way to those they dominate. In Illustration 8.3, the contrast between the two houses, and between the two trees, is greater than that between the large tree and small house, or the large house and small tree.

3. *Shape:*

The similarity or contrast of shape between elements. In Illustration 8.4, the shapes form one set of relationships because of their similarity of scale, and another set because of their similarity of shape.

4. *Value:*

The similarity or contrast of value between elements. In Illustration 8.5, the shapes form one set of relationships because of their similarity of scale, another because of their similarity of shape, and still another because of their similarity of value.

5. *Rhythm:*

The sense of a common movement between several like or unlike elements. Rhythm relationships are often similar to those of direction. Usually, rhythms are sensed among a group of elements repeating a similar movement. The more often lines, shapes, etc., repeat the same curve or tilt, the stronger the sense of rhythm. Rhythm also occurs when elements appear at more or less regular intervals, generating a sense of beat. The repeated folds in a long, flowing dress, or the uplifted limbs of a tree, are examples of moving rhythms; a row of glowing street lights at night, or the buttons of a coat are examples of a "beat" rhythm. The sense of rhythm is one of the stronger forces in unifying a drawing, and can weave together many otherwise unrelated elements (Illustration 8.6).

6. *Proximity or Density:*

When like or unlike elements are seen as belonging together because they are closer to each other than to other elements in the pictorial field. In a drawing of forms as unlike as leaves, locks, and cups, they will appear as related when one or

*Illustration 8.2*

*Direction. The sense of slow movement occurs when a direction is comprised of complex or varied components (A). When components are alike, and when they appear in a regulated sequence, the sense of fast movement is conveyed.*

*Illustration 8.3*

*Scale. Relationships of size are more clearly discerned between like forms.*

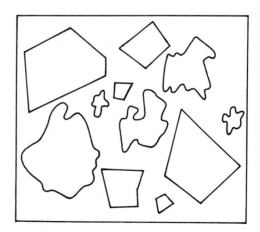

*Illustration 8.4*

*Shapes related by similarity and scale.*

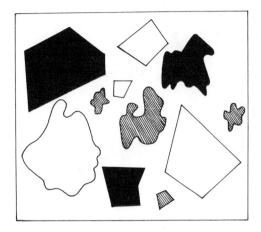

Illustration 8.5

*Like values can relate forms of various sizes and shapes.*

**A**

**B**

Illustration 8.6

*Rhythm. In A, moving rhythms relate the leaves, chair, gown, hair, and curtain. In B, the boats, paddles, and poles create beat rhythms as well as moving ones.*

more clusters of these forms is separated from other forms, or surrounded by forms unlike any in the cluster (Illustration 8.7). It is nearly impossible to overcome the influence of strong groupings. We cannot see an apple in a bowl of fruit as separate from the rest.

7. *Closure:*
When elements (often line) are so close, they appear to touch each other or a border of the page,

or seem to complete a shape. Closure can be a compelling illusion. It is difficult to disregard the circular "shape" a ring of dots suggest. Although no line delineates the shape, we sense its presence (Illustration 8.8).

8. *Character:*
The similarities and contrasts of elements because of the character—the artist's handling—of the lines, shapes, and values that form them. For example, two very similar shapes may contrast in the way they are drawn if one is carefully rendered and the other is loosely stated. Conversely, in a drawing where everything is broadly and loosely suggested, two unlike volumes, even located far apart on the page, may relate if both are highly detailed in their execution.

9. *Weight:*
When elements convey a similar or contrasting weight because of the sense of gravitational pull. All drawings convey a sense of gravity at work among the elements. Gravity is more strongly felt in three-dimensional drawings than two-dimensional ones, but it is never absent as a visual force.

An element's weight is affected by its position in the pictorial field. When located near a drawing's edge, an element appears to require more counter-balancing weight than an identical one located at the drawing's center. Generally, elements to the right of center seem heavier than the same elements placed to the left of center.[1] As shown in Illustration 8.9, size, value, and clarity also influence the impression of weight.

10. *Tension:*
When two or more elements, or parts of the same element, opposed or attracting in some way, suggest some kind of impending action. The participants of a tension often share strong similarities in other respects, but seem poised and about to attack or pull away from each other. They may appear about to tug at, pull away from, or press against each other. Elements in tension suggest a dynamic "awareness" of each other. Although opposition is often their basic stance, they always suggest a magnetic attraction. This dual relationship makes elements in tension seem to pulsate. Often, the members of such a relationship are roughly equal in their impact in the pictorial field. Tension can be sensed between elements nearby or far from each other, and between confronting groups of elements. Tension is also sensed between elements that seem to support or unbalance each other, or when elements are engaged in contrasting relationships, such as movement. Tension can occur within a single element, as, for example, the tension we sense in the heavy, rounded bottom of a waterdrop shape (Illustration 8.10).

[1] Rudolf Arnheim, *Art and Visual Perception* (Berkeley and Los Angeles: University of California Press, 1954), pp. 1–26.

*Illustration 8.7*

*Proximity. Unlike objects can be related by placement.*

*Illustration 8.8*

*Closure. Although dots and lines do not connect, we complete the connection to understand their collective configuration.*

*Illustration 8.9*

*Weight. Scale (A), value (B), and clarity (C) affect the sense of weight.*

*Illustration 8.10*

**Tension. Forms in tension, whether they attract or repel each other (or parts of themselves), share a dynamic bond. In A, tension is felt at the base of the shape. In B, the black and white ovals, and the black "stems" forming the white oval (through closure), convey tensions between themselves. The ambiguity of the negative-positive relationship of all the black and white shapes also creates a sense of tension among them. In C, tension is felt between the forms "struggling" for balance; in D, between the two attacking shapes. In E and F, tension is felt between the two diverging shapes; in G, between the two converging ones.**

A drawing's balance depends on the relational forces of its elements. Although relationships of weight are important to the balance of any drawing, its final resolution as a successful design is not, as sometimes assumed, primarily a balancing act of weights. Its equilibrium is determined as much by the forces of direction, rhythm, tension, etc., as by gravity.

The balance between a few elements can be readily judged, but as more relationships and forces enter the configuration, they generate still others by geometric progression. The artist does not see or even sense them all. He is guided toward equilibrium by an overall sensitivity to a drawing's "rightness" of balance—as much a matter of intuition as intellect. As with any other aspect of responsive drawing, its design results from the negotiations between facts and feelings.

## THE CONFIGURATION AND THE PAGE

When the artist begins to draw, force-producing relationships begin between the elements and between them and the page. These relationships exist as two- and three-dimensional events simultaneously. Sometimes, relationships that are two-dimensionally complemental with the drawing's design on the page conflict with three-dimensional meanings, and vice versa. For example, the eight shapes in Illustration 8.11A relate in a balanced, unified way. There is a gradual pro-

gression in their scale, their several directions and abutments offer interesting variety, and the design of the two larger shapes embracing six smaller ones form a discernible theme. Regarded as blocks in space, the abutments between their planes and the containing borders of the spatial field, as well as the abutments between themselves, weaken the impression of volume in space. Such tangential connections make it difficult to know which of the blocks is ahead of the other, or which is larger.

The six little shapes in Illustration 8.11B are, from the standpoint of two-dimensional design, too small to relate to the large shape of the picture-plane. Instead of the interaction between all the shapes, as in Illustration 8.11A, here the little shapes form two small clusters, and the shape of the picture-plane remains passive. Additionally, the senses of tension and direction between the two clusters of shapes creates a diagonal "tug" that disturbs the vertical-horizontal orientation of the picture-plane. This kind of tug is far less disturbing when it runs parallel to the vertical or horizontal directions of the picture-plane because then it repeats one of those directions. Similarity of direction is a strong visual bond, and one that any vertically or horizontally placed element in a drawing shares with the page. The first diagonal mark or force in a drawing is obviously "alone." There are no "friendly" directions to relate with. Worse, it upsets the drawing's existing directional scheme. Therefore, diagonals are usually counterbalanced by other diagonals, as in Illustration 8.11A, where sets of oblique lines cancel each others' movements.

In Illustration 8.11B, no good compositional end is served by the placement of such small volumes in so large a field of space, but the blocks are clearly presented as forms in space. Additionally, the sense of weight adds a second force. Acting somewhat as a counter-force, the pull of gravity starts a downward tug. This "promise" of a downward movement of the blocks, especially of the one on the right, seems to lessen the imbalance between the blocks and the page. If we turn this illustration on its side, the sense of gravity, plus the forces of direction and tension, unite to create an even stronger diagonal pull. Seen right-side-up again, we sense the moderating effect of weight on the diagonal position of the blocks.

Although responsive drawings always convey some impression of the third-dimension, they are formed by flat lines and tones upon a bounded, flat surface. Their organizational resolution must be compatible with their two-dimensional facts,

*Illustration 8.11*

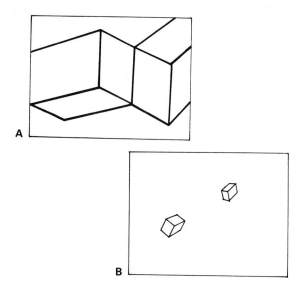

as well as their three-dimensional impressions. These facts and impressions must have a complemental relationship—they must "work with" each other and with the page.

Many drawings are quick sketchbook notations, or brief preliminary sketches. Such spontaneous, on-the-spot efforts, generally try to capture a subject's essential character and action, study some particular structural or textural aspect of its forms, or serve as a preliminary design strategy for a work in another medium (Plates 1.2, 2.8, 3.5, 7.15, 7.21). Often, such sketches are not intended to be integrated with the page. Even here though, an intuitive sense of balance between configuration and page, of the influence on the thing drawn by the shape of the surface, causes unconscious decisions about the placement of the drawing (or the several independent studies) on the page.

In Raphael's page of sketches (Plate 8.1), it is clear that the artist is absorbed in examining the volume of a draped figure and some hands, and not (intentionally) concerned with the design of the page. Even so, it is difficult to imagine redesigning this page of studies in some better way. Each independent segment is placed with a sensitive regard for the others. Similarly, Cantarini's studies of an infant (Plate 8.2) are drawn as independent configurations on the page, but collectively they form a large, reversed "C"-shape on the page. The gentle nature of this large curve, and of the several smaller ones that connect one figure to another, reenforces the mood and the handwriting of the drawing. Both the Raphael and Cantarini drawings are, however, unintentionally, well-designed works. But drawings that show no relationship between the configuration and the page at best, simply lack the organizational benefits of a union with the page; at worst, and more frequently, they are diminished by its absence.

Other drawings, although they may not fill the page, *do* intend an interrelational bond between the configuration and the page. Such drawings are unlike the usually more formal compositions of painting that engage the entire picture-plane. They are conceived (or resolved) as arrangements of forms in spatial environments that depend on, but do not touch the page's limits to make sense as a design.

In such drawings, visual issues actively involve the entire page. The outer zones of drawings that do not extend to the limits of the page may be empty of drawing marks, but not of visual meaning. They always have shape, scale, and value, convey directions, and are similar to, or in con-

*Plate 8.1*

*Raphael* (1483–1520). STUDY FOR THE PARNASSUS. Pen and ink.
TRUSTEES OF THE BRITISH MUSEUM, LONDON.

trast with various parts of the configuration. They are always a part of the drawing's design. The page's shape and scale influence the configuration's evolving *representational dynamics*, that is, what the *things depicted* do as actions (falling, running, tilting, etc.), and what the *visual dynamics*, the abstract relational energies do as actions. These actions, along with a drawing's expressive meaning, are called a drawing's *content* (*see* Chapter Eleven).

Because so many responsive drawing's are spontaneous, brief, and image-oriented, artists often use such a design strategy. It permits a strong concentration on the subject. Often, the surrounding, empty area of the page acts as a "shock absorber" against which the drawing's forces are turned back upon themselves to start the cycle of action over again. This strategy allows a fuller concentration of responsive powers on the subject than when they are divided between it and the

187

Plate 8.2

*Simone Cantarini* (1612–48).
STUDIES OF AN INFANT IN VARIOUS POSES.
Red chalk.
THE PIERPONT MORGAN LIBRARY.

the figure on the left. This force is continued in the neck and chest of the horse, and in the lines near the man on the right. The release of such explosive force warrants the thick, surrounding buffer of space (Illustration 8.12A). We can sense an "implosion," too. The empty area absorbs the "shock waves" and sends them back again. These sensations keep alternating as we look at the page. Both the drawn and empty areas contribute to, and share these pulsations. Had Rembrandt continued to draw the entire horse, the empty area would have been cut in two, destroying the surrounding buffer and possibly the radiating force as well. Had he made this drawing on a larger sheet of paper, the impact of the explosion would have been greatly reduced and the subject overwhelmed by the scale of the empty area. No "echoes" would return from the limits of the page, because they would be beyond the range of the drawing's forces, and no rapport between the drawn and empty areas would exist. The configuration would be isolated in a sea of paper.

All of the ten general types of relationships are present in this drawing. We see how powerfully direction is used, and how it pervades the entire composition. The rhythm resulting from the many "spokes" of direction that radiate from the drawing's center adds force to that action. An almost equally powerful visual theme that also moves through the drawing is generated by directions, rhythms, and tensions (Illustration 8.12B).

Beginning with the near man's lower leg, a vertical movement spreads left and right in a fan-like manner. The angle of the near man's lower arm, and the repeated lines of his waistcoat convey one half of the fan's spread; the other half is conveyed by the lines in the far man's coat, by the several brushstrokes defining the horse's mane, and by the lines of the background

demands of a full-scale compositional scheme. But this does not mean that such drawings are less united with the page than are those which fill it entirely. It means only that the encircling, undrawn area is assigned the less active, but no less important role of containing and modifying the visual dynamics of the configuration.

In Rembrandt's drawing, "The Mummers" (Plate 8.3), the configuration is well within the limits of the page, but strongly interrelated with its shape and scale. The drawing "opens up" in several places to admit the surrounding empty area of the page, physically fusing with it. The frequent reappearance of the white page within the drawn areas helps unite both. But the strongest bond between the configuration and the page exists in the organizational dependence they have for each other.

Near the drawing's exact center, the hand holding the reins marks the center of an expanding burst of lines, shapes, and tones of such power that we sense its radiating directional force in the hat, collar, elbow, leg, and reins of

*Illustration 8.12*

A        B

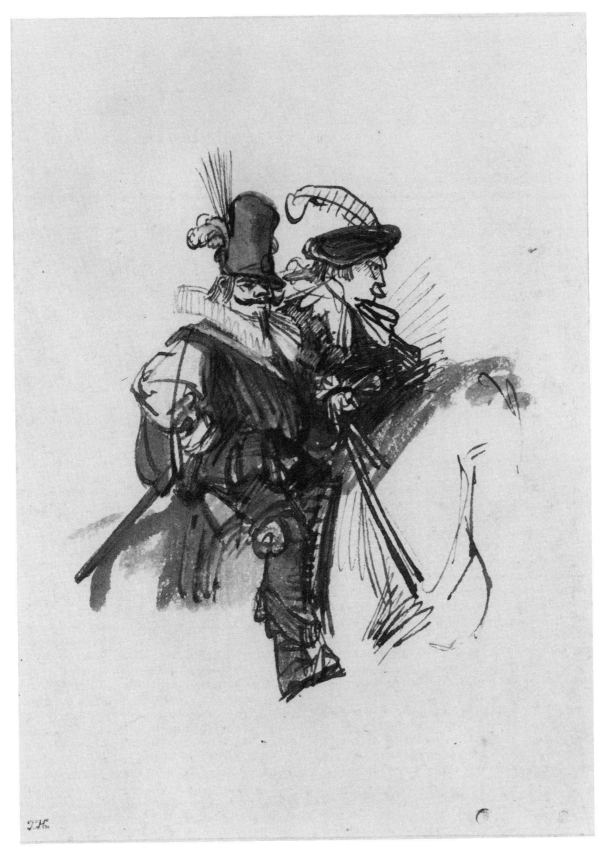

*Plate 8.3*

*Rembrandt van Rijn* (1606–69). THE MUMMERS.
Pen and ink with wash.
THE PIERPONT MORGAN LIBRARY.

near the man on the right. This fan-like action creates one tension between its two halves, and another between it and the inverted "V"-shaped counterforce formed by the directions of the sword and the reins. The "V"-shape is reenforced by some lines in the near man's saddle, and some of the lines between the leg and the reins. Tensions between the various lines and brushstrokes of the horse make these marks seem to attract each other. These tensions, and the sense of closure between the marks, help us to "see" the largely nonexistent animal. The proximity of the two figures, and the dominant dark value between them, unite the men into one great diamond-like shape that is centrally placed on the page. Weight, too, is centrally balanced in this composition. Notice how Rembrandt's handwriting—its consistent, animated energy—reenforces the power of the actions described above, and helps to unite the drawing. The diffuse sense of overall balance, involving every component, is less easily described, but can be "tested" by covering any segment of the drawn area by a small piece of paper, or by reducing the size of the page by covering one or more of its edges with black or gray paper. Doing either will destroy the drawing's stability.

But these are only *some* of the relational activities. There are many more in the drawing. Indeed, each of the marks has some function that contributes to the drawing's design and unity. Each defines, acts, and interacts.

Beginning students often question whether or not an artist consciously intends each of the force-producing relationships in a drawing. They doubt that the visual dynamics always represent deliberate judgments, and suspect that many of the relationships pointed out in a particular drawing never entered the artist's mind—and they are right. It was observed earlier, that after a drawing is well under way, there are just too many relationships and forces for the artist to see and sense them all, and that the drawing's resolution depends on intuition as much as intellect. Again, the character and goal of a responsive drawing is partly determined by subconscious interests. The content of any drawing contains certain intangibles that are not only subconscious expressions of the artist, they are resistant to any attempt at analysis by others.

As we examine other drawings in this chapter, we should remember that any analysis of a drawing's design reveals only some of its relational activities (probably those reflecting the analyst's own instincts for organization)—and that many of these may well reflect the artist's intuitive impulses. Also, we must recognize that even if a

drawing's relational life *could* be fully and objectively probed, a key, if impalpable ingredient would still be missing. This "mysterious" intangibility certainly concerns a drawing's expressive aspects, but it is not limited to them. It is a quality that permeates the drawing, transforming the means into meanings. If we regard responsive drawings as works that can create graphic equivalents of living organisms, then whatever gives the graphic organisms "life" is as mysterious as those powers that animate and sustain living things in nature. Therefore, intellectual dissection can no more determine this "something plus" that separates art from competence than the character of a man can be learned by surgery.

What *can* be learned about design strategies and the uses of relationships makes analyzing drawings an important source of information and insight. Although the beginning student rightly senses that drawing is not a wholly conscious activity, a more pertinent question would be: Are these relationships really present? In the analysis of Plate 8.3, the several relationships and forces discussed occur too consistently and are too critically established to be mere chance. Moreover, the absence of visual discords—of elements *not* engaged in the several actions discussed, or not otherwise contributing to the drawing's order—is, again, beyond chance. Whatever an artist's personal "formula" is, between reason and instinct, the fact remains that in great drawings, a great many questions and needs have been well answered.

Although very different in style, mood, and subject, Diaz de la Peña's drawing, "Landscape" (Plate 8.4), shows a use of the empty areas of the page similar to that in Rembrandt's drawing. Here, a "ground burst" of radiating directions spread out upon the horizontal plane of the field almost fades away at the edges of the page, retaining the encircling, single shape of the rest of the page. Again, the plan is the use of the outer portions of the page as a force-absorbing belt of space. The trees, lifting vertically from the center of the burst, take on more contrasting force from it. But unlike the vigorous energy in Rembrandt's drawing, the forces in la Peña's drawing are of a more muffled kind. The overall compactness of the configuration, the pronounced texture of the chalk medium, the restricted value range, and the soft edges of the forms make this a "quiet" design, compatible with the subject's restful mood. The surrounding space, especially that above the landscape, which reduces and absorbs the forces, helps to convey this idea.

The surrounding buffer in Kenneth Callahan's drawing, "Summer Bug" (Plate 8.5), does have

Plate 8.4

*Virgile Narcisse Diaz de la Peña* (1808–76). LANDSCAPE.
Black chalk.
STERLING AND FRANCINE CLARK ART INSTITUTE,
WILLIAMSTOWN, MASS.

Plate 8.5

*Kenneth Callahan* (1906–   ). SUMMER BUG.
Sumi ink.
WORCESTER ART MUSEUM.

*Plate 8.6*
*Katsushika Hokusai* (1760–1849).
A MAID PREPARING TO DUST.
Brush and ink.
FREER GALLERY OF ART, SMITHSONIAN INSTITUTION,
WASHINGTON, D.C.

some light washes of tone near the insect, but again the space serves to contain and contrast with the action of the configuration. In this drawing, a sense of the bug's slowly moving legs is conveyed by the sense of rhythm between them. Callahan uses the weight and dominance of the dark tone on the last segment of the bug's body to counter-balance the downward tilt of the form, and to show a single, strong contrast which makes the drawing's fragile delicacy more evident.

It is interesting to compare drawings of a similar subject and action by Hokusai (Plate 8.6) and Rodin (Plate 8.7). Both use a broad "pedestal" of shapes and volumes to support the strong actions of their subject, both emphasize the rhythms of drapery and figure, and, except that in Hokusai's drawing the subject is reversed, both resolve the overall configuration into a rough "C"-shaped curve.

Hokusai places the figure to the right of the page, while Rodin places it almost centrally. These differences in location are due mainly to

the tilt and actions of the figures. In Hokusai's drawing, the extended towel at the top and the swirling robe at the bottom of the page swerve abruptly from the figure's nearly vertical direction to move rather forcefully to the left. Had Hokusai placed the figure to the right, it would have produced a very large pocket of empty space on the left, out of scale with the other shapes on the page, and crowding the figure unnecessarily to the right. Her slight leftward tilt also permits Hokusai to place the figure near the right side. Were she vertical, there would be too much weight and attention on the right.

Rodin's design of the figure, though there is not a single vertical line in the drawing, taken collectively *is* vertical. Placing it near the right side would upset the drawing's balance, moving it to the left would make the background shapes monotonously even. Notice that background shapes echo the triangular shape of the woman's drape.

*Plate 8.7*

*Auguste Rodin* (1840–1917). NUDE.
Pencil and watercolor.
COURTESY OF THE ART INSTITUTE OF CHICAGO.

Our study of these drawings indicates that some artists may not consciously include design considerations as part of their initial excitement about a subject (especially in brief notations or preparatory sketches). But there is universal recognition that responses, once translated into marks upon the page, stimulate another category of response—a response to the organizational needs of the evolving drawing within the limits of the pictorial field, and which includes the pictorial field as a consideration in forming the design. Whatever visual and expressive motives combine to begin a drawing, its realization is influenced by the visual events resulting from the size and shape of a particular bounded area as well as the visual nature of the subject and the characteristics of the medium used. Although these drawings do not fill the page, they *use* the page as an active part of the design, and not as a passive, blank area, unrelated to the image.

Other themes require other solutions. Often, as in painting, artists draw to the borders of the page. This is more frequently the case when an artist's initial interests in a subject include its potentialities for compositional design. That is, their attraction is stimulated by perceptions that anticipate the interaction of subject and page to create an organized system of design compatible with their interests in the subject. Although all responsive artists regard the subject and the design it suggests to be interdependent matters, artists vary widely in their emphasis upon one or the other of these interests.

Campagnola's interest in the subject (Plate 5.7), and Lautrec's interest in the drawing's design (Plate 3.2) hardly show extremes of emphasis on either consideration, but clearly reflect a difference in their responses to each. For Campagnola, the balance between directions, the contrasts and tensions between elements, and the rhythmic play between straight and curved edges is subdued. The forces *are* there, the drawing "works" as a design, but the design is below the surface— an intangible sense of order. In the Lautrec drawing, the directions, contrasts, and rhythms are pronounced. As with all good designs, neither drawing can be cropped without destroying their balance and order.

Hopper's drawing of an interior of a theatre (Plate 8.8) conveys an even-handed interest in both considerations. He captures the massive scale and baroque style of the theatre—we sense its spacious interior and false grandeur. But Hopper is equally interested in the forces that convey these qualities as visual events in their own right.

Many of the components of the drawing are designed to suspend at oblique angles from cen-

Plate 5.7

*Domenico Campagnola* (c. 1500–52).
BUILDINGS IN A ROCKY LANDSCAPE.
Pen and ink.
THE PIERPONT MORGAN LIBRARY, NEW YORK.

Plate 3.2

*Henri de Toulouse-Lautrec* (1864–1901).
LA PERE COTELLE.
Charcoal with colored crayon.
COURTESY OF THE ART INSTITUTE OF CHICAGO.

Plate 8.8

*Edward Hopper* (1882–1967).
Burlesque Theatre, Times Square.
Charcoal.
THE CORCORAN GALLERY OF ART, WASHINGTON, D.C.

trally located columns that curve to the left and right near the top of the page. To the columns' left, the theatre boxes tilt down toward the left; to the columns' right, the curtains and stage tilt down toward the right. Together, these tilting forms—and the shapes, lines, and values of which they are comprised—act like chevron-marks crossing the page. This action of the chevron-marks, and the rising, double-arching vertical direction that counters it, is the drawing's basic design theme. The design works with the shape of the page, and is as much a part of the drawing's content as the page is part of the design.

Hopper's use of bold contrasts of direction, scale, value, and rhythms intensify the tensions between suspended forms to either side of the central columns. Note that some of the force of the various directions gains momentum from Hopper's consistently loose, energetic handling of the charcoal.

Perhaps because most artists turn to drawing to state linear, rather than tonal ideas, to plan, explore, and note down essential actions and edges, direction and rhythm are two of the relational forces more often important in depicting and de-

signing. To more fully experience direction and rhythm at work within and among the forms of drawings, it will be helpful here to analyze a few of the drawings in the book by making some drawings that extract these relationships.

### EXERCISE | 8A

You are to make three drawings on separate sheets of tracing paper, using any moderately soft graphite pencil, and a colored chalk or crayon pencil. There is no time limit on these analyses, but you should not extend any of the three phases of each much beyond fifteen minutes. Select any three of the reproduced drawings in the book that show strong directional and rhythmic activity.

*The First Phase:* Using the colored pencil, draw the directional activities first. This is done by placing a sheet of tracing paper over each drawing and, using a loose, free line, selecting those directional activities you regard to be the major ones—those which have the most visual impact and action. Begin by searching for those actions of movement that unite parts of forms, unite interspaces and parts, and even the elements that form them. Depending on the drawings you have selected, these directional actions may correspond to the axes of forms, shapes, values, or textures. They may also be along the edges of any of these, or found in a more "pure" state in the route of independent lines. When several forms and/or their interspaces appear to continue a direction, even though such units may be separated in the drawing, your directional lines should continue from one to the other without stopping, as in Illustration 8.13. In the drawings you are analyzing, such directional movement is felt as energy. You are making these energies visible. Try to grasp the directional action of these forms and their elements by promoting an empathy for their behavior. Although you are looking for directions that continue between larger units, you may find that directions first seen as independent ones join to flow with others. When a direction is conveyed by a form's edge, do not copy the contour, but draw the general character of its movement. As in gestural drawing, seek out the broad, main movements of the drawing's components.

*The Second Phase:* When you feel you have established each drawing's major system of directional forces, using the graphite pencil begin to draw its rhythms. As mentioned earlier, the sense of rhythm will occur as movements or as beats. As with all relationships, they can exist between any of the elements, and also between any of the

Illustration 8.13

*The analysis (B) is an extraction of the strongest movements of and between the forms in A. In C, the analysis appears upon the drawing as it will in your exercise.*

A     B     C     D

Illustration 8.14
Beat rhythms.

representational impressions the elements produce. Unlike the major directional forces that require strong or extended actions to have compositional significance, flowing rhythms are generally built up by repetitions of smaller directions among the elements, as well as among major ones. "Beat" rhythms are generally seen in the reappearance of any element or form (Illustration 8.14). Sometimes, both kinds of rhythm will apply to the same formations, as in Guardi's "A Venetian Scene" (Plate 8.9). Here, the figures collectively offer a system of fence-like, short vertical directions, and a beat of small, dark and light values. Notice that, collectively, the figures also form the strongest directional force in the drawing.

As you analyze each drawing for rhythm, you can expect to be shunted onto a directional track now and then. Flowing rhythms frequently merge with directional actions because both are concerned with movement (Plate 8.10). Keep the lines and tones representing rhythms general and simple, as in the analysis of the rhythms of Pascin's drawing in Illustration 8.15.

Because you have been using two different colors, it is easy to see which parts of the drawing emit both forces simultaneously. There may be a few passages of a drawing that do not yield either force. Such segments may have other functions that have to do with other kinds of relational activity, and will be relatively dormant as carriers of directional or rhythmic force.

When you have completed all three analyses, study each alongside the reproduction to see where these forces were most active. Often, the lines and tones of an analysis form a balanced composition, revealing some of the drawing's design strategy. Comparing the three drawings and their analyses will help you to see differences in

Illustration 8.15

An analysis of Plate 3.9, showing linear rhythms such as those which flow between the chair and figure, and beat rhythms sensed in the organic shapes of the figure and in the fan-like line-groups throughout the drawing.

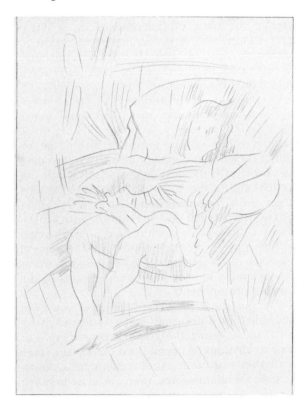

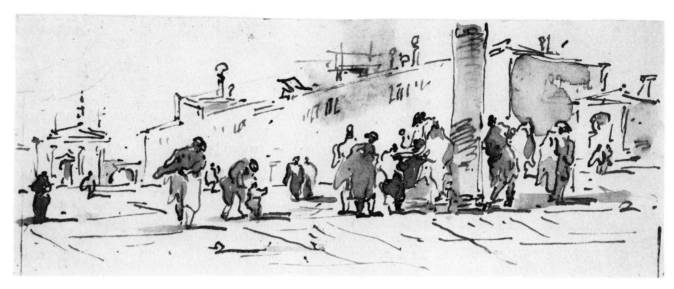

*Plate 8.9*

*Francesco Guardi* (1712–93). A VENETIAN SCENE.
Pen and wash.
COURTESY OF THE FOGG ART MUSEUM, HARVARD
UNIVERSITY
CHARLES A. LOESER BEQUEST.

*Plate 8.10*

*Egon Schiele* (1890–1918). TWO GIRLS EMBRACING.
Charcoal.
DIAL COLLECTION. WORCESTER ART MUSEUM.

*Plate 3.9*

*Jules Pascin* (1885–1930). GIRL IN AN ARMCHAIR.
Charcoal, some yellow chalk.
COLLECTION OF THE NEWARK MUSEUM.

their use. The analysis of these forces tells something about the artist's visual (and expressive) interests; they also indicate the amount and power of such forces necessary to create the various directional and rhythmic qualities in these drawings.

*The Third Phase:* Now, with the reproductions nearby as models, using the graphite pencil continue to develop the drawings somewhat further. It will not matter that you may be using a medium different from that of the original. You need not go on to make an extended, accurate copy of these drawings, but just far enough to "flesh out" the skeleton of your analysis of each. As you do, compare the interrelated nature of the drawing's *what,* its representational dynamics, with these two relational aspects of the drawing's *how,* its design. In good drawings, *all* of the relational factors that form the design form the image.

For an additional, helpful exercise, analyze some of your own drawings this way, to see how you have used these forms. You will probably find afterward that returning to strengthen the interweaving, animating, and unifying roles of direction and rhythm in your drawings can improve them.

Analyzing the drawings of master artists for these, or any other relationships, helps to more fully understand the necessary union between the perceptual and conceptual aspects of drawing. Two common hazards of such analyses are the assumptions that all of the artist's responses to his *constant* subject and his *evolving* drawing are conscious and deliberate, when, as we have seen, many are essentially intuitive actions; and that such analyses explain a drawing—or an artist. However, not until we have first fully experienced the existence of such forces as universal, integral, and inescapable participants in the act of drawing, will these insights become a subconscious part of our comprehension, and of our means.

## THE ELEMENTS
## AS AGENTS OF DESIGN

The central theme of this chapter is that the quality of a drawing's design, and the visual dynamics that express it, are never expendable niceties, but fundamental to its meaning and worth as a system of expressive order. If we regard a drawing's design as the artist's strategy for organizing his visual and expressive responses, then the relational activities of the elements can be regarded as the tactical means used to effect

that strategy. And, as we have seen, relationships begin with the first few marks. Perhaps that is why so many artists, even in the briefest of preparatory notations, not only intuitively organize independently drawn sketches into some system of design, but also have an awareness of each mark as a unit of energy. It is as if these artists cannot help responding to the intrinsic forces within a mark as well as those that spring up between marks. They seem unable to accept the imbalance and disunity that such unresolved forces insure. The sensitive artist reacts to a drawing's disorder with anxiety-producing tensions. Such drawing's do not "feel right." When stability and unity are achieved, there is a release of tension. Drawings developed without an organizational strategy, or even an intuitive tendency toward some plan for the disposition of parts on the page, always produce disorder and ambiguity. When an overall strategy is absent, the interrelating and unifying activities of the elements are absent. Whatever else such drawings may convey, disharmony is always part of the message.

Here, we will examine a group of drawings that provide opportunities to consider some of the elements' design activities not yet discussed, or only touched on earlier. As previously noted, their possibilities for visual activity are unlimited, but seeing some of the ways in which they relate and act may stimulate the search for others.

Ingres' "Study of Drapery" (Plate 8.11) shows his sensitivity to, and interest in second- and third-dimensional matters at the same time. We are as aware of the structural nature of these forms as of the swirl of black, gray, and white shapes forming them. They are simultaneously seen as planes and shapes. Ingres' main strategy is to organize the drawing by stressing the animated, voluptuous swirls with rhythms that result from repetitions of line and shape. Many lines, some of them really thin shadows, follow the same routes, each adding to the sense of direction. Most of the drawing's black, gray, and white shapes are strongly related to the lines in their action. Note that a majority of them are variations of a boomerang shape. They range from narrow "V"-shapes, to very open, rounded "V's." Most of these below the horizontal midline are placed right-side-up; above the midline, most are inverted. The more we look at the drawing, the more evident it is that almost every line, shape, and tone is a variation of this "boomerang" idea. The main thrust of the volume—where it seems headed—and where it is heaviest, is toward the lower right corner of the page. Ingres has built up quite an energetic sense of weight moving in

*Plate 8.11*

*Jean Auguste Dominque Ingres* (1780–1867).
STUDY FOR DRAPERY.
Black crayon.
THE METROPOLITAN MUSEUM OF ART.
ROGERS FUND, 1937.

199

that direction. He checks its action by the strong tension at the knotted section on the drawing's left, and by the strongest concentration of black in the drawing, below the knot, in the lower left. This "tug-of-war" between the pulling to the left by the knot and the black tones on one side, and the movement of heavy volume straining to the right on the other, creates a balance based on the most tenuous resolution of forces. The drawing is continuously and almost simultaneously beginning and stopping its action. It no sooner achieves a balance than it is set going again. Note that the five rather thick shadow-lines in the lower right swing up toward the drape's knot to help "return" the energy to its source. Note, too, that the most inclusive shape we can find, the one that takes in almost every mark on the page, is again a large, almost page-filling boomerang shape. Ingres' overall strategy can be seen as motivating the action of the elements at every level. Reinforcing the intensity of the action, the manner of applying the chalk is boldly emphatic, its character giving a final, unifying note to the drawing. Here, the elements of line, shape, value, and volume all function at the three levels referred to earlier. Each, in addition to depicting the impression of a drape, has its own semi-autonomous action. That is, each reflects Ingres' sensitivity to the medium and his attraction to their visual dynamics as satisfying events in their own right. Finally, each element participates in carrying out an overall design plan.

How very different from Ingres' powerful action is Sheeler's "Barn Abstraction" (Plate 8.12). Here, there is a firmly stabilized balance of forces. The image is lean and sharply focused. Each mark counts. The organizational plan depends on a system of vertical and horizontal directions, conveyed by deliberate, diagrammatic lines, and rectilinear shapes. The impression of volume is subdued, being conveyed mainly by the overlapping geometric shapes. There is movement here, but it is stately and restrained. Even the textures, variations on the density of massed lines, move across the page in three deliberate steps. The picture-plane moves subtley back and forth, conveying a sense of deep space above the buildings, becoming the facing planes of the building's walls and then moving forward to become the foreground—without a mark being drawn *in* the sky, *on* the walls, or *upon* the foreground. Openings in the roof and walls, and around both sides of the grouped buildings enables the picture-plane to imply these different spatial functions. Note

*Plate 8.12*

*Charles Sheeler* (1883–1965). BARN ABSTRACTION. Black conté crayon.
PHILADELPHIA MUSEUM OF ART.
THE LOUISE AND WALTER ARENSBERG COLLECTION.
'50-134-183

that the drawing's stability is partly due to the roughly equal visual strength between vertical and horizontal directions. The largest building on the right, and containing the biggest, heaviest weight of black tone, does not tip the drawing to the right. Balance is achieved by the tensional pull and weight of the long "overhang" of the lower buildings on the left, and the solitary, strong diagonal edge in the drawing, by its striking departure in direction, attracts our attention away from the right. Other, subtle diagonal directions *are* sensed in the staggered placement of the roofs, in the base-line of the building on the left, and in one of the roof lines. In this deceptively simple-looking drawing, all the elements are present. Each helps advance the "weaving" of the vertical and horizontal directions into a stable design. All of the ten basic kinds of relationships are also here. Direction, weight, and tension have already been mentioned. The repetition of vertical and horizontal lines and shapes conveys the sense of flowing rhythm, and the pace of the black shapes, the beat rhythm. Sheeler utilizes the contrast between the scale of the yawning barn-opening and the window to convey dominance. The sharp difference of value and scale between various shapes suggest other impressions of dominance that work to balance the composition. The sense of proximity works to unite the low, long buildings on the left as a unit that contrasts with the taller unit of the barn to its right.

Here, Sheeler, whose drawings are so frequently concerned with a convincing impression of volume and space (Plates 4.17, 5.4), seems to be reminding us that drawing is not sculpture. Because responsive drawing begins with perceptions of forms in space, the importance of an ability to see, decipher, and transpose real volume into graphic terms was stressed in the preceding chapters. But the impression of volume is a graphic tool, not a fixed responsibility. Because drawing is *not* sculpture, there should be no sense of a constant obligation to carved, convincing solids. There should be no barriers in conveying those responses that intensify a subject's essential meaning to us.

Compare Sheeler's drawing with Tiepolo's drawing of a similar subject (Plate 8.13). Here, volume is a more active element. It counterbalances the drawing's overall tilt to the lower left by the massive weight of the building on the right. Notice Tiepolo's use of value to create tonal accents of white within the grays of the buildings. These do more than convey volume; they relieve the sameness of the gray tones and

Plate 8.13

*Giovanni Battista Tiepolo* (1696–1770).
A Group of Farm Buildings.
Pen and bistre wash.
COURTESY OF THE FOGG ART MUSEUM, HARVARD UNIVERSITY.
GIFT OF DENMAN W. ROSS.

give the darker pitched roof more emphasis in the drawing's balance. Unlike Sheeler, who uses the elements for a balanced awareness of the drawing's two- and three-dimensional life, Tiepolo relies on every element mainly to convey volume—but each *does* have a two-dimensional function. Note that the strongest concentration of line and texture fall just where their direction, shape, and value are most effective—in the pitched roof. It presses against the building on the far right to add the needed counterbalancing weight and attention to that side of the drawing.

Picasso's "Three Female Nudes Dancing" (Plate 8.14) shows the power of the element of line used in an open, calligraphic manner. Despite the unconnected, almost independent nature of the lines, they still convey volume. But volume, and the shapes and planes that build them, are hinted at, rather than emphatically declared. This is not to suggest that these are weakly presented, but, rather, that Picasso's plan requires such teasing suggestions. There is the *exact* degree of volume present to convey Picasso's visual theme: the simultaneous life of a line as an edge in space, and as a line on paper. Again, as in Sheeler's drawing, the picture-plane occupies several positions in space at the same time that it continues to exist as a flat surface. This dual impression of the second- and third-dimension is insistently conveyed by the fact that there is not

*Plate 8.14*

*Pablo Picasso* (1881–    ).
THREE FEMALE NUDES DANCING.
Pen and ink.
PERMISSION S.P.A.D.E.M. 1972 BY FRENCH REPRODUCTION
RIGHTS, INC.

a single enclosed shape in the drawing. Here, the sense of closure is intentionally weak. Just as we begin sensing several shapes as forming volumes, the openings between the lines remind us that we are looking at ink lines on a flat surface. But the moment we register that fact, the lines begin to make shapes and forms again. Thus Picasso creates a tensional play between the lines that the mere delineation of forms in space cannot achieve. This dual life of line, or any other element, is always present to some degree as part of the intended or subconscious theme of all good drawings.

In Picasso's drawing, as in Sheeler's, the dual life of the image is evenly advanced. Were the lines less or more descriptive, the tension would be lessened. As it is, we react to the behavior of the lines as Picasso meant them to function. We cannot miss reading the drawing as three dancing figures, and we cannot miss the fact that we are looking at ink lines marked upon a flat surface.

However, making the impression of volume clearer does not have to diminish a drawing's two-dimensional activity. If its two-dimensional design is bold enough, if the elements always advance both considerations, a drawing can give a strong, simultaneous sense of volume in space and of elements on a page. In the drawing by Wen Cheng-Ming, "Cypress and Rock" (Plate 8.15), we can read the drawing's line, shape, value, and texture as flat occupants on the page *and* as forms in space. Here, there is no mark that fails to depict, act, and interact. Again, the theme is an explosive eruption that spreads out from the center of the configuration's base. Note the clarity of the negative white shapes, and the strong directions activating every part of the drawing. The artist places the main thrust of the forms to the left of the page, countering the configuration's location on the right.

A similar strategy is used by Degas in his drawing "Three Dancers" (Plate 8.16). Located in the lower right, the figures are balanced on the page by their united, powerful thrust to the left. The weight of the figure in the foreground, and the direction of the bench she is seated on, act as additional counter-balancing factors. Note that Degas's positioning of the other two figures causes them to "run off" the page. This snapshot treatment has the effect of making us more aware of their shape-state than we might otherwise be. And Degas uses shape to reinforce our sense of the second-dimension. His heavy emphasis of line on the edges of forms intensifies their shape-state and the force of their thrust to the left. This repeated use of heavy lines also serves as a unifying rhythm. Note how all the limbs of the figures stand out—to be seen as repetitions of an arc moving to the left.

In another Degas drawing, a preparatory sketch for a portrait of Emily Duranty (Plate 8.17), stabilizing the heavy oblique mass in the lower right becomes the major organizational task of the rest of the drawing. Degas uses the longest vertical line in the drawing, the upright support of the lower bookcase, to "spearhead" the downward movement of the other vertical lines and shapes on the left, thus anchoring the weight of the bookshelves to the left instead of the right. The converging lines of the bookshelves also help to pull to the left, countering the weight of the pile of books and papers in the foreground. Note how Degas uses values to bridge the space between the forms in the foreground and background, and how broadly he suggests the shapes, values, and textures of the books.

*Plate 8.15*

*Wen Cheng-ming* (1470–1559). CYPRESS AND ROCK.
Brush and ink.
NELSON GALLERY-ATKINS MUSEUM, KANSAS CITY, MISSOURI
(NELSON FUND).

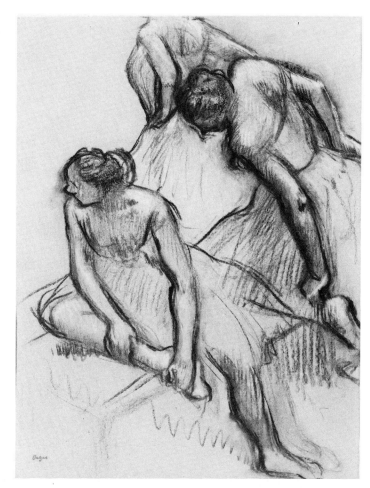

*Plate 8.16*

*Edgar Degas* (1834–1917). THREE DANCERS.
Crayon and pastel.
COURTESY, MUSEUM OF FINE ARTS, BOSTON.
BEQUEST OF JOHN T. SPAULDING.

*Plate 8.17*

*Edgar Degas* (1834–1917).

BOOKSHELVES IN DURANTY'S LIBRARY.

Charcoal, heightened with white chalk.

THE METROPOLITAN MUSEUM OF ART.

ROGERS FUND, 1918.

In Deibenkorn's drawing of a reclining figure (Plate 8.18), value-shapes are the main elements in conveying the forms and in establishing the design. Again, we are made aware of the multiple activities of the elements, and of their bold, two-dimensional life on the page. Here, the sense of volume is sometimes strikingly convincing, especially in the figure, without any lessening of the vigorous action of the elements in simultaneously performing visual activities among themselves. In the figure's upper body, the lines and brushstrokes defining the forms of the head, shoulder, and breasts also enact a handsome interplay of values, shapes, and lines which has meaning as a visual event in its own right. Note the directional forces forming a large "X" that spreads throughout the drawing. The overall white vertical shape of the figure is contrasted with the large, black rectangle in the upper right area of the drawing. The reappearance of "shards" of white reminds us that the *impression* of volume in space should not make us overlook the *fact* of ink marks on paper.

A survey of the drawings in this book will show that the elements of every one exist on the several levels discussed. The two- and three-dimensional design of each is not the result of chance. Each tries to contain and resolve the forces within it.

The following exercise consists of brief suggestions for challenging your sense of balance and unity—through the use of the elements—to depict, act, and interact.

## EXERCISE | 8 B

***Drawing 1.*** Using any medium and paper and selecting any subject of your choice, make a drawing that is contained well within the limits of the page, as in Plates 8.3 through 8.7. Begin by making a gesture drawing that stresses the subject's overall directional and rhythmic forces. Seeing these forces, decide on a design strategy. At least some of what you have extracted *already* represents a kind of subconscious design strategy. You have stressed certain relationships that another artist drawing the same view might not stress. He might find another system of directional and rhythmic relationships that reflect *his* interpretation of the subject's arrangement. But seeing what forces have emerged from *your* response to the subject, decide how they might best function to marshall your subsequent responses toward the drawing's balance and unity. As you draw, think about the role of the encircling space of the picture-plane. How far can the configuration spread on the page before its forces are too strong to be contained by the encircling space? Is there too much space—does the image merely float on the page, leaving its empty areas passive? Are the shapes of the picture-plane actually part of the drawing's design?

***Drawing 2.*** Select one of your analyses from Exercise 8A (or make another from one of the drawings in the book). Using the analysis as your basis, develop a still-life arrangement that re-enacts the same directional action. For example, in Rembrandt's drawing (Plate 8.3), the explosive spread of its directions and its second directional theme discussed earlier should guide your placement of the components of the still-life

Plate 8.18

*Richard Diebenkorn* (1922–    ). RECLINING NUDE.
Ink and wash.
SAN FRANCISCO MUSEUM OF ART.

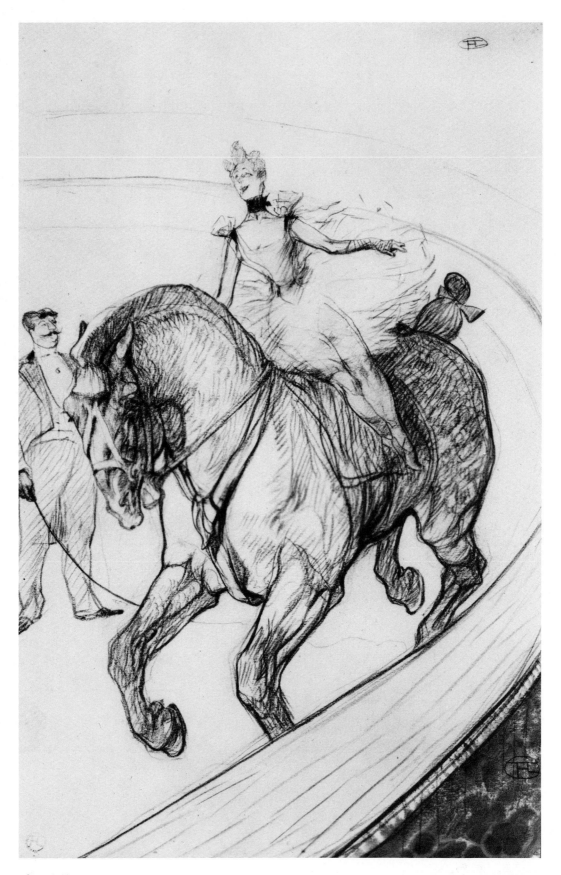

*Plate 8.19*

*Henri de Toulouse-Lautrec* (1864–1901).
EQUESTRIENNE.
Crayon.
MUSEUM OF ART, RHODE ISLAND SCHOOL OF DESIGN,
PROVIDENCE.

arrangement. Your completed drawing of the still-life should suggest the same directional action of the original drawing's design.

***Drawing 3.*** Using tracing paper, carefully trace the major linear and tonal aspects of the Lautrec drawing "Equestrienne" (Plate 8.19). Turning your tracing over, you will notice the reversed view is no longer balanced on the page. The drawing now seems to race down toward the lower right corner. Taking any liberties you wish, make any necessary changes, additions, or deletions that you feel will balance the drawing and maintain its unity.

***Drawing 4a.*** Arrange any subject in a way that you feel suggests an interesting design strategy for a horizontal format. The drawing should fill the page, as in Plates 5.7 or 8.18. Plan to develop a drawing that will show each of the ten basic types of relationship engaged in forming the drawing's design.

***Drawing 4b.*** Without changing the subject, or your view of it, draw it again to make an equally good design in a *vertical* format. Now, you may need to increase or decrease the scale of the parts in the second drawing to help you develop a workable composition. Therefore, the only permissible change is the inclusion of a little more of the subject, or a little less, in the second drawing. Again, plan to include examples of all ten relational categories.

***Drawing 5.*** Using only a calligraphic line, make a drawing that is just as active two-dimensionally as it is three-dimensionally, as in Plate 8.14.

***Drawing 6.*** Using only ink and brush (thinning with water as necessary), make a tonal drawing that is as active two-dimensionally as it is three-dimensionally, as in Plate 8.18.

In this examination of visual issues, we saw that each mark adds a unit of energy to the drawing's representational and abstract meaning, and that the resulting configuration's design is dependent, in part, on the dimensions of the page. To disregard these fundamental *given* conditions of drawing prevents our seeing the ways by which compositional order and unity are achieved. But self-consciously planning the visual function of each mark is impossible. As we have seen, both judgments and feelings must negotiate the drawing's final form. The exploration of force-producing relationships can extend the responsive options we can call on in developing this final form. If a drawing's visual resolution as a system of expressive order is as much the result of subconscious knowledge and need as of intentional strategy, then a study of the visual means that can stimulate such knowledge, need, and strategy, informs both our intellect and our intuition.

To broaden the options of both is essential because our responses to the relational life of the elements on the page involves the same kind of comprehension that determines our responses to the subject. Expanding our understanding of drawings as designs expands our perceptual and conceptual skills and interests. It also adds to the range of expression of those intangibles of temperament and idiosyncracy that meet the last requirement of a good drawing: the sense of a genuinely personal—and thus genuinely original—view of what it was about a subject's actual and inferred qualities that made us draw it.

CHAPTER

# Expressive Issues

## THE

## FORMING OF MEANING

### A DEFINITION

Here, let us define responsive drawing as the *personal* ordering of perceptions. *How* and *what* we draw results from the quality of our perceptual comprehension and the ways our aesthetic concepts and temperamental attitudes govern both our perceptions and responses. For some artists, these concepts and attitudes may be mainly concerned with visual considerations; for others, with expressive ones. But all the interests we bring to a subject are concerned, to some degree, with both. Some affect the way we see the subject. Others are influenced by the subject's affect on them. Still others affect, and are in turn affected by the emerging drawing. That is, we bring understanding to, and gain understanding from each drawing. In responsive drawing, perception and conception are interdependent and mutually supporting considerations, and consequently, so are the design and the emotive character of the resulting works.

As mentioned in Chapter Eight, to separate the deeply interrelated issues of organization and expression risks the misunderstanding that they are independent, when, in fact, every mark that adds to a drawing's design, adds to its expression. In Chapter Eight our attention focused on the ways elements triggered relational forces that

helped form the design. Here, we will explore ways elements convey feelings and moods. But we should remember that the same relational forces that organize our responses to the subject *and* the emerging drawing express our feelings about the overall meaning and character of both.

Like the expressive use of line, all the elements can convey predominantly emotive themes—not only by what they depict, but through their empathic nature. That is, they can be expressive at the representational and abstract levels simultaneously. Expressively motivated lines can be sensual, aggressive, shy, sluggish; they can create relationships with other lines or other elements that stress such expressive characteristics throughout a drawing. The other elements can, between them, also convey such feelings, both by their intrinsic character, and their relational activities. Again, a drawing's expressive dynamics, its emotive theme, like its visual dynamics or organizational theme, are produced through the relational behavior of the elements, beginning with the very first marks. Therefore, to the responsive artist, whether a drawing's dominant theme is visual or expressive, neither theme can have aesthetic meaning except in the presence of the other. For him, these are fundamentally interlaced concepts.

Cezanne's drawing (Plate 9.1) is primarily concerned with analyzing and organizing volumes through the selective use of planes. Visual interests are emphatically dominant. But the search for, and satisfaction in the discovery of structural keys to the economical presentation of the subject's volumes is a major source of Cezanne's excitement—and the lines express this. The authority and urgency of the lines reveal both the artist's depth of commitment to his visual theme, *and* his feelings about it.

Guercino's drawing, "Head of a Man" (Plate 9.2), is not visually less active than Cezanne's. Indeed, the drawing of the head has, something of the same interest in planar construction, but it *is* more expressively active. Here, the lines and tones endow the man's character with some of their own power and energy. The expressive dynamics are not concerned only with psychological or humanistic matters. Guercino calls our attention to the similarities of the curvasive actions of the collar and hair by curvilinear lines that organize as they express, and even continues such lines into the background. The cumulative energy of so many swirling lines cannot be read with the calm possible in viewing the Cezanne drawing. Guercino succeeds in conveying his expressive interest in the man, but he is equally successful in creating a field of powerful visual and expressive energies. The man, and the lines that depict him, both express strength, authority, and intensity. The drawing's design supports its expressive theme.

Whether our drawings are dominantly visual or expressive, or whether these considerations receive somewhat equal attention is also determined by our perceptual skills, our attitudes, and intuitions. For Rembrandt, visual and expressive dynamics are not only inextricably fused—they are almost always equally active issues. His drawing, "Young Woman at Her Toilet" (Plate 9.3, *see* also frontispiece) strongly conveys his equal interest in design and expression.

Visually, the alternating light and dark tones that cross the page, and the tensions between them produce a bold design. The oblique direction formed by the two figures is countered by the opposing direction of the two masses of dark tone, by the seated woman's folded arms, and by some of the folds in her skirt. As in "The Mummers" (Plate 8.3), radial forces beginning in the hand of the dominant figure create a flower-like shape that enlivens the figure and "holds off" the enclosing dark tones. The similarity between the positions of the arms of both women, and the slashing, downward brushstrokes at their waists,

further unify and animate the drawing. Note how the light tones, flowing down through both figures toward the lower right corner, enter the foreground and sweep to the left, rising along the left side of the page to begin the cycle of action again. This is not a placid design. Its overall stability is based on barely contained forces of considerable power.

Expressively, the design is no less powerful. The energies forming the visual issues are, of course, themselves expressive forces. But there is also another pervading emotional quality. An ordinary domestic scene is here transformed by an expectant atmosphere. The light does not merely illuminate the women, it dignifies and graces

*Plate 9.1*

*Paul Cézanne* (1839–1906). SKETCHBOOK page 21 (recto). Pencil.
COURTESY OF THE ART INSTITUTE OF CHICAGO.

Plate 9.2

*Guercino (Giovanni Francesco Barbieri)*
(1591–1666). HEAD OF A MAN.
Pen, brown ink wash.
THE METROPOLITAN MUSEUM OF ART,
HARRIS BRISBANE DICK FUND, 1938.

them—it gives their actions an indefinable importance. The sudden shock of value contrasts, the boldness of the tonal shapes, the urgency of the lines, and the sweeping movements combine to create a spiritual presence in this intimate scene. For Rembrandt, visual design and expressive mood are mutually reinforcing and inseparable aspects of a drawing's content. He demands a fusion between visual and expressive interests.

The reciprocity between the visual and expressive dynamics of drawing can be seen even in the need to rely on expressive terms to describe visual issues (as in Chapter Eight and in the above brief analysis of Plate 9.3), while expressive themes are conveyed by describing the visual behavior of the elements. To better understand the expressive nature of the elements, let us examine them each in several moods.

## THE ELEMENTS AS AGENTS OF EXPRESSION

Although the expressive use of line has already been discussed, it will be helpful here to see some clearly different expressive states of this element. In Illustration 9.1, the four groups of lines shown, while hardly representative of lines' expressive range, do demonstrate some general types of expressive line. Group *A* are patient, slow, and earnest lines. As in Pascin's drawing (Plate 3.9), they are often sensual, searching, and tactile. Group *B* are bold, energetic lines. Sometimes playful or sensual, they are always fast-moving, even frenzied, as in Van Gogh's drawing (Plate 3.16). The harsh, slashing lines in Group *C* are always aggressive, often explosive. Sometimes, as in Matisse's drawing (Plate 4.11), their thick-

*Illustration 9.1*

A                B                C                D

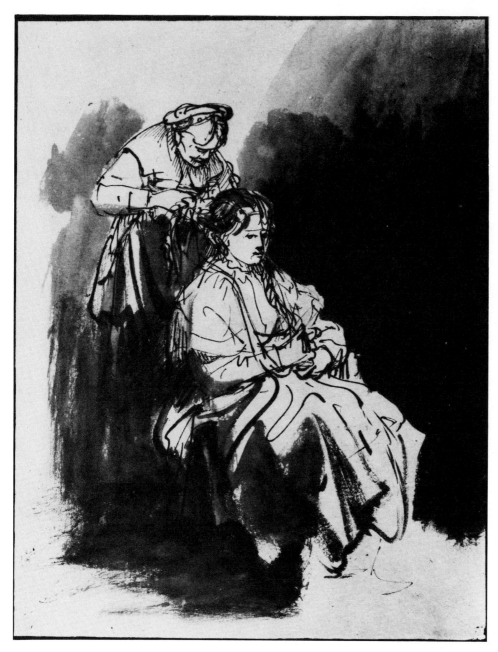

*Plate 9.3*

*Rembrandt van Rijn* (1606–69).
YOUNG WOMAN AT HER TOILET.
Pen, ink and wash.
ALBERTINA MUSEUM, VIENNA.

ness and the density of their clashing assaults on each other form tones. Group *D* are gentle, caressing lines. Not as slow and specific as Group *A,* or as animated as Group *B,* they move gracefully, as in Picasso's drawing (Plate 3.10), or in the late Kamakura Period drawing (Plate 7.18).

But any kind of line can be used for expressive purposes. This is especially so in combination with other types of lines, such as those described above, or when used in drawings that are mainly tonal. Depending on the context in which a line occurs, even a simple straight line can evoke powerful expressive meaning. In Kathe Kollwitz's drawing, "Woman Seated With Folded Hands" (Plate 9.4), the slight, short charcoal stroke depicting the woman's mouth more eloquently conveys the woman's purse-lipped, introspective mood, than any extensive rendering of the lips could. The "knife-slit" nature of the line intensifies the artist's expressive meaning. It not only depicts the gesture, it enacts it.

The Kollwitz drawing also shows its mood through shapes and values that evoke feelings.

*Plate 3.9*

*Jules Pascin* (1885–1930). Girl in an Armchair.
Charcoal, some yellow chalk.
COLLECTION OF THE NEWARK MUSEUM.

*Plate 4.11*

*Henri Matisse* (1869–1954). Figure Study.
Pen and ink.
COLLECTION, THE MUSEUM OF MODERN ART, NEW YORK.
GIFT OF EDWARD STEICHEN.

*Plate 3.16*

*Vincent Van Gogh* (1853–90). Grove of Cypresses.
Pencil and ink with reed pen.
COURTESY OF THE ART INSTITUTE OF CHICAGO.

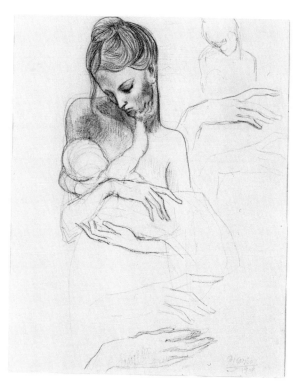

*Plate 3.10*

*Pablo Picasso* (1881–    ). A MOTHER HOLDING A CHILD AND FOUR STUDIES OF HER RIGHT HAND.
Black crayon.
COURTESY OF THE FOGG ART MUSEUM,
HARVARD UNIVERSITY.
BEQUEST OF META AND PAUL J. SACHS.

have been consciously selected by the artist. Whether supplied by intellect or intuition, they form part of the completed drawing because they were necessary to the artist's expressive meaning. To adjust an old adage: expressive intent, like love, "finds a way."

Here, the relational forces of shape, direction, rhythm, scale, value, weight, character, and tension are in strong alliance with the expressive goal.

*Plate 7.18*

Late Kamakura period.
WHITE-ROBED KANNON FROM KOZAN-JI TEMPLE.
Brush and ink.
THE CLEVELAND MUSEUM OF ART,
PURCHASE, JOHN L. SEVERANCE FUND.

The black cast shadow that "overshadows" the rest of the drawing's elements is not large, dark, and unfocused by chance. Its dominance in the drawing is expressively necessary. Kollwitz seems to suggest it as a symbol of tragedy. Our universal apprehension of dark, unknown, ghost-like shapes and forms are awakened by the shadow. Kollwitz blurs its sharply defined and blackest segment with an outer, dark gray tone, further suggesting an apparition-like presence in shadow. The woman's right shoulder, almost lost in shadow, seems to be caressed by the broad strokes of dark tones that fuse the woman to the black shadow. All of the drawing's shapes, and the lines that define their edges, seem to flow toward the shadow as if attracted to it by some force. Only the folded hands, their stark whiteness contrasting with the shadow, seem free of this attraction.

This flow of the shapes, which is supported by sweeping, charcoal tone-lines, may or may not

*Plate 9.4*

*Käthe Kollwitz* (1867–1945).
WOMAN SEATED WITH FOLDED HANDS.
Charcoal.
COURTESY, MUSEUM OF FINE ARTS, BOSTON.
HELEN AND ALICE COLBURN FUND.

Directions and moving rhythms lead from all parts of the figure to the cast shadow's "head," while the dominance of the shadow unifies and speeds up the figure's implied movement toward it. The sense of the woman's fragility, relative to the massive shadow, gives the shadow more visual strength. This tension in their visual substantiality and in the contrasting light tones of the figure with the dark tones of the shadow, all serve expressive, as well as organizational dynamics.

Like line, shapes conform to general types. In Chapter Two, we saw that all shapes can be finally grouped into two basic categories: geometric and organic. But these categories are too general in discussing expressive uses. Illustration 9.2 shows five subdivisions that typify the most frequently used shapes. Group *A* are stately, usually stabilized shapes that suggest a dignified, calm air, as in Seurat's drawing (Plate 4.12). Group *B* are active, agitated, and sometimes quite complex. Sometimes their action is directional, but often it is contained within the animated behavior of the shape itself. Tiepolo's (Plate 2.3), Rembrandt's (Plate 4.5), and Guardi's (Plate 8.9) drawings show the intense activity of

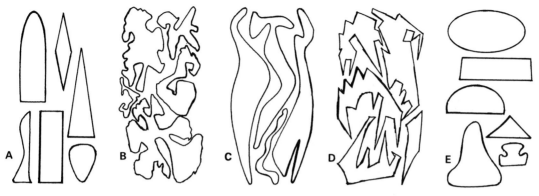

*Illustration 9.2*

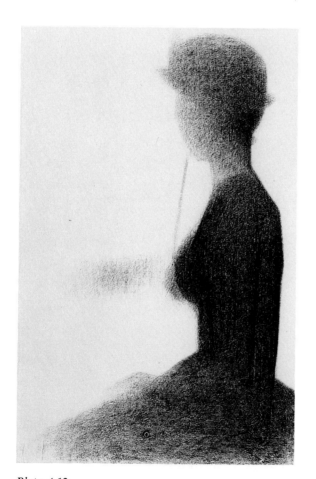

Plate 4.12

*Georges Pierre Seurat* (1859–91). SEATED WOMAN.
Conté crayon.
COLLECTION, THE MUSEUM OF MODERN ART, NEW YORK.
ABBY ALDRICH ROCKEFELLER BEQUEST.

Plate 2.2

*Giovanni Battista Tiepolo* (1696–1770).
TWO MAGICIANS AND A YOUTH.
Pen and brown ink wash.
THE METROPOLITAN MUSEUM OF ART.
ROGERS FUND, 1937.

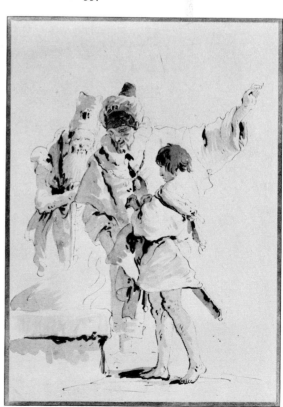

Plate 4.5

*Rembrandt van Rijn* (1606–69).
LANDSCAPE WITH COTTAGE.
Pen, brush and ink.
ALBERTINA, VIENNA.

Plate 8.9

*Francesco Guardi* (1712–93). A VENETIAN SCENE.
Pen and wash.
COURTESY OF THE FOGG ART MUSEUM, HARVARD
UNIVERSITY
CHARLES A. LOESER BEQUEST.

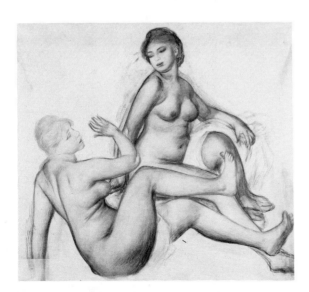

Plate 2.8

*Pierre Auguste Renoir* (1841–1919). THE BATHERS.
Red chalk.
COURTESY OF THE FOGG ART MUSEUM, HARVARD
UNIVERSITY.
THE MAURICE WERTHEIM BEQUEST.

these shapes.    Group *C* are rhythmic, moving shapes. They may suggest fast movement, as in Renoir's drawing (Plate 2.8), or, when more convoluted, slower movement, as in Scheile's drawing (Plate 8.10). The angular, sometimes jagged shapes in Group *D* are usually active, even explosively so, as in Rembrandts's (Plate 8.3) or Wen Cheng-Ming's (Plate 8.15) drawings. Group *E* are stable, usually inactive shapes. They suggest a dependable firmness, as in Holbein's drawing (Plate 7.7) or Sheeler's drawing (Plate 8.12).

In Seligman's drawing "Caterpillar" (Plate 9.5), rhythmic and angular shapes struggle and resist each other. But the elegance of the rhythmic shapes, and the precise, restrained handling, as well as the absence of sudden, extreme value changes or strong directions, suggests a quiet contest, rather than a dramatic struggle. As this

*Plate 8.3*

*Rembrandt van Rijn* (1606–69). THE MUMMERS. Pen and ink with wash.
THE PIERPONT MORGAN LIBRARY.

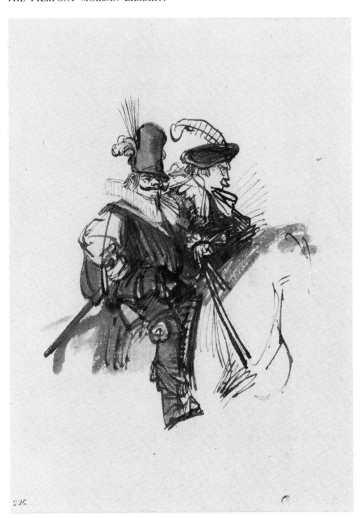

*Plate 8.10*

*Egon Schiele* (1890–1918). TWO GIRLS EMBRACING. Charcoal.
DIAL COLLECTION, WORCESTER ART MUSEUM.

example shows, some of a drawing's expressive character is revealed by the nature of the shapes, and some by their collective behavior.

There are endless ways in which shapes, or any of the elements on the page can suggest expressive meaning. We should recognize that the character and behavior of elements may complement or conflict with a drawing's representational dynamics—the action of the identifiable objects depicted. In a drawing with stilled motion, the presence of many shapes such as those in Groups *B, C,* or *D* of Illustration 9.2, would work against the sense of stationary forms. Those in Groups *A* and *D* would tend to diminish a strong, dramatic behavior and mood dependent on movement.

A          B          C          D

*Illustration 9.3*

*Plate 8.15*

*Wen Cheng-ming* (1470–1559). CYPRESS AND ROCK.
Brush and ink.
NELSON GALLERY-ATKINS MUSEUM, KANSAS CITY, MISSOURI
(NELSON FUND).

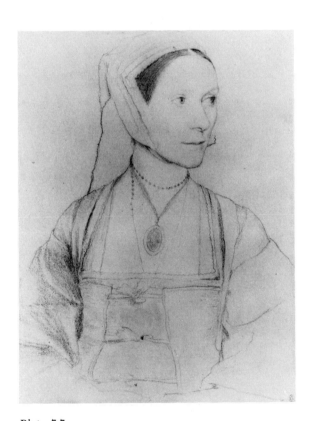

*Plate 7.7*

*Hans Holbein, the Younger* (1497/8–1543).
CÉCILY HERON.
Natural black chalk.
ROYAL COLLECTION, WINDSOR CASTLE, COPYRIGHT
RESERVED.

*Plate 8.12*

*Charles Sheeler* (1883–1965). BARN ABSTRACTION.
Black conté crayon.
PHILADELPHIA MUSEUM OF ART;
THE LOUISE AND WALTER ARENSBERG COLLECTION.
'50-134-183

The four shape arrangements in Illustration 9.3 show some of the limitless possibilities for shapes' expressive activity. Those in *A* move toward a common point on the page as in the Kollwitz drawing (Plate 9.4). In *B,* the upper, active shape appears to be attacking the placid one below, while the shapes in *C* seem to strain toward each other. Notice the sense if tension at the point of impending contact in these arrangements. In *B* and *C* there is also tension between the shapes themselves, as we experience a back-and-forth recognition of each shape's situation. The shapes in *D* unite in a circular movement around the page. Shapes engaged in such rotating actions can generate strong emotive energies, as in Ingres' drawing (Plate 8.11), or Munch's lithograph, "Self-Portrait with a Cigarette" (Plate 9.6).

The expressive nature of volumes is revealed

*Illustration 9.4*

by their weight and scale, by their physical characteristics which, like those of shape, range from the placid and stilled to the aggressive and active, and by their association or contrast with other volumes. In Illustration 9.4, the types of volumes in *A* (and the shape-state of the planes that form them) combine in a balanced arrangement of great stability. In *B,* the same volumes, rearranged, create tensions and instability. Vol-

*Plate 9.5*

*Kurt Seligman* (1900–    ). CATERPILLAR. Varnish, black crayon and wash.
COURTESY OF THE FOGG ART MUSEUM, HARVARD UNIVERSITY.
BEQUEST OF META AND PAUL J. SACHS.

Plate 9.6

*Edvard Munch* (1863–1944).
SELF-PORTRAIT WITH A CIGARETTE.
Lithograph.
DIAL COLLECTION.
COURTESY OF THE WORCESTER ART MUSEUM.

Plate 8.11

*Jean Auguste Dominique Ingres* (1780–1867).
STUDY FOR DRAPERY.
Black crayon.
THE METROPOLITAN MUSEUM OF ART. ROGERS FUND. 1937.

umes possessing complex contours, such as those in da Vinci's drawing (Plate 3.3), seem more animated and intense than those with more simple contours, such as those in Watteau's drawing (Plate 4.13). Like the Watteau, they can express gentleness or, as in Villon's drawing (Plate 6.12), aggressive severity.

The volumes in Lebrun's drawing, "Kneeling and Standing Figures" (Plate 9.7), behave somewhat like the volumes in *A* and *B* of Illustration 9.4. Compare the relative stability of the figure on the left with the tumbling forms of the figure on the right. In this powerful drawing, Lebrun uses sharp, slashing lines, ponderous volumes, strong tensions between the slow-moving shapes, and sudden eruptions of light tones on a black surface to convey a haunting atmosphere of both coarse and spiritual forces. But it is the strange floating quality of these heavy forms that is most provoking and expressive. This becomes evident by turning the drawing upside-down. When the volume is less convincing, the drawing's overall mood is lessened.

But lessening the impression of weight and structure can be an expressively powerful tactic. In Mazur's drawing, "Her Place (2); Study for Closed Ward #12" (Plate 9.8), the skeletal-like volumes of the figure and the chair are sometimes left open to fuse with other parts of each

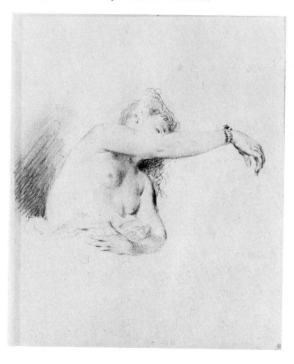

Plate 6.12

*Jacques Villon* (1875–1963). PORTRAIT OF BAUDELAIRE.
Etching.
COLLECTION, THE MUSEUM OF MODERN ART, NEW YORK.
GIFT OF VICTOR S. RIESENFELD.

Plate 9.7

*Rico Lebrun* (1900–64).
KNEELING AND STANDING FIGURES.
Brush and ink.
PHILADELPHIA MUSEUM OF ART.
PHOTOGRAPH BY A. J. WYATT, STAFF PHOTOGRAPHER.

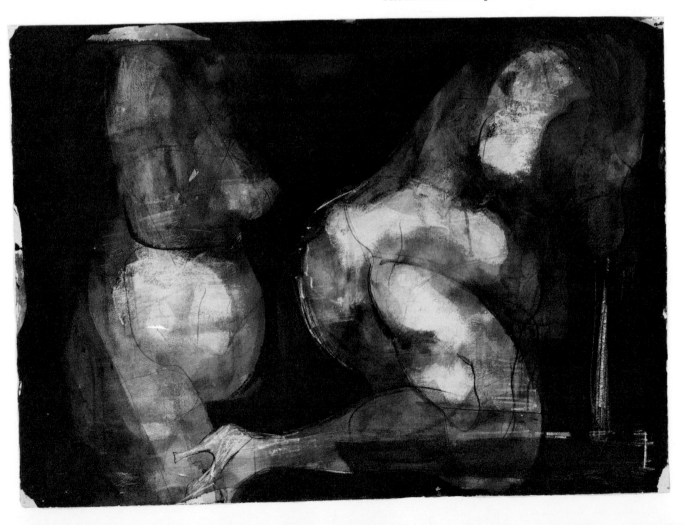

other and the page, lessening the impression of volume and creating angular "shards" of positive and negative shape. This produces an active field of harsh planes and dark shapes with a "raw," torn quality. The overall pattern of angularity expresses the drawing's shocking message. The woman's grim state is also conveyed by the intense light, and the bold shadows it produces, matching the harshness of the shapes and volumes and of the interior.

The sense of a volume's weight can be a strong expressive force. We are not usually consciously aware of the force of gravitational pull unless we sense its absence, or when it suggests danger. Vespignani relies on our appreciation of the meaning of its force in his drawing, "Hanged Man" (Plate 9.9). The artist does not abuse our sensibilities by emphasizing the victim's agony, or by a strong impression of heavy volume. Here, to our relief, volume is somewhat subdued. The image is clear enough. Instead of a tasteless description of one man's execution, the artist

emphasizes the indignity and tragedy of Man as a thing. Here, the expressive meaning appears to point to Man's universal inhumanity. The man's isolated, labelled, and broken body is felt as an obscene violation, a precious loss rather than a repellent sight.

Vespignani intentionally keeps the divisions of the page simple. There is even some ambiguity between the second- and third-dimensional state of the background. The absence of a single white tone casts a gloomy pall over the entire scene, its stillness conveyed by the simple, block-like character of the divisions. The only movement is in the oblique edge of the shadow, pulled away like a curtain. Both lighter and darker in value than any other part of the drawing, the figure's overall lighter tone, and the thin dark tone surrounding it, isolate it in space. Vespignani contrasts the simple purity of the man's forms with the clothing's tangled state, and with the harsh, scarred and lettered poster. The awful stillness of the figure is intensified by this

*Plate 9.8*

*Michael Mazur* (1935– ). HER PLACE (2); STUDY FOR CLOSED WARD #12. Brown wash, brush, pen and ink. COLLECTION, THE MUSEUM OF MODERN ART, NEW YORK. GIFT OF MRS. BERTRAM SMITH.

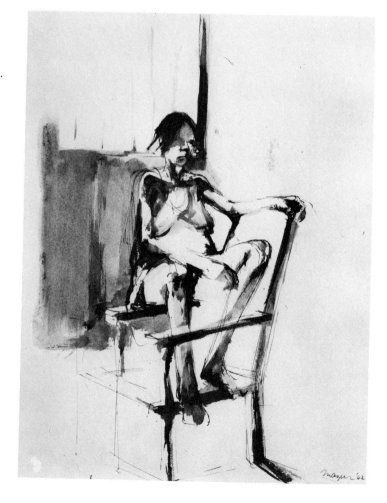

*Plate 9.9*

*Renzo Vespignani* (1924–    ). HANGED MAN.
Pen, brush, and ink.
COLLECTION, THE MUSEUM OF MODERN ART, NEW YORK.
PURCHASE.

contrasting activity of the lines, shapes, values, and textures upon it.

The possible kinds of textural activity in drawing are unlimited, but all can be divided into two basic categories: the controlled, mechanical, and sometimes regularly patterned textures; and the loose, active, and usually unregulated ones. The textures in Sheeler's drawing (Plate 8.12) are an example of the controlled, regulated kind; the strident overall texture of the lines and tones of the seventeenth century Venetian drawing (Plate 4.1), an example of the loose and active ones.

In Chapter Four, textures in nature were seen to be any kind of discernable grouping of colors, values, shapes, or volumes, or any distinguishing characteristics of a volume's surface-state. Here, we must include the textures that media produce—the rough grain of chalk or crayon, the fused stains of ink washes etc., and, as in Plate 4.1, the textures of shapes, lines, values, and volumes on the drawn page.

The textural life of volumes can be highly expressive, as in da Vinci's drawing of stratified rock (Plate 6.8). The expressive role of a medium's texture can be seen in another da Vinci drawing, "A Storm Over a Mountain and a Valley" (Plate 9.10). Here, the chalk's rough texture helps to convey the charged atmosphere. The rugged grain of the chalk's particles envelops the components of this panoramic scene in tones that unify them, and evoke the feel, as well as the look of a rainstorm.

Da Vinci relies on the expressive power of textures throughout the drawing in creating its tumultuous mood. He divides the page into four horizontal bands of texture. First, the storm clouds' churning turbulence is in marked contrast to the straight lines of the rain that form the second band of texture. Below this, a generalized impression of the distant town is suggested by the short vertical and horizontal lines, the trees, and by lines describing the letter *C* at various angles. Finally, the looser, complex texture formed by circular lines, structural line-groups, long and rhythmic curved lines, and small, block-like shapes, conveys the impression of the rolling hills of the foreground. Except for the texture that represents the town, all are loose and active. The drawing's turbulent mood is emphasized by the top and bottom bands of texture. Both suggest strong curvilinear movements that "bracket" the area of the storm and intensify its mood.

We have seen value's power as an agent of expression in most of the drawings in this chapter. Values are bolder and more energetic when

Plate 8.12

*Charles Sheeler* (1883–1965). BARN ABSTRACTION.
Black conté crayon.
PHILADELPHIA MUSEUM OF ART;
THE LOUISE AND WALTER ARENSBERG COLLECTION.
'50-134-183

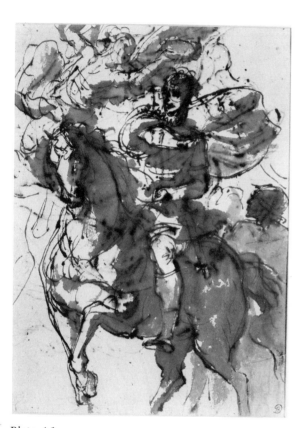

Plate 4.1

*Italian, 17th century. Venetian School.*
A TRIUMPHANT GENERAL CROWNED BY A FLYING FIGURE.
Brush, pen, and ink.
COURTESY OF THE FOGG ART MUSEUM, HARVARD
UNIVERSITY.
BEQUEST OF META AND PAUL J. SACHS.

Plate 6.8

*Leonardo da Vinci* (1452–1519).
OUTCROP OF STRATIFIED ROCK.
Pen over chalk.
WINDSOR CASTLE, ROYAL COLLECTION,
COPYRIGHT RESERVED.

*Plate 9.10*

*Leonardo da Vinci* (1452–1519).
A STORM OVER A MOUNTAIN
AND A VALLEY.
Red chalk.
ROYAL COLLECTION, WINDSOR CASTLE,
COPYRIGHT RESERVED.

drawn with abrupt changes between them, as in Mazur's drawing (Plate 9.8). They convey more dramatic and even brooding moods when such changes involve large areas of dark tones, as in Rembrandt's drawing (Plate 9.3), or when forms emerge from dark or black backgrounds, as in Lebrun's drawing (Plate 9.7). When a drawing's overall tones are light, as in Cezanne's drawing (Plate 9.1), or when the values change gradually, as in Dürer's drawing, "Hands in Adoration" (Plate 9.11), they are usually less bold or active. Slower value progressions such as those in Dürer's drawing, by their subtle nuances of change, suggest a calmer mood. Note the volume's great clarity conveyed by the black *and* white line-groups. In addition to their incisive structural use, these lines build gradually to a crescendo of light tones on the lower part of the left hand and sleeve. This emphasis of light has dramatic

impact because of the overall tone of the page.

Again, in Courbet's drawing, "Landscape" (Plate 9.12), intensity of light has dramatic impact. The drawing's value-variations are gradual, but the framing of a large square of light tones by the darker trees and their shadows makes the light on the trees and field within this frame radiate an intense glow. Indeed, in this stage-like scene, *light,* not volume, appears to be the central attraction.

Just the opposite overall tonal arrangement is used by Goya in his drawing "La Mercado" (Plate 9.13), but the child's upturned face is made to radiate light by the surrounding dark tones. The virtual absence of moderating gray tones gives this drawing an air of intensity and drama. Here, the shapes match the values in boldness, adding to the sense of expectancy.

Plate 9.11

*Albrecht Dürer.* (1471–1528). HANDS IN ADORATION.
Black and white tempera on blue paper.
ALBERTINA MUSEUM, VIENNA.

Plate 9.12

*Gustave Courbet* (1819–77). LANDSCAPE.
Charcoal.
MUSEUM BOYMANS-VAN BEUNINGEN, ROTTERDAM,
THE NETHERLANDS.

*Plate 9.13*

*Francisco Goya* (1746–1828). La Mercado.
Brush and wash.
PRADO MUSEUM, MADRID, SPAIN.

## OTHER FACTORS OF EXPRESSION

The medium always participates in a drawing's expressive character. It does so by its intrinsic traits, and by the way it is used. But the same medium can augment many kinds of expressive meaning. In Chapter Seven, we saw that the intrinsic characteristics and the limits of most media permit a wide range of use. Still, depending on the expressive theme, some media will be more adaptable to the artist's intentions than others.

The selection of a medium should be based on the congeniality of its traits and nature to the theme. Lebrun, in his drawing of two figures (Plate 9.7), might have achieved similar results with chalks, but it is obvious why he did not use graphite or pen and ink. In Flaxman's drawing, "Woman Seated on the Floor" (Plate 9.14), the soft graphite allows a quiet delicacy of line and

tone that echoes the subject's quiet delicacy. Flaxman uses graphite's dry, granular character to produce wool-like lines that help convey the drawing's soft, gentle mood. But the same medium, in Mullen's drawing, "Study for Sculpture" (Plate 9.15), is used to support a powerful and threatening image. Unlike the Flaxman drawing, its angular shapes, sudden value changes, strong directions, and machine-like volumes all suggest bold, aggressive action—and graphite's characteristics, as used here, add to their collective expression. Here, graphite's granular quality helps to produce a rough, abrasive texture and a clouded atmosphere that infer something of the drawing's menacing temper. Note how Mullen uses erasures as a means of creating fast, slashing tones and lost edges.

Here, another device is used to intensify meaning: *distortion*. This term should be understood not only in its strict dictionary definition, "to twist out of shape or change the appearance of,"

*Plate 9.14*

*John Flaxman* (1755–1826).
WOMAN SEATED ON THE FLOOR.
Pencil.
COURTESY, MUSEUM OF FINE ARTS, BOSTON.
GIFT OF ROWLAND-BURDON MULLER
AND WILLIAM A. SARGENT FUND.

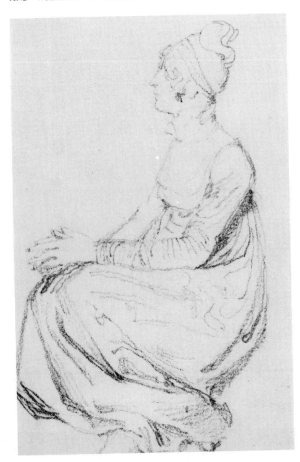

Plate 9.15

*Michael Mullen* (    –    ). STUDY FOR SCULPTURE.
Pencil.
COLLECTION, THE MUSEUM OF MODERN ART, NEW YORK.
ETHEL R. SCULL FUND.

but also in the broader sense of any kind of emphatic exaggeration, addition, or deletion of a subject's properties. To some extent, all responsive drawings can be regarded as "distortions" of the subjects they depict. As we saw in Chapter Five, even when a high degree of accurate representation is intended, the transposing of real volume and space into marks upon a flat surface makes some distortion unavoidable. But the

term is generally used to describe obvious changes in a subject's proportions, surfaces, or other physical characteristics, or in its perspective, illumination, or clarity. The figure in Mullen's drawing, or those in Lebrun's, would be regarded as distorted, but the figures in the Rembrandt and Kollwitz drawings (Plates 9.3, 9.4) would not.

Mullen's treatment of the figure's head distorts it into a threatening, mask-like form. The arms

and legs are reduced to hard, tubular volumes; hands and feet almost disappear; the torso is reshaped into a heavy "battering ram." These distortions intensify the artist's interpretation of the figure as a menacing powerful creature. Poised to attack, its threatening stance is heightened by its facelessness and by the harshness of its forms. Even when the drawing is turned upside down, it conveys aggressive action.

Any of a subject's measurable or emotive aspects can be distorted. In the Mullen drawing, the proportions, perspective, values, and clarity of a human figure are all affected by the artist's expressive theme.

A very different kind of distortion occurs in Tchelitchew's drawing, "Tree Into Hand and Feet With Children" (Plate 9.16). Here, distortions not only add to, they constitute most of the drawing's expressive message. In this largely imaginative drawing, the "realistic" metamorphasis of a tree into human form is, of course, impossible without resorting to distortions. But the artist does not only depend on figurative depiction to convey the drawing's ominous and mysterious mood. The expressive nature of the elements contribute almost as much to its emotive force as do the figurative surprises they produce. This becomes evident by turning the drawing upside down. Now, even with the figurative aspects subdued, the drawing's spidery, brooding mood can be sensed in the relational activities of the elements, and in the character of the handling.

## ADDITIONAL EXAMPLES OF EXPRESSIVE RESPONSE

The possibilities for expressive response are unlimited. Not only does every responsive artist tend toward some general personal style of expression, but also in each of his successful drawings, some original variant on the possibilities for expression occur. The several types of expressive attitudes to be discussed here are offered as helpful examples from the unlimited possibilities available to a searching, sensitive artist. Exploring some of the vast possibilities for conveying expressive meaning encourages a more daring

*Plate 9.16*

*Pavel Tchlitchew* (1898–    ).
TREE INTO HAND AND FOOT WITH CHILDREN.
Watercolor and ink.
COLLECTION, THE MUSEUM OF MODERN ART, NEW YORK.
MRS. SIMON GUGGENHEIM FUND.

exploration of the elements, media, and the device of distortion in our own drawings.

Sometimes distortions are so well integrated, subtle, or consistent, that we are not at first aware of them. They are, in fact, only slight exaggerations, and are not apprehended as distortions. But the emotive power of these subtle amplifications can be considerable. Manet, in his drawing "A Man on Crutches" (Plate 9.17), only slightly exaggerates the figure's bulk by subtly stressing the balloon-like nature of the sleeves and coat. These rounded forms seem even fuller and more weighty by their contrast with the rather weak-looking and spindly crutches. Manet's emphasis on the figure's heavy bulk gives added meaning to the empty space alongside the right leg. The artist shrewdly guides our attention to this space by using a roughly symmetrical pose and view. Because we see two roughly even halves of the figure, two arms, and two crutches, only the missing leg upsets the completion of this simple system of paired forms. Additionally, the figure is placed in a position on the page where the missing leg would have occupied the picture-planes' central vertical axis—the most stable and balanced vertical position possible.

In the context of the broad, loose handling of Guardi's "Architectural Capriccio" (Plate 9.18), the highly distorted figures in the drawing's lower left corner, and those on the landing and staircase higher up, seem perfectly "correct," and expressively, they *are*. Closer examination will show that all the forms in the drawing are only general and very free suggestions—pillars do not reach their bases; ledges, stairs, balustrades, and walls wander out of alignment or disappear altogether; shadows start and stop suddenly; the drawing's perspective seems in places to go awry. This sense of instability in the structure of the scene's forms creates an unsettled, excited air. Guardi, using splashes of tone and a darting, nervous line, adds to this mood by transforming what we know to be hard, architectural forms into vibrating, gestural ones. A spirited "ripple" of energy moves among the forms, changing inert structures into animated, almost organic ones. The drawing's overall expression of nervous energy emerges from the artist's emphasis on gesture and on loosely established generalities, and from the urgency of the lines and tones.

In Delacroix's drawing, "Forepart of a Lion" (Plate 9.19), the artist's interest in the structural volume of a lion is shared with a felt appreciation of the animal's self-assured air of power. Delacroix stresses the lion's weight and strength by simplifying and thickening the volumes of the

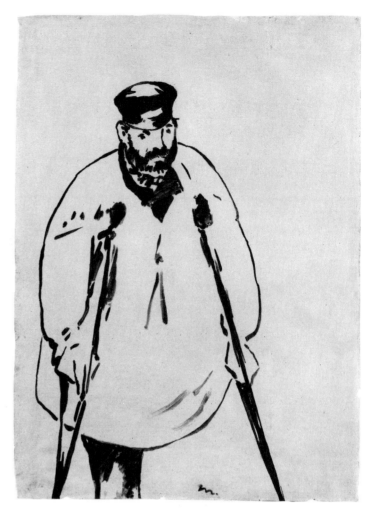

Plate 9.17

*Édouard Manet* (1832–83). A Man on Crutches. Brush, black ink, and tan wash.
THE METROPOLITAN MUSEUM OF ART, HARRIS BRISBANE DICK FUND, 1948.

animal's mane and head, and by arranging their contours to form a continuing, massive block of volume. The mane is depicted by boldly drawn structural lines, most of which are placed more or less vertically to further increase the sense of weight. To suggest even more weight, the lion's mane is shown as quite dark throughout, and darker still in its lower parts. The impression of heavy mass is so convincing that we sense the strain on the sturdy legs. Note that the assertive handling of the black crayon echoes the subject's temperament.

The influence of our expressive meanings upon our treatment of volume is interestingly revealed in comparing Guardi's "softening" of geometric, inert volumes, and Delacroix's "hardening" of organic ones. This is clearly evident in Delacroix's block-like treatment of the mane and head, and in the squared-off contour of the lion's face. Guardi's expressive intent would have

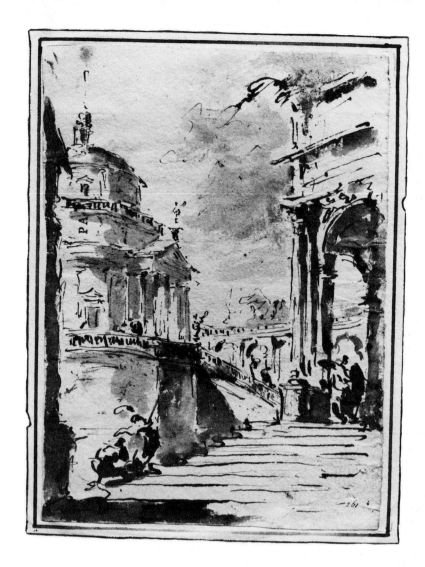

Plate 9.18

*Francesco Guardi* (1712–93). ARCHITECTURAL CAPRICCIO.
Brush and wash.
VICTORIA AND ALBERT MUSEUM, LONDON.

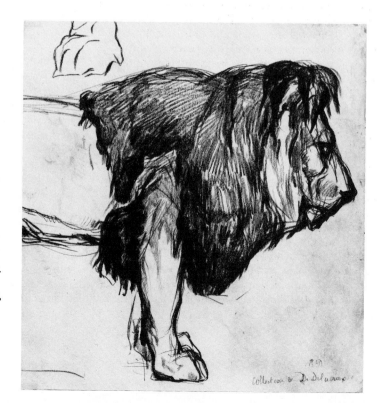

Plate 9.19

*Eugène Delacroix* (1798–1863). FOREPART OF A LION.
Black crayon.
THE ART MUSEUM, PRINCETON UNIVERSITY, PRINCETON,
NEW JERSEY.

been stifled by solid, stable volume; but Delacroix's expressive intent is conveyed by it.

In Daumier's drawing, "The Lawyer" (Plate 9.20), again shapes and masses are simplified, but not to increase the sense of structural volume. Here, they cause a steady lessening of volume, as we read the drawing from top to bottom. In fact, covering the top half of the drawing shows the remainder quite without any suggestion of volume. Instead, the lower half of the drawing seems to suggest "torn," ruffled, value-shapes. The further up we look, the more the image develops into volumes until finally, in the figure's head, the impression of volume is strongly conveyed. By making the figure's shoulders and head the most convincingly three-dimensional of the drawing's forms, by placing the strongest contrasts of value here, and by the provocative, somewhat caricatured expression of the face, as well as by the animated quality of the lines and tones that produce it, Daumier fixes our attention on this part of the drawing. The broader, lighter, and flatter character of the drawing's lower half contributes to the crescendo of attention upon the lawyer's malicious smile, and the drawing's loose, energetic behavior helps to convey the impression of his movement. Although we do not see his legs, the figure's overall tilt, and the "windblown" behavior of the shapes and tones suggest that he is walking quickly. Notice that the head, although its volume is more fully developed than that of any other part, is no less vigorously drawn. As this drawing shows, the consistency of commitment to a particular attitude of expression, partly reflected in a drawing's handling, is important. In the best drawings, the artist always sustains his expressive intent. Deviating from it weakens both the drawing's design and its expression, and makes the content self-contradictory.

Another drawing by Daumier, "The Song" (Plate 9.21), shows a consistency of intent sustained throughout a more developed and demanding work. Again, as in the previous drawing, the features of the faces (and the body of the centrally placed figure) and slightly caricatured, exaggerating the expressions and the characters of the four men. Contrasts of value are also exaggerated, creating an impression of intense light playing across the group that boldly sculpts the forms as it gives them a sense of dramatic importance. Daumier deletes all extraneous detail. The clothing and hands of the figure are broadly stated—even the men's heads are simplified toward the back of each, away from the expressive features of their faces. The background contains no forms—it is simply a darkened area. Here, as

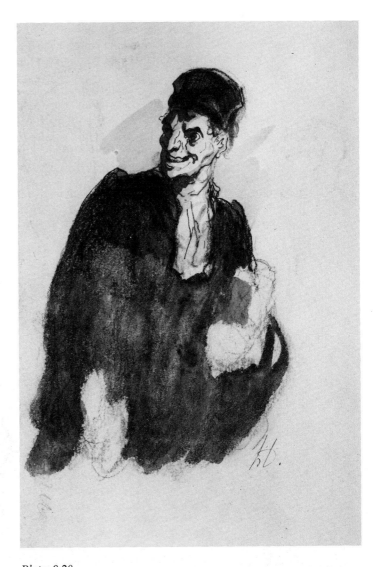

Plate 9.20

Honoré Daumier (1808–79). THE LAWYER.
Black chalk, pen and wash.
MUSEUM BOYMANS-VAN BEUNINGEN, ROTTERDAM, THE NETHERLANDS.

in the previous drawing, only the facial features are developed—with a strong interest in conveying the details of careworn folds and wrinkles. Daumier's sympathetic emphasis of these weathered faces, temporarily enlivened by drink, suggests that the group's impromptu song is as sudden and temporary as the intense light is to the darkened scene—that the usual state of both is more somber. Note how the artist combines light and dark tones with vague and clear edges to help guide us toward areas of emphasis. Note, too, how the thick, rounded character of the forms, whether of a body or a finger, is everywhere the

same. Even the volume-summary of all of the four men forms a monumental, rounded, half-sphere, its curved edge conveyed by the arc of the heads.

Daumier's mastery of facial expressions is evident in these four faces. The lines and tones of each not only model the form, they also enact the gestures that animate the features of these men. Note especially the pulling action of the eyebrows and wrinkles of the forehead of the man on the far right. Indeed, there is not a line or tone in the drawing of the head that does not help convey the drinking action. The shapes, volumes, and directions of the head even suggest

the direction of the movement of the head back-wards. Such eloquently expressed human actions do not emerge merely from patient scrutiny, but from perceptions guided by humanistic interests.

Such interests lead Rembrandt in his draw-ing "Girl Sleeping" (Plate 9.22), to include a bold darkening of the upper left corner of the page, to fuse the figure's forms with those of the bed, and to simplify drastically many of the forms, especially in the lower half of the drawing, in order to convey a sense of a supernatural pres-ence. Here, the brushstrokes appear to hover between a linear and tonal role, their semi-auton-omous and largely two-dimensional activity trans-

*Plate 9.21*

*Honoré Daumier* (1808–79). THE SONG.
Black chalk, pen and black ink, grey wash, and watercolor.
STERLING AND FRANCINE CLARK ART INSTITUTE,
WILLIAMSTOWN, MASSACHUSETTS.

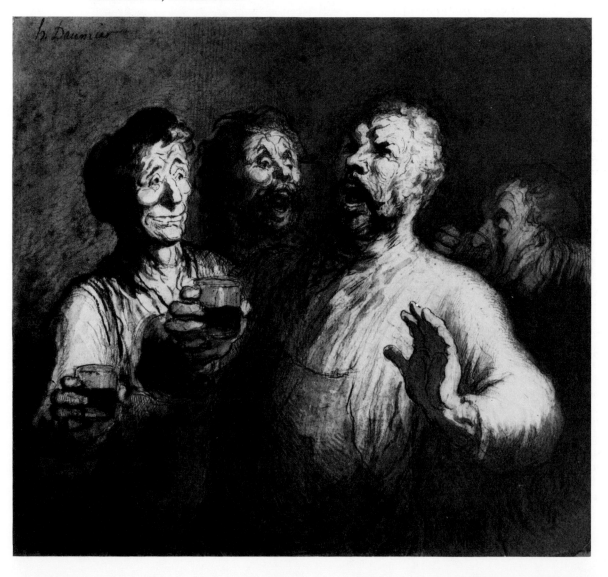

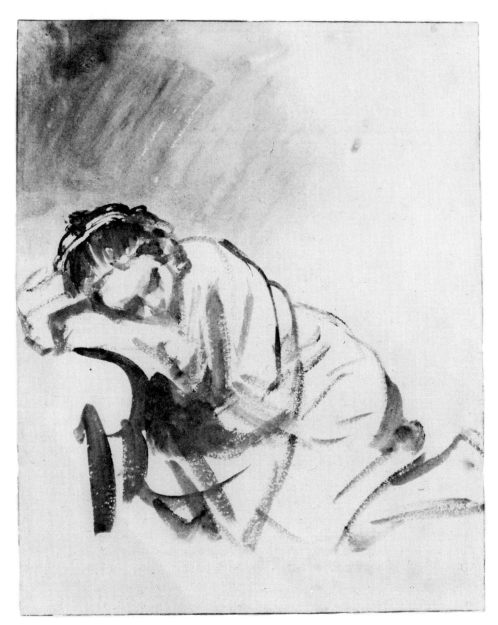

*Plate 9.22*

*Rembrandt van Rijn* (1606–69). GIRL SLEEPING.
Brush and wash.
TRUSTEES OF THE BRITISH MUSEUM, LONDON.

forming the girl and her bed into swaying, restless lines and shapes that contradict her passive state. This contrast between the inaction of the figurative information, and the agitated energy of the elements, suggests that the forms are being acted on by some force. This sense is further strengthened by the dark tone's retreat before a strong, pervading light. Together, these qualities transform the scene of a sleeping girl into something with deeper significance.

Claude Gellée (also called Claude Lorrain), in his drawing "Study of a Tall Tree with a Man Climbing up It" (Plate 9.23), stresses scale differences and a sense of movement to convey the quiet drama of a figure climbing to a great height. The difference between the size of the man and the tree is emphasized by the artist's selection of a view far enough back to include the entire length of the tree. Also, considering the size of the leaves, it appears the artist has some-

Plate 9.23

*Claude Gellée (Claude Lorrain)* (1600–82).
STUDY OF A TALL TREE WITH A MAN CLIMBING UP IT.
Pen and brown ink.
THE NATIONAL GALLERY OF CANADA, OTTAWA.

what reduced the scale of the man to the tree. Gellée conveys the windblown movements of the leaves and branches by stressing the roughly bell-shaped forms of the leaf-clumps, and by locating them in positions and tilts that cause relationships of rhythm among them. Its movements are further conveyed by oblique line-groups alongside and upon the trunk that the man is climbing, and upon the clumps of leaves to the man's right. Though hardly intense or powerfully dramatic, Gellée's drawing is not less successful in conveying its expressive meaning than others we have discussed. The sense of gentle swaying movements, and the underplayed human drama is supported by the graceful, easy handwriting and the consistent avoidance of strong value contrasts.

Although in examining these drawings we have been concentrating on expressive factors, it must by now be evident that the artist's visual and expressive interests are deeply interrelated, and

that any drawing action generally involves both considerations. However, recognizing the discernable difference between selections and changes based on visual issues and those which serve expression, helps us to better govern and integrate both kinds of response.

The drawing exercises that follow are intended to help you experience the role of the elements, of media, and of distortion in conveying expressive meanings.

### EXERCISE | 9A

Genuinely felt responses to a subject cannot often be produced on demand, and there is no really adequate substitute for such expressive sensations. The best test of the ability to freely utilize expressive factors must occur in drawings of subjects that strongly engage your feelings. But, here, by aiming pairs of drawings toward clearly opposed expressive goals, you may, if you can invest these goals with some degree of meaning, begin to experience new attitudes toward the uses of the elements, your media, and the devices of distortion or exaggeration.

There are no time limits on any of the following drawings. Except for the first four drawings, you can use whatsoever media (and as many as) you wish, on any suitable supports, of any desired sizes. Because of a medium's influence on a drawing's expression, it is advisable to vary these, but in each drawing, the primary consideration in selecting a medium should be its compatibility with your expressive goal.

***Drawings 1 and 2.*** Using a nude model as your subject, make two drawings of the same pose, from the same position. In Drawing 1, use pen and ink and any suitable paper about 10″ × 14″. Your expressive goal is to depict the model as passive, at rest. Try to convey a sense of tranquility and stillness. Here (and in all of the drawings in Exercise 9A), consider an overall design strategy before you begin to draw what you feel will stress your meaning. Because expression is conveyed by the elements as well as the character of the forms they produce, think about their use here. A tentative, general plan should, of course, be based as much as possible on responses to the subject. In all of the drawings from the model, the subject should include his or her immediate environment. Once you begin, do not feel bound by any prior strategy, should visual or expressive events or opportunities suggest a new plan for achieving your expressive goal.

236

In Drawing 2, use any friable black chalk, the softer, the better, and any suitable paper, approximately 18″ × 22″. Now, your expressive goal is to depict the model as powerful, aggressive, and active. Again, consider a general approach before you begin.

Having just selected very different qualities from the same view of the same pose, you will, of course, have to search for those actualities or potentialities that will serve this new goal. In this admittedly arbitrary search for clues to support expressive themes that the model may not easily suggest, you can more fully appreciate the many choices possible in the "raw material." The more you study the forms and consider what choices and changes would help convey your expressive goal, the more they will appear. It is obviously helpful to pose the model in a way that will suggest some possibilities for either of these opposing expressive goals.

In both drawings, do not force the medium to go against its inherent characteristics. Also, do not, in these first two drawings, rely on bold distortions. Indeed, try to avoid any but the most essential distortions, and keep these subdued to minor adjustments. As you begin to *feel* an expressive intent, subtle exaggerations will occur without your awareness. These unbidden changes are, here, far more preferable to those you may choose to make. In general, bold distortions make subsequent responses to a subject more difficult because the constant subject and the evolving drawing are pulled farther and farther apart.

***Drawings 3 and 4.***   Select a new pose that will again allow some possibilities for the two opposing expressive goals of Drawings 1 and 2. This time, exchange media and try to make Drawing 3, using chalk, convey gentle passivity, and Drawing 4, using pen and ink, aggressive power. With this exchange of media, new possibilities and restrictions of expression occur, requiring new strategies and perceptions. Again, distortions should be few and minor.

***Drawings 5 and 6.***   Place the model in a new pose that offers some possibilities for depicting it as transfigured into a wraith, or cloud-like form in Drawing 5, and into a machine-like form in Drawing 6.

In Drawing 5, try to show the model as being almost weightless. You may want to regard the forms as somewhat translucent and ethereal. Here, you can either extend this mirage-like image to include the figure's environment, or use

the substantiality of the surrounding forms as a contrast to those of the ghost-like figure. In Drawing 6, using the same pose, try to regard the model as robot-like. You want to convey the sense of the figure's heavy weight and unyielding rigidity.

In this pair of drawings, distortions can become bolder and more frequent, but should be stimulated by the model's forms and grow from them as essential exaggerations of observed clues, rather than tacked on arbitrarily to the image. For example, in conveying the feeling of the model as a machine, you may logically want to exaggerate the various interlocking unions of the forms (especially at the joints) to suggest machine-like fittings, or simplify forms into more severely "tooled" forms, but deciding to add gears and shafts here and there is not invention stimulated by observed potentiality, but by prior concepts about what machines should look like. In these two drawings, and in all the drawings to follow, use any media and materials you wish.

***Drawings 7 and 8.***   Pose the model in a standing position that conveys some rhythmic movements. In Drawing 7, *subtly* suggest that the forms are made of some soft, wax-like material that has just begun to melt. Here, distortions are built into the situation, but should be used with finesse. Try to feel the sense of weight straining the softening, projecting, or supporting limbs, how they have begun to yield to gravitational pull, and how their forms have begun to change.

In Drawing 8, use the same pose to subtly suggest the figure has begun to be transformed into a tree. Try to believe that this is actually happening, it will help you make inventive changes stimulated by perception, rather than by memory.

***Drawings 9 and 10.***   Make both drawings from the same view of a landscape. In Drawing 9, try to convey the scene as forbidding, mysterious, or dangerous. In Drawing 10, the same scene should suggest a peaceful, welcoming mood. This time, resist *any* tendencies toward obvious distortions of the proportions, perspective, or contours. That is, try to record the subject's physical forms with a reasonable degree of objectivity. Rely instead on your use of the elements, especially value, and your handling of the media to convey your intent. This will influence the physical state of the forms anyway, but here, the selections and changes you make should

result from utilizing line, value, texture, etc., to express your meaning rather than pronounced additions, deletions, or other drastic changes in the subject's actualities.

In this chapter we have emphasized examples by artists who are strongly expressive in order to more easily recognize the expressive factors at work. But it is really impossible to imagine a drawing without some expressive meaning. This may be subconscious and unintentional in some; in others, the desire to express may be held in check to help unselectively duplicate a subject. But this restriction is itself expressive of holding back intuitions that permit the genuine satisfaction of released feelings in the act of drawing. In still other drawings, expressive meaning, if disregarded, makes the drawing's emotive character confused. There may be conflicting meanings, or a lack of expressive focus, and *these* characteristics are expressive. They reveal an aimlessness of meaning, a wandering of purpose. There are drawings that are largely bravado—bold flourishes that are without solid fact or feeling—and drawings that are timid, uncertain, and bored.

All drawings reveal something of the artist as a person: his greatness or smallness of character, his view of what is worthwhile, even glimpses of his philosophy. To disregard the given condition of expression as part of every drawing's content dissipates forces that could give greater purpose, meaning, and impact to our drawings.

# 10

# Pathologies of Drawing

## SOME SYMPTOMS OF DEFECTS

## A DEFINITION

A responsive drawing reflects the graphic equivalent of certain of a subject's qualities that are essential to the artist's intellectual and intuitive interests. It also reflects his judgments and feelings about the design and expression of these qualities, within the fixed boundaries of a flat surface. This graphic equivalency is a different but parallel state of a subject's significant qualities, and consists of the relational activities of the marks that convey it. Together, they create a system of expressive order that can be thought of as a graphic "organism," one whose actions and energies convey a sense of "life" within and among the marks. Like living organisms, graphic organisms depend on the successful and interrelated function of their parts for life. They can be organizationally and expressively "healthy," or "suffer" various disorders that weaken and limit their effectiveness.

To regard drawings as organisms that roughly parallel some of the qualities and frailties of living ones permits a useful analogy. This helps us better understand how important the behavior and character of all a drawing's components are

to its artistic well-being. It also helps us apply the same analytical honesty to our examination of the results that the act of drawing demands because we expect "diagnostic" objectivity when examining any organism's soundness. In fact, one of an art teacher's most essential skills is just this ability to objectively analyze a student's work, based on its visual and expressive nature—that is, its content. Such constructive analysis, not the unselective rejection of the student's intent, is the teacher's primary responsibility. Total objectivity is not possible, involving, as it must, the teacher's own aesthetic persuasion and temperament, but it is a goal of a conscientious teacher. The teacher whose evaluation is directed less at a drawing's particular weaknesses and strengths than toward its general aesthetic thrust and whose advice refers to stylistic directions other than that of the drawing under examination, is like the doctor who prescribes a favorite medication, whatever his patient's ailments.

But there *are* drawings that show such extreme disorder and/or innocence that the student's problem is not merely inconsistencies and

misconceptions in drawings basically showing a sound approach. Rather, such drawings show an underlying innocence towards the fundamentals of perception, organization, and expression. In such cases, the teacher should rightly be less concerned with correcting each symptom, than with curing the problem itself. The teacher then does not direct a student's development toward a particular aesthetic ideology, but turns him away from concepts in which perceptual, organizational, and expressive failure is certain.

We are all limited by the quality of our perceptual comprehension, and by the kinds of responses they stimulate. The beginning student's comprehension and range of response will expand greatly as he develops. If he is developing his skills with little or no professional guidance (and some great draughtsmen such as Rembrandt, Van Gogh, and Cezanne had little formal training) the experiences and insights that expand ability must come through his own efforts to study drawings, to continuously keep drawing, to learn about the materials and the history of drawing, and to sustain his commitment to drawing during the inevitable periods of little forward progress. If the student is in a program of art study, some, perhaps much of his abilities will reflect good instructional guidance. But like the student working alone, the responsibility for his artistic growth is, finally, his own. It is developed through the same initiative to search out his own experiences, information, and interpretations. Both students, during their period of study, and certainly afterwards, must continually develop their own aesthetic sensibilities *and* diagnostic skills.

The level and nature of the student's creative goals, and his ability to analyze the factors that hinder achieving them, are usually more sharply formed and more wisely based by students in a formal art program. The abrasive exchange of ideas between the art student, his fellow-students, and teacher, and the teacher's own excited involvement in art help stimulate the formulation of good creative attitudes and challenges. Too often, the student who is developing his abilities on his own cannot discriminate between the processes of drawing, which are universal; and the techniques of drawing which are personal. Without the guidance of a knowledgeable teacher to help him overcome perceptual and technical problems, and to help him understand the conceptual matters of design and expression, the student may lose much valuable time developing superficial expository skills instead of analytical responsive ones.

But both students can and must engage in the equally important examination of the drawings of every period and culture with a view to grasping the universal values and goals of artists as far removed in time and culture as cave artists and contemporary ones.

All great examples of drawing show the qualities of expression and order, and do so with great economy and authority. But all should be studied primarily as manifestations of creative experience, rather than displays of skill. They can teach us much about drawing and about Man. Both students must measure their own drawings against their own goals, and against those universal qualities that all great drawings reveal.

An artists's approach is not altogether freely chosen. Part of what motivates the way we draw is determined by our instinctive need to have certain undefinable qualities present in the drawing. Such intuitive, idiosyncratic needs are as insistent as they are intangible. Though we cannot point to the places in a drawing where they manifest themselves, we reject those of our drawings in which these qualities are absent. These unique and necessary influences are rooted in our subconscious reason and need, and, as mentioned in Chapter Eight, are sensed rather than seen—they permeate a drawing. Examples of great drawings show the artist's acceptance and utilization of these intuitive needs.

But students or artists whose drawings are heavily influenced by other artists may largely mask these qualities because they are "speaking" in another's "voice." If these intangibles that convey a personal and original presence are submerged in their drawings, whatever else the drawings may have gained through such influences, they will lack a certain natural conviction and spirit. These intangibles cannot make a drawing great, but their absence rules out greatness. They cannot be measured, analyzed, or altered.

But many other factors in our drawings can. We will now examine some of the "ailments" of drawings. The more we learn about graphic defects—why drawings fail—the more we can do to avoid them and diagnose their presence when they occur.

However, there is a danger here. We should not pursue the impossible goal of perfection—assuming that a drawing has failed because one part or one aspect of it has failed. There is no individual without some blemish or flaw, nor is even the greatest drawing flawless. Many fine drawings show some minor waverings in organizational or expressive continuity, or some minor

failure in perception or handling. The wonder is not that a drawing can be great despite its imperfections, but that so much eloquence and strength is ever achieved with so few flaws. In fact, works of art are incredibly durable, even when fairly pronounced problems exist. In Millet's drawing, "Shepherdess Knitting" (Plate 10.1), the figure's right foot is, at first, difficult to find. We are provided with no clues that explain how it came to be positioned on the figure's left side, or why it is at so marked an angle. *In the context of the drawing's overall structural and spatial clarity,* this appears to be an inconsistency. The dark form upon the figure's left shoulder is also somewhat independently stated, and unaccountably dark. Togther, these two departures from the representational "pace" of the rest of the drawing make the form at the shoulder seem only weakly related to the

*Plate 10.1*

*Jean François Millet* (1814–75).
SHEPHERDESS KNITTING.
Crayon.
COURTESY, MUSEUM OF FINE ARTS, BOSTON.

other forms. The several lines from the top of the page to the figure's head seem to define a tree's edge, but their collective tone brings the lines forward where they can also be interpreted as descending into the figure's head. Despite these ambiguous passages, the drawing's gentle charm and the seemingly effortless way that Millet conveys volumes and the character of the shepherdess is impressive.

The durability of a work of art can also be realized by seeing the fragments of drawings, paintings, and sculptures from antiquity. The expressive order of many of these is so much a part of every segment, that even surprisingly small fragments seem able to overcome the absence of the rest of the work to convey their aesthetic meaning.

But in the following examination of common defects in responsive drawing we should recognize that what may be a failing in one drawing's context, may be a vital function in another. More often than not, a response is right or wrong in relation to the nature of the rest of the drawing, and not in relation to any established conventions. The following defects, then, do not refer to any particular aesthetic ideology, but rather to the universal aesthetic principles of unity of a drawing's abstract and representational aspects, and of a *consistency* in its economy, diversity, authority, and honest commitment. Knowing about some of the more common symptoms of perceptual, organizational, and expressive failure expands the criteria we can apply in evaluating our drawings.

## PERCEPTUAL DEFECTS

Learning to perceive is of course, the basic skill. Seeing the generalities before the specifics, sorting the essential from the superficial, being receptive to relational matters, and analyzing and measuring our subjects are the insights fundamental to any growth as an artist. The following perceptual defects are among the most frequent and vexing.

1. Poor sense of scale relationships (proportion), placement, or shape-state awareness: is generally a result of sequential assembly. It also suggests a weak grasp of the need for relating activities in one part of a drawing to those in another part. Often, especially in figure drawings, the forms will steadily decrease in scale from the top toward the bottom of the configuration, re-

*Illustration 10.1*

*Sequential drawings often result in intended changes in the scale of the forms (A). Disregarding the spatial relationships between forms can result in their being drawn as interpenetrated (B).*

vealing no regard for relating the scale of parts, or for searching out the subject's gestural character (Illustration 10.1A). Sometimes volumes are drawn in positions that would have them occupy the same space (Illustration 10.1B). That this can occur in the works of gifted artists is seen in Claude Gellée's drawing of cattle (Plate 10.2), where parts of the two cows at the far left seem to exist in the same space. Here, too, the placement of the cow at the top of the page makes it appear to be standing on the back of the large cow in the foreground. Yet, Gellée's ability to relate the various elements and analyze the structure of the cow in the foreground show him to be perceptually sophisticated.

*Plate 10.2*

*Claude Gellée (Claude Lorrain) (1600–82).*
A HERD OF CATTLE.
Pencil, sanguine and wash.
COURTESY, MUSEUM OF FINE ARTS, BOSTON.

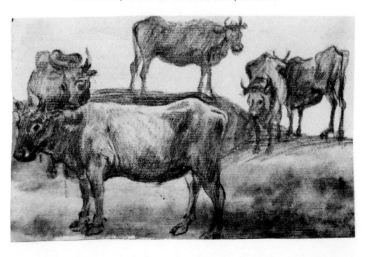

2. Conflicting perspectives: a common result of sequential assembly, it is symptomatic of a disregard for relating the positions in space of all the drawing's forms, and of the need to perceive the angle of their edges and of their axes. When forms are developed from the general to the specific, and when observations are "proved" by testing them against the principles of perspective, such defects are far more easily avoided. Failure to do so can result in any of the strange relationships seen in Hogarth's drawing, "Satire on False Perspective, Frontispiece to Kirby's Perspective" (Plate 10.3).

3. Overabundance of details: again, often a symptom of sequential assembly, it suggests an inability to analyze and select the subject's essential directions, masses, and planes. When these perceptions are not made, an exclusive concentration upon surfaces is usually at fault. Often, it is due to an overconcern with a reportorial attitude—tell it all, everywhere. Ironically, an overabundance of detail often markedly contrasts to a scarcity of convincing volume.

4. Parts stronger than the whole: often connotes more interest in the smaller forms that constitute a larger volume than in the larger volume itself. In the Augustus John drawing of a woman's head (Plate 10.4), the features of the eyes, nose, and mouth are tonally stronger and more fully realized forms than that of the head, of which they are parts. The hair and forehead, and those more "open" areas of the front of the face, as well as the neck, are left more broadly stated and lighter in tone. Here, the strong relationships between the rhythmic curves in every segment of the drawing considerably help to subdue the discrepancy between the strongly modelled features and the weakly stated head and neck.

Sometimes, as we saw in Chapter Eight, such studies of particular forms are preparatory notes for a work in another medium (this appears to be a study for a portrait). Even so, the fullest understanding of the nature of a larger volume's small parts is better achieved in the context of their structural and organizational relationships to it.

5. Weak sense of volume: when not due to an overemphasis on details, surface textures, or sequential assembly suggests an inability to analyze and relate the subject's components in order to extract the direction of their forms, their volume summaries, the interlockings of their parts, and the forces of pressure and tension—all of which, as we have seen, help convey structural volume. Sometimes, too, it is due to a timid use of value, or an over-dependence on the volume-producing ability of delineating outlines.

6. Hard, monotonous outline: suggests a belief in the ability of the outlined limits of a form to convey everything about a subject's volumetric character. The reluctance to leave the "safety" of the delineating edge to model the interior of a form

Plate 10.3

*William Hogarth* (1697–1764).
SATIRE ON FALSE PERSPECTIVE.
Engraving.
COURTESY, MUSEUM OF FINE ARTS, BOSTON.
HARVEY D. PARKER FUND.

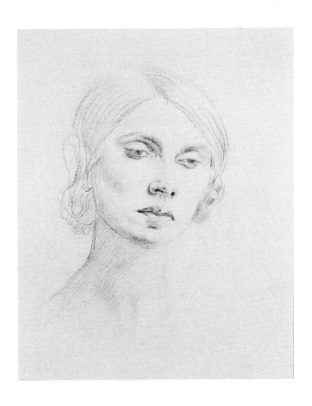

Plate 10.4

*Augustus John* (1878–1961).
HEAD OF A YOUNG WOMAN.
Pencil.
COURTESY, MUSEUM OF FINE ARTS, BOSTON.
HELEN AND ALICE COLBURN FUND.

makes some of these drawings look ghost-like. Usually, when interior modelling does occur, the use of single lines to suggest subtle changes in terrain, such as occurs in a figure, produces "scars" on the white shape of the interior, rather than an impression of undulating surfaces.

7. Stiff, wooden drawings: suggests an over-cautious concern for error, and a bypassing of gestural drawing. Ironically, the fear of error—of making a mess—has probably ruined more drawings than any other single attitude. It is virtually certain to produce drawings that suffer the grave defect of stilted, dead forms. In responsive drawing, there is safety only in perception, analysis, and uninhibited response. Here, caution is dangerous.

   Stiff, wooden forms also frequently occur as a result of an overuse of straight lines and hard, right angles, sometimes to the exclusion of all curved lines, as is sometimes seen in some mannered techniques.

8. Tonal "anemia": occurs in tonal drawings when there is a fear of using dark tones, especially over large areas, even though a drawing's volumes, composition, or expressive meaning requires it. Beginning tonal drawings on a toned surface (either a tinted paper, or one that is given an all over coating of charcoal or graphite) is useful in overcoming a reluctance to use bold, deep, values.

9. Formula solutions: when remembered cliches replace responses to any of a subject's actualities. There is a failure to respond because of disinterest in various parts of the subject, an inability to visually comprehend them, or a preference for familiar solutions. Such drawings do not seem convincingly in touch with nature. In part, they are not. When memory replaces perception, formula replaces nature.

10. A breezy, sketchy manner: usually false flourishes that imitate the economical, authoritative, and always fully engaged lines and tones of master artists. These usually convey little or nothing more about a subject than loose generalities. Often symptomatic of a superficial understanding of perceptual skills, such drawings are generally ambiguous about volume and space, design, and expression. At best, they are interesting "promissory notes," at their worst, and more frequently, they are displays of flashy pretension.

The discovery of perceptual defects in our drawings requires more than a willingness to examine and challenge their measurements. Although it is essential to go back and discover measurable discrepancies that we did not recognize during the act of drawing, we must also apply evaluative criteria to examining *any* perceptual attitude or habit that hinders our perception.

In the excited involvement with the many interlaced factors of response to the subject *and* the evolving drawing, overlooking a scale relationship, the misjudging of an angle, or any other *unintended* change is an understandable occurrence. Viewed later, unintended exaggerations of scale, placement, value, etc., are often glaringly evident; but overworked, monotonous outlines, formula solutions, or an over abundance of detail will remain "invisible" defects, if not critically investigated. Their reappearance in our subsequent drawings is certain unless we objectively examine the concepts and procedures of our overall approach to drawing. Here, the emphasis is on the need to perceive and analyze a subject's measurable actualities *for any kind of graphic goal*, and on some of the common perceptual defects that indicate faulty procedures and judgments. How we perceive is not the same as what we do about our perceptions. In analyzing the perceptual defects of our drawings and working to overcome them, we should also be gaining insights into our general approach that lead to artistic (and personal) growth.

## ORGANIZATIONAL DEFECTS

The way we order our responses conveys our aesthetic and temperamental interests. It reveals our understanding of the relational life of the marks that constitute our drawing. Sound perceptual skills require sound organizational sensitivity if they are to have any creative worth. The following organizational defects are those most often seen in student drawings. Some are easy to spot, some are insidious and subtle, all diminish a drawing's design and consequently, its meaning.

1. The labored drawing: often results from fussy embellishments of parts with unnecessary details and "finish," isolating them and reducing their relational activity. It can sometimes be traced to a poor choice of media, where numerous attempts to force a medium to react to the artist's needs causes a general loss of spontaneity. Sometimes there is an "obsessional" concentration on some particular organizational or expressive theme so exclusive that the drawing's overall economy, spontaneity, and character are lost.

   Drawings are often overworked because their representational aspects are over-emphasized. Such drawings reveal a high degree of accurate representation—of illustrative fact—not a high degree of visual-expressive design. Responsive

drawings are complete when they cannot be made more visually and expressively exciting and succinct. "Finish," in the sense of photographic naturalism, is often the finish of a drawing's relational, abstract life. Accurate representation and inventive graphic design are not mutually exclusive, but the more figuratively accurate a drawing's imagery becomes, the greater the demands on our understanding of the abstract and organizational powers of the marks that make our images.

2. Redundancy: the use of lines and tones for the same function in a single volume. This suggests a mistrust of values to convey the impression of volume without the aid of a final, encompassing outline, as in Illustration 10.2. Although line and tone may work together in many ways, using both to say the same thing usually harms a drawing's overall freshness, economy, *and* impression of volume. The duplicative behavior of line and tone is more confusing than clarifying because the role of each is obscured by the presence of the other.

3. Random use of lines and tones: usually occurs when there is no general strategy for the roles of line and tone in a drawing. In such drawings, some parts may be depicted by line only, other parts by tones, and still others by various combinations of line and tone. Although variations in their use are often desirable and necessary (Plate 6.3), extreme differences that lack any compelling visual or expressive purpose, make it appear that two or more unrelated attitudes are at work in the same drawing (Illustration 10.3). Such an erratic use of line and tone suggests a confusion or innocence about visual issues, goals, or both.

4. Ostentatious facility: occurs when adroit cleverness in the use of media, or deft expository devices are dominant goals. Although facility, or inventive and masterly control, is a desirable quality, drawings in which cleverness of execution is primary appear to be performances for approval rather than felt responses. Such drawings often reveal only a passing interest in visual issues, and a fascination with deft solutions to figurative illusions. When facility makes a drawing a system of clever representational mannerisms, instead of helping to articulate an organized personal and penetrating interpretation of nature, the drawing becomes illustrative rather than pictorial, exhibition rather than experience.

5. Lack of unifying directions and rhythms: suggests a sequential approach. Completing parts one at a time seldom permits their being freely woven together by directional and rhythmic forces. This stilted approach is not relied upon by artists who are sensitive to the movements or beats between elements and the forms they create. Again, lack of such relational forces usually comes from an over-emphasis on representational aspects.

*Illustration 10.2*

*The outlines in A are unnecessary. They tend to flatten and harden the forms. The same forms in B, minus the outlines, are more convincingly volumetric.*

*Illustration 10.3*

*Arbitrary changes in the handling of a drawing suggest indecision and an insensitivity to the drawing as a unified design.*

6. Inconsistency in the role of the third dimension: like any other random factor, suggests a lack of a sustained, overall visual or expressive attitude or confusion over the drawing's goal. Many drawings do have transitions of emphasis between the second and third dimension, but the *random* disappearance of volume and spatial depth shows an unawareness of the fundamental need to convey one overall frame of reference in a drawing. When elements in one part of a drawing convey three-dimensional impressions, and those in another do not, there must be some general design strategy that relates and unites these parts. In Plate 8.12 and in Illustration 10.4A, the interrelationships of the second and third-dimension are clearly intended aspects of both designs. But Illustration 10.4B seems merely an incongruous combination of the second and third dimension.

245

A   B

*Illustration 10.4*

*In part A, two and three
dimensional considerations are
integrated; in B, the second
and third dimensions are unrelated
and suggest conflicting goals.*

7. Random placement of the configuration on the page: suggests an indifference to their relational influences. As we saw in Chapter Eight, a drawing's design consists of the configuration *and* the page. Disregarding the visual role of the page's shape and scale in a drawing's design bypasses a fundamental means of amplifying the configuration's visual and emotive character. In Illustration 10.5, the active, dark shape in *A* overwhelms the several white shapes and seems crammed into the picture-plane, straining for release. The same shape in *B* appears less active, and not at all crammed in. In fact, it appears somewhat isolated in so large a field of space. In *C*, it has been located in a position on the picture-plane that creates imbalance. Besides destroying the equilibrium of the design of the page, this can sometimes weaken the overall nature of the configuration. An image that is itself stable, if placed badly on the page, becomes part of an unstable design.

An incompatible relationship between the configuration and the page sometimes occurs in the work of capable artists, as in Vigée Lebrun's

drawing, "Figure of a Woman" (Plate 10.5). In what is otherwise an excellent drawing, the lack of "breathing space" around the figure, especially at the top where the head touches the edge of the page, produces a slightly claustrophobic impression (although the drawing may have been cropped by another hand at a later date).

8. The divided drawing: when strong vertical, horizontal, or diagonal lines, values, or forms cut and thus isolate one part of the drawing from the rest, destroying its unity, as in Illustration 10.6A. In Cheruy's drawing of a church interior (Plate 10.6), the group of columns on the far right cut the drawing vertically. But they are joined to the rest of the drawing in several ways. One of the strongest connections is the unseen—but clearly suggested—arch spanning the interspace between them and the center group of pillars. The similarity of value and texture between the two massive pillar groups, and their relationship with the third group on the left, as well as with the smaller pillars and arches behind them, all form strong visual bonds of association.

*Illustration 10.5*

*The character and behavior of a configuration are influenced by its
relationship to the bounded field. In A, the shape appears to be powerful
and its explosive force seems "choked" by the tight enclosure. In B, the
shape seems less powerful. In C, its position and scale destroy its balanced
resolution with the page.*

A   B   C

*Plate 10.5*

Louise Élizabeth Vigée-Lebrun (1755–1842).
FIGURE OF A WOMAN.
Red chalk.
COURTESY, MUSEUM OF FINE ARTS, BOSTON.

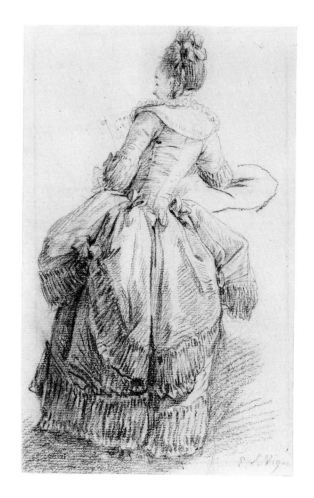

*Plate 10.6*

Germaine Rouget Cheruy (1896–     ).
VÉZELAY, LA MADELAINE, THE NAVE.
Ink on Japanese paper.
COURTESY OF THE FOGG ART MUSEUM, HARVARD
UNIVERSITY.
GIFT OF E. W. FORBES.

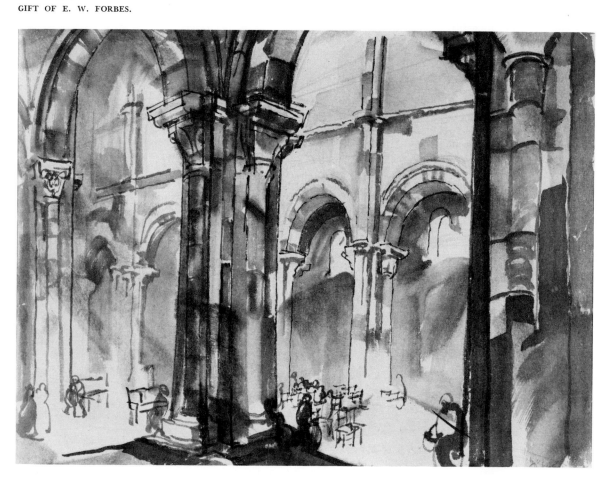

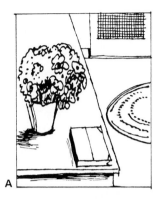

Illustration 10.6

*Overlapping (B) can help avoid isolated segments, as in A.*

When a section is unintentionally "severed" from the rest of a drawing, the two parts can be strongly joined through direction, rhythm, value, and texture, as in Cheruy's drawing, or by placing one or more forms in a position that crosses the boundary to join the parts together, as in Illustration 10.6B.

9. Imbalance: results from the visually uneven placement direction, density, and weight of the elements, and of the forms and spaces they create; also from the relationships that exist between them. It sometimes results from such an exclusive concern with a drawing's representational aspects that its intrinsic visual issues go unheeded. Balance is partly guided by intuitive reason, but cannot be consciously ignored. The artist's design strategy should include a tentative judgment about the scale and placement of the configuration on the page that will assist the drawing's balance.

To create a balanced drawing, the artist must cancel out visual forces that cause the design to appear to be falling or crowding to one side, or that give any other impressions of unresolved instabilities among its parts. There are two basic ways of cancelling out such forces. One answers a strong force on one side of the drawing with a similar force on the other side, as in Illustration 10.7A. This *symmetrical* solution, if too evenly established, can be rigidly formal, dull, and obvious. But when subtly used, it is a dependable way of producing equilibrium. In Rembrandt's drawing, "A Cottage among Trees" (Plate 10.7), and Villon's drawing, *"Etude Pour Cour de Ferne Cany Sur Therain"* (Plate 10.8), balance is achieved through roughly symmetrical forces. In both, a gentle curve, horizontally oriented and cresting near the drawing's center, describes the contour of the foreground's shape. In both, the curve's crest is the location of a strong mass that acts as a fulcrum for the rest of the drawing's forms and forces. Both artist's flank the central mass with other masses that bear some resemblance to each other. Rembrandt continues the symmetrical system in the fences and in the distant horizon, making them quite similar in many respects to their counterparts across the page. Villon repeats the diagonal lines in the sky with the lines in the foreground.

A second way to cancel out strong visual forces is to answer them with different but equally strong forces, as in Illustration 10.7B. This is an *asymmetrical* solution. Because asymmetry is the more prevalent state in nature, and because it offers unlimited design possibilities, asymmetry more frequently occurs in responsive drawings, as a glance at the drawings in the book show. In Ingres' drawing, "View of St. Peter's in Rome" (Plate 10.9), the placement of the cathedral to the left of center—its great facade and dome producing the strongest vertical directions in the drawing—is answered by the encircling sweep of the buildings, and by the forceful curve of the roofed colonnade in the foreground. The single vertical direction of the obelisk on the right adds its energy to the drawing's balance, and serves as a unifying echo of the vertical forces of the cathedral.

As mentioned in Chapter One, a gestural approach gives the artist an overview of the drawing's general compositional nature and needs. In many drawings where imbalance occurs, the failure to establish the design's basic gestural premise prevents their balanced realization.

10. The generalized drawing: suggests the artist's doubts about how to realize some of the smaller, more specific aspects of the subject and the design. Often, students establish quite handsome draw-

Illustration 10.7

*Balance through symmetry (A), and asymmetry (B).*

*Plate 10.7*

*Rembrandt van Rijn* (1606–69).
A Cottage Among Trees.
Pen and bistre.
THE METROPOLITAN MUSEUM OF ART.
BEQUEST OF MRS. H. O. HAVEMEYER, 1929.
THE H. O. HAVEMEYER COLLECTION.

*Plate 10.8*

*Jacques Villon* (1875–1963).
Etude Pour Cour de Ferne Cany Sur Thérain.
Pen and ink.
PRINT DEPARTMENT, BOSTON PUBLIC LIBRARY.

ings of the subject's generalities, and a good, equally generalized design, but seem unable to apply or sustain the attitudes and commitment that brought these broad states about in establishing the drawing's smaller units. Of course, many artists intend a simply stated image that avoids specificities, and some of the best drawings show an impressive economy; but all are *concise* rather than general. They may be simply stated, but they are rich in visual and expressive meaning.

In contrast, the generalized drawing only suggests possibilities and hints at conclusions. Its simplicities are often vague and seem more like tentative assumptions than convictions. Some students (and artists) make simple and general drawings in admiration of the economy of master drawings—and some do bear a superficial similarity to such drawings. But it is perceptual and organizational sensitivity, and not simple solutions for their own sake, that leads to concise drawing. For the student, these sensitivities are heightened by making drawings that probe, analyze, and declare conclusions about small as well

as major aspects of a subject, and their design on the page.

All student drawings need not be extensively developed to include a host of small, specific observations. But students need to develop the ability to state any specific detail to overcome unselective generality. They must, from time to time, reinforce the experience of applying the same degree of analysis and commitment to smaller units that is given to major ones. This is important for another reason. Just as the search for the broad essentials of a subject's differing parts helps the student to see relational similarities between them, in drawing the smaller forms he comes to see the subtle differences between similar parts. For example, while it would, at the outset, be important to see the similarity between the twigs of a branch and the fingers of a hand holding it, it is also important, later in the drawing, to be able to discern the differences between each twig and between each finger. Ironically, the insights that come from perceiving and responding to a subject's smaller actualities,

*Plate 10.9*

*Jean Auguste-Dominique Ingres* (1780–1867).
VIEW OF ST. PETER'S IN ROME.
Graphite pencil.
COURTESY OF THE ART INSTITUTE OF CHICAGO.

and controlling them in a system of expressive order, is the fastest and surest way to meaningful economy.

## EXPRESSIVE DEFECTS

Although, in the act of responsive drawing, perception, organization, and expression are interdependent considerations, the expression of our genuinely personal responses to a subject's abstract and representational meanings is the fundamental role of these considerations. Drawings in which our own expressive responses are stifled or disregarded, or fail to touch on important visual facts or inferences in the subject or organizational ones in the drawing, are either impersonal, confused, or derivative. The following expressive defects are some of the ways in which expression fails to participate in the responsive process.

1. Expressive reticence or blandness: suggests an over-concern with representational "correctness" or inhibitions towards the intuitive and emotive responses that modify perceptions. But, as observed in Chapter Nine, even this reticence is an expression of a felt attitude. The beholder senses a restraining of impulses that both empathy and intuitive knowledge demand. If the artist doesn't risk commitment to his responses at their deepest level, the beholder feels this hesitancy.

All art teachers are familiar with the student who makes conscientiously observed drawings that carefully avoid responses to the subject's visual and expressive potentialities. At one time the art academies insisted on just this kind of disciplined concentration on measurable matters. It constituted the main and sometimes only area of perceptual awareness. But such student drawings often appear leaden, lifeless. Drawings that avoid the abstract and emotive energies that create the graphic equivalent of life in responsive drawing *are* lifeless.

Here, it is helpful to compare two figurative drawings. They suggest the differences in attitude and result between an almost exclusively reportorial approach, and one that utilizes expressive impulses and impressions. The anonymous Dutch or German drawing, "Study of Ten Hands" (Plate 10.10), shows a great concentration on recording the observed changes in the terrain of each part, with little evident concern for the gestural, rhythmic flow within or between them. Here, each finger is drawn rather independently, with hardly a clue to its participation with others in forming greater units of form—or as engaged in pointing, gripping, or supporting actions. In almost every instance, there is no convincing impression that the arms really continue to exist

inside the sleeves. For all the concentration on individual volumes, many volume relationships do not convince. For example, in the middle drawing on the far left the structural means by which the forearm interlocks with the hand is unclear. Gradually, the *surfaces* of the hand are emphasized, rather than their structure, weight, power, and overall expressive character. Instead of a sense of each hand's essential character an accumulation of surface characteristics results. These hands "describe," but they do not "enact." The artist is skillful. Some passages, such as the hand in the lower left corner *do* begin to "live." But the drawing's stance basically comes from the scrutiny of small forms, rather than the perceptive and empathic comprehension of large ones. A clue to the artist's thinking occurs in the beginning stage of the pointing hand in the upper right half of the page. It is already a carefully delineated record of the outlines of the forms. Nowhere can we find a gestural or analytical line. Nowhere do lines express movement or energy.

Compare this start of a drawing with the several in Rubens' drawing, "Study of Cows" (Plate 10.11). A different kind of sensibility is at work here. In the upper left and right corners of the page and even in the more developed drawings in the lower right, lines search for the actions, pressures, and tensions of the forms of the animals. In these beginning stages, Rubens is not concerned with careful delineation, but with the rythmic flow between the forms, their structural nature, and the *feel* of their movement. The benefits to both the structural and expressive clarity of the drawings which include the intensifications that feelings demand is clear in the drawing of the three large cows. The artist's response to their ponderous bulk and weight, their slow movements, and to the powerful pressures and tensions created by the inner structural forms supporting and straining against the walls of the supported forms, has created convincing, living images of visual and expressive significance. All this is more than the result of scrutiny—it is the result of perceptions selected, altered, and ordered by *feelings*.

It is feelings, too, that causes Rubens to select (however subconsciously) an overall design that fans out toward the beholder: strong, curved movements sweeping to the left and right. Note the emphatic clarity of the forms. Heavy, interlocking, but rhythmically related masses, and line groups that move almost sensually upon the changing "topography" of the animals' forms, convey Rubens' emphatic understanding. These qualities, like the design itself, are strong, deliberate, and graceful. Compare Rubens' design with that of Plate 10.10. Again, there is a kind of restrained quality to the arrangement of the hands and arms. They form an overall checkerboard pattern, somewhat mechanical and monot-

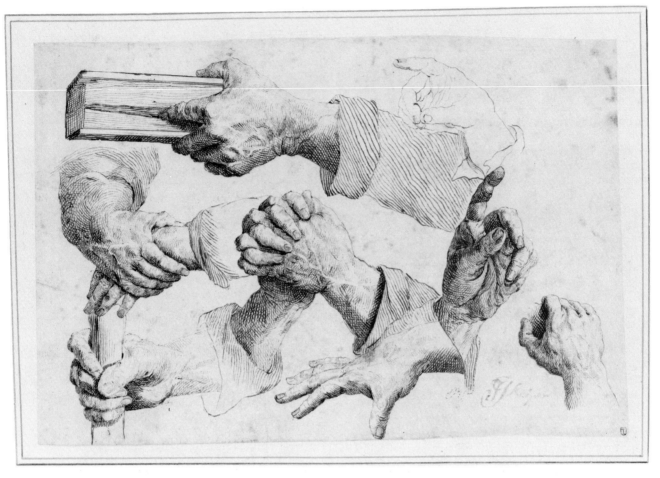

*Plate 10.10*

*Anonymous Dutch or German School.*
STUDY OF TEN HANDS.
Pen and brown ink.
THE NATIONAL GALLERY OF CANADA, OTTAWA.

onous. Unlike the design of the Rubens' drawing, this design seems rather unrelated to the character of the subject.

In the drawings that appear expressively constrained, more than a comfortable expression of felt responses is absent. They appear diminished in the clarity and force of their responses to the subject's measurable matters as well.

2. The literary or illustrative look: occurs when an artist is more concerned with storytelling, or with conveying some social, political, or religious message through a drawing's figurative matter than with creating a system of expressive design. Any literature or storytelling message can be a valid property of any drawing (Plates 3.8, 9.9, 9.20), but should never reduce the creative depth of a work.

Whether or not it does diminish a drawing's

aesthetic worth depends on the artist's ability to govern two quite different kinds of expression. As we have seen, some artists actually need an essentially nonvisual theme. For them, conveying a social, spiritual, or other kind of message, far from competing with the demands of expressive order, stimulates it and is, in turn, enhanced by it. When there is such an interwoven relationship between graphic expression and nonvisual meaning, the results (as many of the drawings in Chapter Nine show) do not appear illustrative. It is only when a literary theme overpowers the artist and compromises his aesthetic sensibilities, or when its demands are incompatible with them, that responses to both the subject and the drawing become less abstractly expressive, and more illustratively so. When pictorial and literary factors clash, the result may be an illustration with

some redeeming artistic worth, or a drawing weakened by the burden of nonvisual issues, but in either case, the result is a lessening of aesthetic depth.

To some extent, many of our responses to a subject's character, meaning, or mood are not directly visual issues. We cannot visually measure dignity, melancholy, or danger. But when such influences on response expand to become a drawing's dominant theme, emphasizing representational issues at the expense of its abstract graphic life, the result is illustration, not art. As mentioned earlier, some artists' creativity is stimulated by nonvisual ideas. Others, who may feel just as deeply about social, religious, or any other nonvisual issue, create works which do not address these issues through the figurative aspects of their drawings. If such "messages" appear, they are felt as intangible qualities of the drawing's content.

3. The picturesque air: is often sensed in works that, like illustrative ones, are more concerned with depiction than with expressive order. It results from a usually sentimental or romantic interpretation of a quaint, strange, or spectacular subject. Often such subjects do not belong to the artist's past or present environment. He comes to them because of their popularity, their exotic or unusual nature, or their literary interest. Sometimes these subjects are symbols of earlier societies. There are still windmills and covered bridges. And it is difficult to see them objectively —as no longer connected to the lives we lead. They have been drawn and painted countless times, often for illustrative purposes. We have all seen works that sentimentally praise such pastoral scenes. Any subject may always be valid, but it is harder to respond to those we have no real familiarity with, or those which have been used so often, so sentimentally. But almost any subject will appear picturesque when an interest in its illustrative and sentimental possibilities displaces an interest in its potentialities to stimulate and influence a system of expressive order.

4. The influenced drawing: usually lacks the conviction and daring felt in those drawings that caused the influence. Here, we are not discussing drawings that show a faint influence of an artist or a stylistic period. An artist, who by tempera-

*Plate 10.11*

*Peter Paul Rubens* (1577–1640). STUDIES OF COWS.
Pen and ink.
TRUSTEES OF THE BRITISH MUSEUM, LONDON.

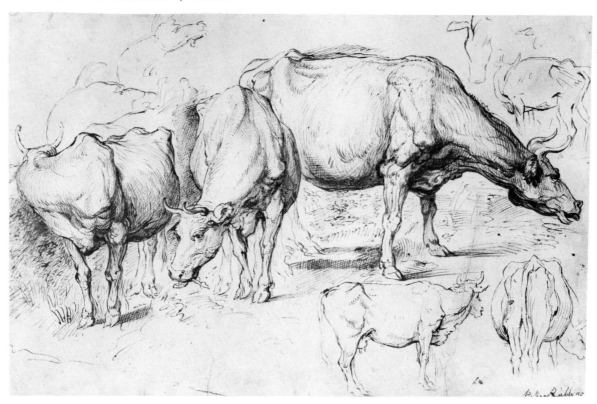

ment and aesthetic disposition finds a point of view "adjacent" to that of a colleague, master, or stylistic period, is bound to reflect some superficial similarities. Sometimes, such "influences" are merely coincidence. Artists whose drawings bear some similar characteristics may not ever have seen each other's works. But even when an artist is influenced, his work is essentially original if it is not restricted by, or imitative of the influencing works. It is not uncommon in the history of art for some artists to expand and develop concepts stimulated by the innovations of others.

But, as mentioned earlier, strong influences will not permit the expression of personal responses. An adopted manner is usually an imitation of a technique rather than a concept, but whichever it is, its presence always prevents the development of genuine creative ability.

The deeply influenced drawing is often unselectively dependent on the techniques and idiosyncracies of the admired artist. In his drawing, "Degradation of Haman Before Ahasuerus and Esther" (Plate 10.12), de Gelder combines many of Rembrandt's characteristics to summon up a Rembrandtesque image. But he only succeeds

Plate 10.12

*Aert de Gelder* (1645–1727).
THE DEGRADATION OF HAMAN BEFORE
AHASUERUS AND ESTHER.
Pen and ink and wash.
COURTESY OF THE ART INSTITUTE OF CHICAGO.

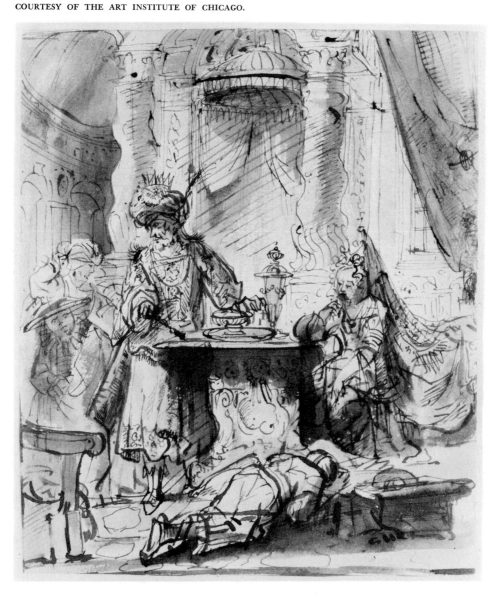

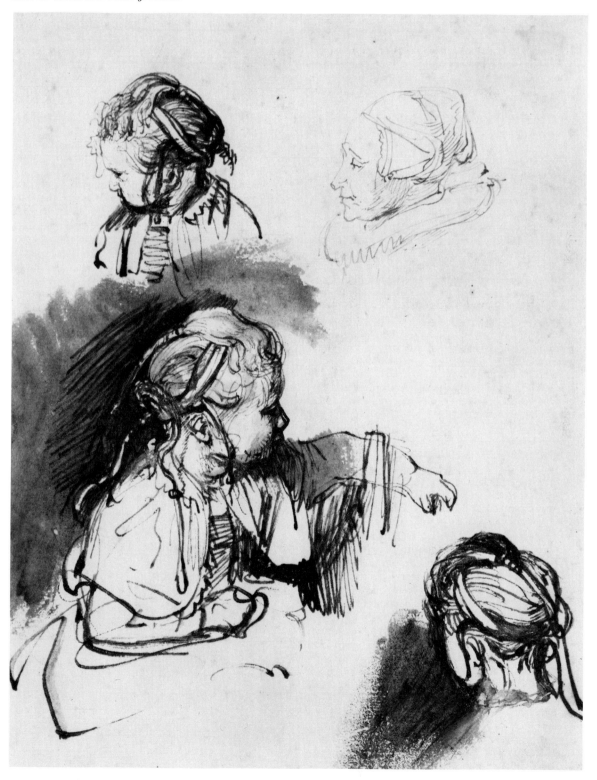

in imitating a number of Rembrandt's personal graphic devices. The marks *are* strongly reminiscent of Rembrandt's handling, but the image they add up to fails to convey Rembrandt's perceptual skill, or the relational and expressive nature of his drawings. In short, the image does not convey a Rembrandtesque *content*. How could it? The lines and tones that are *necessities* for Rembrandt—that result from his negotiations between perception, feeling, and intent—all serve to amplify his unique and deeply felt responses. No one can summon up another's sensibility, and no sensibility can create and sustain the results of another.

De Gelder's understanding of volume and design does not support the kinds of daring that are natural and necessary for Rembrandt. Note the evasive ambiguities in the forms of the figure. None of the heads or hands convey the weighty mass, the volume summary, the design or expressive force of comparable forms in a Rembrandt drawing. Compare the bold control of the heads and hands in Rembrandt's drawing, "Three Studies of a Child and one of an Old Woman" (Plate 10.13), with those in the de Gelder drawing. Note, too, that where Rembrandt creates a transition between broad and precise kinds of handling, de Gelder's changes in handling are abrupt inconsistencies that serve no visual or expressive purpose. Where Rembrandt's washes of tone are emphatic, conveying the impressions of light and volume, de Gelder's are uncertain—sometimes rather tightly encased by line, sometimes obscuring volume, and sometimes simply inconclusive and weak. They appear somewhat unrelated. The evenly-spaced diagonal lines that cross the center of the drawing, unlike the lines behind the seated child in Rembrandt's drawing, do not stay well back, but come forward and hover in space somewhere between the figure of Ahaseurus and the pillars in the background. De Gelder is uncertain about the perspective and the architectural forms on the far left, and some of those in the center background are left unclearly stated as volumes in space.

These are some of his drawing's defects. They suggest the limits of his perceptual, organizational, and empathic comprehension. No technique, or imitation of technical mastery can camouflage such limits. The attention and energy focused on the imitating of another's point of view obstructs those abilities the artist *does* have, and further weakens the results. But the heavily influenced student or artist who begins to trust and respect his own responses soon finds a satisfying natural freedom that imitation will never allow.

5. Conflictual meanings: are sensed when a drawing fails to convey a consistent visual attitude, mood, or handling. It is sometimes symptomatic of a disinterest or confusion concerning parts or aspects of a subject. But changes in goals and handling after a drawing has begun, for whatever reasons, can easily produce conflicting results. Such drawings suggest a weak grasp of those factors that establish unity. The freedom of response to a subject, and to its organized expression on the page does not extend to arbitrary changes in attitudes toward it or to its manner of presentation within the same drawing. For example, in a landscape drawing that is primarily tonal and concerned with aerial perspective, atmosphere, and mood, a sudden switch to a linear, diagrammatic exploration of the structural and spatial aspects of a house in one corner of the drawing is a glaring inconsistency (Illustration 10.8).

Such conflicting goals are not uncommon in student drawings. This understandably results from experiencing the many new ideas and challenges a good program of art study provides. But conflictual meanings violate one of the most fundamental ideas and challenges of any art form: the organizational and expressive need to sustain a single overall meaning. This does not mean that multiple goals are impossible in drawing. In the example above, both tonal and diagrammatic ideas *can* be quite compatible, if an interest in both is made an integral and consistent aspect of the drawing's expressive order.

Conflictual meanings may sometimes be sensed when a drawing's figurative expression is at variance with the expressive nature of the handling and design. For example, in a drawing of a figure performing some dramatic action requiring strong physical exertion a delicate, deliberate handling, and a design that stresses horizontal and vertical

*Illustration 10.8*

*The linear, diagrammatic handling of the house is an isolated and inconsistent departure from the tonal character of the drawing.*

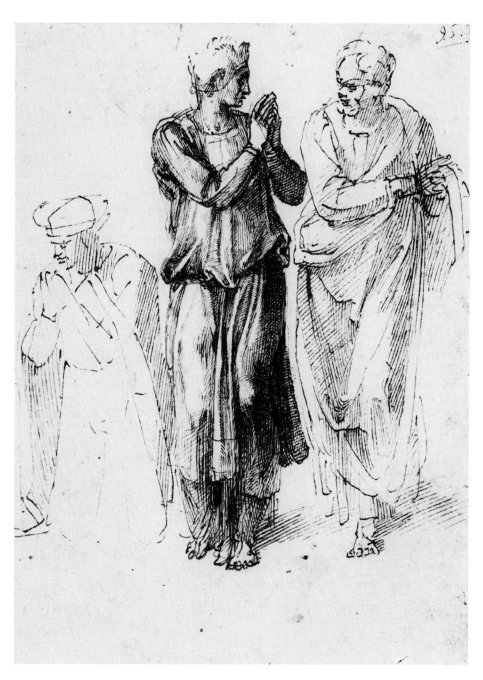

*Plate 10.14*

*Michelangelo Buonarroti* (1475–1564).
STUDIES OF FIGURES.
Pen and ink.
TEYLERS MUSEUM, HAARLEM, HOLLAND.

directions or otherwise appears tranquil or stately, will tend to weaken or contradict the figurative action.

Expression and order are the dimensions of an approach to drawing that will yield works that live. Beginning students so often become preoc-cupied with techniques and disregard the general responsive direction of their statement. Or, busy learning how to see, they lose sight of what it is they intend to convey. But techniques and per-ception are servants that perform best to the best demands. And the demands of a sensitive, analytical, and empathic sensibility, perceiving

and ordering in a personal way, creates original style. Style, in fact, is the key to our priorities.

We have examined many symptoms of basic weaknesses in responsive drawing. There are others, but those discussed should provide a basis for the evaluation of our drawings that further experience will broaden. In responsive drawing, the most pernicious, underlying cause of so many defects is the faulty perception that results from a sequential approach. As Michelangelo's drawing, "Studies of Figures" (Plate 10.14) so well demonstrates, beginning with a search for a subject's visual and expressive essentials provides the comprehension and the control that lead to sound drawing.

The order in which the problems was discussed roughly reflects the order in which many respon-sive drawings evolve. Although expressive re-sponses are among the first we make, we must first perceive. But we continue to respond, in a visual-expressive way, as we organize those per-ceptions on the page. This is when a drawing begins to have an organic life of its own. This synthesis of organized, empathic perceptions be-comes a responsive drawing.

What engages our thought and participation —as well as our admiration—in a responsive drawing is the activities that suggest choices and energies contending with each other. Their reso-lution into a system of expressive order invites us into the drawing—not merely to admire, but to participate in the negotiations that organized them into this living system.

11

# Conclusions

*As the Line Moves*

*In its own doing, points*
*Of feeling take shape. Design*
*Curves with the gestures of time.*
*The slow hand works to catch*
*A heart quick in its choice*
*Of meanings. What firm marks*
*Reveal and order, the mind*
*Feels while the drawing forms*
*Those inward places opened*
*By the line as it moves.*

MARTIN ROBBINS

We have shown the content of a responsive draw-ing to be the overall character of its representa-tional and abstract behavior—the total impact of its depictive, organizational, and expressive meaning. Content, then, is both the summary of the artist's interests and the character of his in-sights and responses. The quality of the artist's perceptual awareness, and the concepts, feelings, and intuitions that influence and shape his re-sponses, determine the quality of a responsive drawing's content.

But these influences of response are always limited and influenced by the quality of the art-ist's perceptual comprehension. We cannot inter-pret what we do not see. Whatever the personal ordering of our perceptions intends as a goal, the more penetrating our perceptual inquiry, the more creatively effective our drawings will be. As e.e. cummings wrote: "always the beautiful answer who asks a more beautiful question." Perceiving a subject's actualities objectively is important. But perception, as we have seen, in-volves more than the ability to measure. First, the artist must grasp a subject's visual and expres-sive essentials and organize them into some chal-lenging graphic theme. In this sense, our per-ceptual sensitivity finds subjects attractive to our aesthetic and temperamental interests, working as a kind of visual detector. It scans our environ-ment for a significant "contact." Our aesthetic and temperamental "receiver" seeks specific stim-uli. Drawing a subject that it does not find at-tracting usually produces weak results.

When a contact is made, a state of excitation occurs. The artist sees potentialities for creative expression in the subject's actualities and infer-ences, and is stimulated to draw. For some artists, almost any subject can trigger creative activity. Others, although just as perceptually sensitive,

are attracted by only a few subjects. But, not surprisingly, as the perceptual awareness of most students develops, the range of subjects they find attracting, increases.

An artist's interests are stimulated because of a rough, general kind of perceptual analysis. Some general ideas and impulses have formed in his mind. These perceptions will have included general information about most or all of the following: the subject's measurements and structure, its spatial behavior, the visual and expressive character of its representational and abstract actions, and its design potentialities. These considerations overlap because they are not seen independently in the subject. For example, perceptions of a subject's measurements *are simultaneously* perceptions of its spatial behavior and its representational and abstract action. These, additionally, become factors in the drawing's design.

Whichever of these perceptual interests first stimulates the artist to draw, the interrelationships between them soon lead to responses to the others. Their order of priority in the completed drawing—how much attention and development each of these considerations gets—determines an artist's style. Students who try to affect a style reverse an important order. Style should result from our aesthetic and temperamental sensibilities; it should not be imposed on them. As mentioned earlier, style is the key to our priorities, and our priorities, the key to our content. It is not altogether a matter of choice, but of aesthetic and temperamental necessity. One of the characteristics of great drawings is the artist's wholehearted acceptance of his own style and character. It is as if the drawing says for the artist, "here I am."

Sometimes, the first general perceptions and responses are themselves the artist's goal. This is often so in quick, preparatory drawings where the artist concentrates on a subject's essential visual and expressive themes—to use them in a major work in another medium.

The initial perceptions that stimulated Baglione's quick sketch, "Group of Four Figures" (Plate 11.1), appear to be the abstract visual energies of massed forms that generate the movement of the forms towards the right side of the page. This sense of movement is further conveyed by the tight enclosure of the picture-plane. Its "squeezing" pressure on the forms suggests their being forced toward the only open area within its boundaries, the space on the right. The sense of forms beginning to advance is also conveyed by the positions and gestures of the

four heads. Starting on the left, each seems more involved with movement. This is a good example of the union of representational and abstract actions. The idea of movement is suggested at both levels. The increasing tilt of the figures and the directional thrust of the lines that comprise them add to the sense of impending movement. Note that the figure nearest to the right side is "committed" to the moving action by being in an off-balanced position.

Because *these* visual ideas dominate the drawing, they reveal that the artist's primary interest is the sense of movement described above. Expression also occurs here at both the figurative and abstract, relational level. We can understand the human *and* plastic gestures. This drawing stresses what the figures and the elements that form them *do,* not what they look like, or stand for.

For Baglione to create this image, he had to perceive in the subject's actualities, the potentialities for the actions just discussed. In turn, these perceptions were possible because he had pre-set interests and instincts that responded to the group's movement. The scope of ideas and impulses that produce the stimulus to draw feeds upon our perceptions. But we can only perceive in the subject and in the emerging drawing what seems relevant to our intellectual and intuitive interests.

By drawing continually, and in examining other's drawings, we can deepen our appreciation for the need to see the relevant abstract and representational essentials in a subject, and in the drawing based upon it. If we do not consider the direction or length of an edge we do not really *see* it; if we disregard the relational possibilities in a subject or a drawing they remain invisible to us, and if we do not respond to the issues of balance and unity our drawings are not likely to possess either quality.

Baglione's quick drawing is profuse in the visual and expressive considerations of the responsive process, but he is responding only to the most general of the subject's properties and design potentialities. Baglione extracts these general essentials to establish the general essentials of an expressive design.

But Snyders, in his drawing, "Study of a Boar's Head" (Plate 11.2), probes and analyzes his subject's forms and forces more deeply. He emphasizes an almost symmetrical design. Part of the design's great energy comes from the subject's smaller forms. Snyders emphasizes the rhythmic curving of forms to the left and right of an invisible border which is the vertical midline

*Plate 11.1*

Attributed to Cavaliere Giovanni Baglione
(C. 1573–1644).
GROUP OF FOUR FIGURES.
Pen, brown ink and brown wash.
THE NATIONAL GALLERY OF CANADA.

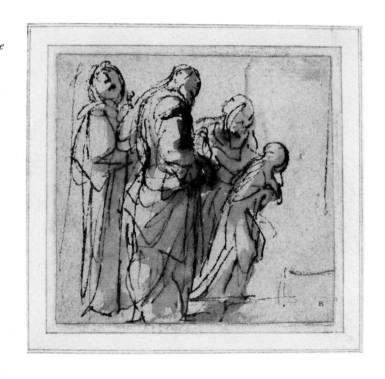

*Plate 11.2*

Frans Snyders (1579–1657). STUDY OF A BOAR'S HEAD.
Pen, brown ink and brown wash.
TRUSTEES OF THE BRITISH MUSEUM, LONDON.

of the boar's head. Tusks, ears, and fur "rush" away from this unseen axis with a force that energizes the image. As in Baglione's drawing, movement is a strong theme; but here, volume is also conveyed with emphatic clarity and force. Were the boar's head drawn on a horizontal axis, the sense of symmetry might appear obvious and monotonous. By tilting the head to the right and counter-balancing it with dark tones

*Plate 11.3*

*Paul Cézanne* (1839–1906). Page from a sketchbook. A CORNER OF THE STUDIO. Pencil.

COURTESY OF THE FOGG ART MUSEUM, HARVARD UNIVERSITY.

BEQUEST—MARIAN H. PHINNEY.

on its left side, Snyders modifies the symmetry, establishing a more interesting compositional idea.

The forms in this drawing are more fully realized than those in Baglione's. It is clear that Snyders' initial stimulation here results mostly from his perceptions of the visual-expressive actions we see in the completed drawing. Probably, Snyders began by establishing these actions in the larger forms, as Baglione did. As we have seen, most responsive drawings begin with some kind of gestural search.

Had Baglione developed his drawing further, it would not have evolved in a way that would deny the general responses already established. It would have been developed by the inclusion of smaller relationships, supporting and strengthening the general responses. When we begin to draw, the initial perceptual grasp—the general interpretation—usually determines the kind and range of responses to follow.

To advance a drawing past the first, broad essentials does require perceptions different from those used to establish the first general responses. The initial responses depend on the ability to summarize our perceptions. Developing a subject's smaller specifics requires an ability to see those differences that support the summary. Snyders is fairly specific in explaining the differences between shapes, forms, values, and textures; but the marks that explain these differences are all simultaneously engaged in developing the drawing's expressive design. They do not merely render.

To perceive relationships between unlike forms, and contrasts between like ones, requires an ability to differentiate between a form's measurable facts and its visual-expressive behavior. Obviously, good perceptual skill must be sensitive to both of these considerations.

Good perceptual skill must also be sensitive to the needs of the emerging design. Chapters Eight and Nine pointed out that responses to the subject, once translated to the page, stimulate new responses—those which meet the organizational and expressive needs of the subject on the page. Sometimes, the initial stimulus comes not only from qualities perceived in the subject, but also to their potentialities in an expressive design. Baglione's first impulse, as we have seen, is to establish a general system of visual and expressive forces. Unlike Snyders, who emphasizes the relational aspects *within* the configuration, Baglione stresses the configuration's relationship *with the page*. But both artists respond to both considerations.

Relying on the perceptual analysis of a subject's measurable matters alone, we miss the visual-expressive forces within it, and fail to benefit from the relational energies between the configuration and the page.

Because sensitive perceptual awareness includes empathic impressions, we *can* speak of the perception of expressive, as well as visual factors. As we have seen, relational activities are always both visual and expressive. A response to one factor is to some extent a response to the other. Here, we are considering the expressive qualities that exist in the actions and energies of the marks and the elements they form. The expressive character of a subject's representational state is, of course, an additional influence on response.

Some of the expressive quality in Cezanne's drawing, "A Corner of the Studio" (Plate 11.3), comes from the character and function of the lines and tones. They deliberately weave a large, stable cross that almost fills the page. Against this stationary design, the paper-like forms appear to move in a gentle arc. The lines and tones throughout the drawing appear to change from fluid states to firm ones. Forms slip in and out of focus. The figurative aspects of the objects depicted conveys little expressive meaning. There is little in this collection of studio paraphernalia that is really engaging. It is only when we react to Cezanne's interpretation of their planes and shapes arranged to suggest both second- and third-dimensional activities—through an intentionally ambiguous system of selections and stresses—that our emotions can become engaged. Only then do the lines and tones and the activity they convey effect our empathic sensibilities—as Cezanne's were. The patient, critical adjustments of movements and edges, of tones and shapes, the delicate overall balance of the elements comes from a profoundly acute and deeply committed perceptual skill. The nature of the marks, as well as the nature of the activities they relate, suggest Cezanne's concerned involvement. The artist's interests are focused on a balanced resolution of visual forces, but expression, even if subconscious and muted, is part of the drawing's content.

Bonnard's sensitivity to the visual-expressive design needed to convey his meaning in "Standing Nude" (Plate 11.4), guides him to a strategy that does not rely on bold relational activity. Bonnard wants an unfocused image. The figure's forms are shown as fluid and soft, their structure is only lightly suggested. The gentle changes in value, the soft, curving lines of the figure, and

*Plate 11.4*

*Pierre Bonnard* (1867–1947). NUDE STANDING. Charcoal.
THE METROPOLITAN MUSEUM OF ART, HARRIS BRISBANE DICK FUND.

the foggy texture of the charcoal medium all promote an impressionistic air. It is even hard to tell whether this is an interior or outdoor scene. Bonnard's attitude to the visual-expressive design is consistent with his interpretation of the figure and is an extension of his responses to the figure. These are not the kinds of ambiguity that come from innocence or indecision. Each is a felt, and—if we can use the term in describing

Plate 11.5

*Giovanni Domenico Tiepolo* (1727–1804).
A Sheet of Sketches.
Brush and bistre wash.
COURTESY OF THE FOGG ART MUSEUM, HARVARD
UNIVERSITY.
GIFT—DR. DENMAN W. ROSS.

Plate 11.6

*Henri Matisse* (1869–1954).
Seated Woman with Hat and Gown.
Pencil.
COURTESY OF THE FOGG ART MUSEUM, HARVARD
UNIVERSITY.
GRENVILLE L. WINTHROP BEQUEST.

a deliberate generality—"precise" response to a design where a hushed, gentle air is intended.

The easy stimulation of our creative instincts by things in nature, the ability to apprehend a subject's general and specific characteristics, and the ability to order our responses into a visual-expressive design are all determined by our perceptual awareness. Again, we cannot see what we do not regard or know.

The development of both our perceptual acuity and our level of response is best achieved by drawings that push the limits of our ability to see and to act. Increasing perceptual understanding and responsive options is a necessity to the growing creative personality. The best artists have always been engrossed students all of their lives. Tiepolo's drawing, "A Sheet of Sketches" (Plate 11.5), contains an anatomical study of a leg, several studies of strongly illuminated heads, and several fragmentary, gestural explorations of parts of the figure. Here, there is no attempt at picture-making—he has no "product" in mind. Rather, Tiepolo is searching for perceptions about volume, light, anatomy, and the general characteristics of human forms. And, responses are being affected. Note the similarity *and* differences between the two centrally placed heads looking to the right. The upper, more carefully developed of the two, shows values used sparingly in the face. Here, lines carry the major responsibility for conveying volume. Below, the same forms are boldly brushed in by dark washes and there is almost no use of line. In these heads, the artist seems to be testing different responsive solutions to the same forms.

Sketchbook studies such as Tiepolo's, in which no *conscious* compositional design is intended, or preparatory drawings, such as Matisse's "Seated Woman with Hat and Gown" (Study For the White Plume) (Plate 11.6) which *are* conceived as designs, are, like all good drawings, attempts to expand perception and response. But because these are both preliminary studies for other works, they show more clearly the searching, changing nature of drawings that are meant to deepen the artist's own understanding. Note the changes in the hat, shoulder, and chair in the Matisse drawing, and also the probing diagrammatic lines of the underdrawing.

Settling for standards that fall just short of the limits of our comprehension and control helps to consolidate what we know—and certainly there is a time to do that. We may, on occasion, wisely choose to explore the possibilities of as much as we can see and do. We should strive to be masters of as much as we understand. But artistic growth comes from an open and flexible attitude to any changes suggested by our experiences in responsive drawings that question and risk, and by our educational, cultural, and social experiences.

One of the inevitable characteristics of good perceptual and conceptual growth is the increasing economy of the means which convey meanings. In responsive drawing, as in any other creative process, organizationally unengaged or repetitive elements are illogical because they are unnecessary, and weakening because they are a burden on the completed system.

But the meaning of economy is not limited to these two factors. In art, economy reveals profound understanding. As the architect Mees Van der Rohe said, "less is more." Of any two drawings of a subject, alike in every respect but that of the means used to state them, the simpler of the two is universally felt to be more aesthetically satisfying. It reveals a more inclusive grasp of the subject's structural, relational, and expressive character, permitting bolder summaries. When a subject's essence is as economically expressed as the artist's aesthetic and temperamental interests permit, the magnitude of his perceptual and responsive powers is revealed. As Henry James observed, "In art economy is always beauty."

But economy, like any other quality in art, when it becomes a conscious goal—an effect—obstructs the sensitive perceptual and responsive behavior necessary to its natural emergence in the context of an artist's creative interests. And economy must always be judged in the context of a drawing's overall meaning. What is an economical grasp of the *necessary* issues for one artist could be excessive elaboration for another. In Bloom's drawing, "Landscape #14" (Plate 11.7), the subtle transforming of limbs and branches into wraith-like animals and humans, and the straining or windswept action of other branches, hand-like in their movements, conveys a bereaved, spirit-haunted mood. Bloom seems to intend the choked, intertwined forms to be everywhere engaged in movement and change. The sense of these foreboding interactions and transfigurations as emerging from and subsiding into the matrix of limbs and branches benefits from the amount and complexity of these forms. But within the context of the artist's intent, this is an economically stated drawing. The form and space are as directly and simply stated as the artist's visual-expressive needs permit. Although a complex drawing, there are no irrelevant

*Plate 11.8*

*Jean-Baptiste-Camille Corot* (1796–1875).
DISTANT VIEW OF THE PALAZZO CHIGI AT ARICCIA.
Pen and brown ink.
THE NATIONAL GALLERY OF CANADA, OTTAWA.

passages, no overworked forms or unnecessary details.

Corot's drawing, "Distant View of the Palazzo Chigi at Ariccia" (Plate 11.8), is an impressive summary of a panoramic view. Here, an economy of means reduces many complex facts about the placement of forms in space, and many relational ideas into "simple" lucid statements. For example, the artist shows the differences between the rocks' weight and hardness and the trees' relatively light, soft nature, by simply varying the density, speed, and straightness of the lines.

And doing so creates an interesting contrast of line actions. Close examination will show just how few marks are being used to convey intricate representational and abstract issues.

In a surprisingly contemporary-looking drawing, "A Harvest Still-Life" (Plate 11.9), Genoels reduces his subject to a system of nervously animated lines that convey a sense of both the second and third dimension. Here, the economical use of line strengthens the sense of decorative pattern.

Turner's drawing, "Stonehenge at Daybreak"

*Plate 11.9*

*Abraham Genoels* (1640–1723). A HARVEST STILL-LIFE.
Pen and brown ink.
COURTESY OF THE FOGG ART MUSEUM, HARVARD
UNIVERSITY.
GIFT OF MR. AND MRS. CHARLES E. SLATKIN.

(Plate 11.10), shows how much can be suggested with a few bold washes of tone. Here, delineating lines are absent altogether. Turner conveys the impression of a dawn landscape in a broad, painterly handling guided by powerful perceptual skill and a determined goal. Note how clearly this "simple" handling depicts grazing sheep, coach and horses, and a sense of vast space.

Rembrandt's drawing, "A Winter Landscape" (Plate 11.11), is a masterpiece of economy. The drawing's design of fast and slow directional movements, enacting the same undulations as the snow covered surfaces, is completely fused with the character of the representational matter. In a drawing of about one hundred lines and a few washes of tone, the artist conveys impressions of linear and aerial perspective, snow-laden shrubs, fields, road, and rooftops. He even suggests the quality of the light, and the feel of a silent, still, winter day. Such a limitation of means strengthens, rather than restricts the artist's visual-expressive intent. Such self-imposed limitations should not be hurdles but necessary confines that intensify meanings. Goethe may have had this in mind when he observed, "It is in self-limitation that the master first shows himself." Economy such as Rembrandt's demands exquisite perceptual apprehension and responses shaped by a lifetime of analytical and empathic interest in nature and in the relational life of marks on a flat surface.

Obviously, the best and fastest way to heighten our perceptual and conceptual powers is to draw as much as possible. But our drawings should

Plate 11.10

*J. M. W. Turner* (1775–1851).
STONEHENGE AT DAYBREAK.
Wash drawing.
COURTESY, MUSEUM OF FINE ARTS, BOSTON.
GIFT OF THE ESTATE OF ELLEN T. BULLARD.

Plate 11.11

*Rembrandt van Rijn* (1606–69).
A WINTER LANDSCAPE.
Reed pen and bistre wash.
COURTESY OF THE FOGG ART MUSEUM, HARVARD
UNIVERSITY.
BEQUEST OF CHARLES A. LOESER.

not repeat old inadequacies. If drawings are not formed by a demanding level of analysis and response, if they do not reflect the visual-expressive life of the image, or if they are not balanced and unified, they only strengthen the grip of old habits.

This book has been largely concerned with concepts that broaden the range of responsive options, and thus with the breaking of older, restricting concepts. A final suggestion to deepen our grasp of drawing is appropriate here. Courses in sculpture, to more directly experience the issues of structural volume, and in two- and three-dimensional design, to more fully explore the relational life of the elements and the organizational possibilities they hold, are most useful. They provide the student with information and insights about responses to the subject and the design, too often obscured in the study of drawing. And because our attitudes toward sculpture and design are less likely to be encased in our early old habits of procedure or prejudice, their study helps to hasten the breakup of old notions about drawing. And old habits *are* insistent. Beginning a drawing by the search for the subject's gestural character, is for most students, an uncomfortably daring step. Many hesitate and resist. Although

they may accept the logic that a cautious collection of parts cannot succeed, the familiarity of this old habit seems preferable to the anticipated "chaos" of a free, penetrating search. And sometimes, the first few attempts at gestural drawing *are* chaotic. It is natural to falter in an unfamiliar process. Here, a trust in the basic principle that governs any building process, the emergence of large essentials before small specifics, may help the student over his first crucial barrier to responsive drawing. Once experienced, the many dividends of the gestural approach described in Chapter One make a retreat to a sequential approach unlikely.

We began with gesture, and we return to it. Its importance cannot be overstressed. Even if, as we develop our individual approach to drawing, the gestural aspects are reduced to a few, faint suggestions, or even mostly just held in the mind, to accept the principle of drawing from generalities to specifics is the symbolic as well as the actual reversal of the cautious, accumulative approach. In whatever way we adjust the search for gestural expression, beginning with the broad essentials before arriving at our own necessary particulars is the best mode of entry into the world of responsive drawing.

# Bibliography

The books listed below are recommended for general reading, and for further information about perspective, media, and materials. The list does not include those books already mentioned in the footnotes.

## GENERAL TEXTS

ANDERSON, DONALD M., *Elements of Design*. New York: Holt, Rinehart and Winston, Inc., 1961.

BLAKE, VERNON, *The Art and Craft of Drawing*. London: Oxford University Press, Inc., 1927.

CHAET, BERNARD. *The Art of Drawing*. New York: Holt, Rinehart and Winston, Inc., 1970.

COLLIER, GRAHAM, *Form, Space and Vision* (3rd ed.) Englewood Cliffs, N.J.: Prentice-Hall, Inc. 1972.

DE TOLNAY, CHARLES, *History and Technique of Old Master Drawings*. New York: H. Bittner & Co., 1943.

HAYES, COLIN, *Grammar of Drawing for Artists and Designers*. Studio Vista, London: Van Nostrand Reinhold Company, 1969.

HILL, EDWARD, *The Language of Drawing*. Englewood Cliffs, N.J.: Prentice-Hall, Inc., 1966.

MENDELOWITZ, DANIEL M., *Drawing*. New York: Holt, Rinehart and Winston, Inc., 1967.

MOSKOWITZ, IRA (ed.), *Great Drawings of All Time* (4 vols.). New York: Shorewood Publishers, Inc., 1962.

SACHS, PAUL J., *Modern Prints and Drawings*. New York: Alfred A. Knopf, Inc., 1954.

## ON PERSPECTIVE

BALLINGER, LOUISE, *Perspective, Space and Design*. New York: Van Nostrand Reinhold Company, 1969.

BURNETT, CALVIN, *Objective Drawing Techniques*. New York: Van Nostrand Reinhold Company, 1966.

COLE, REX V., *Perspective: The Practice and Theory of Perspective as Applied to Pictures*. New York: Dover Publications, Inc., 1927.

NORLING, ERNEST R., *Perspective Made Easy*. New York: The Macmillan Company, 1939.

WATSON, ERNEST W., *How to Use Creative Perspective*. New York: Reinhold Publishing Co., 1960.

WHITE, JOHN, *The Birth and Rebirth of Pictorial Space*. London: Faber and Faber Ltd., 1957.

## ON MEDIA AND MATERIALS

DOERNER, MAX, *The Materials of the Artist and Their Use in Painting*, Eugen Neuhaus, trans. New York: Harcourt, Brace Jovanovich, Inc., 1934.

DOLLOFF, FRANCIS W. and ROY L. PERKINSON, *How to Care for Works of Art on Paper*. Boston: Museum of Fine Arts, Boston, 1971.

KAY, REED, *The Painter's Guide to Studio Methods and Materials*. Garden City, New York: Doubleday & Company, Inc., 1972.

MAYER, RALPH W., *The Artist's Handbook of Materials and Techniques* (rev.). New York: The Viking Press, Inc., 1970.

WATROUS, JAMES, *The Craft of Old Master Drawings*. Madison, Wisc.: University of Wisconsin Press, 1957.

# Index